ANDRE MASSON

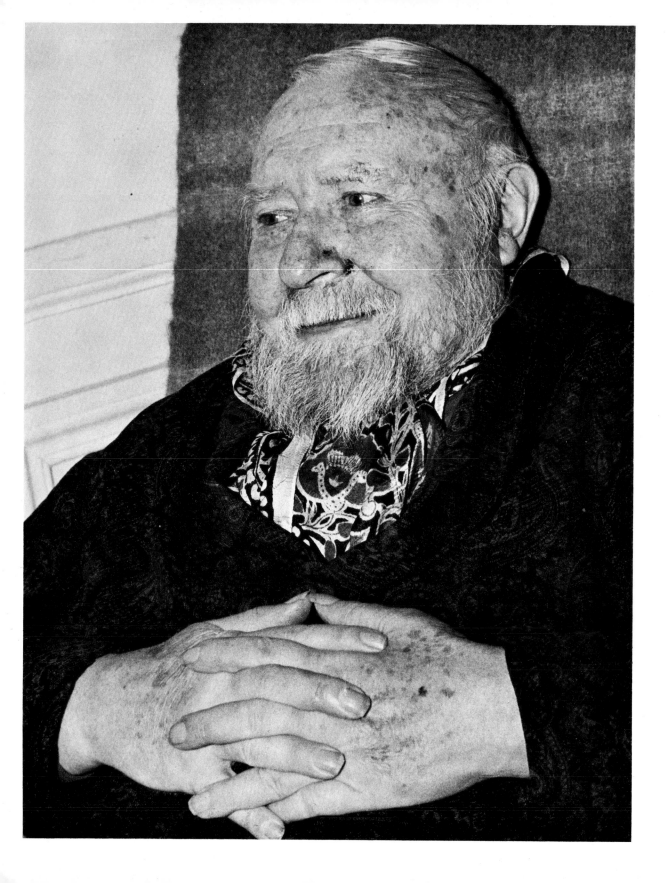

ANDRE MASSON

BY

WILLIAM RUBIN

AND

CAROLYN LANCHNER

THE MUSEUM

OF MODERN ART

NEW YORK

Copyright © 1976 by The Museum of Modern Art
All rights reserved
Library of Congress Catalog Card Number 76-1492
Clothbound ISBN 0-87070-465-6
Paperbound ISBN 0-87070-464-8
Designed by Carl Laanes
Type set by Custom Composition, Inc., York, Pa.
Printed by Rae Publishing Co., Inc., Cedar Grove, N.J.

The Museum of Modern Art
11 West 53 Street
New York, N.Y. 10019
Printed in the United States of America

Cover: Detail from *Entanglement*. 1941
Frontispiece: André Masson. Paris, 1976

ILLUSTRATIONS

Page numbers marked with an asterisk indicate works reproduced in color.

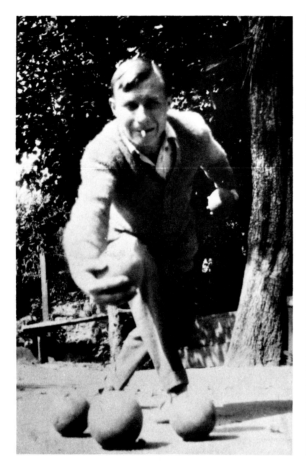

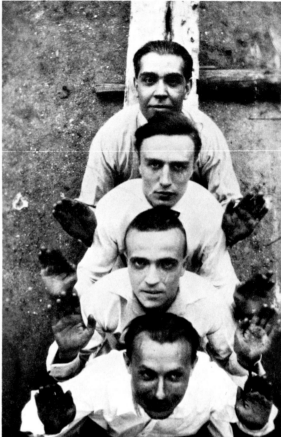

André Masson.
Plestin-les-Grèves. 1923

André Masson (foreground),
Michel Leiris, Roland Tual, Juan Gris.
Nemours-près-Fontainebleau. 1924

ACKNOWLEDGMENTS

A BOOK SUCH as this requires the assistance and collaboration of many people. We have been most fortunate in the help we have received and the goodwill with which it was given. Foremost among those to whom we wish to express our gratitude is André Masson himself. Much of the documentation cited in this volume (all quotations from the artist for which no source is indicated derive from direct conversations) comes from discussions—some of which go back twenty-five years—with the artist. In the last two years, during the preparation of this monograph and its accompanying exhibition, Masson has, despite personal inconvenience, made himself accessible at all times and responded not only with generosity and forbearance, but often with beguiling wit to sometimes tedious questioning regarding dates and events long passed. Masson's wife, Rose, has also been a paragon of patience in giving us of her time and in clarifying many matters relating both to this volume and the retrospective exhibition.

Of the several dealers who have kindly provided us with photographs and documentation, we must first extend our thanks to the Galerie Louise Leiris. Its directors, Daniel-Henry Kahnweiler, Louise Leiris, and Maurice Jardot, have opened their extensive files to us, supplied us with many photographs, and in every way been unfailingly helpful. For the many hours spent assembling material for us we also wish to thank Bernard Lirman and Jeanne Chenuet of the gallery staff. Lawrence M. Saphire of the Blue Moon and Lerner-Heller Galleries, New York, and Eleanore Saidenberg of the Saidenberg Gallery, New York, deserve our special gratitude, as does Michael Hertz of the Michael Hertz Gallery, Bremen.

We are indebted to Frances Beatty, doctoral candidate at Columbia University, not only for the preparation of the Chronology, but for her generosity in putting at our disposal the results of her considerable research on Masson's work of the twenties. Doris Birmingham, doctoral candidate at the University of Michigan, has also kindly allowed us to benefit from her research on Masson's American period. The extended citations from the French in "André Masson: Origins and Development" have been translated by Robert Bullen and Rosette Letellier.

Random House, Inc., has kindly granted permission to quote from "Musée des Beaux Arts," reprinted from W. H. Auden's *Collected Shorter Poems, 1927–1957,* copyright 1940 and renewed 1968 by W. H. Auden, all rights reserved. Viking Penguin, Inc., has granted permission to quote from "Tortoise Shout," reprinted from *The Complete Poems of D. H. Lawrence,* edited by Vivian de Sola Pinto and F. Warren Roberts, copyright 1964, 1971 by Angelo Ravagli and C. M. Weekley, executors of the estate of Frieda Lawrence Ravagli, all rights reserved.

Many members of the Museum staff have made important contributions to the book and its accompanying exhibition. Principal among them is Charlotte Kantz, curatorial assistant in the Department of Painting and Sculpture. She has been tireless, patient, and skillful in coordinating a multitude of tasks relating to both the publication and the exhibition. Sharon McIntosh has been involved in almost every aspect of this project; once again her efficiency has lightened the load for all who have worked with her. Bonnie Nielson-Lowe, Diane Farynyk, and Ruth Priever typed much of the manuscript.

Special acknowledgment is due to Francis Kloeppel, whose expert editing, unfailing diplomacy, and perceptive suggestions have been invaluable. Other special expressions of thanks must go to Carl Laanes, whose design for the book expanded our own conception of it, and to Jack Doenias, who ably saw the volume through production. Frances Keech handled many details of correspondence for permissions. Inga Forslund prepared the Bibliography with her accustomed diligence and skill.

Other staff members whose valuable contributions apply particularly to the exhibition are Jane Adlin, Senior Cataloguer, Betty Burnham, Associate Registrar, Jean Volkmer, Chief Conservator, Antoinette King, Senior Paper Conservator, Richard L. Palmer, Coordinator of Exhibitions, and his assistant Rosette Bakish.

Although it is not possible to list all those who have liberally given of their time and knowledge, we gratefully acknowledge all such assistance. Among those who have been especially helpful are Jane Sabersky, Stanley William Hayter, and Archibald MacLeish.

W. R., C. L.

ANDRE MASSON
AND
TWENTIETH-CENTURY PAINTING

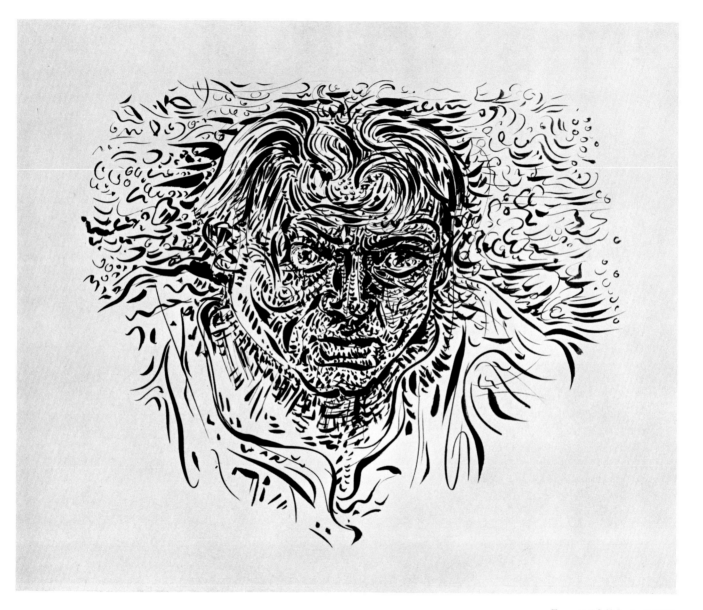

Torrential Self-Portrait. **1945.**
Ink, 18⅞ x 24″.
Collection Rose Masson, Paris

ANDRÉ MASSON is fond of saying that his painting is too Surrealist for those who disliked Surrealism and not Surrealist enough for the true believers. Indeed, though some of his work was enthusiastically received by even the most orthodox Surrealists, accounts of Surrealist painting by Surrealist critics have, in fact, treated him as a somewhat alien figure. One major history of Surrealism, for example, sees him as less significant to the movement than Oscar Dominguez.[1]

The gulf between Masson's painting and that of the other Surrealists of record is, however, illusory to the extent that it follows from a definition of the movement's art proposed by writers formed by the Surrealism of the thirties, when Surrealist taste was very different from what it had been in the pioneer years of the movement (1924-29) or was to be during its World War II exile in the United States. This body of writing reinforced the image of Surrealist painting—based largely on news-media publicity of the thirties—which was epitomized by the illusionistic "dream imagery" of painters such as Magritte, Tanguy, and Dali. While this kind of painting was in fact central to Surrealism at the end of the twenties and remained so for the next decade, it nevertheless represented only one side of Surrealist art, and not necessarily its best. The definition of Surrealist art it exemplifies leaves little room for the work of either Miró or Masson, both of whom were pioneer painters in the movement; it also requires a rather one-sided view of the art of Max Ernst. A broader, more historically accurate view of Surrealist art would encompass two kinds of painting, one abstract, the other illusionist, each engaged in a common search for a poetic art (peinture-poésie).

Such a revised public perception of Surrealist art must begin with the fact that the painting of the movement's pioneer years—the five years separating the first manifesto (1924) and the second (1929)—was primarily of a nonillusionist type. Dominated by the styles of Miró and Masson and the relatively abstract work of Ernst during that period,[2] it reposed largely on the technique of automatism, which was at the center of the definition of Surrealism in the first manifesto.[3] The pictorial poetry of the pioneers thus derived from a practice analogous to Freud's "free association." The "hand-painted dream photography" of Dali, who confirmed the direction of the second wave in 1929, had its parentage in the psychoanalytically inspired narrations of dreams, the récits de rêves. The imagery of the latter depended on a collaging of motifs realized in a

Notes to this text begin on page 76.

trompe-l'oeil technique whose deep perspectival space and modeling in the round produced an almost academic illusionism. That of the former was arrived at through automatism and improvisation. These two forms of Surrealist painting were not exclusive, however, and certain painters, notably Ernst, tended to move freely from one to the other, or to combine their elements.

All the pioneers working in a relatively abstract manner between 1924 and 1929—Masson, Miró, Ernst, and Arp (who had been assimilated to the movement)[4]—had, significantly, experienced Cubism and knew the work of Klee. The main influence on the others, the illusionist imagiers, was the spatial theater of de Chirico with its unexpected, collage-like juxtapositions of motifs. It should be observed, however, that all Surrealist painters, whatever their methods, proceeded "in favor of the image," to use Breton's phrase. The word "abstract" must therefore be understood differently than in the work of a Braque or Matisse—and certainly that of a Mondrian or Rothko. The Surrealists never made nonfigurative pictures. No matter how abstract certain works by Miró, Masson, or Arp might appear, they always allude, however elliptically, to a subject. The Cubists and Fauvists selected motifs in the real world but worked away from them. The Surrealists eschewed perceptual starting points and worked toward an interior image, whether this was conjured improvisationally through automatism or recorded illusionistically from the screen of the mind's eye.

Neither Masson, who responded primarily to Analytic Cubism, nor Miró, who was more influenced by the Synthetic form of the style, had any intention of enlarging or continuing Cubism. On the contrary, they belonged to a generation avowedly in revolt against everything for which Cubism stood. At the center of this reaction was the need to reject "pure painting" (peinture-peinture or peinture pure), of which Cubism was considered at once the paradigm and symbol. When Miró announced, "I shall break their [the Cubists'] guitar," he was attacking the putatively Cubist idea that the motif of a picture should be a mere studio prop, serving simply as a pretext for autonomous visual structures that contained the "real" meaning.[5] Surrealist painters intended to come to grips once more with subjects inherently more important than the pictures that illustrated them. Birth, death, sex, war, and the unplumbed recesses of the mind—none of which seemed to matter in Cubist painting—would return to

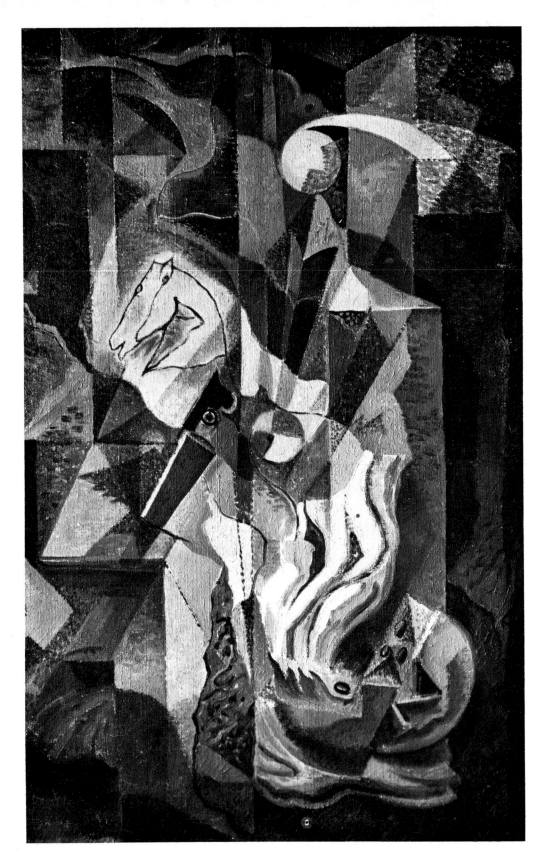

The Constellations. 1925.
Oil on canvas,
39⅜ x 25⅝".
Collection
Simone Collinet, Paris

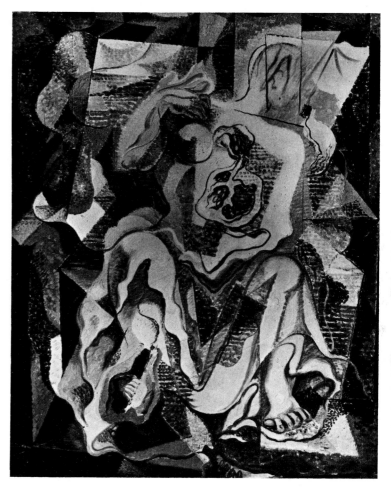

Woman. 1925.
Oil on canvas, 28¾ x 23⅝".
Collection Larivière, Montreal

the center of the picture-making process, not in the form of direct illustration, as had been the case in earlier art, but through the indirect, allusive means of a poetic imagery based on imagination rather than perception.

The anti-Cubist rhetoric engaged in by even the most abstract Surrealists masked two facts of which they were nevertheless at least partially aware at the time and which they were later to acknowledge freely. The need to "put down" Cubism, the art of the previous generation, whose abstractness, whose disengagement from the particulars of political, social, and psychological life, had seemingly been discredited by the crises of World War I,[6] obscured the fact that Cubism—even in its High Analytic form—was far from "pure." If it is only in recent criticism that the richness of Cubism's poetic content has been measured,[7] the Surrealists were certainly cognizant of its presence—not simply in the fragments of texts inscribed on the surfaces,[8] but in the choice of motifs and even in such plastic elements as the light and space.

At the same time, Masson, Miró, and Ernst were cognizant—if not fully—of the dependence of their work of the middle and late twenties on the formal structure of Cubism, notably in the scaffolding of the pictures, their distribution of accents, and their shallow space. In this regard, the beautiful Massons of 1924–25 are exemplary. The content of these pictures is Surrealist, their syntax largely Cubist. Even in the sand paintings of 1926–27, where the Cubism would cease to be apparent in Masson's work, it would still constitute its infrastructure.

THE OFTEN HYBRID subjects of Masson's pictures of the middle twenties (pp. 17, 18) suggest a constant state of generation, eclosion, and metamorphosis. Horses become celestial signs—an allusion, perhaps, to the Dioscuri—while architecture dissolves into humanoid forms; the limbs and extremities of human figures issue into birds or fish, their organs become flowers or fruit. A sense of pervasive movement, and sometimes even violence, emerges from these transformations, as in the instance of the woman (right) whose breast becomes a foetal bird and whose foot a pomegranate, the "golden apple" which Paris gave Aphrodite.[9] The pictures teem with elements that seem to be growing and changing. But this *élan vital* is in constant confrontation with processes and symbols of dissolution and destruction—an alternation that produced the poetic and the visual rhythms of the pictures, their character-

Nudes and Architecture. 1924.
Oil on canvas, 28¾ x 36¼".
Collection Mr. and Mrs. Nesuhi Ertegün,
New York

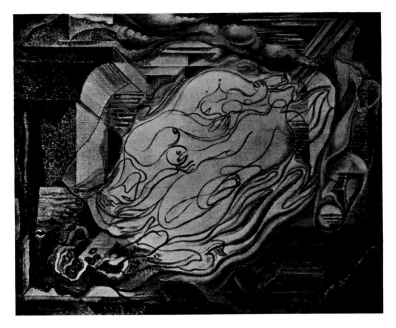

istic "pneuma." Masson's universe, writes Daniel-Henry Kahnweiler, "was not a world of forms, like that of the Cubists, but one of forces . . . The Cubists lived in an Eden from which unhappiness and death were banished. Masson's world of forces is shaken by frenzied passions. It is a world where people are born and die, where they are hungry and thirsty, where they love and kill . . . This tragic art, which remains a stranger to nothing that is human, is truly the art of a generation which, even as it aspires to the Dionysian exaltation of Nietzsche, trembles before the prevailing *weltangst.*"[10]

Despite their Cubist scaffolding and articulation, the morphology—the form language, as it were—of these early Massons is largely anti-Cubist. Like Arp, Miró, and many later Surrealists, Masson was drawn to a form of biomorphism as an alternative to the more regular, geometric forms of Cubism, though Masson's line is usually more meandering, more organic in character than specifically biomorphic. The High Analytic Cubist configuration, on the other hand, consists of an architectural scaffolding (i.e., predominantly vertical and horizontal) situated in an indefinite but seemingly shallow and luminous space whose Rembrandtesque light sometimes crystallizes as sprays of Neo-Impressionist brushstrokes. The fragmentary shapes that emerge and submerge in this penumbra tend to align themselves with the verticals and horizontals of the frame as if by magnetism. Diagonals are not infrequent, but are locked into the manifest grid, while arabesques are rarer and almost invariably enclosed within straight lines. The result is a composition whose stability is continuously reinforced by our perception of the smaller and more subtle manifestations of its underlying architecture.

Such straight-edged verticality and horizontality are not so much the properties of man as of the man-made world, the environment that man creates to complement himself in order to function with maximum stability. The Cubist picture speaks in the language of this external world meditatively and abstractly, from a position once removed. Dada and Surrealist artists found this attitude of transcendent order and reserve too detached, too disengaged from man's psyche and passions, from his need for movement and change. Not surprisingly therefore, in creating an art that would, in Tzara's·words, "return to man," these artists developed a form language evoking the interiority—psychological and physiological—of man. The very terms "organic" and "biomorphic" testify to the new humanism.

opposite:
The Wing. 1925.
Oil on canvas, 21⅝ x 15".
Staatliche Museen Preussischer Kulturbesitz,
Nationalgalerie, Berlin

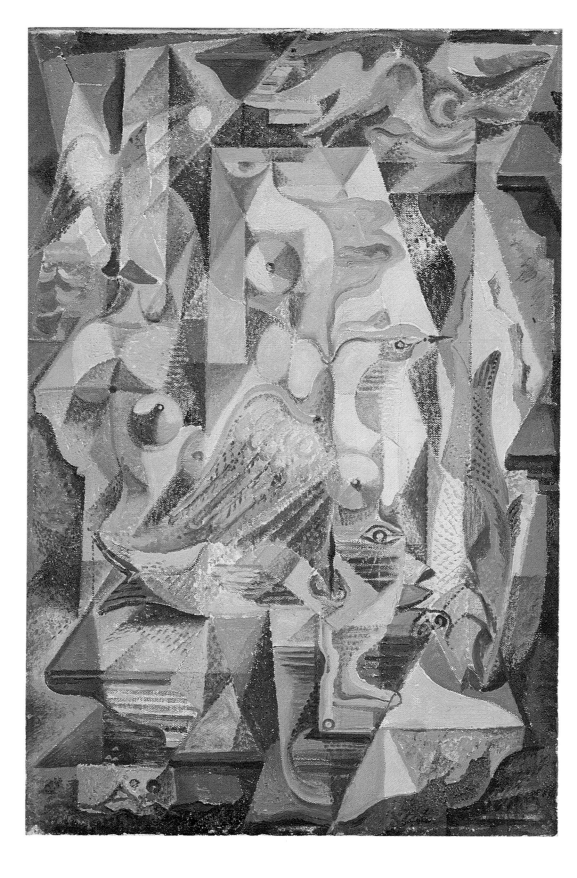

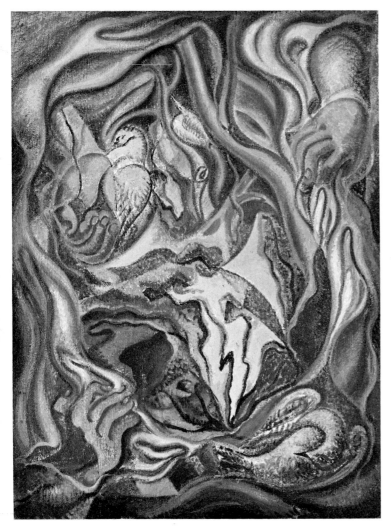

opposite top :
Automatic Drawing. 1924.
Ink, 9½ x 8".
Private collection, New York

opposite bottom :
Automatic Drawing. 1925.
Ink, 17 x 12⅛".
Private collection, Stuttgart

The beautifully painted early Massons of 1924–27 are a paradigm of this evolution. They accept as a starting point the light, space, and nuanced shading of Analytic Cubism and—at least in 1924–25—the Cubist scaffolding itself. (Indeed, in some of the earlier examples, just as in Picasso's landscapes of Horta de San Juan, the "architecture" of the composition is one with the represented architecture, though this more literal identification disappeared as Masson proceeded.) As the pressure of Masson's personal subject matter makes itself felt, the grid scaffolding gives way to a configuration of meandering lines and organic shapes. This individual imagery first takes over in the center of the picture (p. 16) and gradually (by late 1926) absorbs its entire surface (p. 116).

The very manner in which these new, anti-Cubist forms emerged—seeming to grow out of one another, their identities multiple here, ambiguous or doubtful there—depended as much upon Masson's perception of the formal possibilities of Cubism as upon the exigencies of iconography. Unlike the sculptural Cubism of 1908–9, the High Analytic Cubism of 1910–12 brought the process of abstraction to a point where it dissolved the prosaic motifs of the pictures, so that their reading became difficult if not impossible. This inherently poetic and speculative ambiguity was intensified by the illusion of transparency resulting from the painterly dissolution of the planes (except near or at their edges) into sensations of light. The resultant play of forms was implicitly more poetic than in earlier Cubism—and its effect was heightened by the addition to the surface of elliptical and arcane fragments of words and phrases. Nevertheless, this Cubist visual poetry derived primarily from references to the objects (and figures) inhabiting the "studio world" of the painter. Picasso was at pains to insist that the "reality" he sought to describe in 1910–12 was still that of the motifs themselves, though he obviously found that reality increasingly elusive, increasingly metaphysical. "It's not a reality you can take in your hand," he said of a work of this period. "It's more like a perfume—in front of you, behind you, to the sides. The scent is everywhere, but you don't quite know where it comes from." [11] While Picasso would not have described the motifs in the tactile 1908–9 form of Cubism in such a way, it remains that for him the reality was still "out there," so to say, rooted in the world of perceptions.

Masson saw that the particular abstractness of High Analytic Cubism could be exploited for the purposes of "internal imagery"—the imaginative, psychologically

induced type of subject that had been explored by de Chirico during the previous decade (and even earlier by Redon), though in a non-Cubist manner.[12] The very transparency of Analytic Cubism could be and was used by Masson to enhance the poetic ambiguity of the motifs, their metamorphosis, their passage between differing levels of reality. The style had already been used to that end, to be sure, by Duchamp, in a few paintings of 1912, and, in a very personal manner, by Klee.

Duchamp, however, was not in sympathy with the Cubism he inherited—indeed, he was trying to overcome it—and the paintings to which I allude, illustrative in an almost Futurist sense, far from realized the poetic possibilities of Cubist syntax. Duchamp was predisposed not only against Cubism but against painting as such, and was soon to abandon it. Klee, on the other hand, was profoundly and positively marked by Cubism, which he managed entirely to assimilate. Masson was familiar with Klee as early as 1922 and, in fact, introduced his work to Miró.[13] Ernst had long been familiar with Klee, and Breton, whose personal collection contained Klees,[14] included four works by the Swiss artist in the first Surrealist exhibition of 1925. Working in relative isolation, Klee had found no need to take a "political" position vis-à-vis Cubism. As a Surrealist, Masson had had to reject Cubism. Indeed, as a poet, he was spiritually opposed to its premises. But as a painter, he was in love with it. If this was an equivocal attitude, it was one which characterized Miró and Arp as well.

Picasso's reaction to Masson's Cubistic 1924–25 paintings is interesting. He much admired the pictures, he told Kahnweiler, and was intrigued by the way Masson had seemingly "turned Cubism inside out."[15] He waggishly chided Masson for "setting us [the Cubists] up only to tear us apart."[16] In fact, Masson's pictures less tore apart Analytic Cubism than they used its pictorial syntax to reverse its own expressive premises. Indeed, these Massons represent but one of many instances attesting to Cubism's amazing elasticity, which permitted it to be absorbed as a crucial constituent in styles as diverse in character as those of Matisse, Boccioni, Marc, de Chirico, Miró, and, later, de Kooning and Pollock.[17] At the time of his remarks to Masson, Picasso himself could not have foreseen the manner in which Cubist syntax would, even in his own work (especially of the thirties), be made to accommodate a morphology very different from the one for which it had been created.

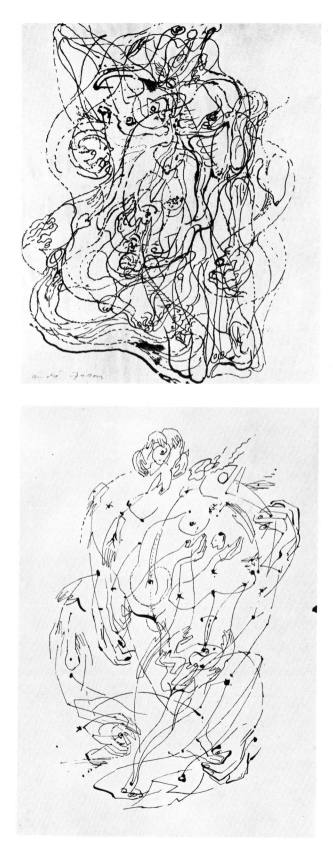

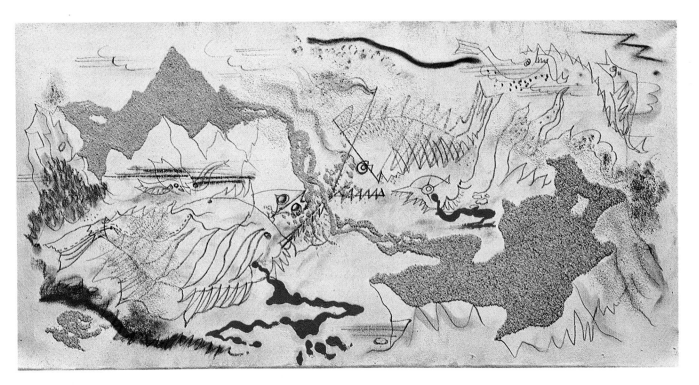

THE NEW FORMS which forced their way into the Cubist structures of the 1924 Massons represented on both the plastic and poetic level a transposition into painting of *trouvailles* of his automatic drawings. These drawings, which Masson had begun to make the previous year, come as close as anything Surrealism produced to the dictionary definition of the term as given in the first manifesto (which some of them antedate).[18] Masson had no particular subject matter in mind as he began these drawings; the hand wandered freely, producing a web of markings out of which subject elements were subsequently, in effect, "provoked." This mediumistic process, it was assumed, would bring to the surface ideas that would otherwise have remained in the unconscious; these, in turn, would force new forms and configurations on the pictures. Masson's 1923–24 drawings are not the earliest automatic ones we know.[19] Indeed, both Masson and Miró (who was to take up automatic drawing a year later) were by then aware of certain Klees which were the fruit of a kind of automatic doodling. Masson's method differed from Klee's primarily in its speed of execution, which was fostered in part to prevent editing and thus guarantee the freshness of the unconscious impulse. Only after the drawing was well under way did Masson permit himself to "step back," so to say, to consider the results. In the tangle of lines, certain forms—perhaps a breast, penis, fish, or leaf—would seem to have suggested themselves, and only then might Masson consciously add detailing to make these clear, just as he might add other markings to assure a consistent pictorial order for the image.

A state of pure automatism cannot, to be sure, be achieved in the making of any object. The functioning of the conscious mind could thus never be entirely eliminated in Masson's drawings even in their early stages—despite the fact that it felt that way to the artist. Whether the reason is this inevitable residue of consciousness or the fact that pictorial order becomes a reflex (like language) for persons formed as painters, the automatic drawings of Masson are marked throughout by certain formal common denominators. The meandering lines, for example, neither cluster into hierarchies nor run off the page.[20] Indeed, they preserve a classic (in the Wölfflinean sense), inherently Cubist "set" in relation to the framing edge, while their accenting (as in **Furious Suns**, above) is often explicitly Cubist.

The automatic drawings provided, then, a reservoir of both forms and subjects for Masson's paintings of

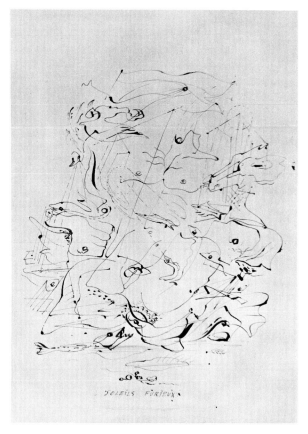

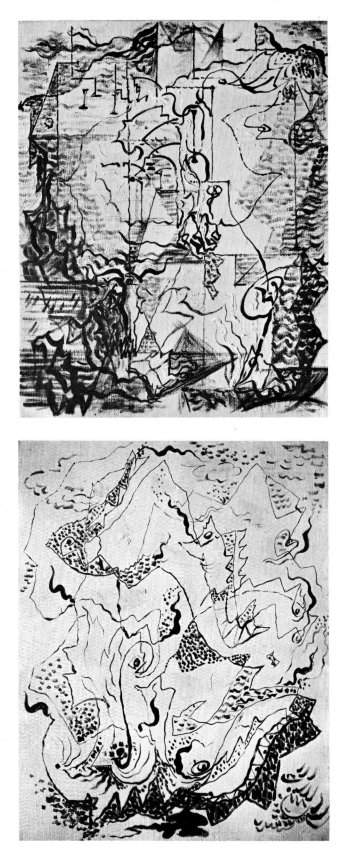

1924–25. The paintings, however, were necessarily executed in a measured, unautomatic way. This lag seems increasingly to have bothered Masson in 1926, and he cast about for a way in which the process of painting could be made to accommodate linear automatism and thus profit from the freshness and directness of the drawings. The problem lay in "drawing" with a brush: constant reloading broke the continuity of the line as well as the sequence of psychic impulses, while the drag of the brush hindered its speed and its consistency (since the brush deposits more pigment at the beginning of its course than later). Kandinsky had faced this problem in the more rapidly improvised of his pictures of 1912–14; he solved it by drawing on the canvas with pen and pencil. Pollock would confront it over two decades later. Masson's problem is illustrated by the transitional **Haunted Castle** (above), executed in the latter part of 1926.[21] Though the Cubist scaffolding persists in the margins, it has dissolved in the center of the image under the pressure of the meandering line transposed from the drawings. But, while the latter is wonderfully evocative, its painstakingly brushed curvilinear contouring lacks the spontaneity and energy of the pen drawings.

Masson's solution to this problem—a solution which in ways adumbrated, albeit in miniature, that of Pollock—involved drawing directly from the tube and pouring a liquid medium (often spreading it with the hand). In the sand paintings of 1926–27,[22] Masson first poured glue in patches and lines over the surface of his canvas, using his fingers to spread it here and there in a sort of automatic drawing. The sand which he subsequently sprinkled over the entire surface remained on the gluey areas and fell away from the rest when the stretcher was tilted. Usually this process was repeated with two or more different textures of sand, as in **Painting (Figure)** (right); in the pictures **Two Death's Heads** (p. 25) and **Fish Drawn on the Sand** (p. 125), the variously textured sands cover the entire canvas. The apparently random spillings and patches formed by the glue and sand constituted a suggestive ground that conditioned the second phase of the configuration—the inscription of automatic drawing. The drawing might be accomplished by spilling a very liquid medium on the sand, as in passages of **Fish Drawn on the Sand** and the black lines in **Painting (Figure)**, or by drawing directly with the tube, as in the passages of blue and red in **Painting (Figure)**. In instances where the canvas was primed, as in **Battle of Fishes** (p. 20), linear detailing might be added with charcoal or pencil.

opposite top:
The Haunted Castle. 1926.
Oil on canvas, 18½ x 15⅜".
Collection Mr. and Mrs.
Claude Asch, Strasbourg

opposite bottom:
Horses Attacked by Fish. 1926.
Oil on canvas, 32½ x 26".
Collection Simone Collinet, Paris

right:
Painting (Figure). 1926–27.
Oil and sand on canvas,
18 x 10½".
The Museum of Modern Art, New York,
Given anonymously

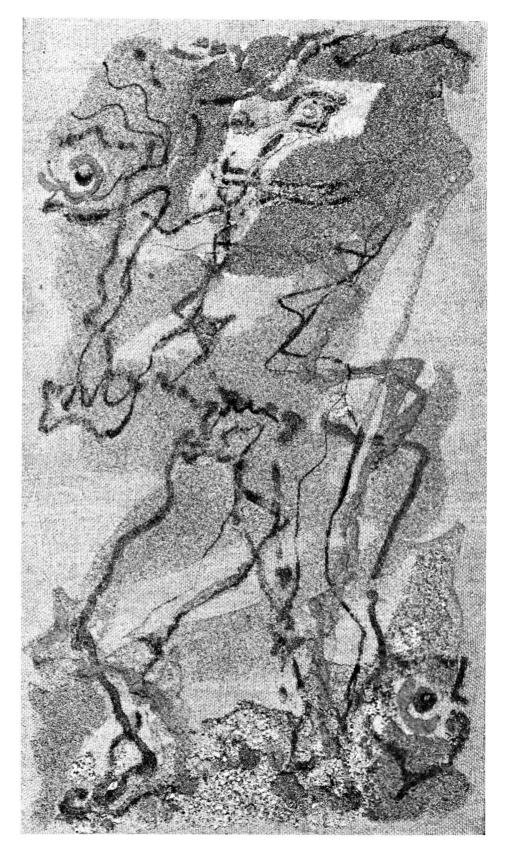

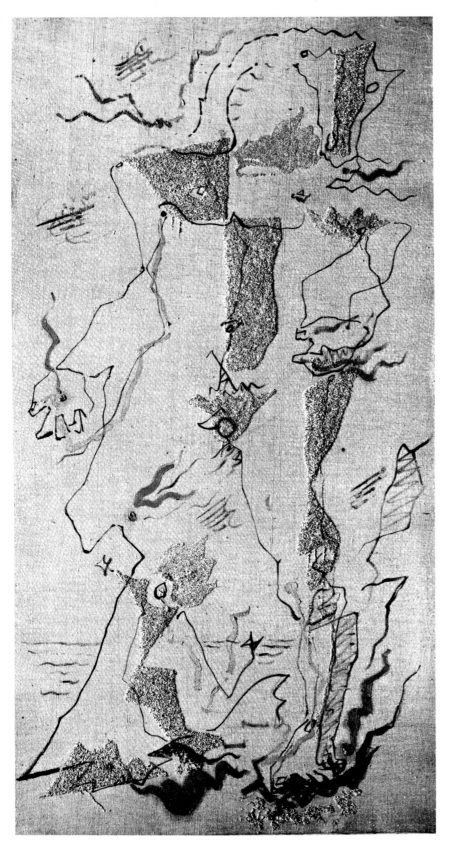

A Knight. 1926–27.
Oil and sand on canvas,
36¼ x 19¾".
Collection Mr. and Mrs.
Bayard Ewing, Providence

opposite top:
Villagers. 1927.
Oil and sand on canvas,
31⅞ x 25⅝".
Private collection, Paris

opposite bottom:
Two Death's Heads. 1926–27.
Oil and sand on canvas,
5¾ x 9½".
Collection Mr. and Mrs.
E. A. Bergman, Chicago

While many motifs of the 1924–25 pictures were carried over—birds, fish, and fragments, notably sexual, of human anatomies—the figurative elements in the sand paintings taken together constitute a reduction of the elaborate bestiary of 1924–25, and their greater abstraction renders them less legible. As the sand pictures were able to accommodate an automatism not present in the earlier oil paintings, the drawing tended to break free of the visible Cubist scaffolding characteristic of 1924–26, though, as in **Painting (Figure)**, the Cubist grid still seems to govern the distribution of accents and the relation of the configuration as a whole to the frame.

THE NEW FREEDOM to draw with pigment and glue that marked the passage of the Cubist armature from the manifest to the infrastructural level of the image went hand in hand with a liberation of Masson's instinct for the violent. The themes of the sand paintings are more aggressive than those of the 1924–25 pictures, the sand often operating as a literal undersea environment in which saw-toothed fish and primordial, unformed creatures struggle with each other for survival. Germination, eclosion, and procreation weigh against death. In **Two Death's Heads**, the easily perceived crania constitute the most immediate level of interpretation, but the evolution of the image virtually recapitulates the life process. Its ambiguous final state represents the accretion of images that began with starfish-like patterns in the sand and passed through motifs suggesting growth and conflict (which were enhanced by poured patches of blood red). Such violent subjects, which were to be renewed in more anthropomorphic form in the Combats and Massacres of the thirties, testify to Masson's obsession with the death struggle. He recalls being traumatized as a child by seeing peasants killing animals—a spectacle that "at once attracted and repelled" him.[23] Later he became similarly fascinated by the subject of abattoirs. Indeed, his abiding love of the Elizabethan theater is due in part to the way it foretold his friend Artaud's Surrealist-inspired "theater of cruelty."

Battle of Fishes is the most individually rich illustration of the universe that is evoked collectively by the sand paintings. Only a small part of its surface is covered with sand—in an irregular, automatic pattern that Masson gradually elaborated as undersea hills, plateaus, and plant life. This provides the environment for a group of sharklike creatures that devour one another. The configuration preserves all the random-

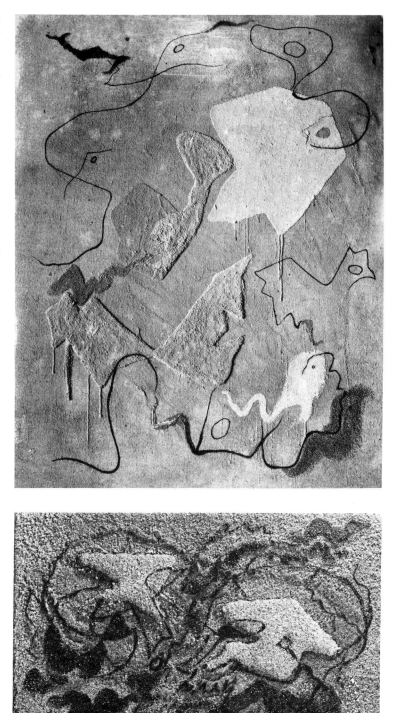

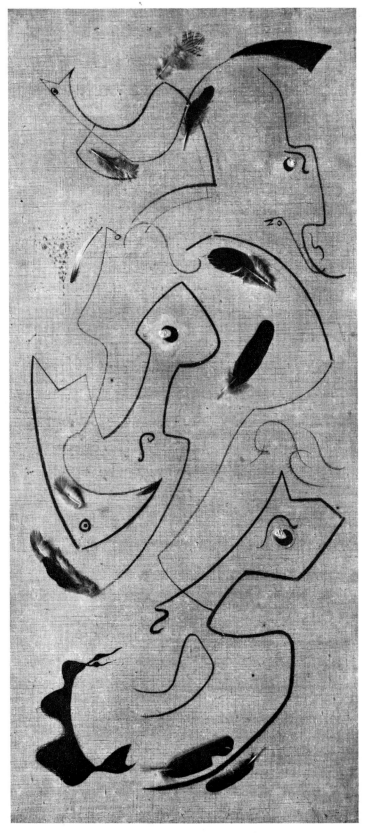

Horses Devouring Birds. **1927.**
Oil and feathers on canvas,
43¼ x 20⅛".
Wallraf-Richartz-Museum, Cologne

ness of its automatic beginnings, not only in the sand passages, but in the contouring and rubbing of pencil and charcoal inscribed around them. Yet it is finally no less ordered—if differently and less immediately perceived as such—than the oil paintings of 1924-25. This purely artistic order, which is arrived at in the later stages of the work, served psychologically for Masson as a symbolic counterthrust to the disruptive elements of his personality, whose unconscious and instinctual drives are the subjects of the pictures. The function of art-making here constitutes for the artist himself a way of holding a violent and passionate temperament in order; aesthetic order becomes a defense against anarchy and death. Though the aesthetic sense has its own deep psychological roots, it functions in Masson's art-making process as the "rational" component, while the automatism allows the expression of primitive, instinctual feeling. Masson's goal was an "easy" relationship between the two, the conscious, aesthetic impulses "riding with" the more automatic activity. The aim was an artistic order that preserved a maximum of the random, improvisational, and seemingly accidental by introducing as late as possible in the process the minimal amount of structure needed to "jell" the work.

THE AMBIGUOUS fusion of the bodies of some of the fish in Battle of Fishes, like the organic metamorphosis of humans into animals in other sand pictures, evokes at once a primordial stage of evolution; it also alludes implicitly to sexuality. Such erotic allusions in Masson's sand paintings are invariably associated with signs of struggle and death. Indeed, Battle of Fishes recalls the shipwreck scene from Canto II in Lautréamont's *Chants de Maldoror* with its agon of humans and sharks ending in the coupling of Maldoror and a shark.

Sexual imagery in Masson varies considerably from period to period in degree of literalness, but it is rarely absent. As Breton observed, "It must be considered the keystone of his art." [24] It appears as the abiding subject of the very earliest automatic drawings, which always had what Masson called a *soubassement érotique.* "It may have been the eroticism of the cosmos [as in Furious Suns]," he continued, "but the element is Eros." [25] One might assume, given the centrality of the sexual instinct in the human psyche, that sexual imagery would inevitably follow from "automatic" procedures. But one has only to note the virtual absence of explicit sexual themes in the imagery of Klee to see that this is not so. [26] Masson's strongly passionate, erotic nature had fixed on a subject area that would

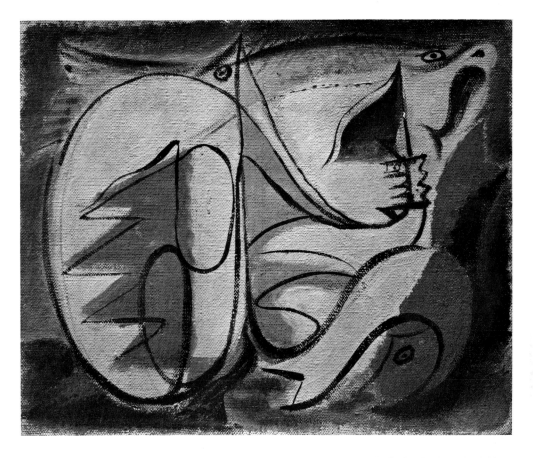

Fish Disemboweling Another. 1929.
Oil on canvas, 8⅝ x 10⅝".
Private collection, Paris

Great Battle of Fish. 1929.
Oil on canvas, 38⅛ x 51⅛".
Lost

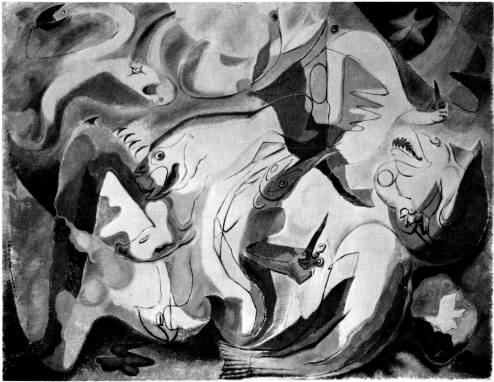

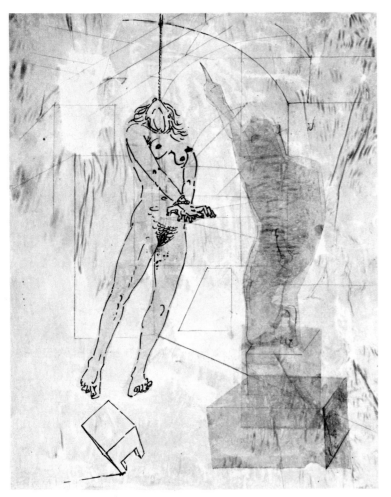

Drawing for "Justine." 1928.
Pasted paper and pencil,
18⅞ x 14⅞".
Collection of the artist, Paris

opposite:
Antille. 1943.
Oil and tempera with sand on canvas,
50 x 33⅛".
Collection Peter Bensinger, Chicago

shortly be formalized and "legitimized" by the Surrealists as the central, most viable modern myth. The great subjects of premodern art, such as history and religion, having lost their power to inspire painters and poets, the Surrealists fixed on the erotic as the sole available theme of sufficient grandeur and universality—and one which had the advantage of metaphorically recapitulating the artistic process.

To say that the erotic is the central theme of Surrealist art and poetry is to repeat a truism. What matters is the particular nature of the sexual imagery as it emerges in the work of each artist. In Dali, for example, it is associated with narcissism, onanism, impotence, and a disgust with women; in Miró it is warm and lyrical, breathing "with the freedom and grace of the India love-manuals."[27] Masson's eroticism is always passionate, and is pregnant with desire and creativity. But it is haunted by aggression, guilt, and mortality. A vagina becomes a flower—but also a saw-toothed trap. A penis is alternately a plant stem or knife. The creative outpouring fostered by the automatic process is sensed as almost orgasmic in character. Unlike Miró, who steps back to consider the drollness of sex, Masson is always caught up in it; his sexual imagery has irony but little humor, even *humour noir.* "Eroticism," he says, "can be considered the essence of what is most serious . . . most grave, and most exalted—since it can lead to the giving of life."[28]

The main protagonists of Masson's erotic drama are the violating male (as in the extraordinary illustrations for Sade, left) and the femme fatale (who may be assimilated to a carnivorous plant or praying mantis).[29] These are absorbed into a pansexual iconography of attraction and repulsion that ranges from the microscopic to the telescopic, in a manner that builds upon the visions of artists as different as Blake, Redon, and Klee. For Masson, *pansexualisme* can mean a visual metaphor as elliptical as "the conjunction of planets." Such a cosmology may, however, evolve in the process of painting itself from a motif as immediate as that of **Antille** (right), which was inspired by a dream of the body of a black woman Masson had glimpsed in Martinique. Her shining brown and purple nudity—intensified by the luminous quality of the sand mixed in the pigment and surrounded by suggestions of exotic birds, foliage, and genitalia—seems visually to dissolve into celestial fireworks. This woman's body, Masson recalled, "contained reflections that make one think . . . of stars [*astres*]—a sort of female cosmic body."[30]

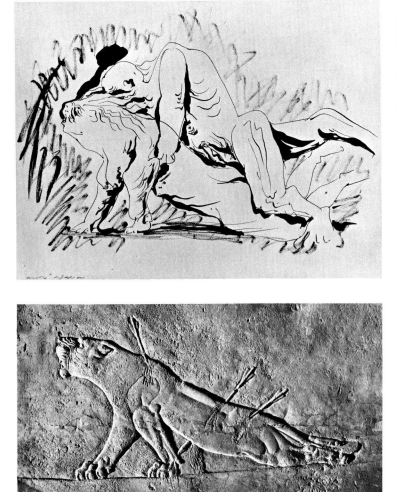

THE HALLUCINATORY and violent character of much of Masson's imagery cannot be separated from his war-time experiences on the line of fire. Indeed, World War I was an event that traumatized his entire generation. The successive movements called Dada and Surrealism—which rose with the first war and survived into the wake of the second—may be said to have existed under the shadow of Ares. Few of the Surrealists, however, experienced war firsthand. Masson was unique among them not only in seeing prolonged service in the front lines but in being gravely wounded, and it is not surprising that his art should be more deeply marked than theirs by the experience of the war.

In the Somme there were no trenches. "You made your body one with the ground," [31] Masson recalls, suggesting a literal starting point for the poetry of the fusion of man and earth, a leitmotif in his art. Already, the aesthetic began to be used instinctively as a defense against madness: in the midst of battle Masson sees a wounded soldier, his body propped on his elbows, his head raised and his mouth open, appearing to call for help; Masson approaches and to his horror finds the handsome young man dead, his body and visage frozen in that posture by rigor mortis; suddenly Masson is reminded of the beauty of one of his favorite sculptures, the Dying Lioness from Nineveh in the British Museum. The image haunts Masson to this day and emerges in his art in many forms; the association of Eros with Thanatos inherent in it is exquisitely evoked in a 1939 drawing (above) in which the lioness, now half human, is violated by death in the form of a male nude (who thus replaces the arrows of the ancient relief).

Masson was gravely wounded in the second afternoon of the great offensive of 1917 at the Chemin des Dames. The stretcher-bearers were unable to get him to safety, and he was left all night on his back in a shell hole, where he was a passive spectator of the battle: *The indescribable night of the battlefield, streaked in every direction by bright red and green rockets, striped by the wake and the flashes of the projectiles and rockets— all this fairytale-like enchantment was orchestrated by the explosions of shells which literally encircled me and sprinkled me with earth and shrapnel. To see all that, face upward, one's body immobilized on a stretcher, instead of head down as in the fighting where one burrows like a dog in the shell craters, constituted a rare and unwonted situation. The first nerve-shattering fright gives way to resignation and then, as delirium slips over you, it be-*

comes a celebration performed for one about to die.[32]

Recollections of wartime experience are transposed in Masson's paintings into metaphors and symbols of differing degrees of remoteness. But even when fairly literal, such as the tombs in his symbolic, Derainesque Forests of 1923–24 (p. 91), they are not consciously evoked. Only after painting the latter did Masson become aware that they had something to do with the graves he had marched past heading toward the front. Shortly before he was wounded, Masson's regiment occupied a position between Craonne and Craonelle— "strangely cranial names," as he observes.[33] These would later appear as skull-like masses of ruined architecture (p. 33). The truncated torsos in the 1924–25 pictures, the themes of the Abattoirs, Combats, Massacres, and Migrations all refer at least indirectly to these wartime experiences.

But the most important effects of the war lay less in the recollection of particular experiences than in the broad changes it wrought in Masson's psyche, and the hitherto unrecognized fears and desires it brought to the surface of his mind. In the first instance these took the form of the symptoms of the nervous depression for which Masson was confined in a psychiatric hospital following his recuperation from his wound. For more than a decade afterward he was subject to profound depressions and occasional uncontrollable acts of violence—a condition exacerbated in the twenties by the quantities of drugs he took in part to relieve the pressure. The most enduring effects of the battle experiences, however, were the profound malaise and the sense of the tragic they induced. Masson recalls a prophetic encounter in this regard. In 1914, before returning to France from his art studies abroad, he had met in Switzerland a German soldier wounded in the first days of the war. The soldier warned Masson not to return to France for military service. "Whatever happens to you," he predicted, "even if you get out alive, you will always remain wounded." He spoke of "those wounds of the soul which never close."[34] Masson, an ardent Wagnerite, was reminded of Amfortas. And, indeed, the recurrence of the violent and the tragic during the more than half-century of Masson's art in turn suggests the stigmatic wound of the Knight of the Grail saved by Parsifal. All this notwithstanding, the field of battle had "enormous compensations" for Masson, apart from the visual spectacle. He had been an extremely introverted, solitary young man. "The field of battle made a human being of me," he says. "It literally threw me into the *humus humain*."[35]

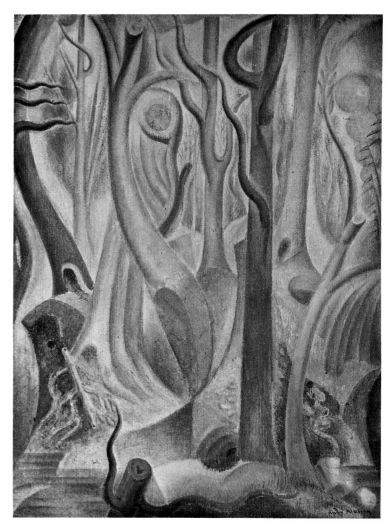

The Pond in the Woods. **1924.**
Oil on canvas, 46¼ x 35½".
Private collection, Paris

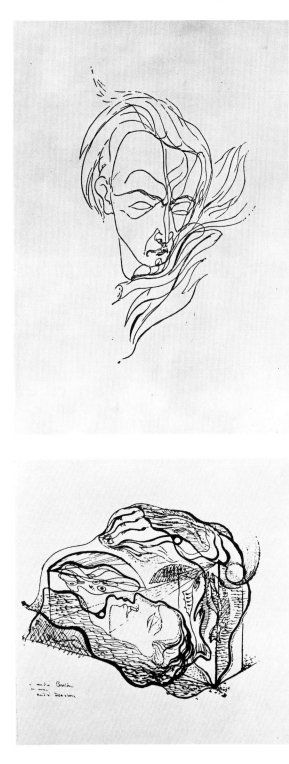

BY 1929 MASSON had broken for the first time with Breton and by that fact with the Surrealist movement—which did not prevent his painting of the thirties from remaining largely Surrealist in character. The causes that triggered the rupture were personal, but it took place in a larger context already embittered by growing differences among the original Surrealists regarding both politics and art. Masson had all along been on intimate terms with Limbour, Leiris, and Bataille, who had remained apart from the movement despite a certain community of interests with Surrealism. Now, these friends—with the addition of Artaud, whom Breton had earlier "excommunicated" as a "mere artist"—were to form the center of Masson's milieu.

The publication of the second Surrealist manifesto in December of 1929 (in what proved to be the last issue of *La Révolution surréaliste*) had signaled not only a profound *crise de conscience* within Surrealism, but a significant redirection of its interests—a redirection which had considerable implications for the plastic arts. Having upheld art as a *means* of expression (an "expedient") in the early days of the movement, Breton now stressed his rejection of art as an *end* of human activity. The second manifesto hardly mentions automatism, which had been at the heart of the definition of Surrealism in the 1924 manifesto. Breton allowed that automatic writing might still be useful, but he deplored the increasing tendency of its practitioners to make art out of it. Automatism would have to be limited to its original experimental, "scientific" purpose, freed from the need of "the artistic alibi." The "profound and veritable occultation of Surrealism," which Breton now proclaimed, struck a mystical and speculative note. Surrealists would have to search for "the philosopher's stone" that would allow the imagination "to take a dazzling revenge on the inanimate." [36]

This new orientation was most hospitable to the mystique of inanimate objects already being explored by Magritte and projected to new prominence in 1929 in the first mature works of Dali. Dali was now the leading figure of the movement—"he for whom we were waiting," as Breton put it—and his work dominated the new review, *Le Surréalisme au service de la révolution*. From "uncovering the strange symbolic life of the most ordinary and clearly defined objects," called for in the second manifesto and best served by the academic illusionism of Dali, it was but a short step to the creation of Surrealist objects themselves. These were to proliferate during the thirties, emerging as

top:
City of the Skull. 1939.
Ink, 24¾ x 18⅞".
Collection of the artist, Paris

bottom:
The Palace. 1940.
Watercolor and ink, 23¾ x 18⅞".
Collection of the artist, Paris

much from the studios of the writers as from those of the painters and sculptors.

Even if concerns outside art had not precipitated Masson's break with the Surrealists, it is evident that Breton's new policies would have afforded little encouragement to a painter of his tendencies. The art that was to receive Breton's patronage for the next decade would be distinctly more literal and illustrative in character than Masson's had been, though even *his* painting would lean in the direction of this thirties style. In the later twenties, the first characteristic works of Magritte and Tanguy were cordially received by Breton, but no more than that; it was clear that Breton's interest at that time lay more in the painting of Masson, Miró, and Ernst. But in 1929 such illusionism, now brought to the highest pitch of trompe-l'oeil by Dali, became Breton's model for Surrealist art.

The aim of this illusionism was a visual poetry achieved through "irrational" juxtaposition and the alienation or *dépaysement* of objects. The impact depended on the convincingly tactile imaging of the objects. "My whole ambition in the pictorial domain," wrote Dali,

is to materialize the images of concrete irrationality with the most imperialist fury of precision.—In order that the world of the imagination and of concrete irrationality may be as objectively evident, of the same consistency, of the same durability, of the same persuasive, cognoscitive and communicable thickness *as that of the exterior world of phenomenal reality.*[37]

This "magic illusionism" had its origin in the collage-inspired, dreamlike juxtapositions of objects in the paintings of de Chirico, whose art had all along been of great interest to Breton and the Surrealists. But the Surrealists missed the point of de Chirico's style, even as they grasped the nature of his poetry. De Chirico's painting involved a very personal mixture of planar (i.e., two-dimensional) forms and deep linear perspectives. His objects, removed from their usual context, were modeled in low relief by a very evident hatching rather than being smoothly (i.e., academically) modeled in the round. He equally eschewed trompe-l'oeil in his illusion of space, which was indicated only schematically—by perspective orthogonals that were never reinforced through atmospheric means. This permitted the planes which are *read* as in the middle distance or in deep space simultaneously to cling visually to the picture plane, giving the image a standard of abstraction that markedly set off de Chirico's painting from conventional illusionism.[38] It

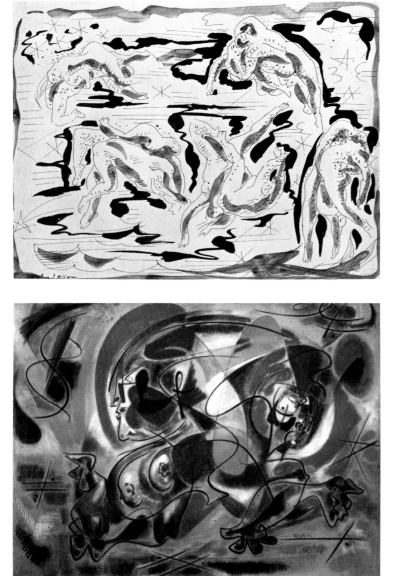

The Demon of Uncertainty. 1943–44.
Pastel on canvas, 29½ x 39⅜".
Collection of the artist, Paris

was precisely this new combination of illusion and abstraction—derived partly in de Chirico's case from an absorption of Cubism (of which he intuited the possibilities more subtly than his Futurist compatriots)—that was missing in the work of Dali (or Tanguy), whose avowed model was Meissonier.

It is difficult to say how much of a loss Masson's separation from the Surrealist circle, and more particularly from Breton himself, represented. If Masson's work of the thirties is less assured and less daring than his painting of the previous decade—or the subsequent one—it is possible that the break with Surrealism had some role in the phenomenon. The loss of milieu was not, however, primarily a question of painting itself. Although history is replete with artists who paint at their best only when working closely with others (e.g., Vlaminck and Derain during the years of Fauvism), Masson was to show that he could work at the top of his possibilities while in isolation—as was the case with his American pictures, executed while he lived in nearly total seclusion in the Connecticut countryside. Moreover, despite Breton's relegation of him to the "nonpersons," Masson continued throughout the thirties to frequent many Surrealist artists, notably Giacometti. He also continued to see Miró—a friendship that continues to this day—though the two were naturally never again as close as in the formative days of Surrealism when they had adjoining studios in the rue Blomet. In addition, Masson expanded his friendships among painters of the older generation to include Matisse.

What was lost to Masson in his break with Surrealism was rather the sense of collective discovery and the consequent exaltation that had marked the pioneer days of the movement—a certain intellectual and spiritual effervescence that was now being experienced by the younger artists of the second Surrealist wave, such as Dali and Giacometti. Then, too, despite (or perhaps because of) their constant quarreling, the absence of Breton himself certainly counted for something in pictorial matters insofar as methods were concerned. Though Masson had practiced automatism, for example, before meeting Breton, the text of the first manifesto, the encouragement of Breton, and numerous conversations with him "rooted me," Masson admits, "in that path."[39]

The paths taken by Masson in the thirties were varied. Different subjects from series to series produced contrasting stylistic formulations and methodologies, with considerable range in the quality of the

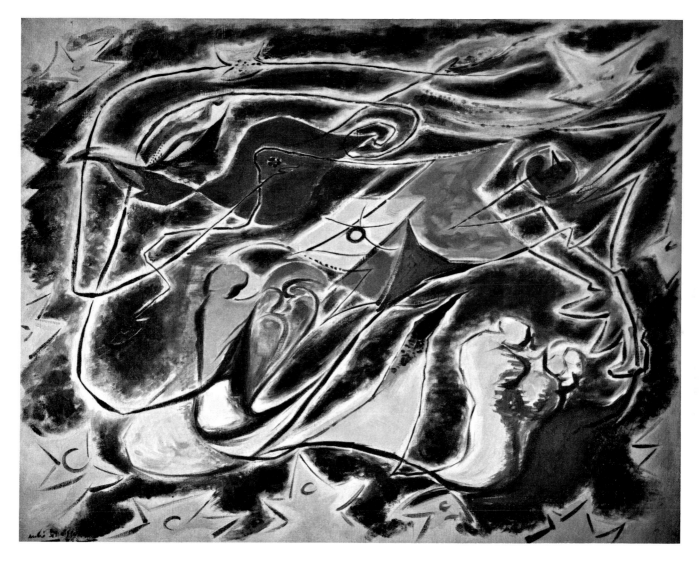

Sleeper. 1931.
Oil on canvas, 31⅝ x 41⅜".
Private collection, Paris

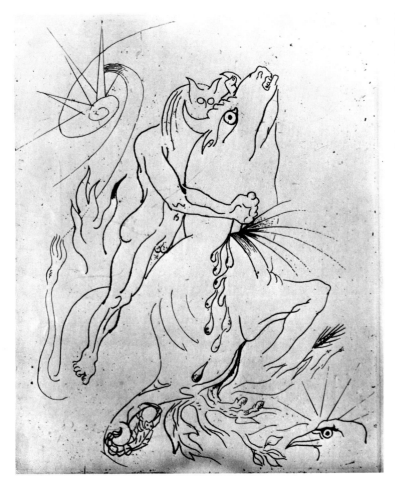

Mithra. 1933.
Etching, 11⅝ x 9¾".
(From *Sacrifices*, published 1936)

results. It is not impossible that the disparate character of his work in that decade would have been altered by the pressure of a critical dialogue, though this would have remained, it seems to me, secondary as compared with the general context, social and psychological, of his work.

IN THE TWO years following the sand paintings of 1927, the sense of violence—as carried especially through the metaphor of animal imagery—became even more exacerbated, intensified perhaps by the anger and pain of marital problems that were soon to lead to a divorce. A series of pastels developed the motif of animals devouring each other, anticipating the Massacres of the early thirties, while oils such as **The Butcher of Horses** (1929; right) prepared the way for the more literal Abattoirs of the following years. Despite this fact, the works of 1928–29 represented, in purely plastic terms, something of a détente as compared with Masson's painting of the three previous years. The language of the pastel series of Devouring Animals (p. 131) introduced, for example, a current kind of biomorphism alien to Masson's best open-contoured drawing, while the oil paintings fell back to some extent on the support of a manifest grid structure. The latter profited, however, from a new simplicity that reflected a shift of interest on Masson's part from the language of Analytic to that of Synthetic Cubism, probably under the impact of Picasso's flat, decorative late-twenties Cubism. **The Butcher of Horses**, for example, consists of a few variously colored ground planes on which are superimposed, in straight lines or in spurts of more seemingly automatic curvilinear drawing, anthropomorphic fragments as well as the heads and bodies of the dying horses.

These late-twenties paintings are bold and very handsome, though their very decorativeness sometimes contradicts the violent nature of their subjects. The same equivocalness with respect to the decorative is also a problem in a number of the Massacres and Combats of 1930–33. The best of these pictures work admirably as configurations. Their crowded surface patterns are diced cubistically, the planes indicated in flat tones of saturated yellows, oranges, reds, and greens for the most part. But such "hot" colors, which Picasso was to use to very expressionist ends in his **Crucifixion** of 1930 (and again near the end of the thirties in **The Weeping Woman**), tend, at least for my eye, not always to convey the anti-decorative conviction called for by the motifs. On the other hand,

The Butcher of Horses. 1928.
Oil on canvas, 28⅞ x 36⅜".
Hamburger Kunsthalle

Aragon Sierra. **1935–36.**
Oil on canvas, 49¼ x 57⅛".
Galerie de l'Ile-de-France, Paris

Massacre in a Field. **1933.**
Oil on canvas, 28¾ x 45⅞".
Blue Moon Gallery and
Lerner-Heller Gallery, New York

De Pie en pie. 1939.
Ink, 9⅞ x 12¼".
Collection of the artist, Paris

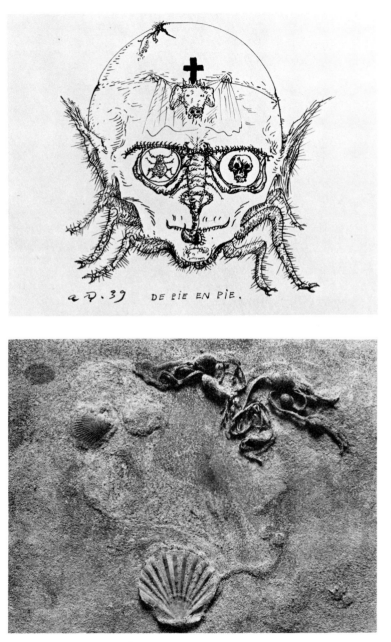

De Pie en pie. 1939.
Ink, 9⅞ x 12¼".
Collection of the artist, Paris

The Depths of the Sea. 1937.
Sand, shells, and algae on wood,
10⅝ x 13¾".
Private collection, New York

Masson turned this same high-keyed color gamut to very good account in 1934 in the Insect pictures.

Though hallucinatory in character, the Insect pictures began from very close direct observation. Masson, who can spend hours "interrogating" a square foot of earth, wanted to express in these pictures what he calls the "magnetic aspect" of the Spanish landscape.[40] The Insects (pp. 42, 43) are the best works Masson produced during his stay in Spain from 1934 through 1936, perhaps because they were prompted by an immediate and personal kind of motif. In any case, the Spanish Myths (p. 36) and the Bullfights (p. 142) are more conventional in every respect, the latter being far too close for comfort to Picasso. Of the former, only the imposing **Landscape of Wonders** (p. 44) of 1935 recaptures the conviction—that sense of the mythic or epic as something directly experienced—which gave authenticity to the war-inspired Symbolic Forests of the early twenties. Indeed, it sprang from a very particular, very singular experience—that of an apocalyptic night Masson and his wife spent lost on the mountainside near the Abbey of Montserrat (of the Parsifal legend). The hooded figure in the painting is a reference to the monks whose chant Masson heard in the distance during the night.

The Spanish Myths and Bullfights, with a few exceptions, show Masson uncharacteristically working in the direction of illustration—a tendency that would culminate in his problematic Animated Furniture of 1938. The only successes this tendency produced are, not surprisingly, a series of frankly propagandistic drawings of 1936 inspired by the Civil War. As with Miró whose anti-war conviction, expressed in **Still Life with Old Shoe**, brought forth a realism unique in his art of the period, it seemed incumbent on Masson in these drawings to produce an imagery understandable to a larger public than that normally addressed by modern art. In 1936 Masson had felt the need for commitment in the Spanish war, though his horrific recollections of World War I and his age determined the limits of his participation. He joined an anarchist union in Barcelona, but refused a rifle when it was offered him, and finally felt compelled to leave the violent atmosphere of Catalonia. Nevertheless he wanted to participate, and his participation took the form of the anti-fascist drawings (above). Masson was alone among the Surrealists in this effort. "I wanted to make a *timbre-lutte,*" he recalled, "to openly pillory the dictators . . . I did comparable things during the Algerian war, in favor of the liberation of Algeria."[41]

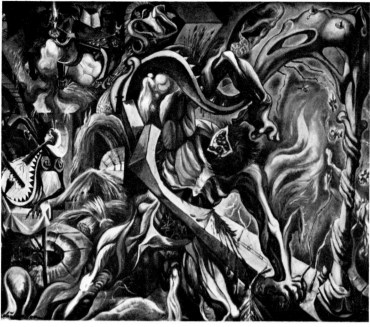

In the Tower of Sleep. 1938.
Oil on canvas, 31⅞ x 39⅜".
The Baltimore Museum of Art, May Collection

Louis XVI Armchair. 1938–39.
Oil on canvas, 28 x 22¾".
Collection Mrs. Henry A. Markus, Chicago

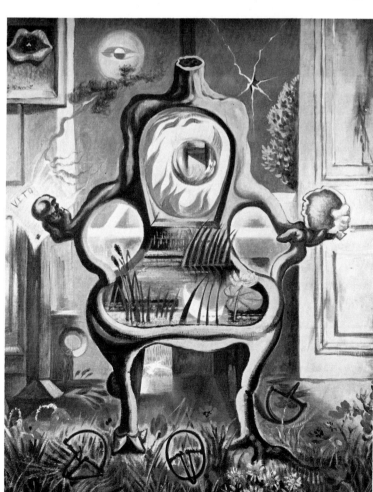

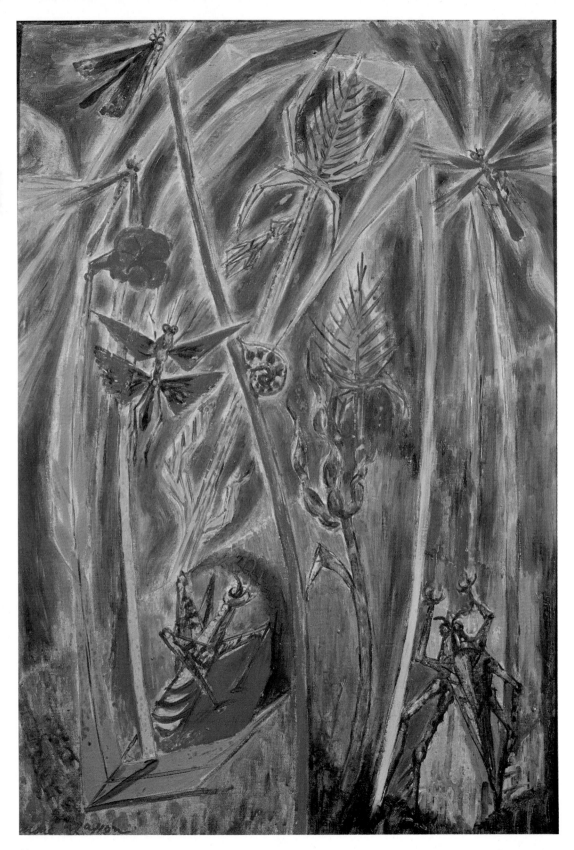

In the Grass. 1934.
Oil on canvas,
21⅝ x 15".
The Mayor Gallery, Ltd.,
London

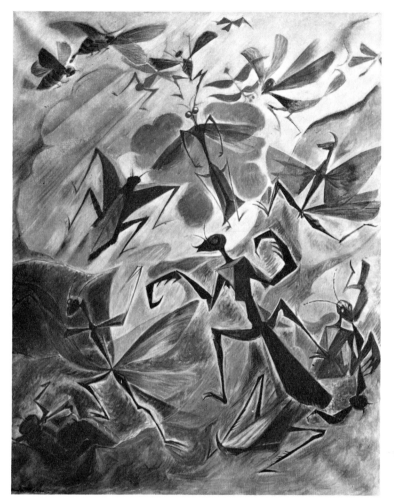

Despite Masson's break with Breton, his work of 1930–36 seems to have been inflected by the contemporary tendencies of Surrealism insofar as it was at once less dependent on the procedures of automatism than heretofore and—in the Spanish pictures especially—accommodated tendencies that were specifically literary. As the Civil War moved toward its tragic denouement, Masson shared the feeling then prevalent in leftist and avant-garde circles that disputes of the type that had earlier rent Surrealism were a luxury that could no longer be afforded. Following his return to Paris in December of 1936, he effected a rapprochement with Breton. Not surprisingly, his reentry into the Surrealist milieu further intensified the movement in his work in the direction of both the illustrative and the fantastical. The result was the Animated Furniture and the Paroxyst pictures of 1937–39, pictures which expectedly were better received than anything Masson had previously done—or was to do—by the now orthodox group that had remained with (or had joined) Breton after the departures and "excommunications" of the late twenties. Masson's reassimilation into the movement was memorialized in the 1939 painting Gradiva (p. 46), on a motif derived from a novel by Jensen which had been of special interest to Freud[42] and, subsequently, to Breton, who named his short-lived commercial gallery of Surrealist art after it.[43]

In the Animated Furniture, Masson was, in effect, tardily responding to Breton's call in the second manifesto for the "occultation" of inanimate objects. The subjects are monstrous *personnages,* more animal than human, which derive from deliberately hallucinatory meditations on pieces of furniture, most often chairs. Masson recalls that he often started with Louis XV chairs because their forms were already "a bit faunish."[44] The images are unrelated in either morphology or character to the furniture-personages of Bracelli, which had influenced the earlier hallucinatory *meubles* of Dali (though Bracelli was to be a point of departure for certain of Masson's drawings of the early forties, p. 45). Rather, they respond to a process of empathizing with an inanimate object—a kind of *hineinsehen,* which Ensor had practiced on the Victorian furniture of his day.[45]

In their evocation of the monstrous, the Animated Furniture and the Paroxyst pictures suffer from a problem of credibility that pervades all the imagery of monsters produced by the Surrealists. Except for the alienated Ensor in certain of his works, the Surrealists were the only painters of our century preoccupied with

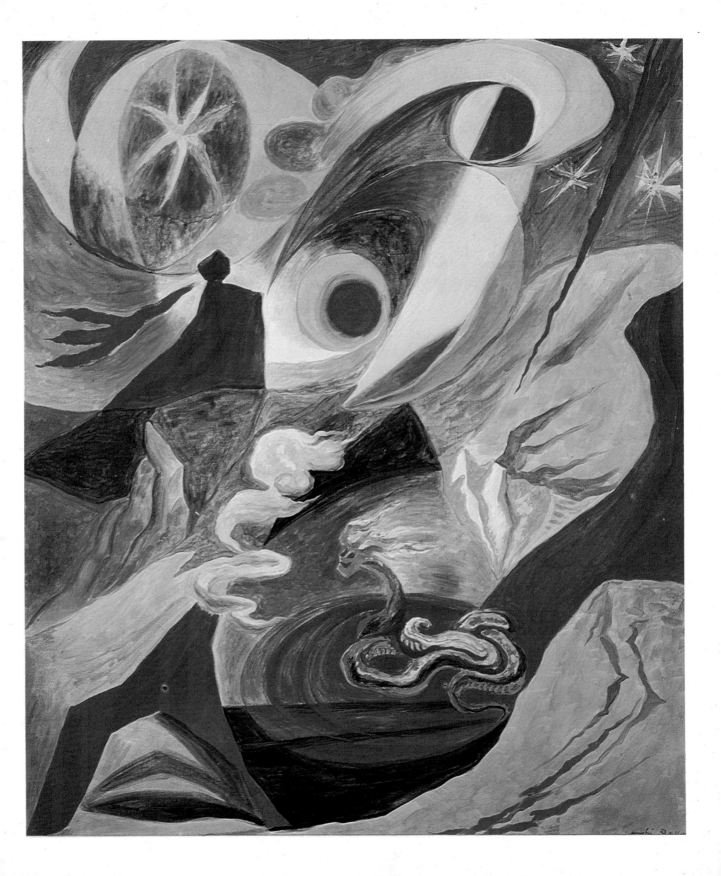

depicting an inner world menaced by monsters. They were alone in cutting these creatures from whole cloth, in taking them seriously. (I distinguish such Surrealist *personnages,* of course, from what might be called "monstrous" deformations of the human figure, such as we see frequently in Picasso, and from the familiar monsters of mythology and literature.) It is for the artist to convince us of the reality of such newly minted monsters. Whatever the commitment of the painter to his imagery, the test of conviction is finally in the eye of the beholder. I, for one, have never been fully convinced by any such invented monster in the work of Masson—or of Miró,[46] Ernst, Brauner, Matta, or Lam. At the time Masson was evoking internal monsters in the Animated Furniture, the real monsters' images were in the daily papers. Even Picasso's turnip-headed Franco of the **Dreams and Lies** finally menaces less than he bemuses. Indeed, one wonders whether in a post-Freudian society the "devil" can be imaged. Klee seems to have understood this. His invented monsters and devils emerge as whimsies and schlemiels[47]—their presumptions deflated by the psychological sophistication of the twentieth-century mind.

The nightmarish quality invoked in the Animated Furniture is intended to be even more violent in the Paroxyst pictures with which they are roughly contemporaneous, and the attempt to convince us of the reality of the irrational drives the painter even more into the paths of illusionism. Both series are characterized by a degree of conventional modeling never seen earlier (or later) in Masson's painting, though this modeling is never as academic as in Tanguy, Magritte, or Dali. The modeling did, however, render some of the Paroxyst pictures—already overloaded with iconographic motifs—difficult to digest visually. In the **Tower of Sleep** (p. 41), for example, is burdened by a surface no inch of which is not cluttered with some hallucinatory object or figure. Such surface crowding is assimilable when the configuration is abstract and the space shallow or flat, as in the various "allover" styles that emerge from late Analytic Cubism[48] and in much of Masson's work of the early forties. In reading **In the Tower of Sleep,** however, both the mind and the eye are constantly stopped and forced to readjust—the mind by the profusion and difficulty of the motifs, the eye by the modeling and the perspective devices which keep pulling it in and out of the space.

AT THE VERY time Masson's work seemed to have evolved in a direction maximally opposed to his former

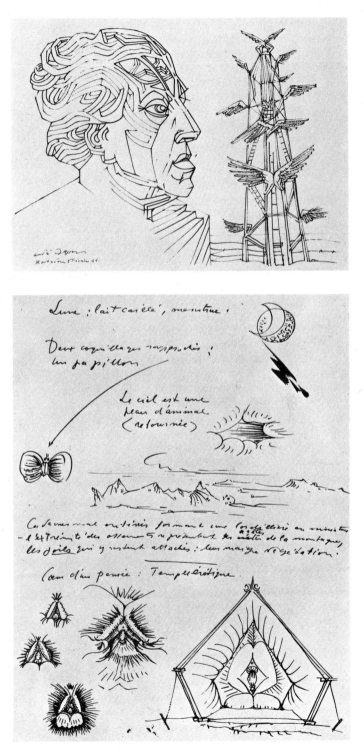

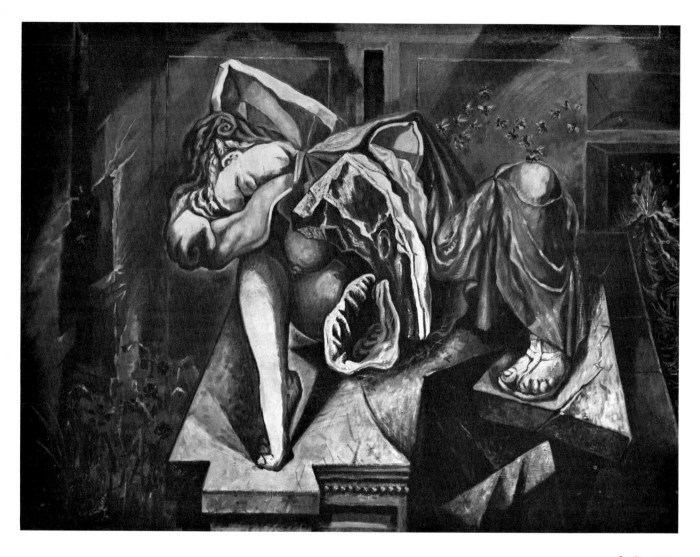

Gradiva. 1939.
Oil on canvas, 36½ x 51¼".
Collection Nellens, Knokke, Belgium

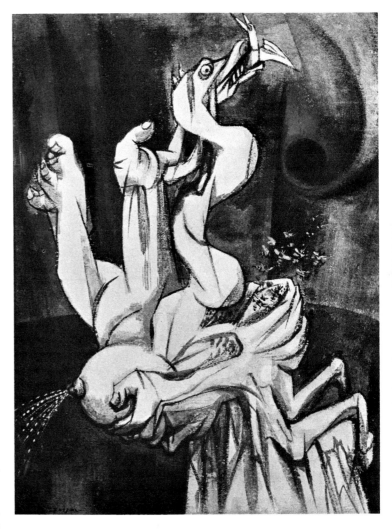

interests, his restlessness—perhaps a dissatisfaction with what he was doing—led him to reconsider his earlier painting with an eye to an alternative to the illusionism of the Paroxyst pictures and Animated Furniture. Having lost the thread of a certain kind of automatic drawing in the late twenties, Masson was now to find—as Heraclitus, his favorite philosopher after Nietzsche, put it—that "the way forward is the way back." His return to his sources, so to say, was as instinctual as it was conscious; it emerged out of the process of working and led him, in such pictures as **Ariadne's Thread** (p. 55) and **The Earth** (p. 151), to a kind of painting at once more abstract and more ambitiously poetic than his illusionist essays of the period. From late 1938 through 1941 these opposed tendencies coexisted in Masson's painting until the more abstract of them triumphed in the work executed during his stay in the United States.

This reemergence of Masson at the end of the thirties as a challenging draftsmanly painter was—not purely by chance, I believe—associated iconographically with the theme of Theseus' emergence from the labyrinth, a salvation made possible for the hero by the thread of Ariadne, which comes increasingly to be literally identified by Masson with his own line drawing. Though the Surrealism of the twenties had been little concerned with classical mythology, mythological themes—interpreted in Freudian or Jungian terms—played an increasingly important role in the Surrealism of the thirties and forties. The fascination with these subjects was by no means restricted to Surrealists, however; myths were of even greater interest to that segment of the French literary avant-garde represented by Bataille, Limbour, and Leiris.

The story of Theseus and the Minotaur was already discerned in the early thirties as the most expedient of classical myths. In the center of the labyrinth—the recesses of the mind—resides the Minotaur, symbol of irrational impulses and mindless energy expressed by a bull's head "collaged" on a human body. Theseus' quest is an allegory of the conscious mind threading its way into its own unknown regions. Sought out in the heart of darkness, the Minotaur is slain, and Theseus finds his way back again by virtue of intelligence, that is, self-knowledge—Ariadne's thread symbolizing the fabric of revelations provided by free association and dream analyses. It is easy to see why the Theseid was recognized as providing a paradigmatic schema for the Surrealist drama, as indeed, for the process of psychoanalysis; it could also be more narrowly inter-

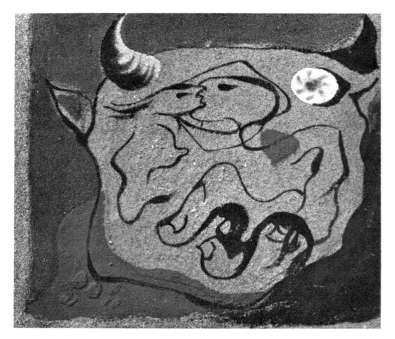

Story of Theseus. **1938.**
Oil and sand on wood, 8⅝ x 10⅝".
Private collection, Paris

opposite top :
Cover for *Minotaure.*
Nos. 12–13. 1939

opposite bottom :
The Labyrinth. 1938.
Ink, 25¾ x 19¾".
Private collection, New York

preted as the struggle of free men against fascism. It was Masson who, with Bataille, convinced Skira and Tériade in 1933 to call their new review *Minotaure*. Picasso, who had portrayed this monster in a collage and painting of 1928 and was now to make it a major protagonist in his art, executed the first cover.[49]

Masson had imaged the Theseid as early as 1922;[50] it played a central iconographic role in his work from 1938 onward, providing the motif for many of his best pictures. The very tangle of lines produced in the first stages of automatic drawing, as the artist interrogated his unconscious, would come to be identified with the labyrinth. And the act of turning this web into a coherent visual image would constitute the emergence from (or solution to) the labyrinth. In this, as in his treatment of the Minotaur itself, Masson remains very close to the poetic and psychological implications of the myth. When he interpolates motifs of his own invention, it is always to enhance the elemental forces of Eros and Thanatos. The humanized Minotaur conceived by Picasso—here gentle in his erotic attentions to a maiden, there pathetic and sympathetic in his blindness—is little evident in the art of Masson.

Given the importance of subject in Masson's painting, it does not seem to me a matter of pure chance that the best of his illusionistic paintings of 1938—one of the few that convince entirely—is called **The Labyrinth** (p. 53). Here we are presented with something far more complex than the familiar "collage" image of the Minotaur himself. Instead, a variety of motifs extrapolated from the classic myth—combined with those from Masson's private associations with it—are incorporated in a single vaguely anthropomorphic, horned being whose feet are rooted in underground chasms and whose torso and head rise like a Surreal totem against a background of darkling sea and sky. **The Labyrinth** belongs to those "metaphysical" paintings in which Masson expressed his symbolic conception of a universe in accord with the precepts of the pre-Socratic philosopher Heraclitus, whose imaginary portrait he executed on a number of occasions (p. 61). The universe of **The Labyrinth** is pictured as subject to continuous metamorphosis, change being for Heraclitus the only reality. The Heraclitan concept of the unity of opposites is expressed in the very metaphor with which the picture begins—the man-beast Minotaur—and extends to include the Four Elements and the three Natural Kingdoms.

In keeping with the historical source of the myth, the labyrinth is literally depicted here as architecture,[51]

whose masonry skin has been cut away to reveal its interior structure. As in the creature's left arm and leg, which reveal a stairway and a column respectively, Masson was working toward a metaphoric identification of man and architecture inspired at once by reminiscences of Piranesi's "architecture of the mind" and the ruined "cranial" villages of World War I (most fully realized in a series of contemporary watercolors and drawings, p. 33). If the horns of this creature, the stepped altar in his head, the masonry maze in his stomach, and the Daedalian bird flying nearby are properties of the received myth, the fishlike exterior of the left arm and hand, the swan into which the bone of the right leg issues, and the spider-like red heart belong to a more private, less collective level of metaphor. The termination of limbs in animal forms in the sand pictures of 1926–27 presented an ambiguity made possible by the high level of abstraction in those pictures. What was expressed at that time through fusion must in the illusionist language of **The Labyrinth** be realized as a Surrealist double image. The vegetal sex is precisely that, and as such inevitably recalls Arcimboldo. But it is also symbolic of the vegetable kingdom, which along with the animal and mineral is represented in **The Labyrinth**, as are the elements of earth, air, fire, and water—all of which are pictured in the state of constant flux in which Heraclitus' cosmology describes them. And as in Heraclitus, the perception of this universe is understood by Masson as the key to self-knowledge, the means of unlocking the individual psyche.

The Labyrinth holds our attention by the intensity of its poetry, but its Thesean and Heraclitan components, both pointing in the direction of self-analysis and self-discovery, are matters of iconography rather than process inasmuch as the style remains largely illusionistic. It is hardly surprising, in retrospect, that the theme of self-interrogation at the heart of this image should have led Masson back to some form of automatism, and, indeed, late 1938 saw the first of a new series of pictures—various versions of **The Story of Theseus** (left) and **Ariadne's Thread** (p. 55)—which derive from improvisational line drawing in an abstract context of flat forms and shallow spaces. Once again, as in the automatic works of the mid-twenties, the resolution of opposites—the unity of man and woman, of man and beast—would appear as a fusion or metamorphosis proceeding directly from the process of drawing rather than as collage-like illusions or double images. As if to affirm the parentage of these works

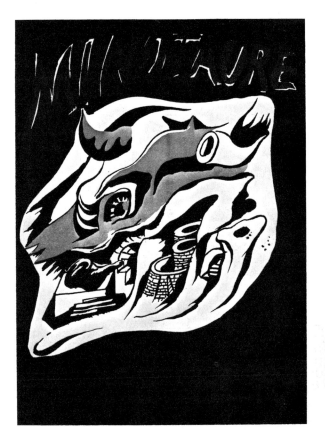

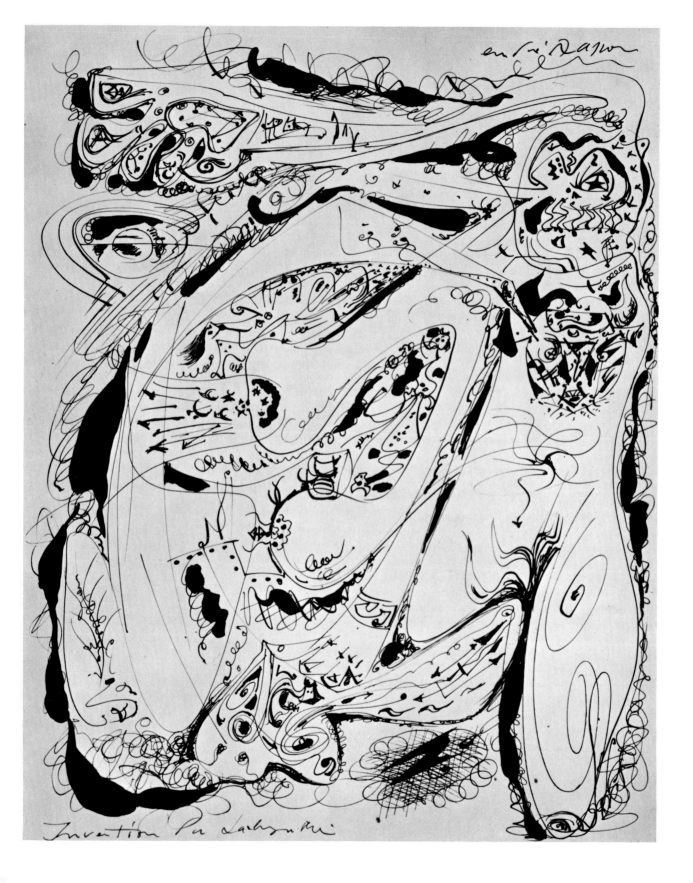

Invention par Lachynski

Invention of the Labyrinth. **1942.**
Ink, 23⅛ x 18¼".
Private collection, New York

with those of the later twenties, Masson painted them on a surface-affirming layer of sand. As befits a series derived wholly from drawing, the format of these Thesean pictures is small; suggestions of the fused figures of Theseus and Ariadne are generally contained within a Minotaur's head, the horns of which are symbols at once of Eros and Thanatos. In effect, Masson had taken possession of his own Ariadne-thread, which had always been improvisational line drawing, and by virtue of this reaffirmation he was to work himself by the early forties into a new world of style and imagery.

WHILE MANY of Masson's drawings of the late thirties—his illustrations for *Les Chants de Maldoror,* for example—are technically as conventional as his painting style of the Paroxyst pictures, the new direction already began to make itself felt in 1938 in a small series of brush drawings devoid of space or modeling of which **The Labyrinth** (p. 49) is the most interesting. The patterning of this image, which is entirely curvilinear, recapitulates a mazelike movement outward from a vortex that was in fact the starting point of the drawing. This abstract suggestion of organic growth, whose patterning implies but does not illustrate the force of the elements, issues from a core which is felt to be in the depths of the psyche. Despite the antistructural nature of the motif, the pattern is nevertheless slightly "squared," so to say, so that typically for Masson it has an almost classic, architectural relation to the borders of the sheet of paper.

The culmination in terms of quality of the drawings inspired by the Theseid is the superb **Invention of the Labyrinth** of 1942 (left). This drawing is more free and more automatic than any Masson executed in the thirties, and its recaptures all the verve and élan of his early Surrealist imagery. More improvisational in its execution than the 1938 ink drawing of **The Labyrinth,** it is also less abstract insofar as the image has been carried to the point where allusions to the particulars of the myth become readable. But they tumble at us in a hallucinatory, illogical way that relates to the real workings of the mind—the free associations captured in the process of drawing—rather than as discrete images, as in the 1938 oil of **The Labyrinth.** Out of the rapid, seemingly random markings of the pen emerge suggestions, subsequently detailed, of Pasiphaë's head (upper right), arm and hand, and vagina, the bull's head and repeated suggestions of his phallus, as well as a host of less identifiable signs.

Multiplication. **c. 1943.**
Ink, 10⅝ x 8¼".
Collection of the artist, Paris

The Metamorphoses. 1939.
Oil on canvas, 70⅞ x 36½".
Galerie de l'Ile-de-France, Paris

The Labyrinth. 1938.
Oil on canvas, 47¼ x 24".
Private collection, Rome

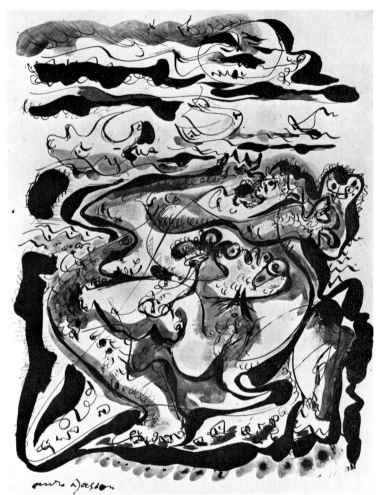

Erotic Earth. **1943.**
Ink and watercolor, 22⅞ x 17¾".
Collection of the artist, Paris

In **Invention of the Labyrinth**, Masson has focused on the erotic aspect of the myth, the coupling of Poseidon's bull with Minos' queen, Pasiphaë—a theme which entered his painting in 1936 and which would reappear in a number of other works of the American period. The extraordinary celerity of Masson's pen drawing here helps characterize the sexual urgency of the theme; the flat brushed areas of black wash were added last, here to detail or echo a motif (the horns of the bull), there to reinforce the flickering scintillation of light and dark which animates the whole. This light-dark patterning, like the shallow space and "comfortable," classic relation of the entire configuration to the frame, reminds us that beneath the Baroque surge of the drawing there lurks that same Cubist infrastructure which provided the underpinning of the sand pictures of the twenties. If I make a special point here about the fusion of a Baroque, curvilinear form language and an allover Cubist substructure, it is because this same combination was to play an important role in the formulation of the forties styles of a number of American painters, notably Tobey and Pollock.

Invention of the Labyrinth may be seen as a reservoir of ideas for a number of images of this subject during the immediately ensuing years, especially a major oil of 1943 (p. 59) and a pastel of 1945 (p. 58), both titled **Pasiphaë.** In the oil, which, like the pastel, translates the sexual interlacing of bull and woman into a horizontal format, the figures are presented with greater discreteness and clarity than in **Invention of the Labyrinth**, though the postures of the protagonists are not fully spelled out. Segments of the bull and woman are shown frontally or in pure profile, as if responding more to a memory image than a thing seen. The profiled head of Pasiphaë—here rendered as a bony, skeletal thing—occupies the upper right, while the bull's head is situated frontally just below. Pasiphaë's arms are cast upward, as in **Invention of the Labyrinth**, whereas in a 1943 drawing (p. 59) that probably just preceded the oil she provocatively offers her breasts. Her vagina, rendered in the oil with considerable realism, is disposed just below the genitals of the bull in the lower center. Common to all these images are shooting stars that endow the event with cosmic overtones.

The 1943 oil of Pasiphaë was built up slowly, the sand-enriched pigment shaded very delicately. As in the Telluric pictures with which it is contemporaneous, the configuration involved a complex jigsawing of shapes. This patterning is very sophisticated except in

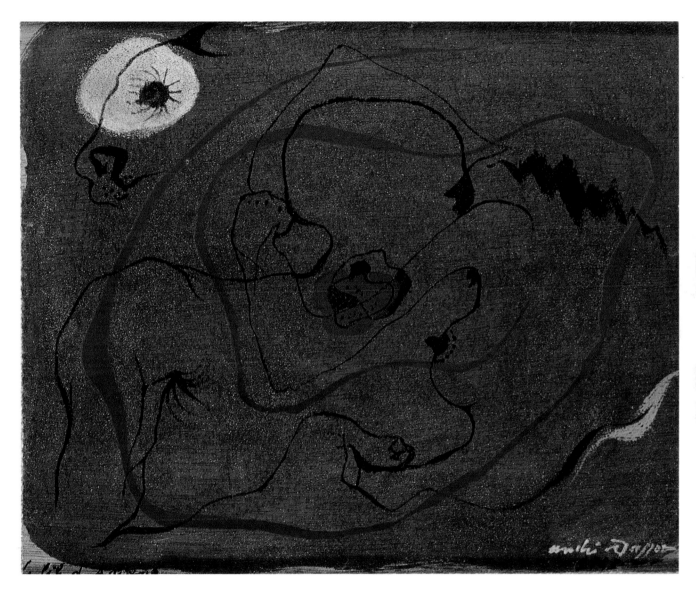

Ariadne's Thread. 1938.
Oil and sand on board,
8⅝ x 10⅝".
Private collection, Paris

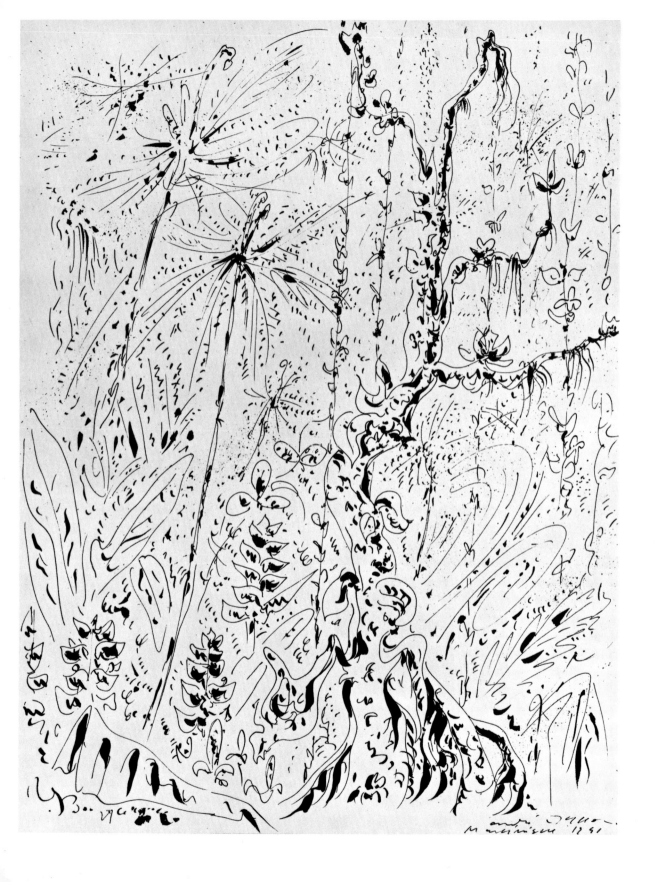

Forest—Martinique. 1941.
Ink, 24¾ x 18⅞".
Private collection, New York

the areas of Pasiphaë's body, where the simple deco-
rativeness—perhaps an echo of the "X-ray" view of
the figure in Picasso's **Girl before a Mirror**—seems to
detract from the air of epic violence and sensuality that
prevails. The studied method of execution used here
involved a considerable loss of the motor character
that was notable in **Invention of the Labyrinth.** Much of
the celerity was to be recaptured, however, in the
pastel variant of 1945, where the medium again allowed
the full play of Masson's draftsmanly powers.

LIKE MANY OF the Surrealists, and a number of other
painters living in France, Masson had chosen after the
establishment of the Vichy government to go to the
United States. There, from 1941 through 1945, Sur-
realism experienced a productive period comparable
to the pioneer years of 1924–29. Most of the Surrealist
painters got on well in New York; Ernst, Dali, and
Matta were multilingual, sophisticated, and gregarious,
and they already had many friends in America.
Masson, who knew no English and learned none, led a
more isolated life than the other members of the exile
group. He settled near Tanguy in New Preston, Con-
necticut, visiting New York only rarely, usually on the
occasion of exhibitions in which he participated.

In his isolation, Masson immersed himself in a world
of nature very different from any he had previously
known. He had been struck on his arrival by the
extraordinary nature of the light in New York and New
England and recalled Matisse's remarks to him in 1933:
"One day you will go to New York; you will be
astonished by its beauty and by the brilliance of its
light." Masson was also overwhelmed by the colors of
the New England autumn, which he recognized as
unique. "In Connecticut," he recalled, "the colors had
exceptional power. The colors of the Indian summer, of
the autumn vegetation, the colorful violence of the sky,
trees, fallen leaves—a whole symphony of tones—
stimulated me to a greater vivacity of color."[52]

Masson's response to nature in New England was
less to depict it (as had been the case in the exquisite
quasi-naturalistic drawings, left, he produced during
his three-week stopover in Martinique en route from
Europe) than to suggest its forces. The morphologies of
the Telluric pictures start from descriptions of actual
living things—foliage, insects, and animals—and grad-
ually evolve into metabiological fantasies worthy of
Redon (whom Masson, alone among the Surrealists,
profoundly admired).[53] In the context of a tonal rich-
ness deeper and more orchestral than that of his

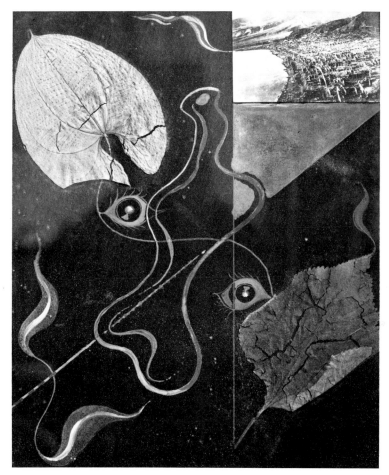

Martinique. 1941.
Collage, 16½ x 13¾".
Collection Rose Masson, Paris

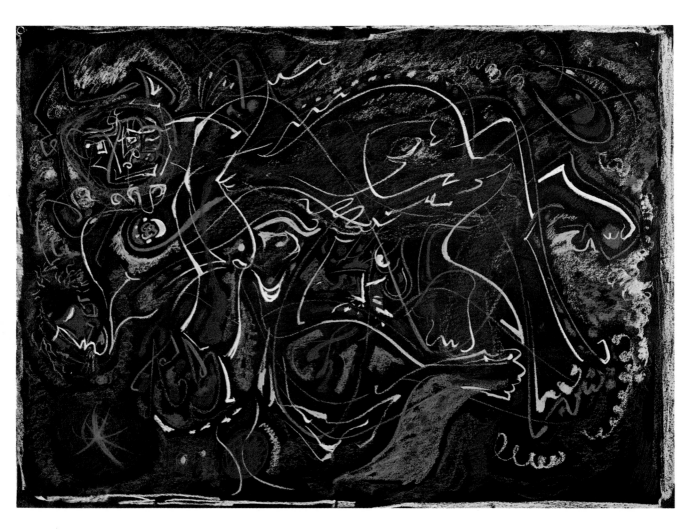

Pasiphaë. 1945.
Pastel on paper, 27½ x 38⅛".
The Museum of Modern Art, New York,
Gift of the artist

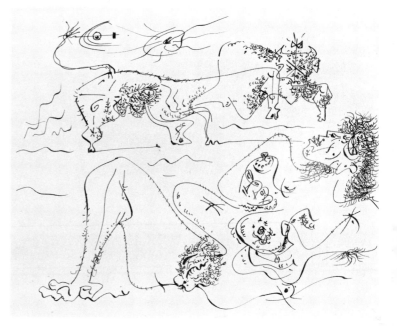

mid-twenties pictures, the themes of germination and eclosion return to inspire a newly inflected and enriched vocabulary of organic forms. These new forms have a rich, glowing, and at times almost phosphorescent quality achieved in part by setting their reflecting, sand-enriched colors against a black or dark brown that provides a kind of background matrix.

The Telluric pictures are marked by a contemplative, meditative cast that distinguishes them from the drawings and paintings in which Masson continued to body forth his energetic *graphisme.* Pictures such as **Meditation on an Oak Leaf** (p. 60) and **Meditation of the Painter** (p. 160) do not evoke the "automatic" draftsman, *l'homme-plume,* the possessor of the living hand, whom we see in the **Torrential Self-Portrait** (p. 12). Rather, Masson is felt as a passive presence—almost a spectator at the unfolding of his own chain of associations—who presides over a metamorphosis of forms that seem nearly to have a life of their own but which are analogues in nature for the deepest impulses of the psyche. Masson described these pictures, "which I ambitiously call chthonic," as "belonging to subterranean forces."[54]

The configuration of **Meditation on an Oak Leaf** is not dominated, as in the graphically inspired work, by a galvanic rhythm that binds the entire surface. The generation of form seems more localized, the contours more individuated. The unity of the composition is not felt through the pulse of the accenting, but rather in the rightness of the jigsawing of the constituents of a complex layout. The picture teems with biological symbols of germination and growth ranging from the suggestions of single cells or larvae to the totem-like configuration as a whole, which is at once, as we shall see, floral, faunal, and human in its implications.

The starting point of the painter's "meditation," which returns time and again, as in a rondo, to bind his chain of associations, is the oak leaf, which is seen in silhouette as a kind of blue "shadow" in the upper left of the picture. Inside that silhouette its shape is recalled in minuscule form in tripartite pattern that suggests cell division. This is at the vortex of a womblike linear pattern that unwinds around it in the manner of the 1938 drawing **The Labyrinth.** As the artist contemplates the leaf he thinks of the cycle of nature and the rapport of that mystery with the traumas and fantasies in the deepest recesses of the labyrinth of his own mind. Another vortex, which is also a kind of womb and labyrinth, unravels to the right, just above the center of the canvas. Here the leaf leads the painter to

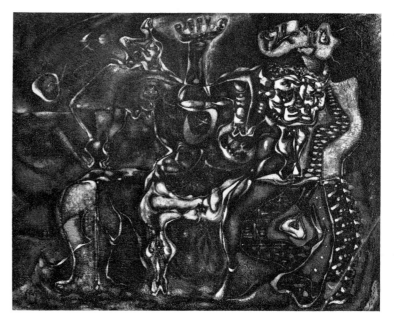

Pasiphaë. 1943.
Oil and tempera on canvas, 39¾ x 50".
Collection Dr. and Mrs. J. H. Hirschman, Glencoe, Illinois

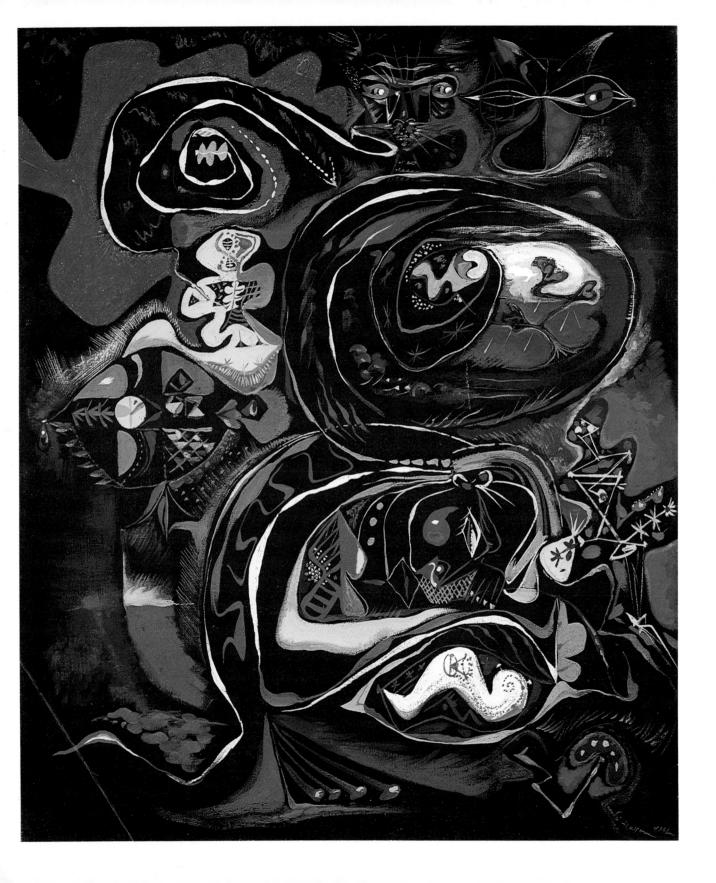

a more biomorphic reverie of ectoplasms in an environment of water and flame. A third covers much of the lower part of the painting and contains within it a tiny image of the artist himself drawing on a sheet of paper—a suggestion that the artistic process is as deeply rooted in the psyche as any aspect of the picture's metabiological poetry. A similar "hidden" embryonic self-portrait is to be found, in a somewhat more decipherable form, in the womblike shape that is visible at the bottom of the superb **Meditation of the Painter.**

As our eye passes slowly from part to part of **Meditation on an Oak Leaf,** we are continuously reminded of the leaf by varied references to its silhouette, its color, its veining. It is constantly multiplying, decomposing, metamorphosing. Here it occasions a play of abstract patterning, there it resembles the palmistry patterns of a human hand. The leaf is conceived as a motif midway between the microscopic and the telescopic, not only a microcosm of a larger cosmology foretold in the mythic, totemic dimensions of the image, but a macrocosm of the subvisible, infrabiological universe suggested in the smaller forms.

In a process comparable to that of gestalt formation, we begin by "recognizing" the smaller units of **Meditation on an Oak Leaf.** Then the eye perceives how they coalesce into larger formal patterns even as the mind speculates on the poetic links implied. Finally, we perceive that the entire configuration constitutes a kind of totem of a private myth—a figure with its right foot forward just left of center at the bottom of the composition. The cat's head which surmounts this totem symbolizes, on one level, the realm of fauna and is extrapolated from drawings of the female pelvic structure.[55] Beyond this it is an association—within the private imagery of Masson—with the Heraclitean philosophy that presides over this fantasy. We have seen that Masson had been constantly interested in Heraclitus' vision of universal, ceaseless metamorphosis in which what we take to be actuality is an illusion, making the only reality that of change, of becoming. The Heraclitean view of the world seemed more than ever appropriate to Masson in terms of his communion with nature in New England, and it is not surprising that images of the philosopher should figure importantly among his Imaginary Portraits of the period. The feline features with which he endows the philosopher in these works (right) are a clue to a personal symbolism represented by the cat's head that caps the totem of **Meditation on an Oak Leaf.**

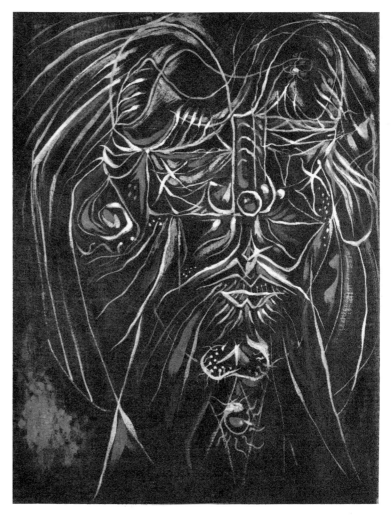

Heraclitus. 1943.
Tempera on canvas, 25¼ x 19¼".
Galerie de Seine, Paris

Rape. 1941, printed in 1958.
Drypoint, 12⅛ x 16".
The Museum of Modern Art, New York,
Lent anonymously

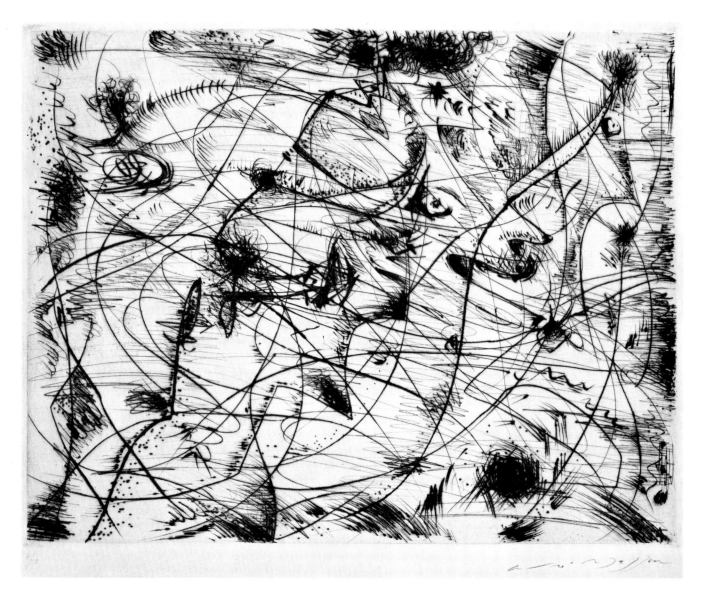

The Telluric pictures of the early forties—Meditation on an Oak Leaf, Iroquois Landscape (p. 165), Meditation of the Painter—are not nearly so automatic as the more graphically inspired paintings, such as Entanglement (p. 69), with which they are roughly contemporary. But when they are compared with the Paroxyst pictures or the Animated Furniture of the late thirties, we become aware of significant differences in method, as well as the marked difference in quality. To execute one of the Paroxyst pictures, it was necessary for Masson to have the entire image in mind before painting. Painting there became almost entirely a matter of implementing an image sketched out in some detail on the canvas, an image that had been transferred there from the screen of the mind's eye. As far as process is concerned, this fixing of an illusion may be described as working the canvas from the outside in. The Telluric pictures, whose final form absorbed many changes improvised during their execution, represented a return to Masson's more familiar process of working from the inside out. The shapes often evolved by growing outward from the nucleus of a small point of color in a manner that parallels the themes of organic growth actually imaged in the painting. Areas of color were not firmly contoured, but were allowed to grow and shrink organically as Masson adjusted his complex equilibrium. If these paintings demonstrate Masson's richest use of color, they also, not surprisingly, show him at his most "painterly," in the Wölfflinean sense of the word. "There is no outline [in them] in the conventional sense," Masson observes.[56]

RUNNING MORE or less parallel to the Telluric pictures, and more daring insofar as they propose some unusually articulated configurations, are a series of purely draftsmanly images of great power and energy executed in America. In their complex interlacings, their run-on calligraphy and allover accenting, these cumulatively constitute a transformation of Masson's linear powers into a vocabulary of painterly effects. Because the images are built up by massing linear accents—whether drawn with a liner brush, a bamboo pen, or a burin—the formats remain relatively small, consonant with the quasi-calligraphic notation that animates them.

The drypoint titled Rape (left), which Masson executed in 1941 at a time when he was working in Stanley Hayter's atelier, carries to a paroxysmal level both the theme and the linear articulation characteristic of the Theseid images of 1939. In the Paroxyst

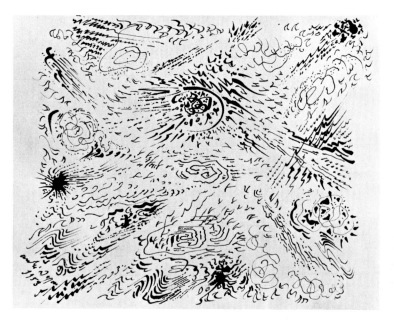

Cosmic Song. 1953.
Ink, 9½ x 11¾".
Collection of the artist, Paris

The Tree. 1943.
Chinese ink, 22⅜ x 13½".
Collection Steven M. Jacobson, New York

pictures, the hyperintense activity had been illusioned as subject but was not part of the making of the image. Here, all the intensity and violence which the subject triggers in Masson's mind is expressed in the manner in which he has engraved the image—a facture that is perceived and savored by the viewer down to the velocity with which the knife-sharp lines cut their way brutally across the surface. The wild, unfettered drawing of **Rape**, which expresses the nature of the theme without illustrating it, seems on the point of falling into chaos but is saved by a last-minute counterthrust in favor of order. Indeed, though the gestural freedom involved in the making of this print goes, in certain respects, beyond even that of the 1926–27 sand paintings, it finally resolves, as they do, into a Cubist-derived configuration—here taking the form of an alloverism which would become common by the later forties. Wild and seemingly accidental as many of the long lines of **Rape** at first appear, they rarely run off the image. Rather, they create a web of a roughly even density (as measured by the frequency of the lines) which sits not uncomfortably in the rectangle of the paper and which is shaded at more or less even intervals to enhance the allover sense of the configuration. In the interstices of this web, whose contours might be considered the detritus of a labyrinth defined by Ariadne's thread, are bits and pieces of male and female anatomies strewn about as if on the battlefield of some epic struggle between the sexes.

In the same year (1941) as **Rape**, Masson executed a small allover painting of unusual and prophetic interest entitled **Entanglement** (p. 69). Here, the fragmentary accents formed by a liner brush are of a more calligraphic order and anticipate the lyrical, more elegant alloverism of a number of later ink drawings, such as **The Tree** (left). The image at first appears wholly abstract, but perusal reveals bits and pieces of animal and human anatomies. In fact the motif is that of Achilles devoured by dogs, the inversion of Achilles' mythic encounter with Penthesilea invented by Kleist for his tragedy named after the Amazon queen.[57] Here again, though in a different manner than in the early thirties, the decorative aspect of the coloring, reinforced now by the lyric calligraphy, provides on the abstract level of the work a kind of ornamentalism that disengages from the now almost undecipherable motif. In **Entanglement**, Masson has anticipated with the brush the celerity and ardor which were to animate the best of his reed-pen drawings of the following years, such as the **Torrential Self-Portrait**.

The Kill. 1944.
Oil on canvas, 21¾ x 26¾".
The Museum of Modern Art, New York,
Gift of the artist

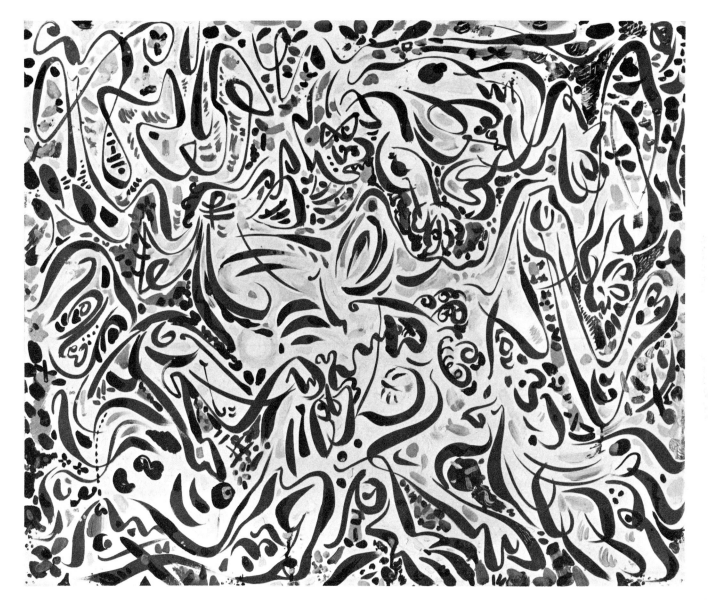

Leonardo da Vinci and Isabella d'Este. **1942.**
Oil on canvas, 39⅞ x 50″.
The Museum of Modern Art, New York,
Given anonymously

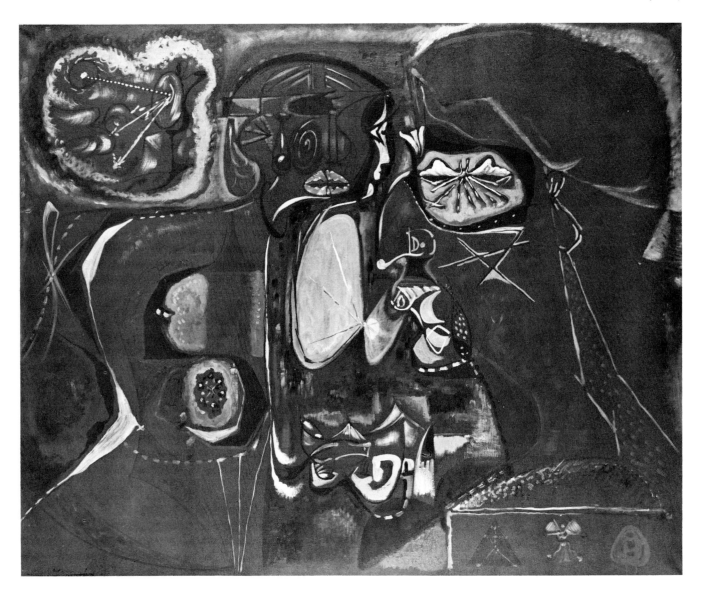

CONSIDERATION of Rape, Entanglement, and other primarily draftsmanly Massons of the early forties requires that I say a few words about Masson's relation in that decade to American painting—particularly that of Jackson Pollock. Like Masson, a number of American painters during that period invoked mythic, symbolic subjects through methods derived from Surrealist automatism and tended to organize these motifs in Cubist-derived configurations, often of an allover character.[58] But these very general affinities were shared by the Americans with Miró (and, to some extent, Ernst) as well as with Masson and reflect a common interest on both sides in the thirties painting of Picasso. While we can observe Hans Hofmann basing a painting (fig. 1) on Masson's Meditation on an Oak Leaf[59] and see Gorky propelled toward his characteristic form language by the experience of Masson's Leonardo da Vinci and Isabella d'Este (left),[60] it is with Pollock in particular that Masson's work had more specific affinities, in part because of certain common denominators in their gifts and in part because of the common character of the pictorial problems they faced. I use the word affinities advisedly here because, although we can document a few instances of direct influence of Masson on Pollock and intuit others, a certain similarity in their enterprises was dictated by this commonality, and anticipations of Pollock in the imagery of Masson need not therefore be functions of a cause-and-effect relationship.

The views of those close to the New York scene in the early forties as to the relation of Masson and American painting tend to vary with the reporter's closeness to Pollock. Thus Robert Motherwell, whose own association was primarily with Matta and Ernst, considers Masson's role minor. Clement Greenberg, whose identification with Pollock in those years is well known, saw the situation differently. "André Masson's presence on this side of the Atlantic during the war," he observed in 1953, "was of inestimable benefit to us. . . . He, more than anyone else, anticipated the new abstract painting, and I don't believe he has received enough credit for it."[61] The "anticipation" of which Greenberg wrote did not refer to the specific influence of given paintings, but rather recognized the advanced nature of Masson's composition, his calligraphic vocabulary, and the particular character of his "automatic" line. To be sure, Pollock may have seen Rape in Hayter's studio, as was suggested by Bernice Rose, who offered it as a possible influence on an

Figures 1–6 are reproduced on page 207.

important Pollock print of 1945.[62] And he was unquestionably influenced by Meditation on an Oak Leaf, of which his Totem I (fig. 2) is an extrapolation. But even in the latter case, a confrontation of the two images impresses us more by their differences than their similarities—differences I describe elsewhere[63] as essentially those of New York and of School of Paris painting.

The very earliest possible reflections of an interest in Masson on the part of Pollock may be embodied in certain of the latter's symbolic pictures that are usually dated "c. 1936" but are undoubtedly later.[64] Paintings such as Circle (fig. 3) and Woman (fig. 4), for example, reflect Pollock's interest in both American Indian symbolism and the work of the Mexican muralists. But there is also a dose of Surrealism in these pictures. Their "telluric" symbolism, brash colors, and pervasively apocalyptic character recall Masson's Spanish Landscapes and Insect pictures. Apart from the Massons of the twenties and thirties shown in The Museum of Modern Art's "Fantastic Art, Dada and Surrealism" of 1936–37, Pollock would also probably have seen Masson's work in one-man shows given in 1932 and 1935.[65] We know also that Pollock saw Cahiers d'art and Minotaure, both of which contained a number of illustrations of works by Masson from the twenties and thirties. Given all this, it does not seem exaggerated to me to see in Pollock's paintings such as Panel C (fig. 5) some reflections of Masson's seated female figures of the twenties and perhaps the Massacres and Bacchanales as well. The latter were shown by Pierre Matisse, and the experience of them can be seen entering Gorky's painting of the thirties.[66]

Whatever affinities and/or influences may be observed between the work of Masson and Pollock prior to the winter of 1942–43, they are clearly secondary to the influence on Pollock of the Mexican muralists and the influence on both Masson and Pollock of Picasso. It is only when Pollock's drawing begins to disengage from shading and starts to constitute an autonomous shorthand of signs, which creates its own surface rhythm, that a real closeness between Pollock and Masson may be perceived. If this new rapid notation of Pollock is at its most prophetic in passages of 1943 paintings such as The Guardians of the Secret, it is already visible in a painting probably made late in 1942, Stenographic Figure (fig. 6), which has deep affinities with the shorthand notation of Masson drawings such as Invention of the Labyrinth. Indeed, Stenographic Figure shows not only how Pollock relates to Masson, but how he does not—insofar as the alle-

Entanglement. **1941.**
Distemper on cardboard, 16⅛ x 12⅝".
Collection of the artist, Paris

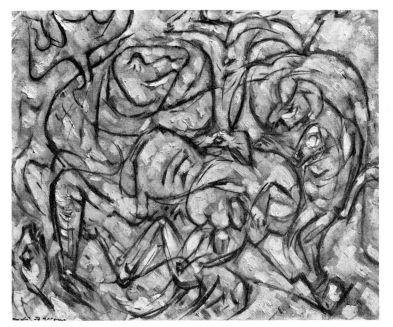

Elk Attacked by Dogs. **1945.**
Oil on canvas, 20 x 25".
Hirshhorn Museum and Sculpture Garden,
Smithsonian Institution, Washington, D.C.

giances to Miró in the figuration and to Picasso in the bold, broad layout and bravura execution remain manifest.

The affinity of Masson and Pollock is fundamentally a question of line, a kind of line that breaks away from description and, hence, from contouring or modeling the surface. Picasso's line, even at its most improvisational, is that of the sculptor. It bites into the surface of the image, implying convexities and concavities as well as shapes. In the period 1943–47, Pollock's line achieved its independence, velocity, and galvanic power precisely by relinquishing step by step this descriptiveness and sculptural quality in favor of greater abstractness and two-dimensionality that ultimately assigned it a more decorative role. Masson had already gone far in the twenties in the direction of this type of drawing. "Line," he remarked, speaking of the sand paintings, "is no longer essentially informative [*significative*]; it is pure élan; it follows its own path or trajectory; it no longer functions as a contour."[67] Yet Masson's description is accurate only up to a point. In fact, his line never became so abstract as to lose its connotative quality. To achieve this, Pollock had not only to use a poured line, but above all to run his lines so close together that none of them would be read as contouring a shape.

Masson's automatism, then, like that of Pollock in the period 1942–46, remained ultimately figurative despite the high degree of abstraction it entailed. When Pollock carried these ideas to the level of a nonfigurative art in his "classic" pictures of 1947–50, he made something of Surrealist automatism that, as Masson himself observes, had never been foreseen by any of the Surrealists. Later, as Pollock's poured pictures became known in Europe, they seem to have influenced, in their turn, both Masson (in such pictures as La Chevauchée) and Miró (in The Bather of Calamayor, for example), though the Surrealist painters never accepted the transition of the painter's gesture from connotative sign to abstract mark. The return of fragmentary figuration—suggestions of the older totemic forms, bits of human anatomy—in Pollock's black pictures of 1951 suggests that its disappearance on the manifest level from his work of 1947–50 did not signify a suppression of the psychic and poetic forces it embodied. On the contrary, these forces are an informing principle whose spirit is the nonplastic counterpart of the infrastructural sense of Cubism in those same works. Certainly, it is the mythic and psychic content of that poetry—another aspect of his filiation with Masson and with Surrealism

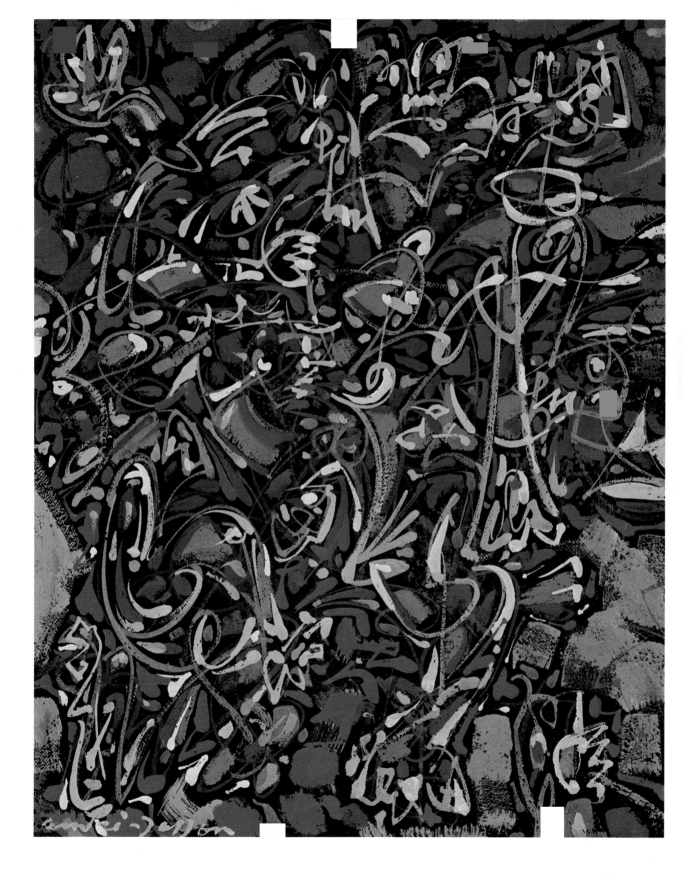

in general—that endows the wholly abstract art of Pollock with a visionary, apocalyptic character not found in Mondrian, Delaunay, and other earlier, Cubist-inspired forms of nonfigurative painting.

IT IS WITH A certain reluctance that I have dwelt in these last pages on the relation of Masson to American painting. Though my own writing has had a role in the discussion of this subject—notably an article[68] published some six years after the remarks of Greenberg already cited—I have come to be troubled by an increasing tendency to make a case for Masson that is essentially historical rather than intrinsic (i.e., resting primarily on the merits of his best work). This attitude was already manifest in the remarks of Greenberg previously cited.[69] To whatever extent such an estimate relies not on an evaluation of Masson in the context of his own possibilities but on an historical view of Masson as having initiated or indicated certain pictorial possibilities which were realized only later by Pollock or others, it seems to me an unsatisfactory one. Whatever role Masson's painting has had in developments that extend beyond his own oeuvre, his finest and most challenging work seems to me entirely fulfilled in its own terms—terms which, for better or for worse, remain very different from those of the Abstract Expressionists and are rooted as well in French, and more specifically Surrealist, concepts of picture-making.

What I take to be the best works of Masson may be found here and there throughout his half-century-long career, but they tend to cluster in the periods 1924–29 and 1942–45, which may be said to be the most seminal periods of Surrealist art in general. If I have a complaint to make against Masson, it is not that his successful pictures fall short of any goal that later painting would fulfill, but that in terms of qualities already realized in them, he seemed often oblivious of the possibilities of extrapolation. One is struck by the fact that Masson made only around twenty, mostly small, sand pictures in 1926–27 and put that line of development aside because, as he said later, "I saw that it could become routine."[70] In this we see on Masson's part a resistance to that commitment to a stylistic identity which is sought by most professional painters. It also reflects an attitude of doubt and suspicion with regard to the métier of the painter that was typically Surrealist (and which Miró, alone among Surrealists, seems to have escaped).

For all Masson's immense love of art, there was and is also something in his temperament that responded to

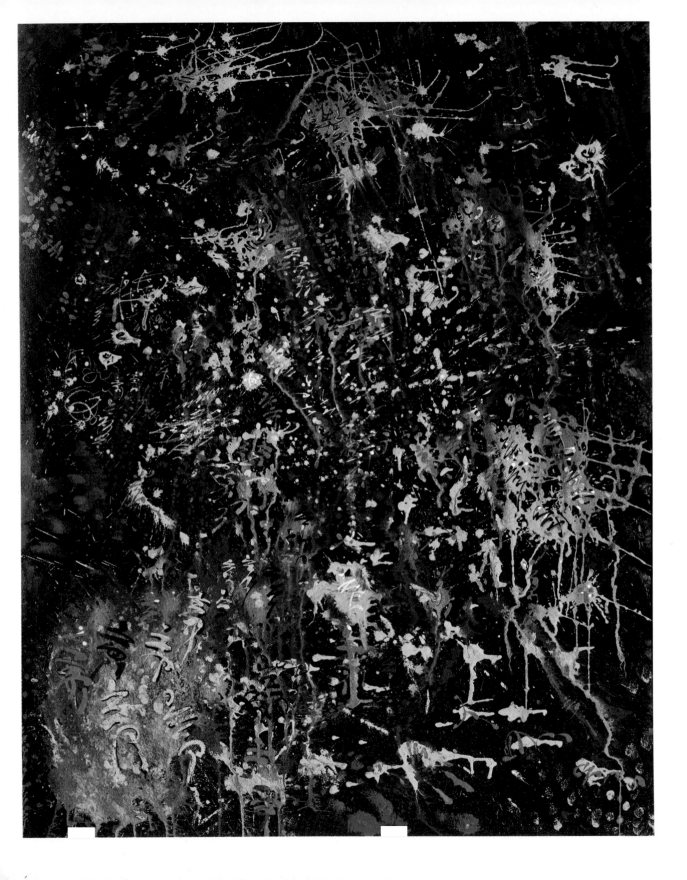

Breton's insistence that painting was but an "expedient." Thus Masson has always found himself caught up in a contradiction, an equivocation which the typical painter, comfortable in the assumption of the absolute power and efficacy of art as such, never has to face. This dilemma is at the root of the constant oscillations of Masson's art, the constant return to figuration and even illusionism at moments when the nature of his painting seemed to imply the autonomy of art.

The constant questioning of values, including that of art, which characterized not only the Surrealists but the whole of the *entre-deux-guerres* generation was an attitude to which Masson's extraordinary mind and sensibility predisposed him, and which was certainly intensified by his experiences in World War I itself. In contemplating Masson's oeuvre, we are confronted with an artist who is finally not unsure of style but of art itself. Even as he loves it and uses it, he is trying to get beyond it, outside it. This makes at once for a formidable variety, but a variety often dictated primarily by extraformal considerations. Such unity as exists in Masson's enterprise is not one of style, although the constant return of his personal form of drawing provides a sense of continuity on that level. Nor is it even one of imagery, though the poetic continuity is more manifest than is the plastic one. The unity is felt rather in the way Masson's strong and very unique personality—as experienced through an amalgam of poetic, philosophic, and psychological attitudes—pervades all he does. The unity is thus that of the man, to which all he does as an artist, good or bad, responds.

We know that, outside certain purely formalistic studies of modern painting, there are no developments in the history of art that are entirely self-winding, independent of extrapictorial forces. On the other hand, it would be idle to deny that most modern painters have tended to formulate their problems of expression, consciously or not, primarily as problems of pictorial syntax. Masson has always posed his problems in poetic terms—which has inevitably led to the constant redirections we see in his painting (and hence partly accounts for the marked variability in the quality of his work). Nevertheless, Masson's unsuccessful pictures bear witness to the authenticity of his enterprise, an enterprise that does not recommend itself to a kind of criticism that views pictures as individual, wholly autonomous systems.

This being said, I return to my insistence that Masson's best pictures hold up extremely well on precisely

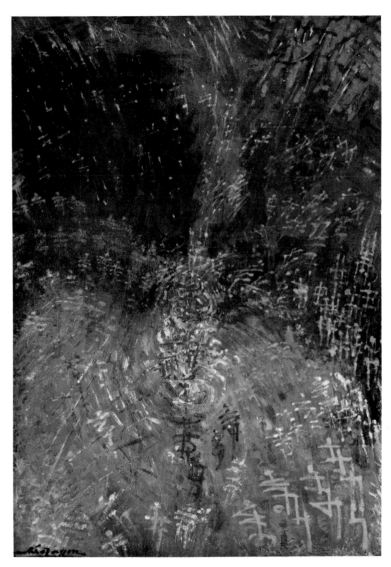

Combat in the Mountains. 1956.
Oil on canvas, 39⅜ x 29½".
Private collection, Lausanne

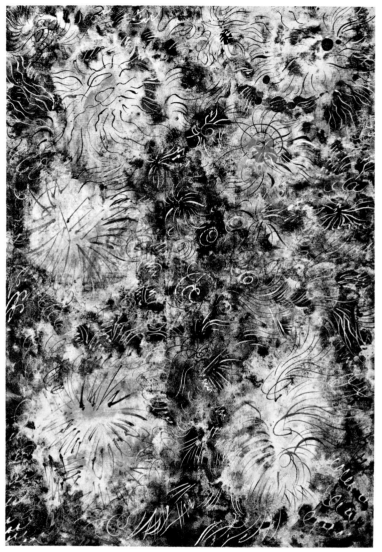

that basis. In the end, Masson, like any painter, must be judged for his successes—by what he adds to our experience. The failures simply fall away. I have found myself returning to his work time and time again over the quarter-century that I have known his painting, returning for qualities that transcend any historical importance these same works may have. That their particular success seems to have necessitated many failures simply suggests to me the precariousness and daring of Masson's enterprise. The excitement and character of his pictures at their strongest is inseparable from the perpetual self-doubt which propels Masson both as man and artist. As Samuel Beckett observed,[71] "Here is an artist literally skewered on the ferocious dilemma of expression . . . [yet] he continues to wriggle."

Fecundation of Flowers. **1955.**
Oil on canvas, 25⅝ x 18⅛".
Private collection

opposite:
The Unseizable. **1960.**
Oil on canvas, 62 x 68".
Private collection, St-Tropez

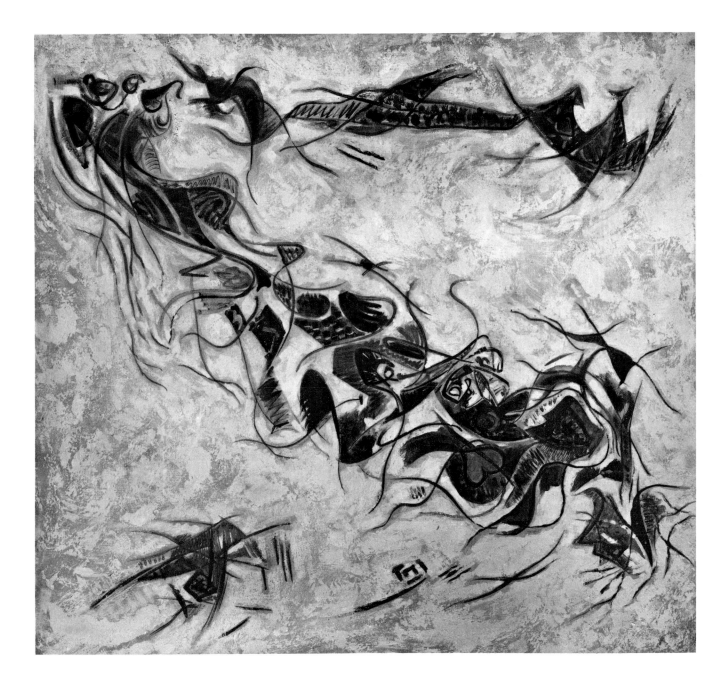

NOTES

1. At least as measured by the length of the discussion and the number of illustrations accorded each of these artists in *The History of Surrealist Painting,* by Marcel Jean with the collaboration of Arpad Mezei, translated from the French by Simon Watson Taylor (New York: Grove Press, 1960). First published in 1959 by Editions du Seuil, Paris.

2. The tendency toward flatness in Max Ernst's *Histoire naturelle* and in the major series of paintings of the period 1925–28 especially—the Doves, Hordes, and Shellflowers—suggests a very definite inflection of Max Ernst's work during that period in the direction of the abstract under the pressure of Miró and Masson. This period of Ernst's work represents something of an interlude between the Chiricoesque paintings done just before and the predominantly illusionist pictures of the thirties.

3. For Breton's definition of Surrealism, see p. 107.

4. Arp's style had been established during the Dada period, when his work played a dominant creative role in the formation of the biomorphic morphology that was to become central to Surrealism. In the twenties he had not as yet become a sculptor and was working largely in terms of reliefs and collages. Breton purchased a number of these and, sensing the similarity in aims and character between the art of Arp and that of Miró, Masson, and the other pioneer Surrealists, began to write about his art. For his part Arp became a member of the movement to the extent that he exhibited with the Surrealists (see note 107 in second section) and participated in certain of their manifestations.

5. The Cubists themselves, of course, never took so formalist and rigid a position. It is not unusual for a generation of painters, in reacting against the art of their immediate predecessors, to oversimplify the earlier position in order better to attack it.

6. For a discussion of the Dada and Surrealist attitude toward the formal pictorial structure of Cubism, see the author's *Dada and Surrealist Art* (New York: Harry N. Abrams, 1968), p. 21.

7. Robert Rosenblum's *Cubism and Twentieth Century Art* (New York: Harry N. Abrams, 1961) and more particularly his essay "Picasso and the Typography of Cubism," in *Picasso in Retrospect* (New York and Washington: Praeger, 1973), pp. 49–75, are especially revelatory in this regard.

8. See André Breton's "Le Surréalisme et la peinture," *La Révolution surréaliste* (Paris), July 15, 1925, pp. 28–30.

9. On a secondary level the pomegranate may also function as a hand grenade. See p. 93 and note 44 (in second section).

10. Preface to the catalog *André Masson,* Buchholz Gallery, Willard Gallery, New York, Feb. 17–Mar. 14, 1942, n.p.

11. From a 1972 conversation with the author cited in his *Picasso in the Collection of The Museum of Modern Art* (New York: Museum of Modern Art, 1972), p. 72.

12. While it is fair to say that de Chirico's manner was not a Cubist one, his painting of 1913–17 was profoundly influenced by Cubism, as I observe below (pp. 33–34).

13. See p. 102 and note 73 (in second section).

14. Actually, Breton's interest in Klee was much less profound than that of Eluard, who purchased works by Klee even earlier than Breton.

15. From notes on a conversation between the author and D.-H. Kahnweiler, summer 1956.

16. Recounted to the author by Masson and cited in *Dada and Surrealist Art,* p. 174.

17. For a discussion of the contribution of Cubism to Surrealism and abstract painting, see the author's "Jackson Pollock and the Modern Tradition, Part III: Cubism and the Later Evolution of the All-Over Style," *Artforum* (Los Angeles), Apr. 1967, pp. 18–31.

18. See pp. 100–102.

19. For earlier instances of automatic drawing, see note 67 in second section and pp. 107–8. For a discussion of the character of Klee's automatic drawing and its relationship to Surrealist automatism, see *Dada and Surrealist Art,* p. 136.

20. There is one notable exception to this observation, a drawing in which Masson glued an additional piece of paper to the original one in order to let his configuration expand. As a result of a misunderstanding on my part, I took Masson's account of this event (some twenty years ago) to suggest that such an additive process was not uncommon in the early automatic drawings (and so suggested in my book, *Dada and Surrealist Art*). It is now clear that this procedure was exceptional.

21. Because the dating of Masson's sand paintings must be restructured (see note 22 below), **Haunted Castle,** always previously assigned to the winter of 1926–27 or to 1927, must be considered as having been completed in 1926. Not only does its style almost unequivocally indicate a step in the evolution of the sand paintings, but the artist years ago said that **Haunted Castle** was painted before the first of the sand paintings and confirmed this to the authors in January of 1975.

22. Masson's sand paintings of the twenties have always been dated 1927 by the artist himself and all who have written on his work. His first use of this technique, however, must have occurred earlier—in late 1926—as is made evident by a letter from Masson to Kahnweiler uncovered in 1975 in the files of the Galerie Louise Leiris by Frances Beatty. In this letter, dated January 8, 1927, Masson tells Kahnweiler that he has just finished twelve sand paintings. The previous misdating is in part the result of the fact that Kahnweiler's Galerie Simon records assigned the date of recently completed work according to the year in which it was received by the gallery.

Placing the sand series earlier than heretofore necessitates a dating change for the group of works that just preceded it, of which **Haunted Castle** (see note 21 above) was one of the earliest. Masson remembers paintings such as **Chevauchée, Children of the Isles,** and **Horses Attacked by Fish** as preceding the sand series, and, while his memory was faulty about the exact date of the sand paintings, it is most unlikely that he would not accurately remember the sequence which led up to the realization of the sand paintings. This new dating explains what had previously seemed the curious barrenness of 1926 as compared with the highly prolific years which preceded and followed. As for the order within the series of sand paintings, we know that **Battle of Fishes** was the first and that the more schematic, such as **Villagers,** tend to have been executed toward the last.

23. Cited in Jean-Paul Clébert, *Mythologie d'André Masson* (Geneva: Cailler, 1971), p. 10.

24. "Prestige d'André Masson," *Minotaure* (Paris), May 1939, p. 13.

25. Cited in Clébert, p. 29.

26. Note that I refer to *explicit* sexual themes. On a subtly allusive and, hence, secondary level of the imagery, Klee's painting is heavily invested with erotic associations.

27. Robert Motherwell, "The Significance of Miró," *Art News* (New York), May 1959, p. 65.

28. Cited in Clébert, p. 91.

29. For a discussion of the iconographic role of the mantis in Surrealist art, see William L. Pressly, "The Praying Mantis in Surrealist Art," *Art Bulletin* (New York), Dec. 1973, pp. 600–15.

30. Cited in Clébert, p. 92.

31. Cited in Clébert, p. 22.

32. Cited in Gilbert Brownstone, *André Masson, vagabond du surréalisme* (Paris: Editions Saint-Germain-des-Prés, 1975), p. 14.

33. Cited in Clébert, p. 22.

34. *Entretiens avec Georges Charbonnier* (Paris: Julliard, 1958), p. 29.

35. Cited in Brownstone, p. 15.

36. ''Second Manifeste du surréalisme,'' *La Révolution surréaliste* (Paris), Dec. 15, 1929, p. 13.

37. *Conquest of the Irrational,* trans. David Gascoyne (New York: Julien Levy, 1935), p. 12; emphasis added. For prior sources in French, see bibl. nos. 54, 78, 142, and 143 in the author's *Dada and Surrealist Art.*

38. For a discussion of this point, see the author's *Dada and Surrealist Art,* pp. 134–35.

39. Cited in Brownstone, p. 83.

40. Cited in Clébert, p. 46.

41. Cited in Brownstone, p. 142.

42. While on summer holiday in 1906, Freud wrote a paper entitled ''Dreams and Delusions in Jensen's *Gradiva,*'' which was published in May of 1907. For a brief outline of the Jensen story see p. 151, and for an extended discussion of *Gradiva* and its iconography see Whitney Chadwick, ''Masson's 'Gradiva': The Metamorphosis of a Surrealist Myth,'' *Art Bulletin* (New York), Dec. 1970, pp. 415–22.

43. Breton opened the Galerie Gradiva at 31, rue de Seine in 1937, the year before he went to Mexico. The name Gradiva referred primarily to the heroine of Jensen's story; however, each letter stood for the protagonist of a love story: Gisèle, Rosine, Alice, Dora, Inès, Violette, Alice. For Breton's discussion of the Gradiva theme in which he links it to the Surrealist cult of object-making, see his 1937 essay ''Gradiva'' included in *La Clé des champs* (Paris, Pauvert, 1967), pp. 37–42.

44. Cited in Brownstone, p. 104.

45. See, for example, Ensor's *Self-Portrait* (1886), illustrated in Libby Tannenbaum, *James Ensor* (New York: Museum of Modern Art, 1951), p. 54.

46. Even the most intendedly savage of Miró's *personnages* (as, for example, those in *Rope and People I,* 1935) are imbued with a kind of whimsy that undermines their seriousness.

47. A classic instance of this is Klee's *Overloaded Devil* of 1932. Here the horned monster is so weighed down with symbols and ornaments, pinned to him as if he had been the butt of ''pin the tail on the donkey,'' that he evokes our sympathy and pity.

48. For a discussion of the relationship of Analytic Cubism to the allover style, see the author's ''Jackson Pollock and the Modern Tradition, Part III.''

49. Picasso's cover was a reproduction of a collage of corrugated cardboard, silver foil, ribbons, wallpaper painted in gold paint, paper doily, paper with graphite pencil, and other materials mounted on wood. The collage is now in the collection of The Museum of Modern Art, New York, Gift of Mr. and Mrs. Alexandre P. Rosenberg.

50. See p. 136.

51. The mythological story of the labyrinth is known to have derived from ancient accounts, which in time became legendary, about the complexity of the architecture of the palace of ''Minos'' in Crete. In the third and early second millennium B.C., Cretan hegemony over the coastal areas of the Greek mainland produced the basis for the Theseid story of the sacrifice of Athenian youths and maidens to the Minotaur. This beast inhabits the complex architecture of the palace, which was known as the Palace of the Double Axes because of its decoration with this motif of Minoan monarchical authority. The Minoan-Greek word *labrys,* from which the word ''labyrinth'' derives, means ''double axe.''

52. Cited in Brownstone, p. 132.

53. In 1955, speaking of the years 1923–25, Masson remarked: ''On my arrival in Paris I had discovered Odilon Redon. It overwhelmed me. But curiously I never spoke of it with my Surrealist friends.'' (Interview with Georges Bernier, ''Le Surréalisme et après: Un entretien au magnétophone avec André Masson,'' *L'Oeil* [Paris], May 15, 1955, p. 14.) For Masson's own appreciation of Redon, see ''Redon, Mystic with a Method,'' *Art News* (New York), Jan. 1957, pp. 40–43, and for a discussion of Redon and Surrealism, see the author's *Dada and Surrealist Art,* pp. 125–27.

54. Brownstone in the catalog *André Masson,* Galleria Schwarz, Milan, June 4–Sept. 30, 1970, p. 27.

55. For further discussion of this point see p. 166 and drawing reproduced p. 147.

56. *Métamorphose de l'artiste* (Geneva: Cailler, 1956), vol. 1, p. 30.

57. According to traditional mythology, Penthesilea, the queen of the Amazons, was slain by Achilles when she came to the aid of the Trojans after the death of Hector. Her courage and beauty were such that Achilles bitterly regretted his deed and fell in love with the dead body of his foe. In Kleist's *Penthesilea,* which appeared in 1808, the Amazon queen, torn between her duty as vestal-warrior and the passionate desire awakened in her by the sight of the beautiful Achilles, succumbs to a kind of blood lust and joins with her hounds in tearing the young warrior to pieces. The relationship between sexual desire and mortal aggression is a recurrent theme in Kleist and accounts in considerable measure for Masson's great interest in his work.

58. For a discussion of this point, see the author's ''Jackson Pollock and the Modern Tradition, Part III,'' passim.

59. Cf. fig. 1. Clement Greenberg first observed the relationship between Masson and Hofmann in *Hofmann* (Paris: The Pocket Museum, Georges Fall, 1961), p. 18.

60. The earliest pictures containing Gorky's characteristic biomorphic language were executed a year after Masson's picture. Inasmuch as the picture was exhibited in New York and promptly purchased by The Museum of Modern Art, which exhibited it again, we can presume Gorky's familiarity with it.

61. ''Contribution to a Symposium,'' published in *Art and Culture* (Boston: Beacon Press, 1961), p. 126.

62. *Jackson Pollock: Works on Paper* (New York: Museum of Modern Art, 1969), p. 18.

63. ''Notes on Masson and Pollock,'' *Arts* (New York), Nov. 1959, pp. 36–43.

64. Substantial revisions were made in the dating of Pollock's work by Francis V. O'Connor in his 1965 Ph.D. dissertation, ''The Genesis of Jackson Pollock: 1912 to 1943,'' for Johns Hopkins University. Further revisions will be contained in the catalogue raisonné of Pollock's work that O'Connor is currently preparing.

65. At the Pierre Matisse Gallery, Jan. 17–Feb. 11, 1932, and Apr. 29–May 27, 1935.

66. For a discussion of this relationship see the author's ''Arshile Gorky, Surrealism and the New American Painting,'' *Art International* (Zurich), Feb. 1963, pp. 27–38.

67. Cited in Clébert, p. 102.

68. ''Notes on Masson and Pollock.''

69. Greenberg's full reference to Masson reads: ''Also, André Masson's presence on this side of the Atlantic during the war was of inestimable benefit to us. Unfulfilled though he is, and tragically so, he is still the most seminal of all painters, not excepting Miró, in the generation after Picasso's. He, more than anyone else, anticipated the new abstract painting, and I don't believe he has received enough credit for it.'' (''Contribution to a Symposium,'' p. 126.)

70. Cited in Clébert, p. 34.

71. ''Three Dialogues'' (between Georges Duthuit and Beckett), *Transition Forty-nine* (Paris), no. 5, 1949, p. 99.

ANDRE MASSON: ORIGINS AND DEVELOPMENT

It is always the same substance that is in all things: life and death, waking and sleeping, youth and old age. For, in changing, this becomes that, and that, by changing, becomes this again. —Heraclitus

If our eye were only more acute we would see everything in movement (the gaze of Heraclitus, of Nietzsche). —André Masson

L'Ephémère (Self-Portrait). 1945.
Oil on canvas, 25 x 22″.
Harriet Griffin Gallery, New York

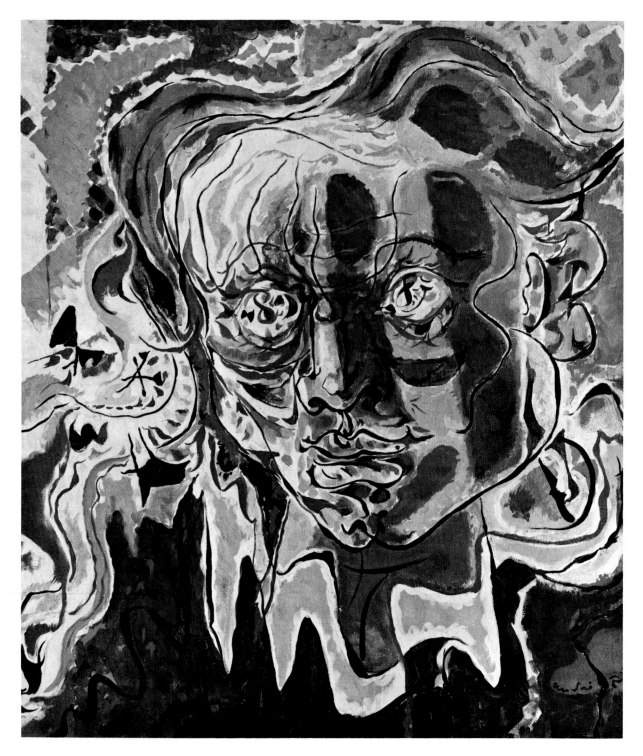

No TRUE HISTORY of Surrealism in painting could be constructed without an account of the role of André Masson; yet both Masson's life and his art stand outside the confines of any collective identification. The thread unifying his efforts over the half-century of his mature career is his undeviating fidelity to the dictates of his inner being—however variable or contradictory. Constancy of this order tends to be viewed as anarchy by society at large and, sometimes to an even greater extent, by the intellectual and artistic community. Masson has not been spared this reaction, and he has had more than passing encounters with official and unofficial sanctions of bourgeois morality, as well as much-documented imbroglios with the Surrealist establishment.

Masson's iconoclasm is not, however, a willed position; it is not, as was frequent in Dada and Surrealism, scandal for scandal's sake, but the expression of a passionate, driven nature in which there is an almost total fusion of the emotional and the intellectual. Extraordinarily perceptive and widely read, Masson early on evolved a personal theogony compounded of fragments and ideas taken from many sources and bound together by his interpretations of Heraclitus and Nietzsche. It is to this inner vision that he has been faithful, attempting in his art to fulfill the heroic virtues represented by Zarathustra: "To tell the truth and to shoot well with the arrow—that is a Persian virtue . . . The self-transformation of the moralist into his opposite—into me—that is what the name Zarathustra means in my mouth."[1]

The eldest of three children, André Masson was born under the sign of Saturn on January 4, 1896, in the village of Balagny in the region of Senlisis, which is the heart of the old royal domain of France. That his birth was presided over by the planet Saturn, which, as Masson points out, has since the Renaissance been associated with the brooding, solitary, and alienated artist, may or may not be telling. But the date and, to a lesser extent, the place were to prove of exceptional importance in the development of his art. Masson's birth in 1896 placed him in that generation of young men who would find their maturity on the battlefields of World War I, and it destined him to begin his adult career as an artist at that point in the twentieth century when Cubism was most pervasively dominant. Both of these experiences, different as they are, radically tested Masson—and profoundly affect his art to this day.

Notes to this text begin on page 202.

The place of Masson's birth was in the general geographical area that had been the home of generations of his family, both on the paternal and maternal side, and it was here that he passed the first seven years of his life. His earliest years were thus spent in one of the most historically rich and naturally beautiful provinces of France, to which his family had deep ties. The abundant ponds, fresh rivers, fertile fields, and rich forests of the Ile-de-France that were so often celebrated by Corot, Monet, and many other Barbizon and Impressionist painters are the backdrop of his childhood memories, and inspired in him his lifelong passionate love of nature. Masson was later to become determinedly nonnationalistic, but this profoundly French heritage forms the basis of his deepest cultural attachments.

In 1903 the family left Balagny and moved to Lille, where Masson saw painting for the first time, in the municipal museum. After a brief period in Lille, the demands of his father's business—a wallpaper agency—took the family to Brussels. So it was that Masson had, as he says, a "Flemish youth," which may account for his remarkable openness—rare among Frenchmen—to Germanic culture.

However Saturn may have influenced his destiny, it was early apparent that Masson would become an artist. He was given to introspection and dreaming, and, in preference to all other activities, he liked to draw. Although the Brussels museum had little or no "modern" art, it was the site of wonderful discoveries. Work by Brueghel and David's *Marat* particularly interested the boy; but two oil sketches—one by Delacroix (fig. 7) and one by Rubens—astonished and excited him. In speaking of the experience today, Masson says that until the instant of his encounter with the Rubens and Delacroix he had had no notion that such painting could exist—"all movement, vision caught in the moment that it was still being dreamed." The only other event of his early youth to which Masson accords a similar formative importance was the revelation of the concept of metamorphosis that Chateaubriand's *René* provided. While he also read Hugo, he says that Hugo was, like David's *Marat*, wonderful and intriguing, but without the incandescent power that fired his imagination in the Rubens, the Delacroix, and Chateaubriand.

Unlike many artists from middle-class backgrounds, Masson never had to contend with family objections to his ambition to become an artist. Less rigid than his father, Masson's mother had considerable influence in

shaping the young man's thinking. Her lack of conventional prejudice is attested to by the fact that in the early twenties, when Lautréamont and Sade were only beginning to be discovered by the Surrealists, she was giving French lessons using their writings as texts—scandalizing, in the process, Masson's father. Although her most direct involvement in determining an artistic career for Masson was in her efforts to obtain his admission to the Brussels Académie des Beaux-Arts, it was her influence that pushed him toward "the nontraditional."

On the strength of some of his drawings Masson was admitted to the Brussels Académie des Beaux-Arts when he was eleven, considerably below the regulation age. His master there was Constant Montald, whose then unusual practice was to have his students work in distemper. This technique, which involved mixing pigment, water, and glue, was to have considerable effect on Masson's palette and method in the early phases of his postwar career in Paris. And his later desire to study fresco painting was partially stimulated by Montald's interest in the fresco painters of the Quattrocento. Through reproductions in a French magazine found in the Academy's library Masson made his initial acquaintance with Redon, Seurat, Cézanne, Gauguin, and van Gogh.

At about this time Masson had his first direct confrontation with modern art when he saw, at an exhibition, Ensor's *Christ Calming the Waves* (fig. 8). Not yet recognized by the art establishment of Brussels, Ensor was instantly appreciated by the young Masson. He remembers the occasion: "I suddenly had the revelation that modern art could be as interesting as art of the past . . . *Christ Calming the Waves* . . . was truly a cosmic canvas. A kind of iridescent maelstrom . . ."[2]

In the year that he began his studies at the Academy, Masson took a job making designs for embroidery. His days were completely filled. Beginning at six in the morning he studied at the Academy, in the afternoon he worked at the embroidery studio, and at night returned to the Academy to make drawings from plaster copies of ancient sculptures. Remembering the time, Masson remarks, "I was lucky; I spent my youth well." This very early apprenticeship, with its complete immersion in vocationally directed activity, seems an anachronistic education, but for Masson it was indeed a fortunate thing. The formal education of *lycée* and university could well have proved stifling for the youth whose energy and originality of mind and enormous talent opened naturally in a climate that combined

intellectual freedom and rigorous technical training. Then as today, Masson was possessed by an almost Faustian thirst for knowledge, and the learning he has accumulated—filtered only by his own mind and interchange with the poets, artists, and philosophers who have been his friends—is astonishing in range and depth. His mordant insight and pointed expression are refreshing and revealing in ways that are often missing among the university-trained. Busy as he was, Masson did find time to audit courses, among them lectures on Elizabethan writers by George Eekhoud, a Flemish writer and friend of the Belgian Symbolists. This was Masson's introduction to a literature of cruelty without moralizing limits—which would later influence his own work as well as that of his friend Antonin Artaud.

Immersed as he had been in the literature of the past and in old-master art, Masson was unprepared for his first brush with Cubism at the age of sixteen. In the spring of 1912, in a popular French magazine, *Je sais tout,* Masson for the first time saw work by Picasso and Braque. Reproduced were two still lifes in High Analytic style and three works from the transitional period of 1909–10, Picasso's *Reservoir* and *Woman with Mandolin* and Braque's *Little Port in Normandy.* The article, "La Peinture d'après-demain?"[3] also included such other peculiar manifestations as Vlaminck's Fauve self-portrait, a detail from Matisse's *Music,* Léger's *Portraits,* and numerous works by the Italian Futurists, among them Severini's *The Pan Pan at the Monico,* Boccioni's *The Farewells* and *Those Who Go,* and Carra's *Jolts of a Cab.* Masson remembers being intensely shocked by the sight of this strange art, and specifically recalls that it was the work of Picasso, Braque, and Léger that prompted him to think such painting could only be produced by men obsessed with railroad accidents. In view of this association and the many Futurist works reproduced, we may wonder if the latter did not also contribute to Masson's reaction. At sixteen Masson was still absorbing the lessons of the past, and the true Cubist shock that would both liberate and imprison his art did not come until after the war.

Shortly after seeing the *Je sais tout* article Masson won the Academy's first prize in painting with a work, now lost, which he describes as having been very much influenced by the Nabis. Masson never availed himself of the studio, models, and small sum that the prize would have brought; in July of that year, at his teacher Montald's summer home, he met the poet Emile Verhaeren, who was not only to be of consider-

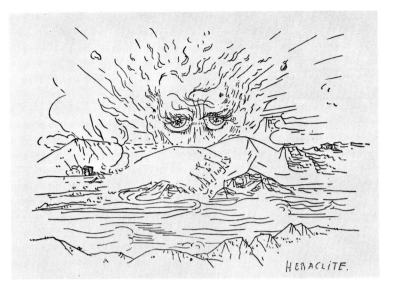

Heraclitus. 1939.
Ink, 19⅝ x 25¾".
Collection of the artist, Paris

able influence in shaping Masson's thought, but launched him on his first trip to Paris. Verhaeren, a visionary, mystic thinker, was very sympathetic to the young artist; he had as well a deep interest in painting that had caused him to be one of Ensor's earliest champions. Seeing Masson's drawings convinced Verhaeren that the young man must go to Paris, and it was his urging that convinced Masson's family to allow the trip.

Wanting to study fresco painting, Masson left for Paris with an introductory letter from Montald to Gabriel Mourey, through whose good offices Masson was admitted to the fresco classes of Paul Baudouin at the Ecole des Beaux-Arts. During this first period in Paris Masson was single-minded in his devotion to his art, interrupting his studies only to go to the Louvre, the Luxembourg, and other museums. Almost his only social contact was with the painter Meurice Loutreuil. Then as now, he was passionately interested in Poussin, whose painting attracted him less for its traditional classic virtues than for qualities of the fantastic that he found in it. Although he saw work by Matisse at Bernheim's, the lively art scene of prewar Paris scarcely touched him. He was, however, drawn to the work of the then still living, but little celebrated Medardo Rosso. The nebulous, floating nudes of Masson's work of 1923–25 may owe a specific debt to Rosso, and, while manifested in another medium, Masson's lifelong concern to endow his art with rhythm and movement runs parallel to that of Rosso. When still in Brussels, Masson had become interested, through reproductions, in the work of Puvis de Chavannes, and one of his first excursions in Paris was to go to see the actual paintings. Although Masson's art is at the opposite pole from the static world of Puvis, the qualities that initially attracted Masson to his work, an unexplained taste for the holy, a hieraticism, a solemnity, inform all his figurative work of 1922–25.

In April of 1914 Masson and Loutreuil went to northern Italy on a grant awarded by the Ecole des Beaux-Arts to study fresco painting. It was a voyage of delight and discovery that Masson characterizes as the "wonderment of the man of the North come face to face with the South," quoting Goethe's words when, at the age of forty, he had first entered Italy, "Finally, I am born!"[4] To catalog the art and sights that Masson found moving as he and Loutreuil traveled in a rough triangle from Pisa to Assisi and Florence would be to write a guidebook of Tuscany—albeit an occasionally very personal one in which Giotto would receive fewer

stars than Pietro Lorenzetti or Uccello.[5] It was the classic pilgrimage of the Western painter to the birthplace of his heritage.

After returning to Paris at the end of May, Masson left almost immediately to stay with friends in Switzerland, in the Bernese Oberland. There the idealism that had formed a kind of isolating cloak around Masson's activities in Paris found its fullest expression. The most significant event in Masson's psychological and intellectual development in Paris had been his discovery of Nietzsche. Unable to remember the source, Masson holds it as an article of his "personal mythology" that Nietzsche fell from the Paris skies "to give me birth."[6] The almost Spartan purity of Masson's life in Paris was very largely the result of youthful zeal in attempting to follow the precepts of his chosen prophet. The seven months he spent in Switzerland were dominated by the spirit of Nietzsche's Ubermensch. Hardening his body by frugal, austere habits and long barefoot walks, and his mind by discussions of music, philosophy, and literature with his highly cultivated hostess and her friends, Masson was striving with all his young strength toward the perfection that Nietzschean man can create only through his own efforts. Nietzsche has had a profound lifelong influence on Masson, but the wholehearted joyful affirmation of self that he felt in Switzerland was a phenomenon possible only to an innocence still intact.

After the outbreak of the war, Masson's Swiss friends urged him not to return to France. But, in much the same spirit that had dominated his stay in Switzerland, Masson felt obliged to go back. There was, he says, no element of nationalism in his decision; he regarded himself not as a Frenchman but as a European. It was as a test of self—an examination of his own strength—that Masson saw his participation in the

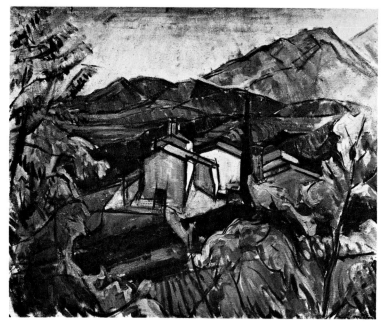

The Capuchin Convent at Céret. 1919.
Oil on canvas, 23⅝ x 28¾".
Musée Municipal d'Art Moderne, Céret

remanded to a mental hospital. Although he was in fact suffering from acute mental depression, it was hardly the best environment to ease the emotional trauma of a recently wounded front-line soldier; additionally, the French authorities showed little disposition to release their captive. Finally, in November of 1918, partially through the intercession of a friend of his mother's, Masson was discharged. The parting advice of the one doctor who had been helpful to him was, "Don't live in cities any more." The immediate period after his discharge was exceedingly painful for Masson, and in many ways he never really "readjusted." Reflecting on that time he says, "It took me months to get back my ego, assuming that term's fullest meaning. That ego had been pillaged. Forever."[9]

Masson stayed briefly with his family, who were then living in Paris, and early in 1919 went to join Loutreuil in Martigues. There, in an abandoned hut overlooking the Etang de Berre, he began to paint again. Although virtually his only contact with modern art during the previous four years had been through reproductions (largely of work by Severini and Survage) seen in Pierre-Albert Birot's magazine, *Sic*,[10] the hiatus of the war had changed his artistic focus. Loutreuil and he had paid their homage to the Renaissance just before the war; now their pilgrimage was to the "shrines" of twentieth-century art. From Martigues they went to Collioure and from there to Céret, where they were welcomed by the painter Krémègne and the sculptor Manolo. Through the latter Masson found a place to live and to set up a studio in the town's empty Capuchin convent, where he painted still lifes and landscapes (strongly dependent on Derain's work of 1911–14), including a view of the convent that is now in the Céret museum (above). The arrival of Krémègne's pupil, Soutine, provided the opportunity for some very spirited, if not completely agreeable, discussions. Masson remembers Soutine as terribly opinionated (he dismissed van Gogh as "an old lady knitting")[11] but almost always stimulating.

In spite of a harrowing encounter with the police in which Masson and Loutreuil were accused of a multitude of villainies—the populace having taken them for two Swiss students who had murdered an old woman while somehow equally suspecting them of being escaped German prisoners—Masson began to find peace in the bucolic life of Céret. There during the summer he met Odette Cabalé, and the following winter, on February 13, they were married. In the late spring, after more than a year in Céret, Masson with

war. He arrived in Paris in December but put off entering the army just long enough to copy Delacroix's mural, *Heliodorus Driven from the Temple,* in the church of St-Sulpice. During the three weeks or so that this took him he also went to the Louvre to see the paintings in the recently opened rooms housing the Cammondo Collection. The Cézannes seemed particularly marvelous to him, and he was—as had been Apollinaire in his review of the June 4 opening of the collection—especially struck by *The House of the Hanged Man.*[7]

Just after his nineteenth birthday in January of 1915 Masson entered the French army as a foot soldier. During the succeeding year and into the spring of 1917 he endured the harrowing, numbing experience of trench warfare. Another nineteen-year-old, then serving behind the lines as an army medical assistant, André Breton, later summed up the effect of the war on the young men of his generation, saying that it had torn them "from all their aspirations to precipitate them into a cloaca of blood, stupidity, and mud."[8] The terrible scenes of this absurd war were to haunt Masson all his life and are at the root of his often very violent imagery. In the offensive of the Chemin des Dames in April of 1917 Masson's active participation ended when he was critically wounded in the chest. For the next year and a half his life was a succession of hospitals. The experience of the war stripped Masson of the little chauvinism he had and triggered a rebelliousness toward authority that has stayed with him all his life. Masson's defiance and scorn of the allied war effort, shouted out before an officer who had forced his arm up, thus reopening his wound, was considered so shocking in its lack of patriotic ardor that he was

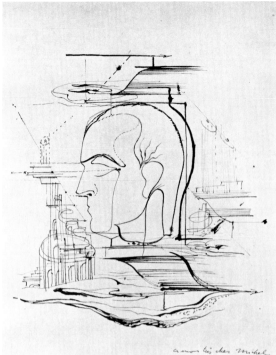

his young wife left for Paris and what was to be the true beginning of his professional career in art.

IN PARIS THE young couple moved in with Masson's family in their apartment near the Luxembourg gardens, and shortly thereafter Masson found a job making pottery in a center for disabled veterans. After spending some time fabricating yellow saucers and teacups on which he painted bamboo leaves, he was able to convince the director that since he worked so much faster than the rest of the employees he ought to work only one day a week. He was thus able to take another job as a night editor at the *Journal officiel.* In between times, with the aid of drugs he took alternately to sleep and to stay awake, he tried to pursue his career as an artist. He had, however, neither the means nor the time to paint more than a very few pictures, and he confined himself, for the most part, to making pornographic drawings, often with rebellious delight on copies of the *Journal officiel.* Much later Breton was to identify eroticism as the key to Masson's entire work. The artist concurs with that judgment, and in 1971 spoke of this first year in Paris as the beginning of his "erotic period"[12]—a time-span then encompassing the fifty years of his vast, extremely diverse output.

Much criticism of Masson has centered precisely on the frequent radical divergence of styles within his work. To some he has seemed unable to find his way, uncertain of which path to follow. That this has seemed so is certainly due, in part, to the extraordinary originality and quality of his best work, beside which his less successful paintings appear uncertain and derivative. But, for all its apparent twists and turns, advances and retreats, Masson's work is united by a basic and nearly always evident philosophy that has changed little over the years. As he expressed it in 1946, "In this certainty—of the precariousness of existence and its continual cohabitation with the void—the artist of today will have to find the authentic expression of his life."[13] And Michel Leiris, whom Masson met very shortly after his arrival in Paris, puts it this way: ". . . far from following in his course the zigzags of someone who doesn't know which saint to pray to, André Masson has always hewn to a line dictated by his clear awareness of the inherent ambiguity of the human condition."[14]

Masson's apprehension of man's condition rests supremely on the concept of metamorphosis, the Heraclitean recognition that there is no reality except

the reality of change, that permanence is an illusion of the senses; nothing is but is in a state of becoming. All things carry with them their opposites; death is inherent in life and life potential in death. Masson's naturally nervous and volatile temperament and his great gifts as a draftsman aside, it is surely this vision of the cosmos perpetually in flux that marks all his styles with an intense sense of movement. In 1921, on the threshold of his career, his credo was "To paint forces: the open road," just as he proclaimed it many years later.[15]

Masson's poverty precluded following that open road during most of his first two years in Paris. Almost immediately after his arrival from Céret, he met Max Jacob at the salon of Mme Aurel, to which his mother had directed him. Following a disagreement with his parents, Masson, his wife, and infant daughter Lili moved to a tiny room in the Hôtel Béquerel on the rue Vieuville, in Montmartre, near Max Jacob and Masson's friend Elie Lascaux. Although still toiling in the pottery center and working nights at the Journal officiel, Masson had to turn his hand to a variety of other jobs. At the Club Faubourg, where he had gone to apply for a job as an extra, he met Roland Tual, with whom he found himself in immediate sympathy. His friends touched in a significant way on Masson's early life in Paris. Through Jacob—who, as Masson says, "did his best to help me survive"[16]—he first made the acquaintance of Miró, and it was through the active collaboration of Jacob and Lascaux that he met Kahnweiler, who was to offer him the means to devote himself to painting. As for Tual, his friendship with Masson was the nucleus of that remarkable group of poets, painters, and writers who were to become known as the rue Blomet group.

Toward the end of 1921 Masson moved with Odette and Lili to 45, rue Blomet. By a coincidence that the not yet formed Surrealist group might characterize as le hasard objectif, Masson's next-door neighbor was the "equally unknown"[17] Joan Miró, a fact not discovered through proximity but at the Café Savoyard in Montmartre, where Max Jacob held "open house" every Wednesday afternoon. In 1972, writing in honor of Miró's seventy-ninth birthday, Masson recalled their meeting. "Max Jacob held court there [at the Café Savoyard] . . . Like a music-hall master of ceremonies, he'd present the poets and artists as they arrived. He played his life with humor, mischievous and debonair at the same time . . . Joan and I went right up to each other, on our own. Why is it that painters know each other as such before they're introduced?"[18]

Through a chemistry that Masson calls "the mood of the times," the studio in the rue Blomet became a gathering place—"not at all a group, but a melting pot of friendships."[19] Tual brought Michel Leiris; Georges Limbour and Armand Salacrou were introduced through Dubuffet,[20] who himself had come through Max Jacob, and Antonin Artaud found his way to the rue Blomet through Lascaux. Hemingway was a not infrequent visitor, and he, along with Gertrude Stein and Salacrou, were among the very first to buy Masson's paintings. Ardently involved with literature and philosophy—Masson describes the phenomenon as a "thirst for knowledge"—the young painters and poets who gathered in the rue Blomet made the studio a place of impassioned intellectual discussion as well as the arena of rather exuberant physical activity. Much to the disgust of Max Jacob, Masson discovered the "meteor"[21] Lautréamont through Roland Tual.[22] Apart from excerpts from Sade selected by Apollinaire, few in the group were familiar with the Divine Marquis, whose work had been officially frowned upon and little published in France before the war. Masson himself knew it only secondhand through a book by Duehren, Le Marquis de Sade et son temps, that he had found on the quays in 1914 just before going into the army. Now, however, "the entire work of Sade was introduced through the efforts of Roland Tual."[23] Dostoevski and Nietzsche—of whose work Breton would later remark, "What I detest the most"—were of capital importance. Alongside the poets who had been important to Masson before the war, Mallarmé and Verlaine, Rimbaud now took a place of even greater significance. Masson remembers, "As for poets, we wanted them to be seers [voyants][24] rather than simple singers of the wonderment or melancholy of life."[25] The German Romantics, especially Richter and Novalis, were read and discussed with enthusiasm. One of the delectations of Masson, Limbour, Artaud, and Leiris was reading in loud, declamatory tones from old French translations of such English seventeenth-century playwrights as John Webster, John Ford, and Cyril Tourneur.

At other times the studio became a boxing gym—Masson and Miró working out, with Hemingway as coach. Masson remembers Hemingway's judgment of Miró as pugilist: "He takes a good stance . . . but forgets there's an opponent in front of him."[26] The floor of the studio, in no better shape than the rest of it (there were gaps in the damp walls over which Salacrou had nailed metal sheets cut from biscuit tins), was

**Sleeper (Self-Portrait). 1925.
Ink. Private collection**

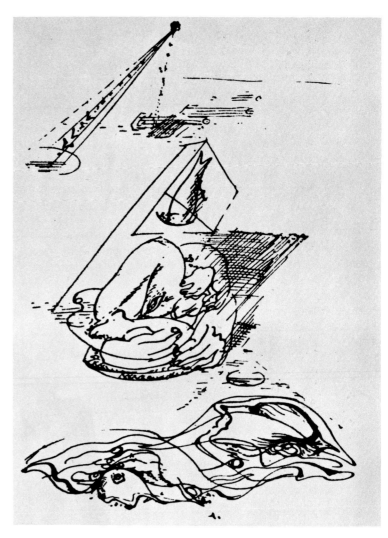

full of holes that constituted a far greater hazard than one's good-natured opponent. Holes or no holes, the studio was nonetheless the scene of dancing "à la Nietzsche," indulged in with the same fervor as the intellectual discussions and dramatic readings.

That the poets by whom Masson was surrounded were of enormous importance to his art both at the time and subsequently—as they were equally to Miró—can hardly be overemphasized. The dominant tradition in painting was Cubism, and both Masson and Miró practiced it, but always with the idea of becoming painter-poets. Masson recalled in 1972:

It was obvious that for Miró as for myself, poetry (in the broadest sense of the term) was of capital importance. Our ambition was to be painter-poets and in that we differed from our immediate predecessors who, while going around with the poets of their generation, were terrified of being labeled "literary painters." As painters purporting to work from poetic necessity, we were taking a great risk. Furthermore, but for a few rare exceptions, the verdict of the French critics observing our beginnings was: "Definition of a Surrealist Painter: not a painter but a failed poet." This was in the best of cases. Often we were charitably advised to "go and have your heads examined" . . .[27]

Before Masson moved to the rue Blomet, an event of the greatest importance to his career had occurred. Through a "coincidence" arranged by Max Jacob and Elie Lascaux, Daniel-Henry Kahnweiler, on a visit to Lascaux's studio, saw two paintings by Masson and liked them sufficiently to follow the career of the young painter; subsequently, in 1923, he gave him a contract. Meager as this was (Kahnweiler himself was in financial difficulty at the time), it allowed Masson to devote himself to making art. In 1942 Kahnweiler recalled his first impression of one of those early works. "It was a still life grouping the humble objects that characterized the still life of that time. Without any doubt this very gifted young man had understood the lesson of the Cubist painters. He realized that the figuration of solids invented by these painters was merely the means of expressing a thought which saw in the imagination the foundations of reality . . ."[28] Before we examine in detail the work of Masson's early years, it is perhaps valuable to record Kahnweiler's recollection of the artist:

. . . the life of Masson is not so different from the life of Picasso. Masson too lived in an absolutely miserable studio in rue Blomet, where, on top of everything else, there was a horrible thing: He lived next door to a factory that ran all day and shook the studio. Everything moved until evening, until the time the machines stopped running. Here he lived with his wife and his little daughter, who was more often with us in Boulogne than with him, since the sanitary conditions were too miserable for a baby. . . . like Picasso, he was surrounded by poets . . . As for the painters, Masson knew almost all of them in Montmartre, for he had lived in a furnished room in Montmartre before moving to rue Blomet.[29]

IN PARIS the period from 1922 to 1930 was tremendously exciting; in all the arts the city was the world's stage. These years saw the death of Dada, then the birth and the adolescent growing pains of Surrealism. For Masson, who was not simply a spectator, these eight years encompassed some of the most fruitful of his career. In its stylistic and imagistic range the work of this first period of Masson's maturity adumbrates that of his entire career, and it was during this time that the main elements of his personal iconography were

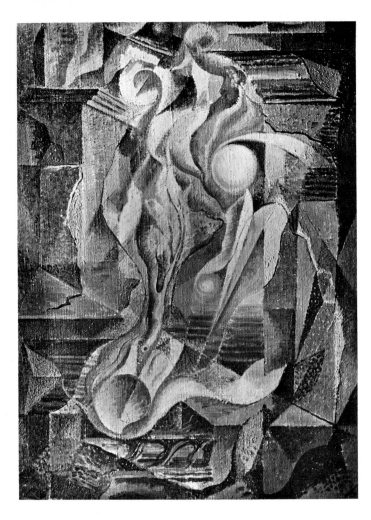

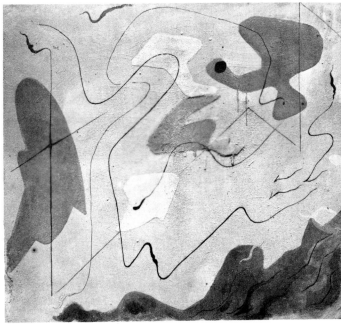

top:
Meteors. 1925. Oil on canvas, 28¾ x 21¼".
Private collection, New York

bottom:
Kites. 1927. Oil and sand on canvas,
42½ x 38¼". Lost

established. On the basis of style and figuration the work divides chronologically into four main groups.

From 1922 to 1924—a period in which the influence of earlier artists is more evident than subsequently—the main motifs are forests and forestlike fantastic landscapes with tombs; still lifes; and card players, seated men, and portraits. During 1922 Masson's debt to Derain is still strongly apparent, especially in the configurations of the forest and still-life pictures. By mid-1923, however, the basic structure of all Masson's paintings, with the partial exception of a few forest pictures, has become that of early Analytic Cubism—with, however, some very personal mutations. Even the still lifes presenting only the traditional artifacts of Cubism are charged with a mysticism and intensity of feeling totally at odds with the classic spirit of Analytic Cubism. And, in spite of Masson's steadily increasing tendency to rely on the syntax and pictorial vocabulary of Analytic Cubism, his need to achieve spontaneity of expression led him, toward the end of 1923, to begin experimenting with automatic drawing. Such drawings occupied him increasingly, particularly as he became involved in the Surrealist movement in early 1924, and culminated in the "automatic" sand paintings of 1927.

By 1925 the syntax of High Analytic Cubism is successfully yoked to visionary content, and configurations adopted from automatic drawing appear in many paintings. Imagery is no longer earthbound, and whatever drama is represented seems to be taking place in the heavens; figures and common objects are invested with mythic and cosmological properties.

In late 1926, using sand, glue, and paint, Masson developed a technique that enabled him to achieve on canvas the freedom and spontaneity of automatic drawing. Eschewing the manifest Cubist grid, the work produced in this manner in late 1926 and early 1927 is perhaps the most historically significant of Masson's entire career. Whatever their fictive representation—whether **Dead Horses, Villagers, Kites,** or a **Battle of Fishes**—all of the approximately twenty sand paintings are to one degree or another hallucinatory marine landscapes. Haunting, disturbing, they exemplify the words of Jean-Paul Clébert: "Between the blue of the sky and the blood of the earth, it's always death that the sea sketches on the sand with its wreckage and seaweed. *The shore is an exemplary place of passage.*"[30]

Cubist scaffolding makes a frank reappearance in Masson's paintings of the last two years of the decade. In 1928 the canvas is divided geometrically by flat,

La Poissonnière. 1930.
Oil on canvas, 38⅜ x 51½".
The Museum of Modern Art, New York,
Gift of Mr. and Mrs. William Mazer

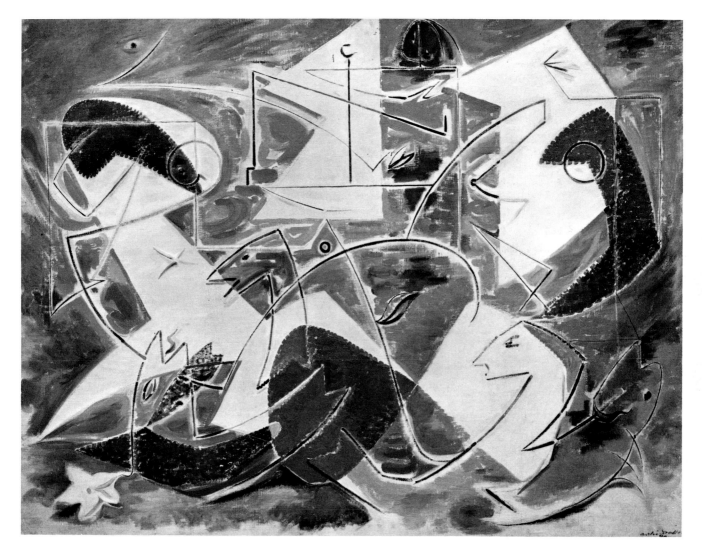

loosely brushed planes of color over which is super-
imposed largely curvilinear, calligraphically rendered
figuration. By 1929 the composition has become
denser, full of swirling, turbulent movement recalling
the frenzy of Lautréamont's *Les Chants de Maldoror.*
The earlier pictures of these two years are not always
concerned with strife, whereas the later ones are
almost invariably depictions of physical conflict. Aside
from some schematic, erotically evocative representa-
tions of nudes of 1928, imagery is mostly drawn from
the animal world—fish, birds, horses engaged in bat-
tle, slaughter, or copulation. These pictures are clear

testimony to the gathering sense of violence that would
surface so unequivocally in the series of Massacres in
the first years of the next decade.

MASSON himself has given us a general description
of his paintings from the years 1922-24: ". . . tradition-
ally modeled, values respected, and color as servant.
Always forms have a tendency to interpenetrate and to
melt into each other. General aspect that of fresco
(sometimes pastel) held over from long habit of paint-
ing and drawing only with powdered colors mixed
with water or stiffened with glue."[31]

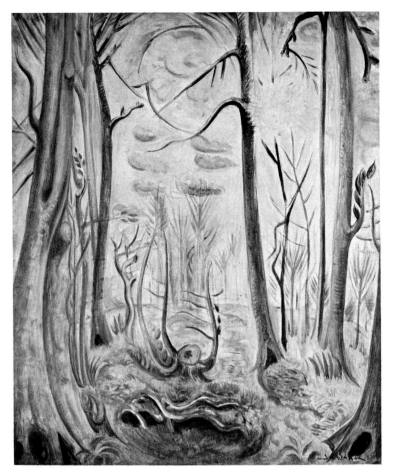

Around the middle of 1922, Masson completed **The Crows** (below), one of the first in his early Forest series. The composition of this painting—as, until mid-1924, that of subsequent work of the same motif—is indebted to Derain and the morphology of certain Fauve landscapes. The similarity, however, is evident only in terms of configuration, not color, which Masson restricts mainly to muted greens, grays, tans, and a coppery brown. A concern with the problem of the framing edge that was to manifest itself in a variety of tentative solutions over the next five years is already apparent in the curving forms of the tree trunks that define the left and right edges of the canvas. In spite of the relative discreteness of forms, the flight of birds from right to left, and the demarcation of a horizon, the space enclosed by the inward-curving tree trunks provides the first faint hint of the kind of vortical schema that would become central to Masson's work in the next three years.

For all that **The Crows** recalls Derain, it is imbued with a sinister, legendary quality not found in the more pacific images of the older artist. The forest has always symbolized mystery; it is the primitive labyrinth, the theme that lies at the heart of Masson's iconography. Although often inspired by the forests remembered from his childhood—he recalls that "in the forest of Halatte there were pines the color of copper" [32]—and those of Brittany, his Forests are not primarily landscapes done or remembered from the motif. Although Masson would later celebrate nature as such, it is not for that reason, but for its quality as "emblematic site," that he chose the forest as one of his earliest motifs. The ambience of **The Crows** suggests Brocéliande, the magic forest of Apollinaire's *Enchanteur pourrissant,* where Viviane enslaved the wizard Merlin. The trees are almost bare, a leaf falls; blighted, the aspect of the forest seems to speak not only of a disaster that has already occurred, but one that still menaces. More than most of his Forest paintings, **The Crows** may be related to Masson's memories of war-scarred trees. Birds, one of the most important totems for Masson, make a first (and very rare for a Forest picture) appearance. There may, indeed, be a conscious reference to Rimbaud's poem "Les Corbeaux," in which the poet speaks of *notre funèbre oiseau noir* flying over the fields of France *où dorment des morts d'avant-hier.* [33] Although he has often rendered them sympathetically, Masson has spoken of the evil nature of birds. Here they are certainly not harbingers of anything good, but rather the dark heralds of some impending doom.

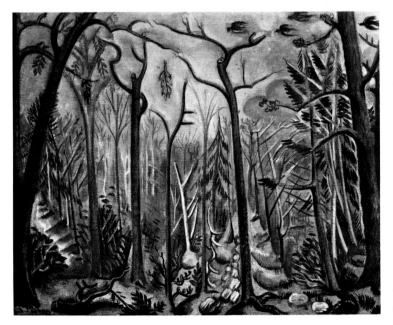

The Crows. 1922. Oil on canvas, 36¼ x 28¾″.
Private collection, Le Havre

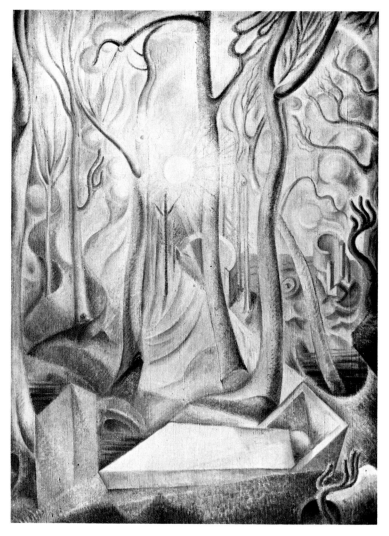

The Cemetery. 1924.
Oil on canvas, 45⅝ x 35".
Musée des Beaux-Arts, Grenoble,
Gift of André Lefèvre

While the trees have not yet developed the "hands" that grasp astral spheres as do those in **The Cemetery** (right) of two years later, their incipiently anthropomorphic twisting and reaching reinforces the fantastic atmosphere. Probably painted very soon after **The Crows** was **The Trees** (opposite), a relatively colorful canvas for that grisaille period, which was one of three pictures bought by Hemingway from Masson's studio. Here again the composition is contained by the rising tree trunks at the outside edges. The motif of astral spheres or multiple suns appears in embryo. In the center is a truncated, octopus-like tree whose severed limbs seem less made of wood than flesh, and, outspread, suggest a trap ready to close. Perhaps unconsciously, Masson is already developing the theme of the trap—just as, in the juxtaposition of the interlocking roots of the foreground with the tentacles of the tree above, he prefigures the menacing entrance to the labyrinth.

It is apparent not only from Masson's Forest pictures, but also, as we have seen, in the earlier, more tentative essays painted while he was still in Céret (p. 84), that he had done a good deal of looking at Derain's work.[34] Two portraits, one perhaps as early as 1921 and the other from 1922, bear further witness to this fact. The first, of Roland Tual, and the second, of Georges Limbour, are somewhat anomalous within the body of Masson's work. Their content precludes classing them with the Forest group, and their syntax is at a remove even from the early, still Derain-like group portraits such as **Card Players** and **Seated Men**. The portrait of Tual, in pale grays, blues, and tans, bodies forth the grace and poetic sensibility of the sitter, but lacks the authority of the later Pierrot-like portrait of **Georges Limbour** (p. 85), in which the elements borrowed from Derain belie that artist's debt to Cézanne. Although the figure is less volumetrically rendered and space is slightly deeper than in contemporary depictions of men seated at a table, affinities are apparent—in the left hand gently curled around the pipe, and the head, which, while not turned fully away, is deeply shaded on the left—with figures from such early works as **A Throw of the Dice** (p. 92) and **The Smokers**. Given Masson's sensibility and the symbolic content intended in his imagery, it is very likely that the light and shadow dividing Limbour's face are a metaphor for the light and dark sides of man's consciousness. As Anna Balakian says in explicating the ideas of Eliphas Lévi, "Man has in him the power to transform the opaque into the translucent . . ."[35] It is certainly

such a concept that Masson wished to express in the more sophisticated chiaroscuro highlighting of his own temple in **Man with an Orange** of 1923 (p. 96) and that of Michel Leiris in **Man Seated at a Table** of 1924 (p. 97).

On the iconography of Cubism, Alfred Barr said: *The cubists, traditionally, are supposed to have had little interest in subject matter whether objectively or symbolically, yet their preference for a rather repetitious range of subjects may be significant. Besides occasional vacation landscapes, Picasso and his colleagues painted figures of poets, writers, musicians, pierrots, harlequins and women; or still-life compositions with ever-recurring guitars, violins, wine, brandy, ale and liqueur bottles, drinking glasses, pipes, cigarettes, dice, playing cards and words or word fragments referring to newspapers, music or drinks. These subjects, both people and things, consistently fall within the range of the artistic and bohemian life and form an iconography of the studio and café. Whether they represent simply the artist's environment or whether*

they symbolize in a more positive though doubtless un-conscious way his isolation from ordinary society is a debatable question.[36]

If we excise "women," who enter Masson's art practi-cally not at all except as phantom figures until 1925,[37] and "words or word fragments," which Masson used only very rarely, and substitute the forest for "vacation landscapes," we have a fairly complete overview of Masson's iconography in the years between 1922 and 1925. In Masson, however, there can be no ambiva-lence about the isolation symbolized—although it is not specifically that of the artist, but rather that of man, all men. And it is precisely the use of Cubist syntax in the service of expressive ends completely at odds with the traditional uses of that discipline that gives his work its special character.

Paul Eluard said in "Au Pays des hommes," written in homage to Masson, "It was in 1923, before the rope, the crown, the flame, and the constellations, the man. The man and solitude shared, the solitude. André Masson rose to bury time under the landscapes and the objects of the human Passion. Under the sign of the Planet Earth."[38]

The silent dramas of men gathered around tables, drinking, eating, playing at dice or cards, and sleeping are, in part, "memories of experiences of peasant or military life,"[39] but the immediate models were the gatherings of Masson and his friends in his atelier on the rue Blomet. Masson expressed his intention when he said, "From our 'anti-cenacle,' from our den, I will make a 'genre picture.'"[40]

Completed before the end of 1922 were **A Throw of the Dice** (above) and **The Repast** (left).[41] Both composi-tions are laterally framed by the inclined figures at the outside edges, and space has become shallower than in the previous Forests and tilts slightly forward. Al-though far more personalized than in Masson's later work, the heads of the participants in these two noc-turnal gatherings are heavily shaded, their individual identities blurred. These images are still far from those of the next three years in which the head is only silhouetted or even simply missing, but this de-empha-sis on that part of the body regarded as the seat of reason already announces Masson's belief in the pri-macy of the dream and the unconscious. Just as intel-lect is played down, sentience is stressed in the prom-inence of the rough male hands loosely, tenderly curved around the humble objects they hold. The ellip-tical choreography of these hands, particularly in the later picture, **The Repast**, shows Masson on the road to

Card Players. 1923.
Oil on canvas, 31⅞ x 21¼".
Private collection

developing the kind of image in which the disembodied hands of men are the chief protagonists.

A Throw of the Dice and The Repast contain elements central to Masson's iconography through 1926 and some that have endured until the present. The title A Throw of the Dice was almost certainly inspired by Mallarmé's famous last poem, "Un Coup de dés jamais n'abolira le hasard," and, in the ensuing years, many of Masson's titles would allude to literature. The hand throwing the dice may be regarded as that of the painter, who, having survived the test of war in what Nietzsche calls "the great dice game of existence," was now embarking on the lifelong adventure that he was much later to summarize in the phrase "Painting Is a Wager."[42] The dice seem to be sliding into the unknown, off the edge of the cubistically tilted tabletop into some abyss below the framing edge. Less developed than in such later pictures as Card Players (right) of 1923, this sense of regions unknown—"the objects placed on the tabletop would slide toward the abyss which no man had dared to bar"[43]—is reinforced by the presence at the top of the canvas of clouds vaporously intermingling with the heads of the players. The same device of the tilted tabletop does not provide any similar sense of actual dropping or falling in the work of Picasso, Braque, and Gris, for their concerns were almost exclusively pictorial and space was manipulated to achieve purely plastic goals. Masson's work, however, is so charged with allegoric and symbolic content that it engages another area of our feeling and so alters our perception. In the lower left quadrant of A Throw of the Dice we see one of the earliest appearances of the curving, diaphanous object that recurs repeatedly through 1926 and is variously a scroll, a palpable cloud, a surrogate flame, and a kind of floating shroud. Here, as often, its exact nature is unclear, but its role in enhancing the enigmatic, dreamlike atmosphere of the setting is not.

From 1922 until the present the pomegranate has been the single most important, almost ubiquitous icon in Masson's work. In The Repast, just slightly to the left of dead center, is the red fruit, open, its flesh exposed, held in the clasp of a male hand. For Masson the pomegranate is at once a symbol of life and death. As the womb, it is the incarnation of fertility and life, and, as the battlefield memory of a soldier's head broken open like a pomegranate, it is death[44]—and "with that goes a kind of return to the fertility image as the bursting open—also menstrual blood." Bread, much less relevant to Masson's iconography than the pomegranate, yet recurring frequently in his early years and emerging again in paintings done shortly before his return to France in the middle forties, is also on the table in The Repast. In this early painting, its symbolic significance as sustainer of life is not carried so much by the loaves in the lower middle or left center as it is in the way it is tenderly, almost respectfully held by the large hand at the left. Later, in many of the automatic drawings, with the same gesture, the hand will enclose a breast (p. 19).

While the basic structure of A Throw of the Dice and The Repast is, like that of all paintings in this series, that of Analytic Cubism, it should be remarked that there may still have been some kind of starting point in the art of Derain, who himself, in 1911–12 and later, had

Table in the Studio. 1922.
Oil on canvas, 19⅝ x 24".
Private collection, Paris

utilized Cubism in a personal way. Masson may well
have seen and been influenced, however uncon-
sciously, by such pictures as *The Drinkers* of 1913–14
(fig. 9) or the *Last Supper* of 1914.

Similarly, although there is a strong Cubist bias in
Masson's still lifes, the earliest do recall Derain. In fact,
Masson, who was to associate the bird with his art and
his person to such an extent that Georges Limbour
would christen him "l'Homme-plume," [45] may have
found in Derain's *The Game Bag* (fig. 10) of 1913 the
initial impetus for the appearance of the dead bird as
a still-life element, as a comparison with **Table in the
Studio** of early 1922 (above) would seem to indicate. As
their titles proclaim, Derain's painting is based on the
traditional hunting still-life, whereas Masson's depicts
the classic accouterments of the studio. Displayed
laterally are a guitar, another musical instrument, two
pipes, a tobacco pouch, a glass with flowers in it, the
halves of an opened pomegranate. What sets **Table in
the Studio** outside convention is the unexpected pres-
ence of the dead bird among the otherwise standard
Cubist trophies. But the bird is not yet invested with the
poetic gravity that we see in such later representations
as **Mask and Square** of 1924; in the earlier picture it is
simply a bird quite evidently, unattractively dead. That
the objects are grouped on a table before an open
window is completely conventional, but that the view
seems to open on mysterious celestial spheres has
virtually no precedent in Cubist art.[46]

Table in the Studio was, like the other paintings
discussed above, one of a surprisingly numerous group
completed in 1922, the last year that Masson was
unable to devote himself entirely to his art. In 1923, with
the signing of his first contract with Kahnweiler, his art
took off and in a remarkably short time demonstrated
a technical sophistication to match the originality of his
thought. Masson recalls, "The period of apprenticeship
was finished for me . . . (providing it ever is fin-
ished)." [47]

Very probably begun late in 1922, one of the first
paintings completed in 1923 is **Still Life with Candle**
(right). Classic elements of Cubist still life—pipe, musi-
cal instruments, a mask, drinking glasses, and scroll of
paper, as well as Masson's ever-present pomegran-
ate—are assembled on a traditionally tilted tabletop set
in a shallow space. This space is nominally that of an
interior, as we see by the flat indication of the joining
of wall and floor. But our apprehension of this assem-
blage of banal objects within a studio environment is
confused by the mysterious intrusion of clouds and
astral spheres, moving in countervailing directions, that
do not seem to give off any natural light but bathe the
composition in a metaphoric translucence. Shadows of
their forms pass through the vase in the center to
become magically imprinted on the paper scroll. It is,
however, not simply in its celestial allusions that **Still
Life with Candle** offers us a peculiarly Massonian ver-
sion of Cubism. It presents as well one of the first
appearances of the lighted candle (very rare in the
imagery of traditional Cubism), one of the most sym-
bolically charged images of Masson's early years. The
flame burns but does not illuminate. Masson remarks,
"As a flame appears in almost all my paintings of that
period, I think it must be a burning flame and not one
giving light . . ." [48] Although it has obvious phallic
associations—one thinks of Novalis' amorous flame—
its primary level of significance for Masson stems from
the ideas of Heraclitus, who regarded fire as the
fundamental substance; "everything, like a flame in a
fire, is born by the death of something else . . . the
primordial element out of which everything else
arises." [49] The devouring flame symbolizes as well the
artist's struggle to find himself and is the visual parallel
of Rimbaud's belief that the artist necessarily immo-
lates himself to achieve self-recognition. Of no compa-
rable importance to his art at the time but nevertheless
of some iconographic interest is the faceted object at
the lower center of **Still Life with Candle**. It is a meteor
chip, or star, an object we shall see again and again in
Masson's work of the thirties and early forties, but
which appears very rarely before 1930.

Along with the conventional artifacts of Cubist still
life and Masson's own additions to that imagery—the

pomegranate, the lighted candle, and vaporous astral bodies—the knife and the fish begin to appear frequently during the winter of 1922-23. The knife is, of course, common in the repertoire of classical Cubism, but in Masson's art it loses its inertia and assumes the aspect of murderous weapon. Just as Miró boasted, "I will break their guitar," so Masson announced, "I will seize the knife immobilized on the Cubist table." [50] The fish appears in a role analogous to that of the bird: it is the creature of the sea as the bird is of the air, and, in the Massonian world where each thing is contained in another, they are both the repositories of man's soul,

his body, and his fate. Both are frequently victims of the knife.

Joining Masson's iconographic appanage at about this same time is the draftsman's triangle, which had precedents in previous art, particularly that of de Chirico, with whose work Masson was familiar. Masson, however, disclaims any relevance between the draftsman's triangle in his work and that of de Chirico, an assertion borne out by the fact that of all his images the draftsman's triangle has the least emblematic presence and is most often used primarily as a formal element in a composition—its surface a trompe-l'oeil

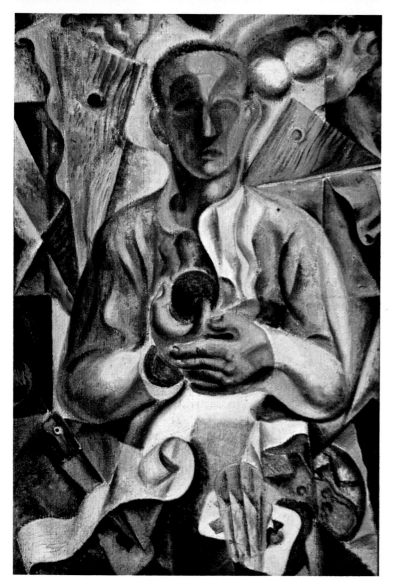

wood-graining that recalls similar effects in the work of Picasso and Braque of around 1912–14.

During the first half of 1923, Masson's work became tighter, more overtly Cubist; effects of transparency became salient, and, particularly in the paintings of Card Players and Forests, took on a centrifugal movement. Salacrou remembers this period. "Every day around five, I'd go and end the afternoon at André's studio on rue Blomet. Other young people used to come and look at the painting of the day and discuss the great problems. André was working a lot and with ease . . ."[51] In the summer of that year Masson with his wife and child went to Plestin-les-Grèves in Brittany with Salacrou and his wife and Michel Leiris.

It was about this time that he painted **Man with an Orange** (left), the first of several self-portraits that date from 1923 and 1924. In the same attitude that he would paint Michel Leiris in **Seated Man** (opposite) less than a year later, Masson gives us an image of himself that is absolutely frontal, the posture rigid and formalized. His blind gaze confronts the viewer straight on. Leiris says of this painting that "the aspect which he [Masson] chiefly sought to emphasize was the metaphysical function of the artist."[52] And, in fact, this representation of a man with an orange seems to hold a mystic significance quite beyond that of a simple self-portrait within a studio interior. The familiar still-life elements have become objects of a cult into whose rites and mysteries the man holding the orange will initiate us. His pose and the gesture with which he holds the fruit have a hieratic quality that paraphrases traditional symbolic modes in sacred art. The orange whose shape is echoed in the various suns spilling forward to touch the artist's temple corresponds by its form to the globe and by its nature as palpable fruit to fertility and life.[53] Although the knife, scroll, playing card, and water glass appear to be on a tabletop, the other objects are no longer "grounded" but float, melding in a low-relief space that paradoxically seems to be only a vignette of some vast cosmic panorama. Hints of the architectural frame that would begin to appear with great frequency at the end of the year are evident in the picture's left edge and in the slight foreshortening of the "ledge" on which the bread partially rests at the lower right.

While at Plestin-les-Grèves, Leiris, who credits Masson with giving him the confidence to become a poet,[54] wrote "Désert des mains," dedicated to his friend Masson. Aside from the reference in the title itself, the poem "catalogs" many of the images that even by that

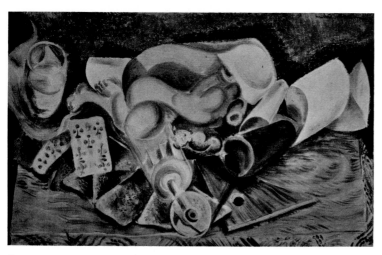

Man Seated at a Table (Portrait of Michel Leiris). 1924.
Oil on canvas, 36¼ x 25⅝".
Private collection, Paris

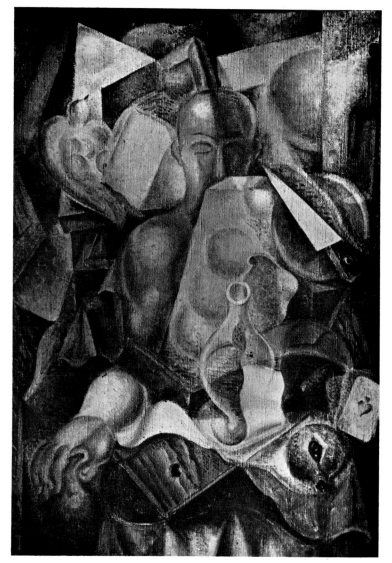

early date had become part of the Massonian vocabulary: "entwined arms" (by which tree branches are also intended), "seashell," "heavy sun" (which, Leiris says, "feeds on the hearts that the earth yields up to it"), "deep lairs," "rivers of fire," "bush of wings," "rocks become clouds," "animal constellations," "bottom of pit," "bodies like clouds."[55] This listing is so inclusive that one would suppose it to have been written two years later. The sympathy between the two men seems to have been so profound that Leiris could anticipate Masson's later imagery—either that or Masson was actually painting "animal constellations," "bodies like clouds," and "deep lairs" much earlier than has been supposed.

The "body like a cloud" is only hinted at before the end of 1923, when its appearance almost parallels Masson's earliest experiments with automatic drawing. One of the first indications of such an image is in **The Cards** (p. 96), painted toward the middle of 1923, in which we see among the standard still-life props, partially reflected in a drinking glass, the sinuous outline of a female figure. Limbour has remarked, "On its first appearance we were made to see the figure through a drinking glass. It was, so to speak, born in the middle of a still life."[56] The figure as plaster cast is a still-life convention that has precedents well before the time of Chardin, and occasionally Masson used it in this traditional way. But its presence in **The Cards**, as in slightly later pictures in which bodies outlined in sepia float diaphanously against architectural backgrounds, can be explained in no rationally plausible way.

For the most part the still lifes of mid-1923 were groupings of familiar objects in a Cubist format but, as Masson says, with this difference: "It happened that clouds would arrive on the table . . . It's also the multiplicity of glasses . . . glass objects."[57] He recounts that Raymond Roussel, who bought one of these still lifes on a visit to his studio, remarked that what most drew him to it was the quality of transparency, and Masson adds, "This transparency was the true theme of the pictures."[58] Leiris has described Masson's way of making these still lifes; "between two pieces of wood forming a kind of box at the base of the studio window, Masson would arrange the objects lighted from behind, lighted by their own substance."[59] The light that here glances about in Cubist patterning seems less solar than lunar, an effect reinforced by the muted and close-valued color. Limbour comments on the pictures of this period:

In those days his colors were subdued, as though jealous of some secret. His objects radiated an internal glow, which was tender and nostalgic, rather as though they were below ground and seen through wisps of blue and green smoke. He used a variety of carefully modulated grays and delicate browns, frequently applied in little brushstrokes with the same sort of grace that characterizes the quick little steps of his walk . . . Of course it was to Cubism that he owed this vibrant brushwork . . . Furthermore, he used a great deal of white, broken by a variety of reflections, which were the emotional substance of his dreaming. His early still lifes were touched with those bewitching whites,[60] and every object has a disturbing and somewhat nocturnal appearance: they seem actually to be wearing a sort of white mask, which appears so very much more strange than a black one. In fact, many of his objects also seem to be wearing a mask of their own

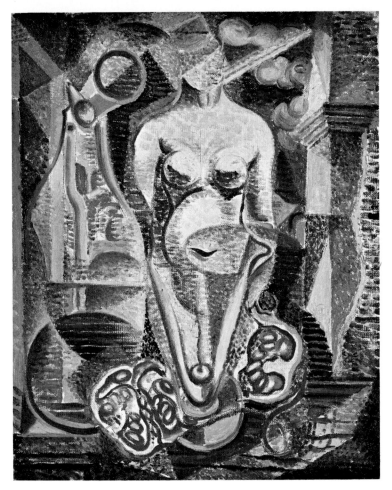

Opened Pomegranate. 1924.
Oil on canvas, 16 x 12⅞".
Collection Mr. and Mrs. Joseph Slifka, New York

sizes the importance of the sense of liberty when, in speaking of the "group," he feels compelled to remark parenthetically that it was in fact the opposite of a group, and adds that there was no concern "with the exterior and with propaganda, no dissension, no intrigue, no rivalry, no one-upmanship, no lying. The greatest brotherhood and trust united these young people . . ." [63] Limbour was the only regular at the gatherings of the rue Blomet who also frequented the meetings of Breton's circle at the Café Cyrano and in Breton's studio on the rue Fontaine. And although Limbour did introduce Aragon to Masson sometime in the latter part of the year, he had the greatest reservations about the desirability of any coming together of the two groups. In 1958 he wrote:

Of these meetings at the Café Cyrano and the rue Fontaine, I said not a word at rue Blomet, no more than I talked of Masson to my friends of the Période floue. Later on I couldn't help but reveal his existence, but I wasn't to be the one, even though I would seem to have been the likely agent—the one most deeply concerned—to bring Masson and the Surrealists together. On the contrary I took the greatest pains to avoid every encounter, to safeguard the miraculous peace at rue Blomet . . . It's easy perhaps to fault such a cautious game, to see in it a backing away from life, a fear of risk . . . In any event it was natural and inevitable that Masson and the Surrealists should someday meet. [64]

In the middle of 1923, however, that inevitable day was still more than seven months away. If we loosely define Surrealism in painting as the attempt to depict inner reality, then in those seven months before his meeting with Breton, Masson was a Surrealist before the fact. The imagery in his paintings became more heavily symbolic, endowed with mystic, oneiric qualities, while their syntax remained essentially Cubist. His struggle to throw off the traces of that discipline was not yet on the surface, but it was already implicit in the tension between content and structure. Years later Masson was to protest that he had never been truly Cubist, for "[the Cubist] will have nothing to do with the representation of dreams of those instincts which lie at the root of our being—hunger, love, violence." [65] With such representation Masson was intensely involved; he wanted to realize in visual terms Goethe's concept "What is within is also without," and that search and desire led him in the winter of 1923-24 to make his first experiments with automatic drawing. Masson's hypothesis, "Perhaps it is really that my romanticism appears Surrealist," [66] contains much truth, but in their

devising, beneath which one has only to look to discover life beating on in its unknown and mysterious aspects. These whites belonged to men's shirts, to walls, to rolls of paper, to clay pipes, to clouds and to those vague beings who are simply called "background figures." Wine lees at the bottom of a glass, or a little area of green somewhere in the picture, shine out like damped but dangerous fires. [61]

Back in Paris after his Brittany vacation, Masson returned to the rue Blomet, where the nightly gatherings of poets and artists resumed in all their fervor and force. Robert Desnos and Raymond Queneau as well as Marcel Jouhandeau sometimes joined the group, but otherwise, in this last half-year before Masson's meeting with Breton, little changed at 45, rue Blomet. Masson remembers, "Fanatics about our freedom, we had a very pure sense of friendship—each was what he was, accepted as such . . . Freedom of access too. That studio was open house at all times. Of course there was a door, and a latch on the door, but no key; that's how a gazelle I was keeping took her key to freedom; there was no other." [62] Limbour, too, empha-

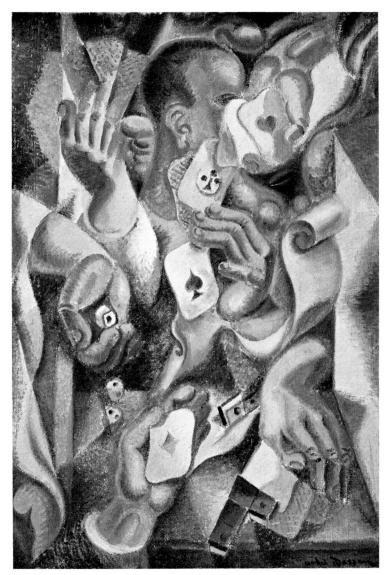

Card Trick. 1923.
Oil on canvas, 28¾ x 19¾".
The Museum of Modern Art, New York,
Gift of Mr. and Mrs. Archibald MacLeish

historical context Masson's paintings of the latter half of 1923 and his virtual discovery[67] of automatic drawing make him one of the authentic prophets of Surrealism.

Although Masson has characterized The Four Elements, painted in the winter of 1923–24, as his first Surreal picture, it was preceded by other works whose dreamlike ambience gives them some claim to primogeniture. Among these is the Card Trick (right), purchased by Archibald MacLeish in 1927. As in The Four Elements (p. 102), the "subject" of the painting is contained within a cubistically articulated architectural niche whose stylistic function parallels that of the stacked picture frames in the work of Picasso and Braque of about 1910–12. Except for the participation of the figure in the center whose head is almost totally obscured, and whose body dissolves against the flat plane parallel with the inside edge of the foreshortened wall on the right, the game we observe is being played by disembodied hands describing a slow, circular dance within the rectilinear limits of an architectural box seen simultaneously at the left from the outside and at the right from the inside. The rhythmic interplay of the hands is reinforced by their diagonal deployment in both directions across the canvas as well as in their specific rhymes—the hand palm-up at the lower left is shown in reverse gesture at the upper right, the hand holding the dice at the left center has its echo in the hand held down over the knife at the lower right. Like the earlier Throw of the Dice (p. 92), with similar overtones of Nietzsche and Mallarmé but in a much more precise and sophisticated way, The Card Trick is a painting about chance in which the card players (interchangeably the painter himself and his poet and artist friends) are magicians and the instruments of the game "signs and talismans wherein are condensed all the obscure forces of the future."[68] The outcome of the game does not depend on the free will of its participants but on the range of possibilities allowed within the immutable structure of cosmic laws. As in many works of this period there is a ritual quality exemplified here in the almost "Egyptian" pose of the figure and the mysterious benediction of the extended right arm. The quasi-religious sense of mysticism enveloping this painting, whose subject is chance, brings to mind Balakian's suggestion that, for the atheist Surrealists, *le hasard objectif* was a virtual substitute for the state of grace.[69] The suits of the cards may be read as symbols of death, life, and sexuality, all of which grow out of each other and whose interrelationship is

an obsessive theme in Masson's art. The diamond that becomes prominent in Masson's work of the late thirties is the visual analogy of the death-dealing knife, and, for Masson, was associated with the diamond sword of Maldoror. The similar forms of the heart and spade are often found, not only in Masson's work but in Surrealist imagery in general, as symbols of the female genitals—the heart, of course, connoting love as well as sexuality. The club, although not so called in French (it is *trèfle,* or trefoil), may by its form have caused Masson to associate it with a weapon; or, as he has rendered it in The Card Trick, it can also be the figure of man or, within the perspective of later Surrealist imagery, the analogue of male genitals. The Card Trick, like the other allegories of chance in the Card Player series, seems, by an ironic confluence of

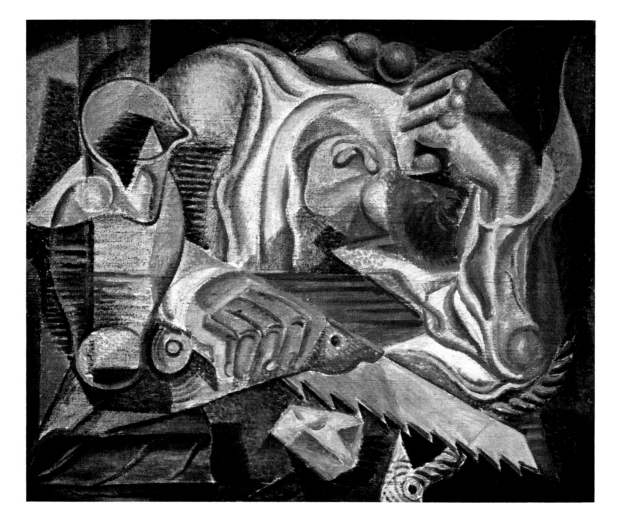

exactly the forces it symbolizes, to have been the unwitting prophecy of the fantastic card games that would actually be played in Marseilles over a decade and a half later.

The Card Trick is one of Masson's last paintings to depict a game in process, or even to allude to a group of men seated around a table—a fact perhaps partially explained by the altered character that the evening meetings were to assume after the interaction of the rue Blomet group and that of the rue Fontaine. Painted at approximately the same time as **The Card Trick**—sometime in the winter of 1923 or early 1924—Sleeper (above) is curious and significant in several respects. It is almost certainly the last image of the seated male figure, head bowed and cradled in the crook of his arm and cupped hand, that has appeared repeatedly through the whole of 1923. Because of the familiarity of this pose in earlier work, the temptation is to place this picture considerably before the winter of 1923; however, stylistically and iconographically it announces the new direction Masson's art was taking in the winter of 1923-24. The cord—which, after the pomegranate, is the most important element in Masson's iconography—makes its first appearance,[70] but, curiously, not surrounded by the most common components of the Massonian iconic vocabulary. The saw had not often appeared before, and the meteorite was, as has been observed, very rare in the twenties. The strip of decorative molding at the lower left is a formal framing device borrowed from traditional Cub-

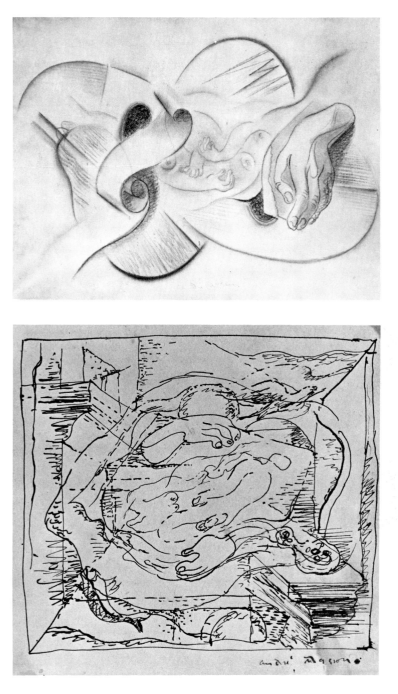

bottom:
Study for "Nudes and Architecture." 1923–24.
Chinese ink on cardboard, 8 x 9".
Private collection

ism; though never obtrusive, it appears with particular frequency in Masson's paintings of 1925 but was seldom used before he executed **Sleeper.**

The special interest of this painting lies in what it reveals about the development of Masson's art in the context of his growing need to break through to a greater spontaneity. Like many artists, Masson often seems to feel a need to retract slightly just as he is in the process of going forward—to find a familiar base from which to make the leap to unknown ground. In **Sleeper** that base is the seated male figure; but the rendering of this figure differs from that of its predecessors. The transparent planes of the right shoulder are coextensive with and melt into the contiguous wall. The body by no means floats, as do the figures of **Two Nudes** painted shortly later, but the brushstrokes have a curvilinear rhythm that points in the direction of the later picture. And, at the outer edge of the curved left arm, a diaphanous, swirling extension of the sleeve suggests the kind of organic unfolding and opening that characterize such later pictures as **The Dead Bird** (p. 18) of late 1924.

The real significance of the **Sleeper** is that from it and certain other contemporary work can be adduced some of the specific ways that Masson in late 1923 came to automatic drawing. Done at almost the same time as this painting is a drawing (above) which, like **Sleeper,** reverts in its imagery to a motif from an earlier period—in this case crossed musical instruments, a format that Masson had almost abandoned since his early Derain-like still lifes. And, as in **Sleeper,** only much more obviously, something unprecedented is happening. In the middle of this unusually carefully executed drawing is the startling apparition of ghostly breasts, hands, a foot, and the curving contours of the female anatomy, all intermingled as though caught up in some puff of smoke. The tight drawing, like the closed position of the sleeper, acts as a metaphor for the formal constraints Masson felt hemming him in, containing his need to express his deepest poetic impulses. He was at this moment almost literally Pierre Reverdy's poet: the dreamer among the ramparts, a captive trying to tear down prison walls—an image he himself would project in many pictures of the next two years. The **Sleeper** and this drawing show Masson at the breakthrough point. Very shortly therafter he made another drawing (right) that is certainly one of the first of the type called automatic; here the male figure of the sleeper, which disappears in the labyrinthine webs of his later automatic drawing, is still

clearly distinguishable, and the head-down, closed posture is revealed as the partial genesis of the cocoon-like outer membrane that surrounds almost all of Masson's early automatic drawing. Soon after this Masson began to paint almost Dantesque images of floating female forms, which, outlined in sepia, seem locked together. Hands and breasts touching, they hover weightlessly before cubistically rendered architectural backgrounds (p. 16).

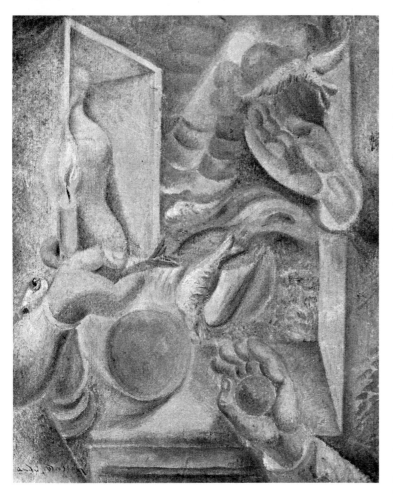

The Four Elements. 1923–24.
Oil on canvas, 28¾ x 23⅝".
Private collection, Paris

a way out of the confines of the French rationalist tradition, a way to arrive at an inner reality.

If any artist exerted a direct influence it was Klee, whose work Masson knew through reproductions in a German book he had found along the quays in late 1922. This experience had a profound impact on Masson, as it had on Miró, to whom Masson showed the book. Masson says, "It was the single most important thing to take us out of Cubism." In Klee's art Masson and Miró saw instinctive, intuitive content married to a semi-Cubist syntax, and it was a revelation. Results of this "discovery" are much more immediately apparent in the work of Miró than of Masson, whose imagery did not so obviously reveal his contact with Klee until 1926. That this is so may have to do with the fact that Masson had greater conventional facility as a draftsman than had Miró, and this very facility acted as an impediment to a more immediate release of his imaginative freedom. Nonetheless, Klee's work was for Masson a door to the expression of the unconscious. It is of some significance that among the reproductions Masson probably saw was *The Eye of Eros* (fig. 11), a drawing of the type Klee produced "automatically" around 1919.[73] Klee's observation that his hand was a "tool obeying the order of a force outside himself" accords with Rimbaud's "I is another," Valéry's "The first line is given to me," and Max Ernst's remark that he was "a spectator at the birth" of his paintings[74]—all of which reflect the kind of giving over of oneself to find oneself that Masson was attempting in his early experiments with automatism.

At the very time that he was evolving this new technique, part of whose essence was its velocity of execution, Masson was laboriously painting **The Four Elements** (left), the importance of which lies not so much in its intrinsic quality as in the rather disproportionate fame it would subsequently gain as Breton's first purchase of a work by Masson. As in the earlier **The Card Trick** and many other paintings of 1924 and 1925, the action of the painting takes place within a kind of architectural "windowbox," and, as in that picture and others of the next two years, the brushwork is indebted to Analytic Cubism. Masson says of it, "It was painted slowly . . . hundreds of tiny strokes finally come together and create the image."[75]

Aside from its likely sources in Masson's reading of Heraclitus—"Fire lives the death of air, and air lives the death of fire, water lives the death of earth, earth that of water"[76]—in its hermetic allusions, particularly to the artist as alchemical magician, its symbolic con-

The evidence of these pictures and drawings of the winter of 1923–24 verifies what Masson has always said, that he began his experiments with automatic drawing before his meeting with Breton in February of 1924. The concept did not, however, spring parthenogenetically from the artist's hand like Venus from the foam. Precedents in literature abounded, and other artists, even if their efforts were unknown to Masson, had made not dissimilar experiments.[71] Certainly Masson's later contact with Breton and the Surrealists would serve to intensify his interest in automatism. Because, however, of the still-intact isolation of the rue Blomet from Breton's circle toward the end of 1923, it is unlikely that Masson was more than peripherally aware of Breton and Soupault's *Champs magnétiques* or of the concern with psychic automatism that was central to Breton and his friends during the *époque floue*, from 1922 to 1924. The initial impetus for Masson was largely drawn from the literature in which he had steeped himself—from Hugo, Baudelaire, Nerval, Rimbaud, and Lautréamont, all of whom to one degree or another had sought in the *dérèglement de tous les sens*[72]

tent seems relatively obvious. As Leiris says: "In the distance, the ocean, as a reminder of origins. Fire of the flame, air of flight, water of the waves and aquatic creatures, rotundity of the earth, the four elements are there indeed. Giving sense to it all . . . the indispensable human kingdom, hands occupied taking hold and letting go, distant silhouette of a desired being." [77]

The Four Elements is not one of the most successful pictures of the winter of 1923–24, possibly because it was painted quite consciously to propound "a philosophy in a picture" [78] and the intent to make this philosophy explicit interfered with more expressive pictorial articulation. At various times in his career Masson seems to have felt the necessity to create a work that would encapsulate his concerns. And, in this respect, The Four Elements is not unlike the sculpture Metamorphosis (p. 126), executed in 1927, which is much more a concretization of Masson's intense involvement with the concept of transmutation than it is a sculptural idea.

The fame of The Four Elements derives from the fact that Breton bought it in February of 1924 from Masson's first one-man exhibition at Kahnweiler's Galerie Simon. It was because of that show, the opening of which Salacrou characterizes as "the great day for all of us" [79] that Masson and Breton finally met. Breton, who, in painting, was ever more concerned with dogma than pictorial validity, was understandably most attracted to The Four Elements, with its Chirico-esque, semi-illusionistic depiction of the dream image. In content, the picture was, so to speak, tailor-made for Breton. One of his most astute interpreters, Anna Balakian, says: "For Breton art involves an even more alchemic operation than poetry, and the artist is the true magician among men. Art is not for aesthetic pleasure, but a rebus holding many meanings; it is an undefined substance containing the power of fire serving for the viewer as a source of meditation and of psychic renewal." [80]

Very soon after buying The Four Elements, Breton went round to Masson's studio to meet the painter whose picture had so pleased him. For all their subsequent disagreements, the initial meeting of Breton and Masson was a great success. Their only points of contention were on Dostoevski and Nietzsche, who were immensely admired by Masson and detested by Breton. During their meeting Breton told Masson of what he and "his friends would soon be working at, that is, a group or a review," [81] and asked Masson if he would be interested in joining with them. So began

for Masson, by nature an individualist and iconoclast, the first period of his official allegiance to Surrealism. Years later, in 1958, Masson remembered having explained his joining to Gertrude Stein, who had remarked, "I can't understand how someone like you, such an anarchist by nature, could be part of a group, become an orthodox on anything! What has Breton done to you?" His response was, "I found him seductive right off, and then he flattered me a lot," and he adds, "At which she laughed, and I'm still laughing." [82] With the joining of their individual careers Masson and Breton effected the fusion of the rue Blomet group with that of the rue Fontaine. Masson recalls: "Everybody who was pre-Surrealist, around Breton and around the magazine Littérature, ended up in my studio in those days. Aragon, Eluard, Théodore Fraenkel, Jacques Baron and his brother Francois . . . Rue Blomet had become one of the pre-Surrealist meeting places. It remained that all through Surrealism . . . Rue Fontaine, in short, was the place of orthodoxy." [83]

Although it was still eight months before Breton would officially promulgate the new doctrine in the first Surrealist manifesto, Masson was ordained in the movement when Breton acquired The Four Elements, the imagery of which, despite its relative clumsiness, documents central preoccupations in Masson's art of 1924 and later. The "desired" being disappears into an upright tomb, itself placed before the sunlit ocean and next to the amorous flame whose contours echo the curves of the phantom figure. As in The Tomb beside the Sea, also shown in the exhibition at the Galerie Simon, the contemporary Still Life beside the Sea, and nearly all the Forest pictures of 1924, an obsessive juxtaposition of tomb with "the crystal waves of the sea" seems to stand not only for the opposition of death with the living waters of the ocean, but as a paean to the sea, the supreme agent of metamorphosis. The tomb, bird, and sea imagery could come straight from Les Chants de Maldoror of Lautréamont, whose own hymn to the ocean in Canto I may have had some influence on Masson: "Thy moral grandeur, image of the infinite, is as immense as the reflection of the philosopher, as the love of woman, the divine beauty of the bird, the meditations of the poet—thou art more beautiful than the night."

Georges Limbour's description of The Road to Picardy in the lyrically imaginative essay he wrote as an introduction to Masson's 1924 Galerie Simon exhibition could as well describe The Cemetery (p. 91), also painted very early in that year. "A frightening land-

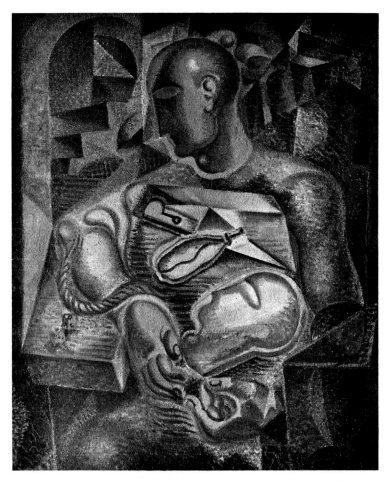

top:
Man in the Tower. 1924.
Oil on canvas, 28¾ x 23⅝".
Formerly collection Pomaret, Nice

scape made up the cemetery of the Man-Feather . . . The trees writhed like the twisted grillwork of monuments after the wild deflagration set off by an explosion . . . Some, protected in earth hollows, retained their primal attitudes, solemn and straight as bodies in coffins. Every afternoon a new sun rose straight up behind the trees."[84] No longer a naturalistic rendering of a vaguely threatening forest as **The Crows** of two years before, **The Cemetery** is almost pure fantasy. Although the forms of the trees still owe something to Derain, they have become overtly anthropomorphic, their limbs terminating in hands that grasp at the spherical bodies with which the sky is filled. A tree-hand even reaches up at the lower right as though seeking the sun visible in the cubistically opened coffin above. Perhaps it was of this image that Jouhandeau was thinking when he said, "The suns lie down in Masson's tombs."[85] The presence of the tomb in the forest beside the sea may owe something to Chateaubriand,[86] but according to Masson himself it is much more the symbol of death nourishing life. The curious circular half-walls that rise from the sea and border the paths seem to be a distant view of the kind of structures in which Masson compresses the figures he painted in 1924.

During this year the characteristic presentation of the figure is shown by such paintings as **Man in the Tower** (above), **Man in Underground Chamber**, and **Man in a Tower**. Vestiges of the Card Player motif remain in such details as the dice in **Man in a Tower**, but these highly stylized images are at a spiritual remove from the "genre" pictures of the year before. Early in 1924 Masson discovered Piranesi, an artist whose influence appears frequently during quite disparate phases of Masson's career. Immediately after finding him, Masson almost literally inserted Piranesi into his pictures in such still lifes as **Italian Postcard**, in which Piranesi reproductions, their contours cubistically fractured, are perceived through a transparent glass. In a less direct, more sophisticated way, Masson interprets the architecture of Piranesi to construct the towers and dungeons in which he places his figures.

Piranesi is known above all for his *Prisons,* and a sense of confinement, both spiritual and physical, is apparent in all Masson's figure paintings of 1924. Masson's ambiguous architecture is, however, not simply the prison; it is also the labyrinth, and, as he later made explicit both in his imagery and writing, the underground house is the analogue of the female body, itself the primal labyrinth.

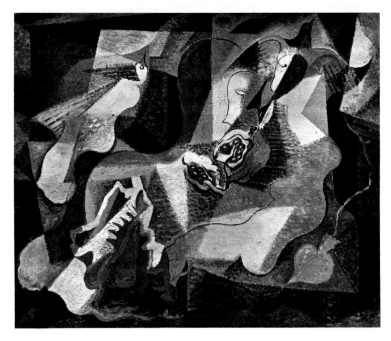

Man in a Tower functions as a self-portrait, and Man in Underground Chamber and Man in the Tower as portraits of friends. Yet, as in the somewhat differently constructed portrait of Leiris, Seated Man, the features are stylized and the eyes are shut or blank, thus lending an anonymity that carries with it a sense of universality. These are metaphysical portraits, which, through a means entirely different from the technique of automatic drawing, aim to produce a similar result, to articulate visually man's inner world. To stretch a metaphor, these are prose descriptions and the drawing is poetic analogy. The multiple suns in these paintings are the basis for much syntactical rhyming, and are also, as Breton perceived, "forever the cocoons of all ideas. . ."[87]

Iconographically the paintings of 1924 were enriched by the prevalence of the cord, the appearance of the scale (a variation of the globe/sphere motif), and—of relatively minor significance—by the short-lived mask. These paintings exhibit the parallel phenomena of an increasingly personalized imagery and, on a formal plane, a markedly more assimilated Cubism, which renders them more traditional than previous work in some respects. Overlapping transparent planes predominate, and the use of internal rhyme is elaborately orchestrated. Probably painted late in the year or possibly the beginning of the next, Sleeper (opposite) is especially illustrative of these tendencies. In this painting a man's head and shoulders are outlined in the center; across his form fall a series of images in bands

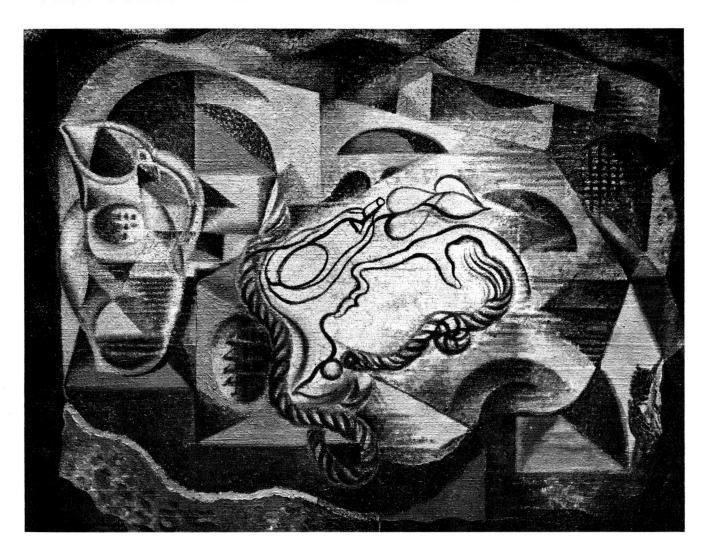

of light that create an onrushing movement from the bottom left corner to the top right. These shapes echo, invert, and accent each other—the outer edge of one often delineates the inner edge of another. Starting from the lower right diagonally across to the top left, forms engage each other in a way that is a *tour de force* reversal of the initially perceived movement across the canvas; thus there is an almost heraldic crossing of swords, punctuated at the point of intersection by the pomegranate. The outline of the back of the woman's profiled body at the lower right echoes that of the head and shoulders of the central figure. The bird's body at the upper left repeats the back profile of the woman and inverts her front outline. At the left center, the mask—rather like that of a hangman or helmet of a medieval soldier, as it more clearly is in a drawing done slightly later—tilts toward the right as if caught up in the rush of the bird's wings above it and repeats in its form the pear-shaped body of the bird. At the lower right, outlined to descant the line of the

woman's form above, is a heart, or perhaps a variation on the card player's spade.

As in the **Sleeper** of the year before, the central figure of the sleeper is, at least metaphorically, that of the artist. Here, however, the sleeper is erect, implying consciousness; but his transparence and ghostly presence indicate that his consciousness is now operating on a deeper level. This same phantom presence appears as a watching figure in **The Constellations** and a number of other paintings of 1925 and recalls the line of Novalis, "The Man totally aware is called the seer."

Throughout 1924 Masson was continuing the experiments with automatic drawing that he had begun early in the year, and the tension this provoked in him—the sense of struggle to bring forth his feeling in paint as he could with ink on paper—is clearly apparent in **The Storm** (p. 105). The painting is a Forest picture, but its trees hardly seem trees. Like his floating nudes these "poisonous"[88] forms have a Dantesque quality, but the sense of agony here is far more acute. Their twisting

opposite:
Les Soupiraux. 1924.
Oil on canvas,
23⅝ x 31⅞".
Galerie Louise Leiris, Paris

right:
Portrait of Roger Vitrac.
Frontispiece for Vitrac's
Les Mystères de l'amour
(published 1924)

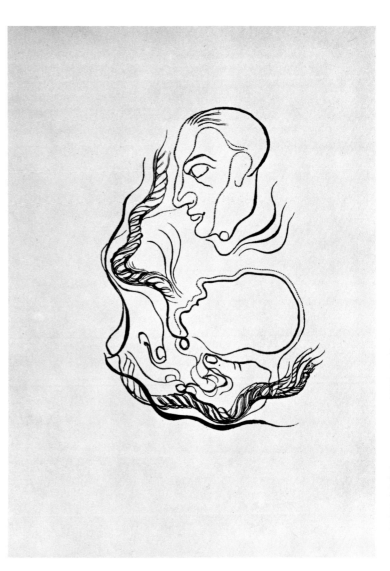

shapes seem anguished bodies, and, just as in the Massacre series of the next decade, the sun above with its characteristic Massonian tail is the constant astral spectator of the earthly drama. The erotic "visceral obsession" that lies at the base of all Masson's automatic drawing is unequivocally projected in this painting, which might serve to illustrate Cendrars's expression "the twisted tree of my desire." [89]

The floating, severed head, an image that appears with considerable frequency in Masson's automatist portrait drawings of the ensuing two years, is clearly paraphrased in two paintings of 1924, **Man in the Tower** (p. 104) and **Les Soupiraux** (left). In evolving this image Masson may well have been inspired by reproductions he had seen of the pastel *Orpheus* of Redon (fig. 14), an artist whom he had always, unlike the other Surrealists, intensely admired. On the basis of the portrait of Vitrac that Masson made as a frontispiece (right) for the latter's *Les Mystères de l'amour*, published in 1924, the extremely similar image in **Les Soupiraux** may specifically be a portrait of Vitrac. In the context of the Piranesi-like labyrinth of **Les Soupiraux**, Masson's association of the cord with Ariadne's thread is suggested. Although the cord might seem to be related to such framing devices as the rope Picasso used to enclose many of his pictures around 1912, it is almost exclusively for its symbolic content that Masson employs it—particularly as we see it in the frontispiece for Vitrac's book, where it provides a visual parallel for the words of Jacques Baron, "the slow navigation of the dream hand over the love-song river knots and unknots the rope of life, the rope for hanging, the rope for dancing." [90]

The effective physical properties of a rope may have had some role in Masson's development of automatic drawing. He says of it: "It's also a kind of writing. A thing I used to do would be to throw a string onto a blank sheet of paper: what you see appear are movements of an undeniable grace. Every time." [91] This description of the string falling on the blank page is metaphorically a description of the artist's deliberate attempt to erase conscious intent from his mind in order to free his hand to obey interior impulses. Masson has described the process: "(a) The first condition was to make a clean slate. The mind freed from all apparent ties. Entry into a state bordering on trance. (b) Surrender to the interior tumult. (c) Speed of writing." [92] Masson's practice of automatism produced some of the most beautiful drawings of his always excellent graphic work, but unlike the cord falling on the blank page, the quality of Masson's art was not the pure result of psychic abandonment. Breton's famous definition of Surrealism, published in the first Surrealist manifesto in the autumn of 1924, reads: "Surrealism, noun masculine. Pure psychic automatism, by which one intends to express verbally, in writing or by any other method, the real functioning of the mind. Dictation by thought, in the absence of any control exercised by reason and beyond any aesthetic or moral preoccupation." [93] Without going into the "Naville crisis" of 1925, in which the whole idea of Surrealist art was challenged as a contradiction in terms, and without belaboring "automatism" as an art-critical term, we may nonetheless recognize that Masson's art—like Miró's or Ernst's—was not produced in the absence of aesthetic preoccupation. Nor could it have been accomplished by a less talented artist.

In this area, however, similar premises tend to produce similar results—as is borne out by the curious

top:
Metamorphosis of Lovers. 1924–25. Ink, 16½ x 11¾".
Collection Simone Collinet, Paris

bottom:
Fini ni moi ce soir à cinq heures. 1925.
Ink, 9½ x 12¼". Collection of the artist, Paris

drawings by Austin O. Spare (fig. 12) reproduced in "Automatic Drawing," an article by Frederick Carter (Spare may have coauthored it) in an English magazine in 1916.[94] The work and theory of Spare and Carter seem to come from Blake and the tradition of English spiritualism which often ran parallel to the cultural wellsprings of the Surrealists but whose lines of intersection were mostly confined to the contributions of German Romanticism. Carter and Spare describe the method whereby "sensation may be visualized":

An "automatic" scribble of twisting and interlacing lines permits the germ of idea in the subconscious mind to express or at least suggest itself to the consciousness. From the mass of procreative shapes . . . a feeble embryo of idea may be selected and trained by the artist to full growth and power. By these means may the profoundest depth of memory be drawn upon and the springs of instinct tapped . . . The hand must be trained to work freely and without control . . . its intention should just escape consciousness . . . and in the ecstatic condition of revelation from the subconscious, the mind elevates the sexual or inherited powers . . . so a new atavistic responsibility is attained by daring to believe—to possess one's own beliefs—without attempting to rationalize spurious ideas from prejudiced and tainted intellectual sources.[95]

In the proliferation of breasts, eyes, hands, and feet suspended within quivering outer membranes, the imagery of Spare's drawings is uncannily like that of Masson. And the line, although mannered in a way that Masson's is not, and possibly owing something to Art Nouveau as well as obviously to Blake, is not dissimilar. Masson's work was later to remind both the Princesse de Bassiano and Adrienne Monnier of Blake. But in 1924 he was only, to use Monnier's later characterization, his "spiritual son." It was not until the following year that Aragon would introduce Masson to Blake's work.

The year 1925 was one of great Surrealist activity, and a particularly rich and productive one for Masson. In December of 1924 the first issue of *La Révolution surréaliste* reproduced automatic drawings by Masson (he would contribute to every subsequent issue except the last in 1929), as well as work by Ernst, Man Ray, and Picasso. During the year Miró and Klee had their first one-man shows in Paris. And the Surrealists, both official and unofficial, had in November a first group exhibition at the Galerie Pierre, with an accompanying catalog by Breton and Desnos. Tanguy, Prévert, and Marcel Duhamel, who shared a house on the rue du

la naissance des oiseaux.

Château, joined the combined group from the rue Blomet and the rue Fontaine. Of great personal importance to Masson was "the entry into our group of Georges Bataille," who immediately put a distance between himself and formal Surrealism, calling it "not dark enough," as in parallel fashion he had called Dada "not absurd enough." Bataille, "the dark god," had a far more profound effect on Masson than had Breton, "the sun god."

The visceral obsession manifested in Masson's automatic drawings and such works as **The Storm** (p. 105) was carried into **The Dead Bird** (p. 18) of late 1924 and **The Amphora** (p. 110), **Man** (p. 110), and **The Prey** of early 1925. In all of these the "skin," or rational image, the outer crust of reality, as represented in **The Dead Bird** by elements from a Forest picture and in the later paintings by architectural components, seems pulled apart, unfolded to reveal inner organic layers. As Masson later wrote, "Cut the ceilings, throw back the walls of the room, remove the partitions of the forest, let the earth flow . . ." [96] These pictures are allegories of birth. The earliest, and most earthbound, **The Dead Bird**, by its title signifies death; but, as in the others, it is death symbiotically, generatively related to birth, as becomes evident in a comparison with a slightly later automatic drawing—one of the few such that bear a title—**Birth of Birds** (right). "The thighs open to flights of wings" and "the belly to other gyrations" [97] in these drawings have clear parallels in the forms of the earlier painting.

The Amphora, The Prey, and Man combine ideas developed from the series of floating nudes of the beginning of the previous year with the metaphoric liberation of an enclosed figure, of the type that was shown in **Man in Underground Chamber.** The sense of flight—the lightness—does not come from any transparency of the figures (they are largely opaque), but from the rhythm of the line; as Masson says, "An unbroken ring abolishes space—spirit of heaviness." [98]

In **Man**, as in much of the work of 1925, syntactical devices function as much symbolically as they do formally. In much of Masson's previous work we have seen the architectural niche used as a frame; here the bursting from it represents not only progress toward an image that will be less bound by the rectilinear limits of the canvas, but also a "philosophical reflection." Masson had enormously admired the work of Poussin since he had discovered his work on his first visit to Paris in 1912, and it was in Poussin's *The Ecstasy of St. Paul* (fig. 13), in the Louvre, that he found the model for the

"exact type of composition" as **Man;** [99] in it the classical frame was "broken open—exterior symmetry allied with interior asymmetry." In the traditional illusionism of Poussin, the wall at the right seems closer than the column on the left; in **Man** Masson's Cubist perspectival variations present the wall at the right from the outside and that at the left from the inside. **Man** is certainly not the first painting in which **The Ecstasy of St. Paul** played a part—we have seen the same kind of perspectival handling in **The Card Trick** (p. 99) and **The Four Elements** (p. 102) as well as still lifes in which objects comparable to Poussin's sword and book are set within architectural frames—but it is one of the earliest to exploit fully its possibilities.

Artaud, the original owner of **Man**, which was shown in the first Surrealist group exhibition in November of 1925, was moved to write of it:
A soft belly. A belly of fine and illusory powder; at the foot of the belly a burst pomegranate. / The Pomegranate

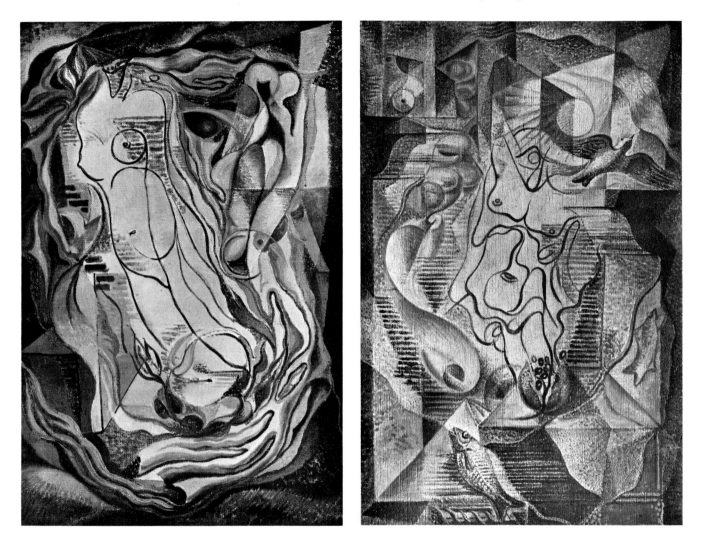

The Amphora. 1925.
Oil on canvas, 31⅞ x 21¼".
Private collection, New York

Man. 1924–25.
Oil on canvas, 39⅜ x 25⅝".
Collection Mr. and Mrs. Joseph R. Shapiro, Oak Park, Illinois

sends forth a circulation of floccules that rise like tongues of fire, a cold fire. The circulation takes the belly and turns it inside out. But the belly doesn't turn . . . / There are veins of winy blood and blood mixed with saffron and sulfur, but a sulfur diluted with water. / Visible above the belly are breasts. Higher, and deeper, but on another mental plane a sun burns, in such a way though that it makes one think that it's the breast that burns . . . / The sun seems to be looking. . . . Its gaze is a cone that upturns itself on the sun. And all the air is like fixed music, but a vast, profound music, well built and secret, and full of frozen ramifications . . . / The canvas is hollow and stratified. The painting is well confined on the canvas. It is like a closed circle, a kind of abyss that turns, and splits into two down the middle . . .[100]

Masson's imagery had always reflected a heavier dependence on analogical than on strictly logical thought processes, and the prevailing influence of automatic drawing in 1925 intensified this tendency. In this year there are virtually no still lifes as such, and correspondences between forms are counterpointed with dizzying virtuosity in the often tightly packed compositions. Cosmic allusions are pervasive, as titles such as **The Meteors** and **The Constellations** indicate. Masson says, "The horse, the fish, and the female breast become constellations."[101] The male figure has

top:
The Wreath. 1925.
Oil on canvas, 36¼ x 28¾".
Museum Folkwang, Essen

bottom:
Automatic Drawing. 1926.
Ink, 16½ x 12⅝".
Private collection, Paris

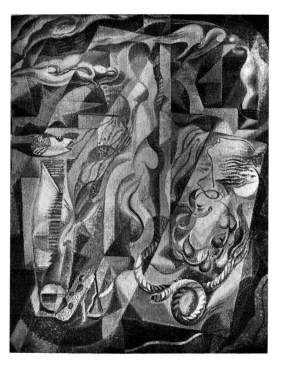

changed; "as for the men, they are in a situation other than that of the preceding period; more episodic, more haggard . . . The figure of the woman becomes dominant . . . Pregnant with considerable fruits. These female figures are always defined starting out from the belly. Strong *graphic* intervention." [102] Almost all his figures are headless, as would be the emblematic "Acéphale," the title and symbol of a magazine founded by Bataille and Masson over a decade later. Except for freely rendered outlines—mostly of the human figure—Masson's almost Neo-Impressionist, bricklike brushstroke continued to predominate, with variations, until sometime toward the end of 1926. His palette, however, became more diverse; rich brown and ocher, set off by areas of red brighter and larger than in his previous work, were often used—sometimes accented by yellow, green, blue, and a kind of succulent aquamarine that he had previously employed sparingly, as in **The Trees** of 1922.

Illustrating this use of aqua is **The Wreath** (right), the painting that reminded the Princesse de Bassiano of Blake. To judge by the organic, unfolded aspect of its upper left and lower right corners, this painting was probably executed early in 1925. The title draws attention to the crown or wreath, an image that appears with particular frequency in Masson's automatic drawing of 1925. Consistent with the concept of making *peinture-poésie,* Masson's imagery is symbolically ambiguous, and, just as it was so often inspired by several sources, it can be interpreted in various ways. Here the juxtaposition of the crown with the cord (always in one way or another Ariadne's thread) and its position on the tomb suggest that this may be the diadem of Ariadne, which after her death became the celestial constellation of Ariadne. As in contemporary automatic drawings (right), the crown is made up of a wreath of heart-shaped forms which signify not only leaves but also, as other work frequently makes explicit, the vagina. The tomb that seems to enclose the sepia-outlined, profiled head is an image that recurs repeatedly in the automatist portraits Masson made of himself and his friends (p. 32). In the drawings, however, the tomb is more confining and seems made of ice or crystal. Masson himself believes that the overall concept of **The Wreath** derives chiefly from his reading in the German Romantics, but concedes that echoes of Apollinaire's *Enchanteur pourrissant* may have been reverberating in his mind—particularly fragments such as "Lying in the sepulcher the enchanter thought of fish and winged beings."

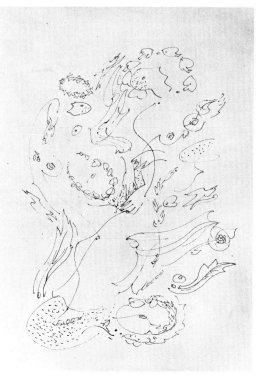

The Star. 1925.
Oil on canvas, 18½ x 15".
Collection Dr. and Mrs. Thomas J. Hardman, Tulsa

Bird Pierced by Arrows. 1925.
Oil on canvas, 24 x 18⅛".
Private collection, Presinge, Switzerland

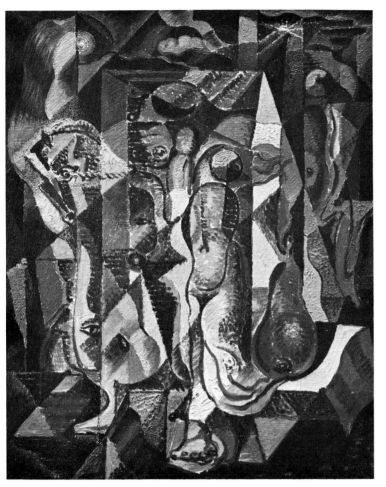

Birds and fish had already been prominent in Masson's art, but in 1925 they, along with the horse, became the central actors in cosmic dramas. In The Constellations (p. 14) the double portrait of a horse outlined in red rises in a kind of ghostly white light, as if by some force emanating from the opened bread in the lower right. As in many paintings of this year the tension and energy of the composition are concentrated in the middle of the canvas. Here, dead center, is a woman's breast faceted in the hard, stylized way that it appears in many other paintings of 1925. A blue blade, Masson's "sexual knife," is next to the breast, and above, as though penetrating it, is a blood-red, dartlike object that appears again in **Bird Pierced by Arrows** (right). The form of this object makes it the analogue of the knife and also of the flying fish (a

Massonian symbol for the penis, as well as allusive to Breton's text, *Poisson soluble,* "soluble fish") as it appears in many drawings and such paintings as **The Wing** (p. 17) and **Bestiary** (p. 114). In all the last-mentioned pictures the composition tends to fall away from the framing edges in a Cubist manner but is otherwise alive with the staccato rhythm of triangular knife-echoing forms articulated in low relief.

The watcher figure at the upper left of **The Constellations** that has previously been remarked in **The Sleeper** of 1924–25 (p. 104) is often presented as a curious, unsettling synthesis of the helmet, torso, eye, and navel, as in **Bestiary** and the later works **Trophy** (p. 115) and **Male Torso**, both of 1926. One has the feeling that this composite is Masson's shadow, and, because of the helmet-like character of the image in combination with titles like *Trophy* and *Bestiary* (the first meaning of which is "gladiator"), that this is Masson as warrior—the battle the pursuit of his art. The image recalls words from Leiris' poem "Désert des mains," written two years previously in Masson's honor: "The Capricorn is a navel harder than the coldest words."[103] Masson's associations with the navel are several. He made the frontispiece for Artaud's *L'Ombilic des limbes,*[104] and in the sense of umbilical cord Ariadne's thread has one of its primary meanings. As in an untitled drawing done toward the end of 1925, Masson often shows the navel in the same way as he does his tailed comets or suns. Once, half seriously, he suggested that we should look at a picture through the navel, thereby getting rid of worthless cerebral baggage and responding, as it were, from the entrails. In a whimsical drawing of 1927, **Child Looking at a Drawing** (p. 21), a few spare lines laid over with wash suggest the head and torso of a rather wary-looking fellow. This personage holds an automatic drawing that is physically connected to his body by a line from its center to his navel; the line continues as the extension of his left arm, and terminates in the queer red accent of a volumetrically rendered glove on the sticklike arm. The drawing seems a straightforward, rather humorous observation on the inspirational sources of automatic drawing.

The influences of automatic drawing are apparent in two of Masson's most important figure paintings of 1925, **The Armor** (p. 115) and the slightly later **The Woman** (p. 15). Of the former Masson says, "This Female Armor has the look of crystal. The head is replaced by a flame. The neck cut. The sex next to an open pomegranate: the only fruit that bleeds; a bird

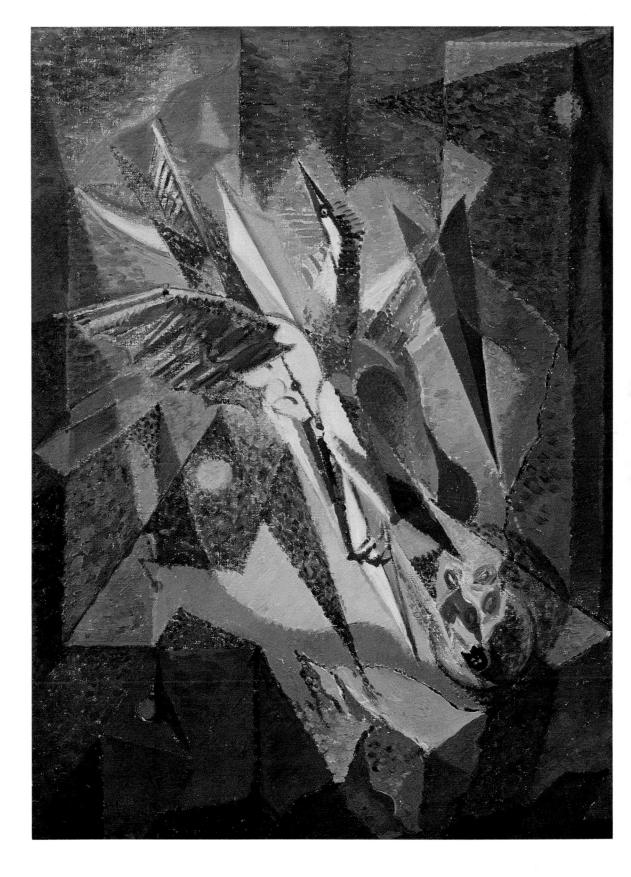

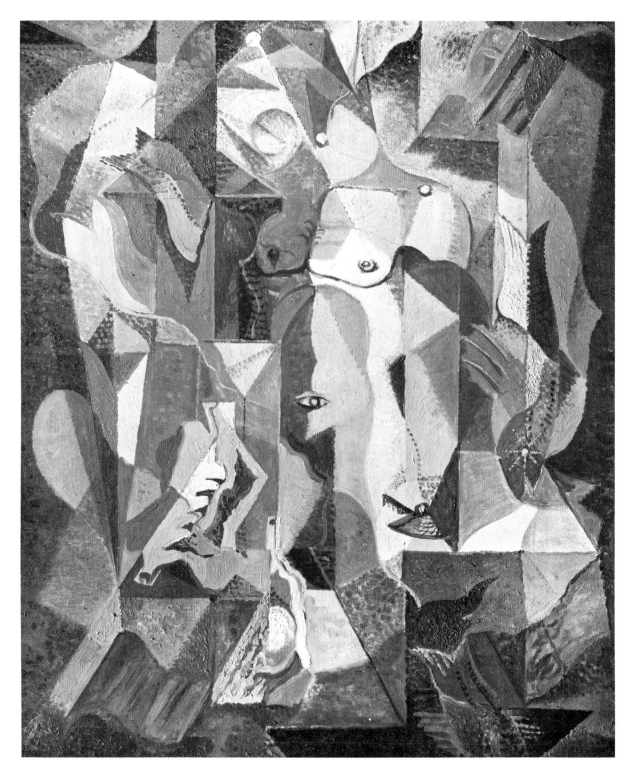

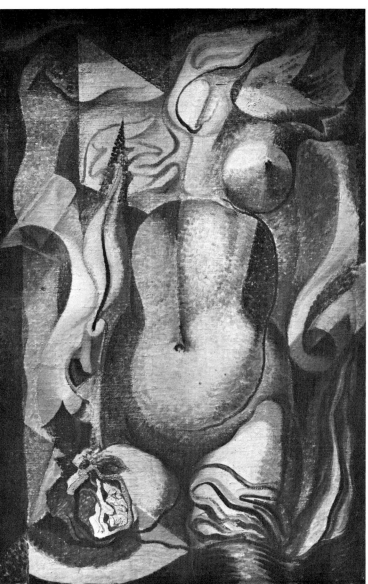

nears the armpit (the nest). The armored body is wound in strips of paper that mime the curves of the female body."[105] **The Armor** was reproduced in the July 15 issue of *La Révolution surréaliste*, and on the previous page is Leiris' "Glossaire: j'y serre mes gloses," a collection of word definitions produced by an associative process that verbally parallels the methods of automatic drawing. Given the closeness of Leiris and Masson and the inspirational force that Leiris found in Masson, certain "stream of consciousness" definitions that Leiris included in his glossary would seem inextricably linked to **The Armor**:

Armor—boughs of petrified tears
Flank—white, it springs like a flame
Torso—living torch, a spire—you leave not a trace

And, in a later similar compilation published in the March 1 issue of *La Révolution surréaliste* of 1926:

amour—armor
Flame—male fluid

The woman's form in **The Armor** presents "the desired being" that we have seen disappearing into the tomb in **The Four Elements** (p. 102), the symbol of both sexuality and death. The equation of eroticism and death was central to the thinking of Georges Bataille, and it was he who first owned this picture. Masson's own fascination with death is amplified by Otto Hahn's description of "the day a bullet ripped into his chest . . . The world around him became something wondrous and he experienced his first complete physical release, while in the sky appeared before him a

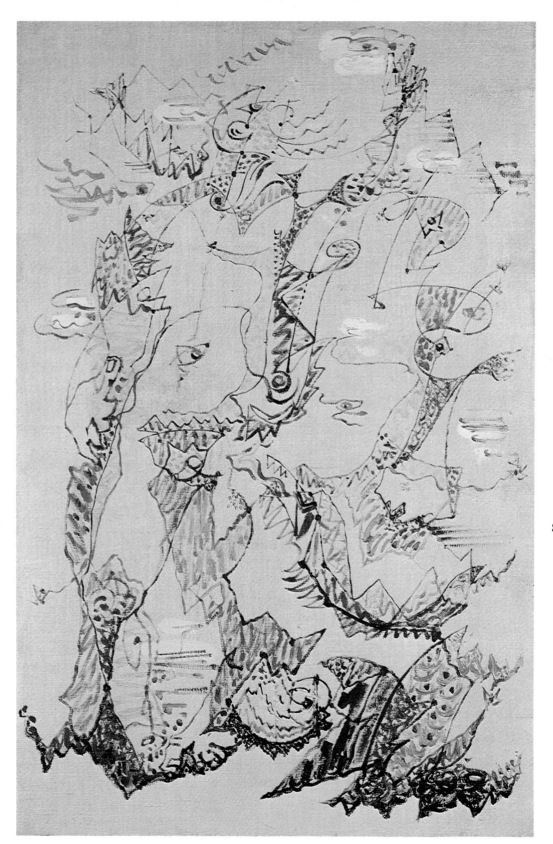

Children of the Isles. 1926.
Oil on canvas, 36¼ x 23⅝".
Private collection, Paris

opposite top :
The Dead Man. 1926.
Oil on canvas, 36¼ x 23⅝".
Private collection, Paris

opposite bottom :
Les Ecorchés. 1926.
Oil on canvas, 28¾ x 23⅝".
Saidenberg Gallery, New York

torso of light and there remained in him only an irrational desire to come closer to the light-drenched torso of death."[106]

The provocative, hallucinatory quality of **The Armor** is poetically remarked by Breton and Desnos in the catalog of the first Surrealist exhibition.[107] "Far off a man is visited at night by the miracles and, better than by a shadow, he is followed by the armor, armor of glass, the cause of his insomnia . . . The man is back again, there, on the road, but he's no longer the same. He stops, musing, before the armor, and seems to resume his way regretfully."[108]

The Woman (p. 15), painted late in 1925, shows Masson further veiling his Cubism. The woman's body has the same or greater monumental presence as that of **The Armor**; but its contours are no longer predicated on the underlying Cubist grid. Direct borrowings from automatic drawing appear, as in the hand curving around a softly delineated breast at the upper right. The figure is invested with mythic, ritual qualities, but is not the Kali-like idol of **The Armor**. She is rather a modern stand-in for Ishtar, the Earth Mother. The attitude of her body and the folds of the drapery suggest the figure at the left of Phidias' *The Three Fates*, the Parthenon sculpture of the goddesses who spin, measure, and cut the thread of life. Her solid limbs have the same bulk as Picasso's women of the early twenties, but evoke none of the stolid, peasant qualities of those figures. She sits with majesty as though on a throne, her breast the sculpted sun-breast-eye that has appeared with obsessive frequency during the year. Although she has no head, a spectral, metamorphosing memory of it seems caught in the angled ocher plane abutting her left shoulder. Just to the left is the ever-present watcher of **Sleeper** and **The Constellations**. The opened pomegranate serves as the symbol of woman's internal organs, as the generative womb. The botanical metaphor of fruit and fertility is carried further in the sensually modeled, cubistically divided pear at the figure's right elbow. The posture of the figure—legs spread, with the left foot solidly planted—anticipates that of **Gradiva**, just as the blood-colored pomegranate is the forerunner of the raw slab of meat that makes up that figure's entrails.

Automatic drawing represented for Masson "metamorphosis in its purest form," and his urge to effect a similar sorcery with paint on canvas drove him more and more toward what he calls an "invisible world."[109] Masson says of this period, "Metamorphosis becomes dominant, death still appears, no longer in

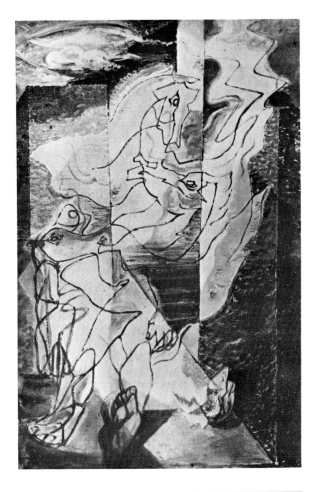

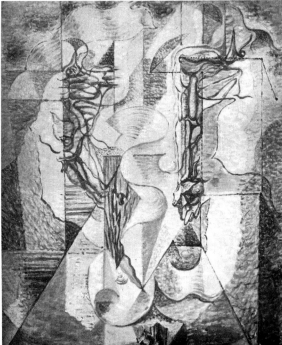

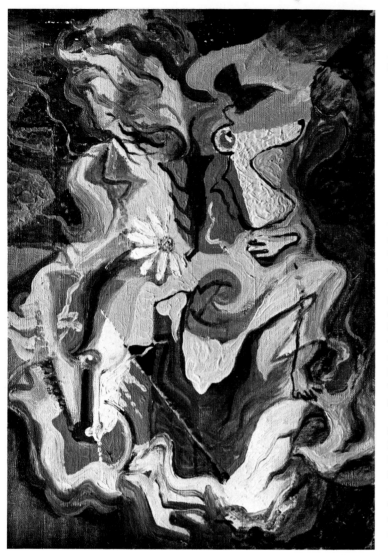

La Reine Marguerite. **1926.**
Oil on canvas, 18⅛ x 13".
Private collection, Milan

appears to emanate from an opened pomegranate. In **The Dead Man** it is partially the play of such light that accounts for ambiguous depths; it both unites and divides the three major rectangular planes of the left side of the picture. The volumetrically rendered "headrest" is extended transparently down into the block of the wall, which, coextensive with what we read as a vertical, then seems to rise forward toward the picture plane. Yet this same light defines the lower edges of the central transparent vertical at the figure's feet, thus establishing it as "in front" of the shaded portion of the "headrest."

The muted color of **The Dead Man** is typical of Masson's work in 1926. That his palette is more subdued than in the previous year may have to do with the increasing importance of calligraphy in 1926. The line that describes the figure in **The Dead Man** extends rhythmically to outline the horses' heads, its trace unbroken except at the barely perceptible intervals where the brush was reloaded. Horses appear with great frequency in Masson's automatic drawings of 1926 and 1927, as well as in the sand paintings which grew out of them. Their presence is explained by Masson: "The horses appear as avengers in most of my paintings. In **The Dead Man**, the man's body is surveyed by phantom horses that seem to accuse him."[111] Spiritually and culturally Masson has always considered himself a "man of the North," and his concept of the horse-judge is not unlike Ibsen's in *Rosmersholm,* in which white horses are the phantom chargers of innocence haunting guilt.

For Masson—and for Miró and many of the other Surrealists, as well as Picasso—the foot has an erotic significance only slightly less important than that of the breast or hand. In drawings such as **Fini ni moi ce soir à cinq heures** (p. 108), the foot spins indiscriminately about with sexual organs, breasts, and hands, and it is partially the influence of such drawings that accounts for the prominence of the foot in **The Woman, Personage,** and **The Dead Man.** Masson remarks: "In my first Surrealist drawings, the figure is very often reduced to a head and a foot. In my paintings, not so. But the foot remains emphatic in my figures. In my **Sleepers** . . . the feet are always thrust forward, in the manner of Mantegna's *The Dead Christ* . . ."[112] Although **The Dead Man** is not strictly speaking a "Sleeper," and Mantegna may not have been in Masson's mind when it was painted, an association of Masson's words with this painting does not seem unjustifiable.

As in **The Dead Man,** Masson's struggle to overcome

the form of tombs but in the form of phantasms. One of the important paintings of this period, in fact, is called **The Dead Man** [p. 117]. He reposes alongside a high wall and is surrounded by phantoms of horses. And by linens that, like ectoplasms, take on the look of winding sheets. It's as though his spirit gives itself over in these forms."[110] The high wall or platform, which appears in many other paintings of 1926 such as **The Sheets, Les Ecorchés** (p. 117), and **Personage,** is a variant of the tomb, especially as it appears in Masson's automatist portrait drawings and **The Wreath** (p. 111) of the previous year, and is, as well, a very sophisticated rendering of the arrangement of rectangular architectural blocks that had previously served as a background in **Bird Pierced by Arrows** (p. 113). The plane of the platform on which the man lies seems to tilt forward, yet, simultaneously, in a trompe-l'oeil illusionism, to recede in depth. As in many pictures of 1925 and 1926 light

top:
La Chevauchée. **1926.**
Oil on canvas, 24 x 15".
Private collection

bottom:
Death's Head. **1926.**
Oil on canvas, 18⅛ x 15".
Private collection

an evident Cubist grid was in 1926 generally expressed by what he has referred to as a "strong graphic intervention." It was not, however, the only solution tried. In **La Reine Marguerite** (left) the grid is almost completely subsumed in a mass of biomorphic forms realized in swirling, agitated brushstrokes that reveal an evident effort "to paint" what he had thus far only been able to draw. Through the suppression of calligraphy he was attempting to force himself to address the problem in paint. The imagery of **La Reine Marguerite** is far more confusing than in most of Masson's paintings of 1926. Evident in the left center is the aster referred to in its title; less obvious is the foot at the right that can be read as the extension of a seated figure in the legs-spread attitude of **The Woman**, possibly a visual pun reflecting the fact that the word for aster in French also designates two particularly well-known French queens, Marguerite d'Angoulême and Marguerite de Valois. Another interpretation, which Masson finds likely, is that the painting contains unconscious allusions to the story of the three Marguerites from the sixth canto of *Les Chants de Maldoror.*

Masson's probable difficulties with **La Reine Marguerite** may have pushed him toward the kind of compromise between painting and drawing exemplified by **The Haunted Castle** (p. 22), **Horses Attacked by Fish** (p. 22), **Death's Head** (below), **The Children of the Isles** (p. 116), and **Chevauchée** (right), which he executed toward the end of 1926.

These pictures mark a genuine consummation for Masson. Although it has been remarked with respect to such paintings that the "set of the image in relation to the framing edge reveals Cubist articulation continuing to operate on an implicit level,"[113] they are, with the exception of the earliest, **The Haunted Castle**, free of the obvious restraints of the grid. The exhilaration of line almost matches that of the automatic drawings—to use Breton's characterization, "the hand takes off"[114] in paint almost as it had in ink. With these paintings Masson is on the road to overcoming the physical limits of paint and canvas and advancing toward the creation of his sand paintings—the best of which superbly fuse image and medium. "Space furnished with forms arranged as in a showcase"[115]—Masson's formula of 1924-25—has been discarded.

Except in the earliest of these pictures, **The Haunted Castle**, architectural elements have disappeared (although they are prevalent in contemporary drawings), and, as in the later sand paintings, images are both resolved and dissolved in the meandering lines that

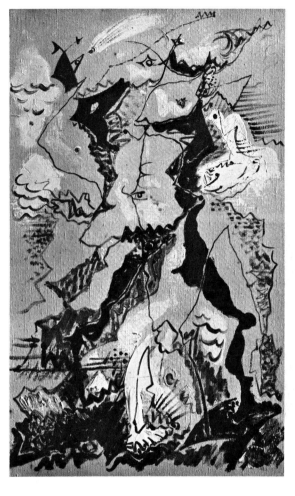

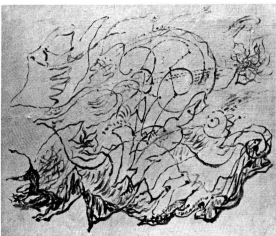

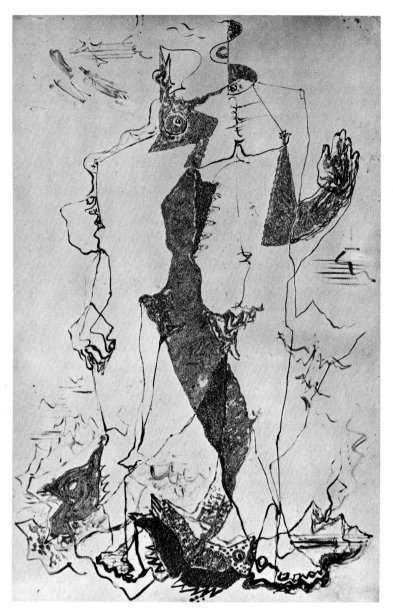

Man and Woman. 1927.
Oil and sand on canvas, 36¼ x 23⅝".
Private collection, Presinge, Switzerland

duce the visible, but makes visible. By its very nature graphic art readily and justifiably leads one into abstraction . . . The purer the artist's graphic work is, the more ill-equipped he is for the realistic rendering of visible things."[116]

In these paintings Masson sometimes chose to apply a thin layer of paint or priming as ground; at other times he left the canvas raw, as in the very beautiful **The Children of the Isles.** However treated, the ground is always essentially neutral; color is applied in the lines, and is otherwise largely confined to filling in random forms with stippled brushstroke. Red, blue, and sepia dominate, but there are occasional accents of yellow, green, and white.

In spite of the relative freedom achieved in these canvases of the latter part of 1926, Masson was still wrestling with "the element of resistance represented by the canvas and the preparation of colors."[117] At the end of the year, while walking on the beach of Sanary-sur-Mer, he was suddenly struck by the beauty of the sand, whose individual grains sparkled with silver and with subtle tones of blue and rose. The idea came to him that this might be the material that would allow him to bypass the encumbrances of oil and canvas. In his first essay with his new medium he placed the canvas flat on the floor and covered it completely with glue and then with sand. But however he tried to modify the result he was dissatisfied, and he destroyed the canvas. His next experiment produced the first—and one of the most successful—of his sand paintings, **Battle of Fishes** (p. 20). After covering the canvas with a thin layer of gesso under which were scattered sparse areas of sand, Masson placed the canvas on the floor and sprinkled glue randomly over its surface. Then, after pouring sand over the entire area, he turned and tilted the stretcher, causing patterns to emerge where the sand adhered to the glue. With a pencil he rapidly sketched in a web of lines whose directions and contours were suggested to him by the shapes of the glue-and-sand "archipelagos." Lastly, with paint spilled directly on the canvas, he elaborated the composition. In subsequent paintings he drew with charcoal, ink, or (occasionally) oil; variously he sifted the sand, incorporated in it bits of shells, applied it layer upon layer, blew it through a straw. Before making his sand shapes he sometimes left the canvas bare, sometimes treated it with a thin film of paint; and from time to time he used a canvas completely covered with sand as his initial ground—always adding at the last "a few lineaments . . . , a spot of sky

cross the flat field of the canvas. More abstract than in previous years, these paintings—like all of Masson's work—are finally representational, and their titles provide at least allusive descriptions of their imagery. Masson has characterized the medium of collage as one of metaphor and that of automatism as one of analogy; the paintings of late 1926 and early 1927 are based on automatism, whereas those of 1925, however much they reflected what Masson calls "correspondences," had to rely partially on a juxtaposition of images not unlike that of collage to achieve their effects. It is the fusion of automatist methods with the medium of paint that results in the greater abstraction of the paintings of late 1926 and of 1927. Paul Klee's remarks of 1920 seem pertinent: "Art does not repro-

120

blue above, a bloody trace below." The paintings are, as Masson says, "almost all quasi-monochrome."[118]

In Battle of Fishes Masson established the locus for all of his sand paintings. Although the ostensible subject of more than half of them is the human figure, all are nonetheless unmistakably marine landscapes. And each poetically equates the depicted with its physical substance—transmuting, as it were, the previous sea imagery into the actual ground of the paintings. Like his automatic drawings, they are all based on Masson's desire to uncover a primordial eroticism—in Leiris' words, to get at "the prime sources of human becoming."[119] In Battle of Fishes conflict is, of course, explicit; with the exception of Man and Woman (left) and The Strollers (right), which are celebrations of metamorphoses of lovers, almost all the other sand paintings are, at least implicitly, violent. It is, however, a lyric sort of violence, very different from the frenetic, Sade-like scenes of carnage that would emerge toward the end of the decade. The overall imagery of these paintings probably owes something to Lautréamont; with regard, however, to the increased importance of the fish and bird, Masson remarks that it "is not without significance that Zarathustra's two companions were the serpent and the eagle."

The fish and the bird have appeared with almost obsessive frequency in work prior to mid-1926, and have implicitly symbolized man himself, but, in late 1926, and into 1927, particularly in the sand paintings, they and the horse become man's clear surrogates, often blending and metamorphosing with his figure. In Battle of Fishes this human-animal mutation is not yet happening before our eyes, but a sense of totemic identification prevails, and is underscored by the bright orange and yellow standard that, in the flowing line of the drawing, is either flying from a lance that is an extension of the contour of the head of the fish in the center or is somehow supported by the sawlike gills of his adversary. Conflict has been implied in the prominence of the knife and in such prior works as Bird Pierced by Arrows (p. 113), but only once, in Combat in an Underground Chamber of 1926 (in which a man prophetically does battle with fish), has it been explicitly described before the execution of Battle of Fishes. The blotch of red paint at the bottom of Battle of Fishes—what Masson calls "the blood stain"—appears in almost every sand painting and recalls Maldoror's description in Canto II, ". . . the drop of blood remains indelible at the same place and will shine like a diamond."

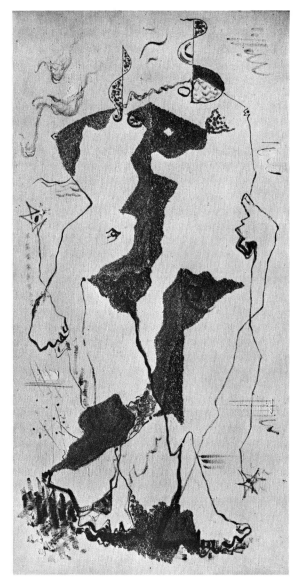

In many of the sand paintings a splash of red paint is localized toward the bottom of the canvas; but, in one of the most brilliant works of this series, Painting (Figure) (p. 23), the "blood stain" ambiguously defines the outlines of a figure. Spilling down the right side of the canvas is Masson's meandering line realized in paint applied directly from the tube. This most abstract of the figurative sand paintings comes nearest to Masson's goal—to translate the spontaneity of automatic drawing into paint.

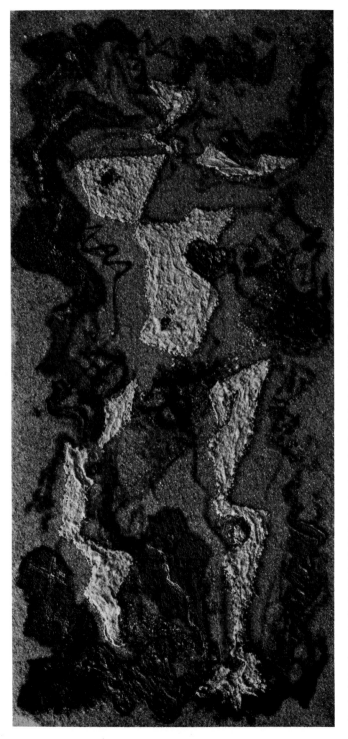

Animal Personage. **1926–27.**
Oil and sand on canvas, 18½ x 8⅝".
Private collection, Paris

Although referred to as "automatic," Masson's sand paintings were even less completely so than were his "automatic drawings." In the latter, line alone was Ariadne's thread that led the artist into the interior of himself; in the paintings line was preceded by the creation of sand areas that represented the first movement of intuition which would lead Masson to find what was truly his. However, just as with the ink drawings, the emergence of figural allusion was encouraged. Masson says that after conjuring up a void within his mind, a race began between his hand and head; that he did not "see" the image until it was picked up by his hand. As Masson recognized, the initial void could no more be total than could the hand describe traces completely without guide. At its most effective it was a process for summoning up unconscious memory. Thus might be explained the relationship of **Fish Drawn on the Sand** (p. 125), perhaps the masterpiece of the series, and **Man, Fish, Star** (p. 124), an automatic drawing published in *La Révolution surréaliste* of June 15, 1926. With several months separating them, the drawing cannot—its automatist character apart—be considered a study for the painting. Their similarities, however, are striking: the left contour of the ambiguous anatomy in the painting parallels that of the more clearly figurative drawing; the inverted bird's head attached to a star appears as the right shoulder in each; the spiraling astral ball of the drawing has become a round, layered sand patch in the painting; and the heart appears within a similarly contoured area in each, as does the fish at the lower right.

The operation of unconscious memory in combination with the artist's necessarily educated hand seems to have had some effect, especially in the work that represents the human figures, in determining patterns of sand and glue, as a comparison of **Man and Woman** (p. 120) and **The Strollers** (p. 121) with the earlier **Chevauchée** (p. 119) and the ink drawing **Metamorphosis** reveals. The areas of sand that unite the figures in the two later paintings are remarkably like the shaded area that functions in the same way in the drawing and the solidly painted, jagged-edged form at the left of **Chevauchée**.

As in the drawing, the figures of **Man and Woman** and **The Strollers** are fused at the genitals—a rather polite paraphrase of certain explicit drawings done at this period. Particularly apparent in **Man and Woman** is the equation of the figures with the fragmentary landscape elements, anticipating (as do all the figure paintings in the series) the body-as-earth images of the

Lancelot. 1926–27.
Oil and sand on canvas, 18⅛ x 8½".
Private collection, Paris

The Hunter. 1926–27.
Oil and sand on canvas, 16⅛ x 6¼".
Private collection, New York

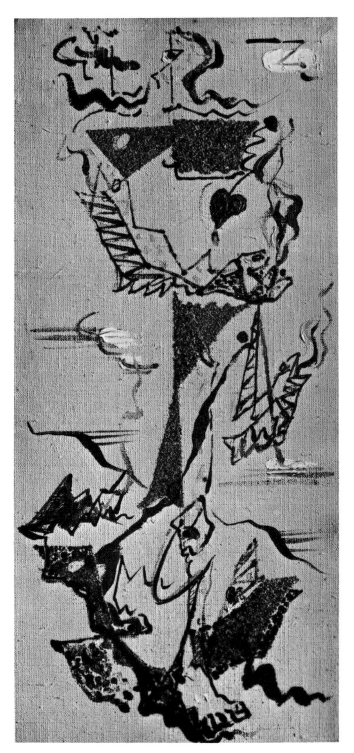

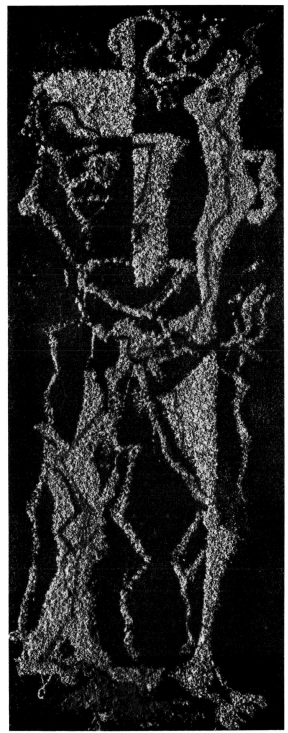

top:
Man, Fish, Star. 1926. Colored pencil,
24¾ x 19". Private collection

bottom:
Shadows. 1927. Oil and sand on canvas,
19¾ x 21¼". Private collection, Paris

opposite:
Fish Drawn on the Sand. 1926–27.
Oil and sand on canvas, 39⅜ x 28¾".
Kunstmuseum Bern, Hermann and Margrit
Rupf–Stiftung

late thirties. In many of these paintings stars, flowers, and leaves seem to grow from bodies that are simultaneously metamorphosing with fish, birds, and horses. Flames emanate from hands, bringing to mind Rimbaud's image of the poet who, like Prometheus stealing fire from Jupiter to animate man, is the true thief of fire.

Such paintings as **Two Death's Heads** (p. 25), **Kites** (p. 88), **Dead Horses**, and **Villagers** (p. 25) tend to be much more abstract than those that present the human figure; but representational clues, however minimal, are always present. **Two Death's Heads** is, in fact, less difficult to read than was the first appearance of this motif in **Death's Head** (p. 119) of late 1926. In **Two Death's Heads**, which is built of several layers of sand, a wandering line traces the outer contours of the two death's heads. The relieved areas of white sand at their centers function in a number of ways; their jagged contours seem a shorthand rendering of skeletal form; the textured whiteness of the sand recalls that of weathered bone; and, like the painted forms at the lower left of the earlier **Death's Head**, their morphology resumes the image of the dead bird as it appears in such paintings as **Dead Bird** (p. 18), of 1924–25. In **Kites** the schematized lines approximate the feel and look of kites flying, just as the line running over variously tinted layers of sand in **Dead Horses** indicates the attenuated lineaments and hoofs of dying horses. As he approached the end of the series, Masson tended to use an increasingly spare, fleeting line, which, in the very nearly abstract **Villagers**, barely hints at the contours of two seated villagers whose spread legs are summed up in the V of the contiguous sand patches at the left. The curving line at the lower left is the inside contour of a leg, and a foot appears at the lower right. In spite of these various and deliberately suggested readings, a true sorcery prevails in that each sand painting, like the shell in which the sea reverberates, recalls its origins.

Masson's obsessive preoccupation with the concept of transmutation led him, toward the end of 1927, to make **Metamorphosis** (p. 126), the only sculpture of the first two decades of his career.[120] With the technical aid of Giacometti, whom he had recently met through Jeanne Bucher,[121] he produced a curious small plaster of an animal-mineral-vegetable being in the process of devouring itself. Intended as an image of "perpetual metamorphosis," the piece is less interesting as a sculpture than as a key to Masson's approach and concerns throughout his art. As René Daumal would

and female sexuality. At the lower right of **The Pursuit** is the schematized foot parallel with the heart-leaf-vagina at the left. The bulbous Miróesque creature is at least two beings, no longer separate but fused through flight and pursuit; both animal and human, it has three penises, one of which is also a nose. **The Pursuit** can be read as a humorous illumination of a premise of Empedocles' somewhat fantastic theory of evolution, which holds that originally "countless tribes of mortal creatures were scattered about endowed with all manner of forms, a wonder to behold."[125] Joining together was a matter of chance and produced hermaphrodites and beings with multiple hands, breasts, etc., and human-animal limbs and organs. **The Pursuit,** which is Masson's closest approach to Miró in configuration, uncharacteristically divides sky and earth by horizon line, instead of suggesting their division by stains of red paint at the bottom and blue at the top; curiously, the multiple suns of 1923–25 appear in the upper left.

In most of the work of late 1926 and 1927 as well as such paintings of the winter of 1927–28 as **Erotic Scene** (p. 129) and **Shell** (p. 129), ground is mainly neutral; consequently the configurations seem, to some degree, free of the confining rectilinear limits of the canvas. In early 1928, however, Masson began to divide the compositional field geometrically; loosely brushed, flat planes of contrasting hues echo the right angles of the stretcher edges. Incident is superimposed on these relatively static backgrounds through strong, schematically rendered brushstrokes. This updated Cubism no longer displays the low-relief illusionism of Masson's work of 1922–26, and color is much richer.

Like **Nudes** (p. 128) and **Nudes in an Underground Chamber** (p. 129), many of these paintings are explicitly erotic. The lozenge—its edges blurred with red paint—that appears at the upper right of the **Nudes** and at the lower left, lower center, and right edge of **Nudes in Underground Chamber** is a sign for the vagina in the work of both Masson and Miró. Its specific reading in **Nudes** and **Nudes in an Underground Chamber** in the context of the surrounding curvilinear calligraphy is clarified by a comparison with the slightly earlier **Erotic Scene** and **Shell.** Although schematic, the two latter pictures are unambiguous in their presentation of the female anatomy. Aside from certain of his automatic drawings, **Shell** is the first work to equate the vulva with a shell, an image that becomes central toward the end of the next decade. The curving lines at the top left in **Nudes in Underground Chamber**

write of it two years later, "This image of a being germinating with anguish announces . . . the greedy reign of Terror-Love."[122]

During the next four years Masson's work emphasized the Empedoclean concept that love and strife are the principal agents of change. About the time that he eliminated large random areas of sand from his painting (**The Knights,** right, is probably the last to include them), he made a few pictures like **Horses Devouring Birds** (p. 26), in which collaged feathers symbolize both the flurry and fatal issue of struggle. Line in this painting, as in **The Pursuit** (p. 127) and **Battle of a Bird and a Fish,** no longer wanders but has become what R. Delavoy describes as "cyclone writing."[123] It records traces of movement; it "signs" the canvas with markings of lust and conflict. As Limbour remarks, "The movement: it is generally that of desire, but the most violent is that of struggle."[124] As in contemporary work by Miró, form is summarized by salient body parts, a foot or a claw, and pictographs whose signification has been established in previous work. Free-floating in **The Knights** is the wreath with a heart that represents love

The Knights. 1927.
Oil and sand on canvas, 36¼ x 28¾".
Collection Guido Rossi, Milan

The Pursuit. 1927.
Oil on canvas, 36¼ x 23¾".
Private collection

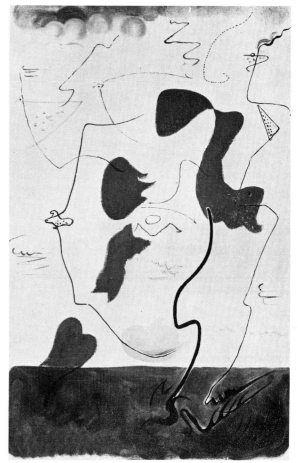

are symbols for the buttocks, just as they are equally breasts like those in the drawing Jubilant of 1926, where they metamorphose into the heads of fish that have the same contours as those in Animals Devouring Themselves (p. 131) of 1929. The pie-shaped object at the upper right of **The Nudes** and **Nudes in Underground Chamber** is a portion of the scale that we first saw in the work of 1924 and appears repeatedly in late 1928–29. The curving black line at the lower right of **The Nudes**, which forms half of a heart, is the erotically evocative arch of a woman's high-heeled shoe. The sexually charged vocabulary of **The Nudes** is reinforced by the lush, sensual purples and greens of the picture.

Probably executed somewhat later than **The Nudes** is **The Rope** (p. 129), whose imagery establishes a paral-

lel between the undulating curves of a woman's body and those of a cord, and poetically interprets the interaction of love and strife. Georges Limbour wrote of it in the introduction to Masson's second one-man show at the Galerie Simon in April of 1929:

*As for love, hasn't he manifestly represented it in a painting called **The Rope**? The serpentine, the flagellant, perhaps even the mortal dance at the side of the woman, beautiful victim who uncoils on a bed of obscurity her curves and her talents as seductrice, revealing by a simple undulation the darkest and usually most hidden of her treasures . . . Voluptuous dialogue of love and combat. It's no sure bet which of the two lovers will better knot around the other, but if anger lands the blows of this coarse whip, I incline to think that the submissive rope will lose no time hanging itself on the woman.*[126]

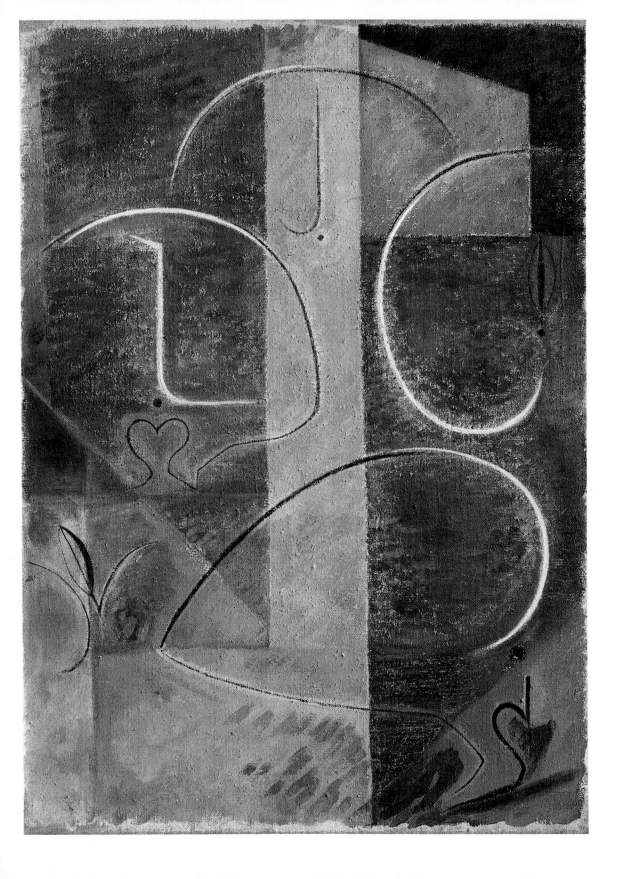

opposite:
Nudes. 1928. Oil on canvas, 39½ x 28¾".
Collection Mr. and Mrs. Daniel Saidenberg, New York

Shell. 1928.
Oil on canvas,
16⅛ x 13".
Private collection

Erotic Scene. 1928.
Oil on canvas, 39⅜ x 31⅞".
Blue Moon Gallery and
Lerner-Heller Gallery, New York

The Rope. 1928.
Pastel, 21⅝ x 18⅛".
Private collection,
Aix-en-Provence

*Nudes in an
Underground Chamber.* 1928.
Oil on canvas, 15 x 24".
Private collection, Paris

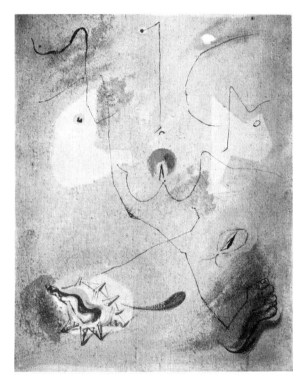

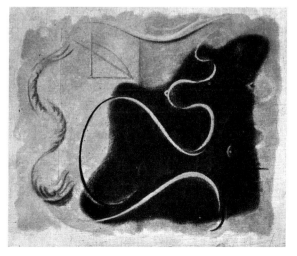

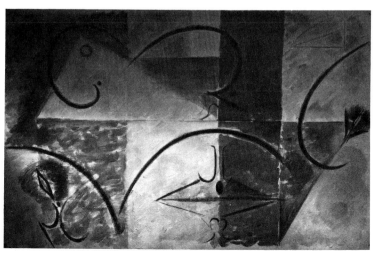

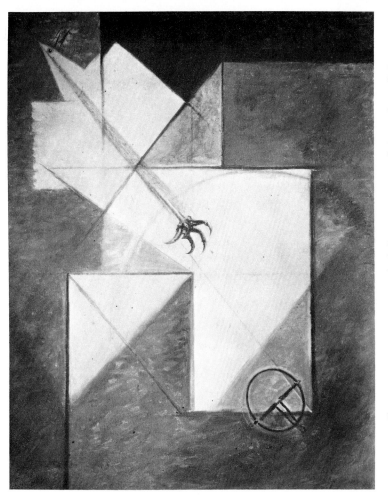

The Trap and the Bird. 1928.
Oil on canvas, 39⅜ x 31⅞".
Collection Garboua, Paris

the canvas, whereas in others, such as Great Battle of Fish, geometric divisions are lost within a mass of swirling, turbulent forms that seem literally the illustration of Maldoror's phrase in Canto III, "a gyratory cyclone lifts a family of whales." The fish whose "hands" grasp knives invert the image of Maldoror, who often assumed animal organs of attack. In The Butcher of Horses and Metamorphosis the "blood stain" reappears, and, against somewhat acidulous greens and yellows, seems even more prominent than in previous work; line is largely ordered on diagonal axes, thus contributing to a sense of tension similar to that of Bird Pierced by Arrows (p. 113) and The Trap and the Bird (left). The primal agony of the beast being slaughtered in The Butcher of Horses is expressed in the quartering of the canvas, each area holding some flailing, vulnerable part, and, at the upper right, the phallic head thrust forward in terrified effort at release. D. H. Lawrence, with whose thought Masson's has points in common, put forth a very similar concept in a poem describing primitive orgasmic agony:

Worse than the cry of the new-born
A scream,
A yell,
A shout,
A paean,
A death-agony,
A birth-cry,
A submission,
All tiny, tiny, far away, reptile under the first dawn
War cry, triumph, acute delight, death-scream reptilian . . .
The silken shriek of the soul's torn membrane
The male soul's membrane
Torn with a shriek half music, half horror
Crucifixion[131]

Although in 1929 Masson did execute paintings not unlike La Poissonnière (p. 89) and The Butcher, syntactically similar to The Butcher of Horses and Metamorphosis, most of the work of this year is much more related to the lost Great Battle of Fish (p. 27). Obvious rectilinear division of the canvas largely disappears, even though it often remains the underlying structural principle. Compositions are dominated by the biomorphic shapes of fish and animals caught up in turbulent, vortical movement. Typical of the work of this year are The Lovers, Wounded Animal, and the pastel Animals Devouring Themselves (p. 131), the quintessential visualization of Zarathustra's "What is this man? A knot of savage serpents that are seldom at peace among themselves . . ."[132]

Woman as "beautiful victim" not only anticipates the Massacres of the early thirties, but is, as well, thematically related to the illustrations (p. 28) that Masson was making in 1928 for Sade's *Justine*.[127]

Violence became more and more the preoccupation in Masson's art in 1928; eroticism was no less prevalent, but it was increasingly expressed in evocations of murder and battle whose clear equivalents are sexual joinings—visually paralleling Georges Bataille's "Coition is the parody of crime."[128] The equation of human and animal life became total, going beyond Victor Hugo's vision, "Animals are nothing but the images of our virtues and our vices, wandering about before our eyes, visible phantoms of our souls,"[129] to the complete totemist identification described by Carl Einstein in discussing Masson's work of 1928–29: "The limits of objects have disappeared. Man no longer observes. He lives within the orbit of objects become psychological functions . . . One could speak of mystical anatomy."[130]

Some paintings, such as The Butcher of Horses (p. 37) and Metamorphosis, retain a semi-Cubist ordering of

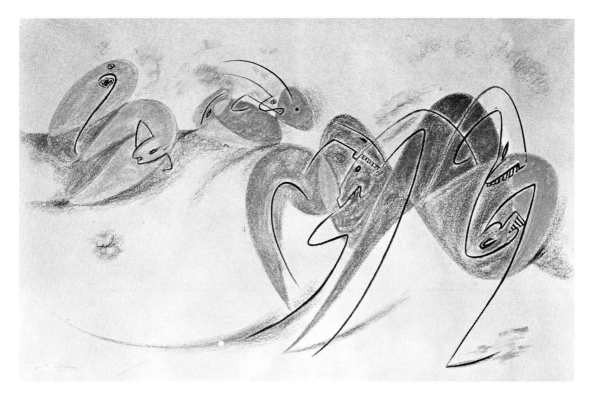

Animals Devouring Themselves was executed in the
summer of 1929 as a study for one of two murals
commissioned by Pierre-David Weil. After giving Mas-
son the commission, Weil asked him to find a sculptor
to collaborate with him on the decor. Masson immedi-
ately went to Giacometti, who agreed to participate
and asked Masson for suggestions as to the kind of
sculpture he would prefer, since it was in fact to him
that the commission had been given. The least authori-
tarian and didactic of men, Masson in no way pre-
sumed to suggest form to Giacometti. That there
was—on equal terms—an interaction between the two
is, however, undeniable. And, in that respect, it is
interesting to compare the imagery of one of Masson's
typical paintings of 1929, The Rendezvous (right), with
Giacometti's sculpture, *Man and Woman* (fig. 15), of
1928–29.

In the same year that Masson and Giacometti col-
laborated on the decor for Weil's house, their "offi-
cial" careers took off on different paths. Giacometti
allied himself with the orthodox Surrealism of Breton,
and Masson declared himself "a dissident." Although
he had been active in the movement from 1924 through

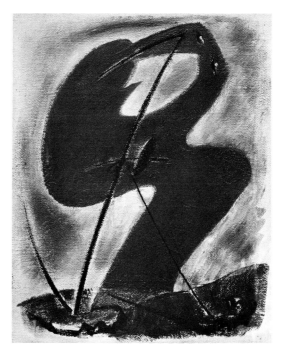

1928—participating in its exhibitions, frequently entering into the nightly discussions at such places as the Café Cyrano and the Café de la Place Blanche, even briefly becoming involved in its *Clarté*-weighted Marxism,[133] and signing its declarations, such as the defense of Charlie Chaplin, "Hands off Love"—Masson lived more and more away from Paris after 1927, and so was simply farther away from the center of Surrealist activity. Even at the time of his closest involvement, however, he had had difficulty reconciling the Surrealist concept of individual freedom with Breton's authoritarian demands for unified group activity. He remarks that Surrealism, like the war, which he had fought as a "diligent warrior" without chauvinism, was an experience in which he had felt obliged to participate.[134] On February 12, 1929, a deliberately provocative letter was sent by Breton to almost all the Surrealists of the moment, as well as others who were no longer adherents; the result was an outright schism that involved Masson's decision to depart. Masson recounts the crucial meeting with Breton that occurred shortly thereafter: "[Breton asked,] 'Why this disaffection?' . . . I summed up my grievances in a few simple words. . . . 'I can't stand the mimesis that goes on around you. I can't understand how someone who doesn't sleep with the same woman you do, who doesn't eat the same things, doesn't read the same books, can change from one day to the next about a certain person or event just because you do.' He answered me . . . 'In any case, Masson, you can't say I ever put pressure on you.'"[135] However this may have been, Breton excommunicated Masson in the second Surrealist manifesto, published in December of that year in the last issue of *La Révolution surréaliste,* selecting him, along with Artaud, Vitrac, Limbour, and Soupault, for special vituperation.

Although the bitter dissension within the Surrealist movement may have had some influence on Masson's work of 1929, the violence of his imagery was to a much greater degree an expression of difficulties in his personal life. Like Picasso's horrific, painfully distorted representations of women which began to appear as his relationship with his wife deteriorated in the late twenties, Masson's art became filled with murders, battles, and devourings in 1929, the year his own marriage ended in divorce. Indeed there is a striking similarity between such works as Picasso's *Figure* (fig. 16), reproduced in *La Révolution surréaliste* of October 1, 1927, and Masson's **Animals Devouring Themselves** (p. 131).

Breton virtually ignored automatism in the second Surrealist manifesto. The omission was prophetic of the new direction the movement would take in the second decade of its existence. Speaking of the origins of the movement, Masson remarked, "In the recent past . . . it's without dispute that two painters are already accepted by all the Surrealists . . . as true harbingers . . . Giorgio de Chirico . . . and Paul Klee. In the language of politics, one might say a man of the right and a man of the left."[136] The decade from 1930 to 1940 was filled with left-wing and Marxist political activity, but its art was to a great degree dominated by the heirs of the right—particularly Dali, whose ambition was to render the dream image with the precision and academic realism of Meissonier. Masson regarded this tendency as a "formidable disaster"[137] far more insidious in its implications than had been the rationalist imperatives of Cubist "terrorism." Nonetheless, he himself did not escape the thrall of the thirties, and much of his art during that period demonstrates a literalness and a return to sculptural modeling and to what he has characterized as "the abusive Italian perspective."[138] For Masson, whose art tends to be more successful as it approaches the abstract, these directions were not beneficial. Although there are many superb paintings from the period and several suites of extraordinary drawings, his work from 1930 to 1940 has not the heroic qualities of the preceding years. Even as the Surrealist movement initially advocated automatism, then largely abandoned it in favor of techniques based on the principles of collage, Masson seems to have felt obliged to render his art less enigmatic, to shock rather than suggest. In both of these phenomena there may be the ghost of French rationalism reasserting itself. Salacrou recounts an incident that took place around 1930: "At André Masson's, Malraux was leaving the studio . . . He reproves André for the realistic elements he's been putting into his canvases to achieve contrast . . . And he adds: 'What would be interesting would be to know why things go wrong. What deep and unknown things inside the creator correspond to his errors.' Masson told me, 'Perhaps for me, it's the fear of not being understood.'"[139]

What Masson's art of the thirties might be—or, indeed, if there would continue to be a Surrealist movement—was then of course an unknown of the future. In a contemporary critique of the new painting, Tériade seems to dismiss Surrealism as a thing of the past, writing, "During the brief career of pictorial Surrealism in France, two painters mainly, Masson and

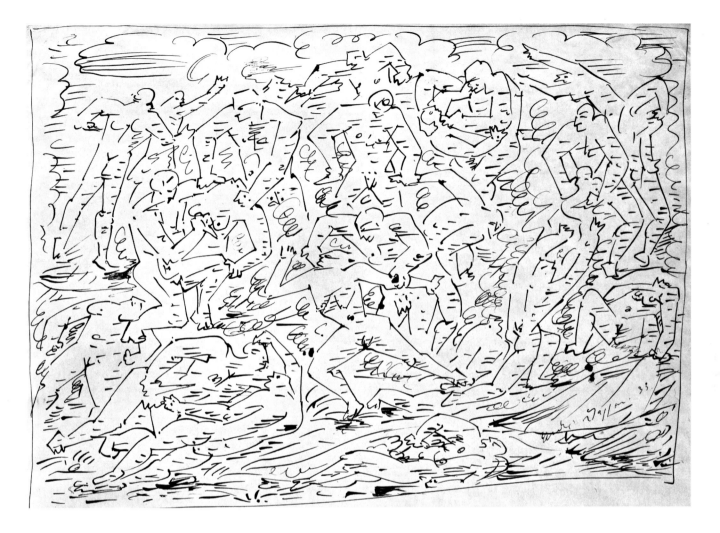

Miró, have extricated themselves from their milieu . . ." He goes on to characterize Masson as having "the nervous sensibility of a Marquis de Sade of painting . . ."[140] Tériade's words, more prophetic than he knew, seem to fit the series of Massacres begun in 1931 more than the work of the twenties.

ALTHOUGH MASSON spent considerable time toward the end of 1929 and into 1930 visiting the slaughterhouses of La Villette and Vaugirard with the photographer Eli Lotar, many of whose photos appeared in Georges Bataille's review, *Documents,* his disposition toward violent imagery seems to have been briefly tempered. He was much inclined to work in pastel, and the palette of his contemporary paintings—usually based on themes of bucolic or rural life—reflects this tendency. Organized along the familiar grid, these paintings are full of rather luscious pinks, pale blues and greens, and delicate hues of peach.

This respite from horrific imagery was short-lived, and by 1931 Masson's work became more exclusively and intensely violent than it had ever been. To use a terminology reminiscent of the Card Players, "Sade begins to outbid Heraclitus."[141] The Massacre series began with drawings of frantic battle in which the animal world no longer represents the human; naked man murders naked man. But, as the series progressed and extended into paintings, woman became the exclusive victim. The psychological reasons for this slaughter of woman are complex, and not fully understood by Masson himself, who commented: "What still characterizes these paintings is that it's almost always women who are massacred. Sometimes there are adolescents, but the mature men escape. I don't know what it means . . . These massacres of female figures take on a ritual, sacrificial cast. I can't believe that they grow out of some misogyny of mine that I'm unaware of. Besides, there's often pity in the expression of the immolator."[142] Several hypotheses, which interrelate rather than exclude one another, are possible. Mas-

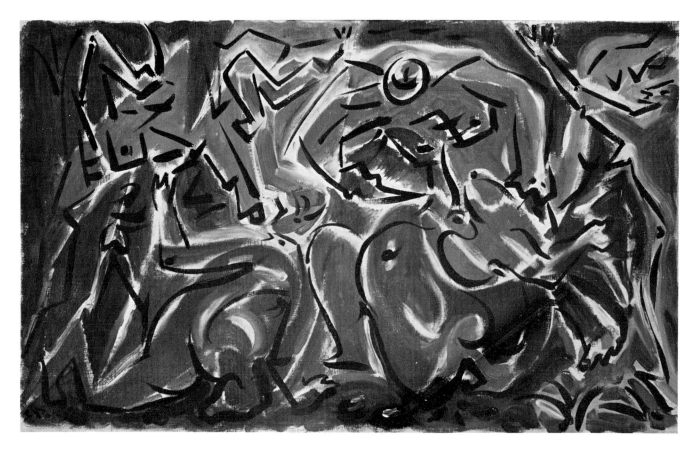

son's personal life was extremely unsettled and turbu-
lent at the time, and this work may express his hostility
toward that being whom he considers *à la source, la
femme aimée*.[143] The attitude of the attackers is often
very similar to that of the man in Day Diagram of 1947
who is about to make love to his wife. As Masson
remarked, the executioner often feels pity for his victim,
and, elsewhere, Masson speaks of the sympathy he
feels for "the refusal of girls and young women to
submit to the brutal covetousness of the male."[144]
Parallel with this empathy toward woman ran the
Surrealist concept of woman as trap, symbolized by
the vagina dentata, which Masson would depict in such
paintings as Trap in the Meadow of 1938. His remark,
"Woman is a trap but a trap you have to go through,"[145]
recalls Maldoror's "I received life like a wound." An-
ticipating later images of the thirties in which man
literally tries to reverse the process of birth, these men
charged with a primal desire murder the female in a

short circuit of the normal cycle in which copulation
leads to birth and birth to death. The concept is very
close to the thinking of Georges Bataille, who held that
"all that is condensed and animated on the earth is
. . . smitten with avidity . . . 'a movement of the whole'
which appears like a movement of general *devourment*
of which the extreme form is life."[146]

The drawings of this series are among the strongest
Masson has ever made. They are done with great
speed—as the artist says, "so spontaneous they are
nearly automatic drawings"[147]—and line is broken by
abrupt, spasmodic changes of direction. These "arrow
lines"[148] echo the knives and penises that are invaria-
bly present. The earlier drawings deploy figures in
friezelike arrangements that may owe something to
Matisse's *The Dance,* but by 1933 are often so densely
packed that almost every area of the composition
flickers with movement, anticipating to some degree
the alloverness that would appear in American paint-

Sleeper. **1931.**
Oil on canvas, 28¾ x 23⅝".
Private collection, Paris

ing almost twenty years later. Pierre-Jean Jouve writes of these drawings: ". . . a unity establishes itself amid all the hatching, the work presents nothing of a single cruel incident, but the *work* accomplished by all couples as one . . . a kind of 'counterpoint' in which every line is a function of another line, every movement crosses another movement, where each act proceeds from the other act by a secret and rigorous development."[149]

The ritualistic killings take place against various backgrounds. Some are set in the Sade-like interiors of castles with the fleur-de-lis of France or a crucifix on the wall; others, like Maldoror's horrible violation of a girl *à la clarté du soleil,* are performed in full sunlight. As Bataille writes, "The erection and the sun scandalize just as a cadaver and the darkness of caves do."[150] All of the Massacres seem to reach back to ancient myth to recelebrate Dionysiac orgies.

Masson's paintings of the period are no less violent than his drawings, and even when not specifically depicting massacres their imagery is thematically related. His sleepers are, in Masson's words, "a little like the murderer who can't keep from sleeping forty-eight hours after his deed though that sleep is very troubled."[151] And Georges Limbour points out that these are no longer like the earlier sleeping figures in which "the man had let his head fall onto his forearms, pushing the glasses back across the table . . . Now what Masson is after is more like *the double of the sleeper.* No more table to support him, he is held prisoner in a network of lines and arabesques that represent the new universe in which he struggles."[152] The **Sleepers** of 1931 (pp. 35, 135), in the supine, foot-forward position of **The Dead Man** (p. 117) of five years before, are the third stage in the evolution of the sleeping male figure. No longer in any recognizable environment, they are lost in the stuff of their dreams; strong color prevails, and the symbolically charged heart and leaf spin through linear webs. In both **Sleepers** done during this year the left hand is thrust out in a clutching gesture that not only suggests pursuit but echoes the attitudes of Masson's earlier sleeping figures. In the vertical painting the hand drips blood, and the whole figure, traversed by bands of green at the thighs and yellow-orange at the shoulders, seems animated in spectral flight; the body twists as in the conventions of a Baroque crucifixion. In an atypical Massacre painting done at approximately the same time, the sleeping male figure is surrounded by harpy-like beings who seem to be some metamorpho-

sis of the murderers' usual victims. Just as the whole series of Massacres appears to allude to Bacchanalian myth, this particular painting brings to mind the Bacchic festival on Mount Citheron at which King Pentheus of Thebes was torn to pieces by his mother and aunts. Perhaps the sunlit slaughters of women are the inverse of the sleeper's dark dreams.

All of the Massacres and thematically related paintings are charged with a Baroque rhythm that recalls Masson's description of his boyhood experiences of the Rubens and Delacroix sketches in Brussels as "still being dreamed." The most successful of the Massacre series approach Masson's idea of great painting, "that in which the spaces between the figures are charged with as much energy as the figures that determine them."[153] In paintings like **Massacre in a Field,** 1933 (p. 39), color and line, figure and ground unite and mesh in a dynamic whole. Masson has described his method of working at the time: "I would start with big stretches of color and at the moment these surfaces became insufficient for me I would add lines, and little by little the theme would come . . . This is how I proceed—and in the end I give the picture a title: it's a Massacre, it's

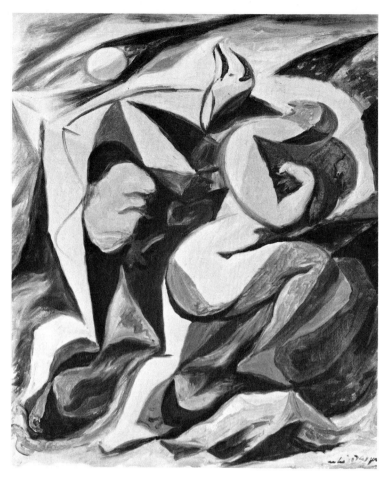

The Sorceress. 1932.
Oil on canvas, 21⅝ x 18⅛".
Private collection, Milan

was probably hiding a depression, a feeling of dereliction, solitude, and despair. I had severed something . . ."[156] Masson's near neighbor and almost his only social contact at the time was H. G. Wells, with whom he had a close and cordial relationship.

Toward the end of 1932, commissioned by the Ballets Russes de Monte Carlo, Masson did his first ballet decor, for Tchaikovsky's *Les Présages*. Matisse, who had visited Masson in St-Jean-de-Grasse, often came to the morning rehearsals. Masson remembers: "One of my joys, in addition to my work with Léonide Massine, was the arrival of the master of *The Dance*."[157] Masson's inner turmoil had not calmed, however, and a combination of financial difficulties and his "untimely bad temper" actually landed him in the jail of Monte Carlo. Matisse then invited Masson to visit him in Nice. The two weeks Masson spent there were, he says, "an oasis,"[158] and in this terribly unstable period Matisse "gave weight to his life."[159] Wells had characterized Masson's paintings as "dream machines," and Masson was to remember Matisse, in similar terms, with great admiration and some humor, as "an extraordinary recording machine, astonishing."[160]

Before beginning work on the decor for *Les Présages*, Masson did a series of drawings, for which Georges Bataille wrote a text, on the theme of Sacrifices, "the gods who die." Of the five subjects for which Masson engraved illustrations,[161] Orpheus, the Crucified One, Mithra, Osiris, and the Minotaur, three were associated with the concept of the sacred bull. In the cult of Mithra all the beneficent things of the earth were supposed to have sprung from the deity's capture and sacrifice of a sacred bull. The soul of Osiris was thought to have inhabited the body of Apis, the Bull of Memphis. The Minotaur was, of course, the terrible half-man, half-bull at the heart of the Minoan labyrinth. Although Surrealism in general would adopt the Minotaur legend and interpret it very much in the light of psychoanalytic theory, for Masson (to whom Freudian psychology was never particularly important) it was at the core of a more personal mythology. Anticipated in one of Masson's earliest pornographic drawings, **The Great Deflowerer Feted by His Victims** of 1922, as well as, by implication, through the cord of Ariadne, the Minotaur had assumed great significance for Masson and Bataille by the end of 1932, and it was at their insistence that the new review founded in May of 1933 by Skira and Tériade was entitled *Minotaure*.

Masson's increasing involvement with Greek myth is attested to by the titles of many of his paintings from

a Pursuit . . ."[154] Although it is unlikely that there are any conscious allusions to Delacroix, Masson's admiration for that master is most evident in the paintings of 1932–33. The Sorceress (above) of 1932 is so close in movement and morphology to Delacroix's sketch for Medea in the museum at Lille (fig. 17) that some lost, boyhood memory of the first Delacroix he had ever seen must have been operating in Masson's mind and hand.

That Masson might have retreated—at least unconsciously—to another time is all the more likely because of the radical breaks he made with his immediate past in the early thirties. At the end of 1931 he left Kahnweiler for a brief period and entered into a contract with Paul Rosenberg. He quit Paris for good[155] in 1932 and went to live in almost total solitude in St-Jean-de-Grasse. He remarks of the period: "My sleep . . . must have been troubled, by intimate conflicts I can't discuss. And by the break with the Surrealist group, which was to have unsuspected repercussions. After having, for the first time in my life, agreed to be gregarious, I found myself back in a solitude I had known since childhood. I had truly a feeling of deliverance. But the feeling . . .

Daphne and Apollo. 1933.
Oil on canvas, 35 x 45⅝".
Private collection

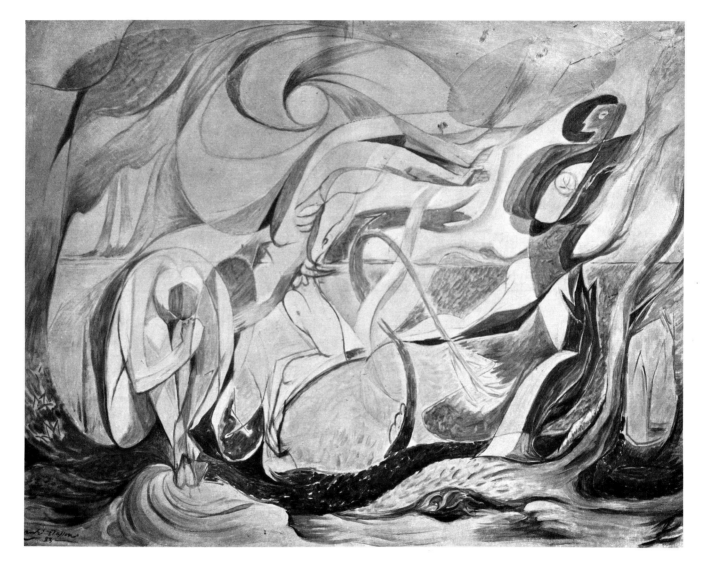

1932 to 1934—**The Silenuses** (1932), **Bacchanal** (1933), **Daphne and Apollo** (1933; above), **Orpheus** (1934), and **The Horses of Diomedes** (1934). In 1933 and 1934 Masson tended to use brighter, cleaner color, with the result that in certain canvases like **Orpheus** the ominous subject matter is secondary to—almost in conflict with—the extreme decorative quality of the painting. It is as though Masson were trying to convey the seductive beauty of the music of Orpheus' lyre in the sweeping patterns of rose, red, green, blue, and purple. In other works, such as **Daphne and Apollo** of 1933, Masson's interest in mythology extends to his method of rendering figuration; Apollo's running figure is a clear paraphrase of the athletes depicted in Greek vase painting. The sun, as usual, is the implacable witness of this queer drama—a girl turning into a tree. The turbulent action is framed by an unfolding of organic forms at the outside edges in much the same manner as in the paintings of late 1924. In the earlier paintings, however, there seemed to be a fleshly, solid substance that was being torn, and the scene so revealed still appeared contained; in **Daphne and Apollo** it is as though a swirling silken veil momentarily discloses action that may continue laterally off the right

edge of the canvas. The figure of Daphne at the left is presented in a position—head bowed and hands clasped around knees—that will become, through Masson's genius at perceiving correspondences between forms, the genesis for a highly original personal iconography. This seated female figure is repeated in a much more stylized way at the lower left of the drawing done for the Prologue of Anatomy of My Universe (above), and extrapolations from it are repeated throughout the sheet. The primary equivalences of Daphne's form are the skull and the female genitals, as a comparison of the Prologue drawing with La Pensée (p. 146) and The Fraternity of the Natural King-

doms (right) reveals. In the light of what we know about Masson's associations of the crown and the leaf, Daphne's form as analogue to the vulva seems particularly appropriate, as in the legend she becomes a laurel tree whose leaves are woven into wreaths for conquering heroes and athletes.

Toward 1934 Masson's life grew somewhat calmer —probably through the influence of Rose Maklès, who was to become his wife by the end of the year.[162] The feelings of alienation produced by his rupture with the Surrealist group were, however, still strong and became intensified by political events in France, particularly the rightist putsch of February 6. The semi-

The Fraternity of the Natural Kingdoms.
1938. Ink.
(Published in *Anatomy of My Universe*)

isolation Masson had imposed upon himself during the period he had lived in St-Jean-de-Grasse was translated into a desire to exile himself physically from France—to attempt a new beginning. With Rose he made a walking trip through Andalusia. After a brief return to France he went back to Spain, where he remained until December of 1936. Masson was, as he says, fascinated, astonished, gripped by Spain, and, although his intention had been not to become involved with its politics, he could not resist the moral claim of the Republican cause; he produced many savagely anti-clerical, anti-fascist paintings and satirical drawings. Contrary to his later war-necessitated

exile in America, this self-imposed Spanish exile did not, for the most part, inspire fresh and original work. Masson himself says, "I don't think it's the best of my work."[163] This is so partially because of Masson's involvement with the Spanish Civil War; later in America, where he was physically removed from the agonizing conflict on the other side of the ocean, he was forced to turn in upon himself to find the sources of his art. The work of Masson's Spanish period is often brilliantly colored and marked by a veering away from mythological themes, and displays a kind of theatrical character in which the artist is much more spectator than actor.

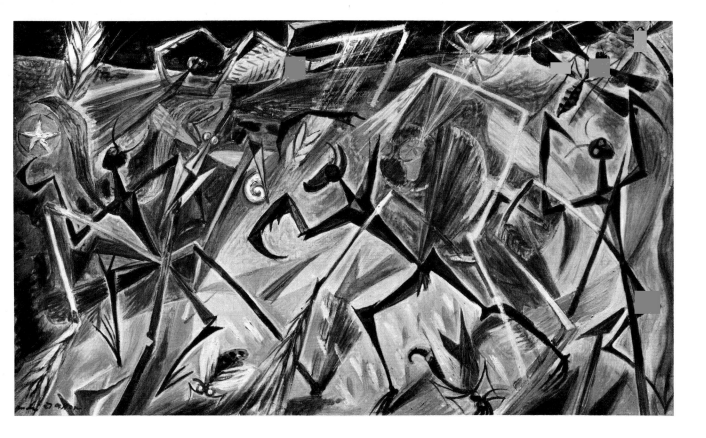

Initially he painted a series of small, intensely chromatic canvases based on insect life, as well as others whose formats recall Miró's work of 1926 and often feature the figure of Don Quixote. The year 1935 saw a group of landscapes—of Toledo, Avila, Montserrat. In these paintings there is a return to deep perspective, and there are sometimes conscious allusions to El Greco, as in **Phantom of a Donkey near Avila.** The bullfight became a central motif in this year—often presenting the anthropomorphic insect as Don Quixote, who himself plays the role of the matador. By 1936 Spain's hold on Masson is demonstrated by the pervasive theme of the corrida in paintings that testify to the artist's renewed interest in mythology, particularly the Minotaur legend. With the exception of the Insect series, the paintings done at Montserrat, and a few landscapes such as **Aragon Sierra** (p. 38), most of the work from 1934 to 1936 alludes allegorically or specifically to the turbulent Spanish political scene.

Although the Insect paintings have clear affinities with the Massacres, which they directly follow, there are significant differences both in spirit and technique. The Massacres are imbued with a sense of cruelty, and the artist's identification with his subject is apparent. Since the insects Masson depicts are frequently praying mantises, whose sexual habits make the visions of Lautréamont and Sade pale, one might expect the

paintings of this series to continue the violence manifest in the Massacres and marine battles. But, even when Masson gives us an image of the female devouring the male as in the lower left corner of **Summer Divertissement** (p. 43), the clear, bright colors and balletic attitudes of the insects convey a sense of joy, an avid delight in life. As Limbour remarks, "Cruelty here yields to grace, and the author of so many massacres and sacrifices did not stress the bloody side of their exploits."[164] Masson's images of insect life are scenes from a light opera staged by a director who wants his audience to view the microcosmic drama from the perspective of a blade of grass. Carefully executed, these canvases have, as Masson says, something of the quality of enamel painting, and the jagged, elongated contours of the insects' bodies have replaced the rounded forms of the figures in the paintings of massacres.

If the lyricism of the Insect paintings recalls light opera, then the apocalyptic visions that Masson gives us in his paintings of Montserrat might be compared to Wagnerian spectacle. Inspired by a night in January of 1935 that Masson and his wife, Rose, spent alone and unprotected at the summit of Montserrat, paintings such as **Landscape of Wonders** (p. 44) and **Dawn on Montserrat** are vast, cosmic dramas in which the caped and hooded human figures not only represent the

Cover for *Acéphale*. 1937.

monks of the nearby monastery but equally symbolize the mystic, religious awe of man in the presence of the staggering phenomena of the universe. In describing that night when he and Rose were stranded at the peak of Montserrat, Masson says, "The sky itself, I thought, appeared an abyss . . . the vertigo of heights and the vertigo of depths both at once. I found myself in a kind of maelstrom . . . there were shooting stars the whole time . . . The world entirely under a cover of clouds. The only place clear was the place where we were. And the sun rose. It was sublime. We were on our summit like Moses awaiting the arrival of the Lord."[165] The color in **Landscape of Wonders** and **Dawn on Montserrat** is brilliant, and with the exception of the figures in the foreground of the latter painting most of the forms are flat. In both paintings the sun swings like a Catherine wheel in a heaven filled with fireworks. Georges Bataille's description of the aspect of worlds lost in the most distant regions of the sky, in an essay which Masson illustrated with drawings related to the Montserrat paintings, might as aptly describe the imagery in the latter: "The disks that appear before our eyes . . . like the tresses of Medusa, they develop in space a number of luminous arms unfolded in spires from the nucleus."[166]

In April of 1936, just as the Spanish Civil War was breaking out, Bataille went to visit Masson in Tossa. Fascinated with Masson's story of the night on Montserrat, Bataille wrote an article on it for the June 15 issue of *Minotaure* in which he reproduced both **Landscape of Wonders** and **Dawn on Montserrat**, and included Masson's poem "Du haut de Montserrat." In the introduction to his essay Bataille remarks that the emotions provoked in Masson by his experience almost exactly parallel his own, and insists that "it is necessary to attach the greatest possible importance to the fact that the reality in question can be attained only in religious ecstasy." Toward the end of the article Bataille writes: "Prometheus moaned as mountains of rocks fell on him. Don Juan was drunk with happy insolence as he was engulfed by the earth . . . The being who is fulfilled by transgression after transgression—when the swelling vertigo has abandoned him to the void of the sky—has become therefore not simply *being* but *wound* and . . . *agony* for all that exists as being."[167] It was in this psychic state, in a Catalonia fiercely opposed to the Falange, that Masson and Bataille collaborated on the first issue of *Acéphale*,[168] a review whose aim, according to Masson, was to "unmask the Religious behind the Political—a

true aggression against those who call themselves religious and those who practice politics."[169] In describing the creation of *Acéphale* Masson quotes Hölderlin's "crushing lines" that seem equally appropriate to the figures whose heads are obscured in the vaults and towers of his paintings of 1924: "Alas both deceptive and bare/The sky like a prison wall/Bows its weight on my head."[170] The emblematic figure that Masson drew for the cover of the first issue is described by the artist: "He was headless, as was proper (his decapitated head in the form of a skull had taken refuge where his genitals should be), his body upright, his legs firmly planted apart in the earth, arms outstretched, in his right fist a flaming heart, in his left a dagger-shaped flower. His body is studded with stars but the entrails show through: the center of the body is

Tauromachic Dream. 1937.
Oil on canvas, 18⅛ x 21⅝".
Formerly collection André Lefèvre, Paris

course, not the chief impetus for his bullfights, which were, obviously, most immediately inspired by his Spanish environment. The ritual, ceremonial side of the encounter between man and animal was what fascinated him: "The visual aspect, the spectacle . . . is magnificent; when man and beast seem wedded. There are sublime moments."[173] As in the work of Picasso on the same theme, the quality of rite is transmuted in the paintings to an allegory of the Passion: "The horse appears as a sacred animal. It takes the place of the Crucified."[174] Conscious allusion to Christian myth is rare in Masson[175] and appears almost exclusively in the thirties and with the greatest frequency during his period in Spain. The figure of the tortured horse, its head stretched upward in agony, derives from Picasso, whose Spanish origins had made the bullfight a recurring motif in his art. Picasso's humanized bull-cum-Minotaur is conceived quite differently from Masson's, however. Masson's Minotaur tends to remain much closer to the original legend; he is the dark mirror of man's instinctual life. Like the decapitated Acéphale whose head replaces his genitals, the Minotaur's capacity for thought has been castrated; he is plunged into a world defined only by eroticism and death.

Masson returned to France at the end of 1936, but his fascination with the bullfight continued and was expressed in a number of paintings related to the theme. Among them was **Pasiphaë**, one of the first versions of several works of the same title that he would later make in America. As in the canvases of his American period, the figure of Pasiphaë is a direct extrapolation from the gored horse of his previous corridas.

The overexcitement brought about by Masson's contact with Spain, particularly the Civil War, which could not fail to bring back his own war experiences, left Masson in a severe nervous state. Feeling the need to be in the country, he and Rose, with Diego and Luis, the two boys who had been born to them in Spain, settled in Lyons-la-Forêt in Normandy. In spite of his precarious mental state, Masson found himself refreshed by the green forests of France after the aridity of the Spanish landscape and started to work without delay.

The immediate prewar years, from 1937 to 1940, have often been referred to as Masson's second Surrealist period, not only because of the orientation of his imagery, but also because of his reconciliation with Breton, which Masson has recounted: "It was then late '36 or early '37. At that time, curiously, through

a labyrinth constructed like a palace. . ."[171] Although not one of Masson's best drawings, this first figure of Acéphale (p. 141) is important in understanding much of the imagery in Masson's work through 1940. Bataille's remarks in his initial essay in *Acéphale* are illuminating in this regard:

Man has escaped from his head as a convict has from prison. He has found, beyond himself, not God, who is the prohibition of crime, but a being unaware of the prohibition. Beyond what I am, I run into a being who makes me laugh because he has no head. He fills me with anxiety because he consists of innocence and crime; he holds an iron weapon in his left hand, flames as from a Sacred Heart in his right hand. In one eruption he unites Birth and Death. He is not a man. He's not a god either. He's not me, he's more me than me, his belly is the labyrinth in which I find myself, being him—that is, a monster.[172]

According to these descriptions, both Bataille's and Masson's, Acéphale is directly related to the Minotaur; his intestines are the labyrinth. In other drawings of the Acéphale persona such as **The Greece of Tragedy** and **Dionysus**, Acéphale is identified with the Minotaur—in the former simply because the figure has acquired the monster's head and in the latter through the ancient equation of Dionysus, who rose from the waves to find Ariadne, with the divine bull that Poseidon caused to emerge from the sea. Many of Masson's paintings and drawings of the next three years and even on into his early years in America centered on the Minotaur legend, but the chief expression of this interest in 1936 and 1937 was in a series of paintings of the corrida. Masson's fascination with the Minotaur legend was, of

top:
Spring 1938.
Oil on canvas, 36¼ x 28¾".
Collection Nellens, Knokke, Belgium

bottom:
Study for stage design
for Cervantes' *Numance*.
1937. Ink

Bataille, who after all was always pretty much the no. 1 enemy for the orthodox Surrealists, I made up with André Breton."[176] The work of this period resumes under new guises and elaborates with intensely expressionistic realism many of his old preoccupations. Masson says: "My pictures attain such a paroxysm of expression that they go beyond the Surrealist norm, which is based on the marvelous rather than the horrible. There's the whole series on the myth of the labyrinth and the Minotaur. There are also Imaginary Cities and Imaginary Portraits."[177] Additionally in 1938 and 1939 he produced two extraordinary suites of ink drawings, **Mythology of Nature** and **Mythology of Being**; filled with metaphysical allusion, they conceptualize, as Masson remarks, "all my philosophy."

Some of the imagery in these drawings is anticipated in studies for the decor of Cervantes' *Numance*, which Masson executed in collaboration with Jean-Louis Barrault in April of 1937. In these the arid Spanish landscape is anthropomorphized. In one (below) a clenched fist thrusts through the earth, and there yawns the entrance to a subterranean structure; in later drawings the opening leads into the labyrinthian womb of the Earth Mother. On a pedestal stands, in Barrault's words, "the profound, totemic symbol . . . of the death's head in the horns of a bull."[178] The crescent shape has already been seen surmounting the heads of figures in Masson's previous Spanish paintings and reappears with variations in subsequent canvases and in drawings for the mythologies. In the *Numance* study, the half-moon is unequivocally the horns of the bull; but, as with other analogous forms in Masson's work, the half-circle has other meanings that often operate interchangeably and simultaneously. One of its interpretations is that of the silhouette of Maldoror's emblematic crab and anvil; it is also an allusion to Isis, goddess of fertility to whom the cow was sacred, the crescent of its horns representing the moon with which she was identified. The legendary attributes of Isis have considerable relevance to the Massonian world; her union with the sun god Osiris, to whom she was both sister and wife, symbolizes the fusion of light and dark. After Osiris was murdered by his brother, Typhon, his body imparted such power to a bush that it grew into a mighty tree. This joining of human and vegetable first appears in the figures of the sand paintings of 1927, where limbs and bodies sprout leaves, and continues with variations until the present.

At approximately the same time that Masson was working on the decor for *Numance*, he painted Ophelia

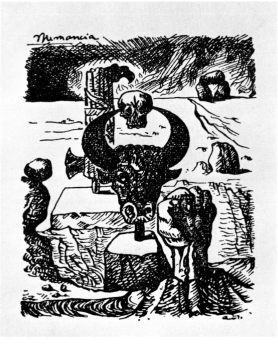

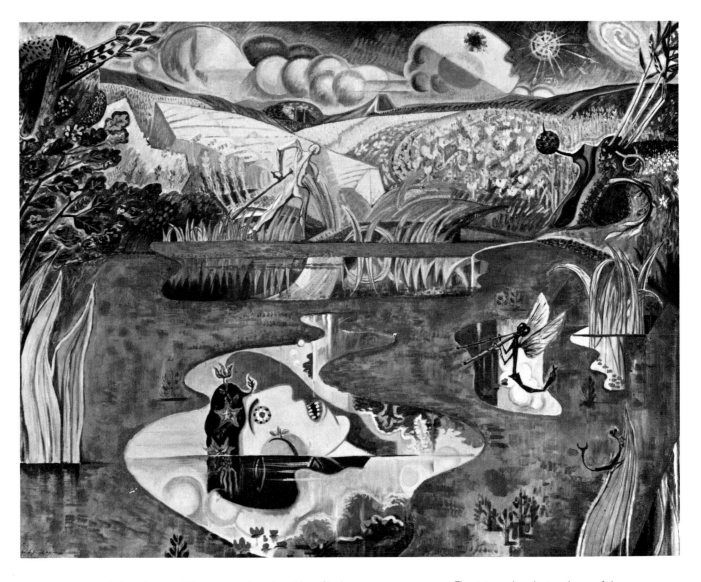

(above), one of the rare works related to a Shakespearean theme executed before World War II. In spite of its title, **Ophelia** represents a confluence of contemporary concerns of the artist much more than it does an interpretation of a scene from *Hamlet*. Its format is that of the Spanish landscapes; the figure of the reaper is familiar from such paintings as **The Harvest** and **Guadix**, where its skeletal form makes plain the association of the reaper figure with death. The countryside we see is not, however, the barren Spanish landscape; it is full of ponds, and the wheat and lush vegetation grow in the fertile fields of France. Slightly Picassoesque, Ophelia's wreath-bound, profiled head staring out of her watery grave recalls the imagery of **The Wreath** of 1925. The silhouette of her head is repeated in a cloud formation in the sunlit sky, which is filled with astral bodies, some of whose forms are like those in the paintings of 1924, while others derive from the heavens of the Montserrat

canvases. The internal radiating lines of the sun are an elaboration of those of Ophelia's eye, the aspect of which is extremely similar to that of the strangling bird in **The Painter** (1937), where the artist's profile is mirrored in the eye itself. At the upper right, underneath unnaturally large blades of grass like those of the Insect series, Masson's **Sun Trap** images of the next two years are prefigured in a peculiar mechanistic extrusion whose sharp curved branch seems to impale rather than to grow a ball of vegetation. **Ophelia** is full of incident, but without the teeming vision of nightmare that such paintings of the next two years as **In the Tower of Sleep** (p. 41) would present. The mood of **Ophelia** is both somber and gay. The sun shines, the fields yield their harvest, and the whimsical insects serenade and cavort; yet Ophelia's death by drowning is the central fact. Although Leiris' interpretation, "The drowning is only abandon, swooning, fusion into the flux of

Ophelia. **1937.**
Oil on canvas, 447⁄8 x 571⁄2".
Baltimore Museum of Art, Saidie A. May Collection

spring,"[179] certainly corresponds, in large part, to the intended significance of Ophelia's death, it does not exclude other implications. It is likely that Masson, just returned from the terrible scenes of the Spanish Civil War and disturbed by the indifference of Europe to fascist horror, is making a statement about the existence of suffering very similar to Auden's poignant lines from "Musée des Beaux Arts":

About suffering they were never wrong,

The Old Masters: how well they understood

Its human position; how it takes place

While someone else is eating or opening a window
 or just walking dully along

· ·

They never forgot

That even the dreadful martyrdom
 must run its course

· ·

In Brueghel's Icarus, for instance:
 how everything turns away

Quite leisurely from the disaster;
 the ploughman may

Have heard the splash, the forsaken cry,

But for him it was not an important failure,
 the sun shone

As it had to on the white legs disappearing
 into the green

Water; and the expensive delicate ship
 that must have seen

Something amazing, a boy falling out of the sky,

Had somewhere to get to and sailed calmly on.[180]

Ophelia was one of eight paintings and three objects Masson exhibited at the now-famous Surrealist exhibition held at the Galerie Beaux-Arts in January and February of 1938. Its fantastic installation, the main hall of which was designed by Duchamp, has been described by Masson:

Except for the first one in 1925 . . . all the Surrealist exhibitions used to be staged. The one we're talking about, for instance—except for the very long corridor of the Galerie des Beaux-Arts where there were Surrealist mannequins and behind each mannequin a Paris street sign (having emblematic value),[181] the main attraction actually—the gallery itself was plunged in darkness and you rented flashlights at the entrance. The ceiling of that very large hall was nothing but coal sacks, empty but still able to shed a little black powder on the visitors . . . There were paintings on the walls and objects on pedestals, though with strange surroundings. Ophelia, for instance, was as though ringed by reeds springing from a

folding bed and by I don't know what else to evoke the atmosphere of a swamp.[182]

Although Masson had been out of France and largely estranged from the Surrealist movement during the pitch of its involvement with object-making, his late start did not seem to stand in the way of his inventiveness—at least to judge from the reaction to the mannequin he costumed for the exhibition (p. 146). Among the mannequins "groomed" by Duchamp, Man Ray, Ernst, Arp, Dali, Miró, and others, Masson's was, according to Marcel Jean, who himself made one dressed as a water nymph, the hit of the show.[183] Masson's own words best describe the figure:

The head of the wax mannequin (not a stylized mannequin but a totally realistic one), beautifully coiffed, was encased in a wicker cage, the cage was traversed by goldfish (they too, perfect copies): some of the fish lodged in the curls, like so many waves, of the mannequin's hair. The mouth was gagged by a strip of green velvet; in place of the mouth was a pansy (artificial flower chosen in a beautiful purple). The conventional pose of this type of figure allowed the placement of tiny birds (stuffed) under the armpits which served as nests. Below the belt, a red cord that simulated a bloody gash, there was in place of the sex an oval mirror surrounded by tiger eyes and topped by a plume. At her feet I had built a base of coarse salt, sprinkled with little traps that closed upon red pimentos (real ones, and unfortunately so, for the day after the opening they shriveled and had nothing at all of that pointed and unmistakably phallic look they had the first day).[184]

In this witty transformation of a store dummy, we recognize some old Massonian associations, and at least two relatively newly evolved images are spelled out. The armpit as nest was a specifically intended metaphor in **The Armor** of 1925 (p. 115); the head encased in a birdcage that holds "floating" fish is the concrete extension of the many images of 1925–27 in which the head becomes ambiguously that of a bird or a fish. The red cord by its physical nature and placement is Ariadne's thread, and, simulating a bleeding gash, is related (by its association to menstrual blood) to the pomegranate in such pictures as **The Armor;** as a wound it recalls the Massacre series. The mirror surrounded by eyes in place of the genitals is at least partially a comment on the general Surrealist desire to visualize sexuality itself. The tiger eyes surrounding the oval mirror have a sinister aspect that relates this concept of the vulva to the vagina dentata. Reinforcing the threatening side of the mirror's invitation were the

top:
Le Bâillon vert à bouche de pensée. 1938. Destroyed

bottom:
La Pensée. 1938. Ink. Destroyed

little traps at the figure's feet that closed on the flesh of phallic pimentos. Obviously intended more humorously than otherwise, these traps nonetheless announce a whole series of works in which grim predatory constructions, hybrid-humanoid furniture, and mechanistic mantises lure, violate, mutilate, and murder their victims.

The violet pansy of the mouth is not the innocent flower it might appear to be; its equation with the vulva is made indisputably clear by a comparison with a drawing of the same year entitled **La Pensée** (below). In French, *pensée* means both "pansy" and "thought"; in the context of Masson's iconography in which the vagina, as the entrance to life and the exit to death, symbolizes the eternally recurring cycle, "La Pensée" becomes the metaphysical Logos and, as such, is the visual parallel of Nietzsche's doctrine of eternal recurrence conceptualized as the "thought of thoughts." In many paintings and drawings of the next two years, the vagina or mouth serves as the entrance to a labyrinth enclosed by a building, the form of which is either that of a male head or a female body. Parodying this concept is the birdcage encircling the mannequin's head. In another related drawing, a page from a sketchbook of 1938 (p. 45), in which images are accompanied by written explications, Masson makes the flower-like form, which, like **La Pensée**, is actually composed of—or extrapolated from—the back view of a woman whose legs are spread, titles it **Coeur d'une pensée**, and uses it as the entrance to a tent which he dubs "Erotic Temple." It is in much this sense that the structure of the mannequin's head may be regarded.

In speaking to Clébert about the 1938 Surrealist exhibition, Masson points out that Breton had particularly remarked his mannequin, saying that **Le Bâillon vert à bouche de pensée** represented "metaphor [for eroticism] in its pure state—I mean impossible to translate in writing."[185] In *Anatomy of My Universe* Masson uses this very quote to caption the drawing **Hatchings and Germinations** (right), reproduced in a chapter significantly titled "The Demon of Analogy." **Hatchings and Germinations** provides a nearly complete encyclopedia of Masson's variations on vulva-like forms. Among other images are the Daphne-derived figure at the top left, the cat's mouth and face that will appear in one of Masson's greatest American paintings, **Meditation on an Oak Leaf**, the shoe with a vaginal slit, the shell, the butterfly-double-hipbone form, and the pomegranate.

Not only were Breton and Masson reconciled, but

Hatchings and Germinations.
1938. Ink.
(Published in *Anatomy of My Universe*)

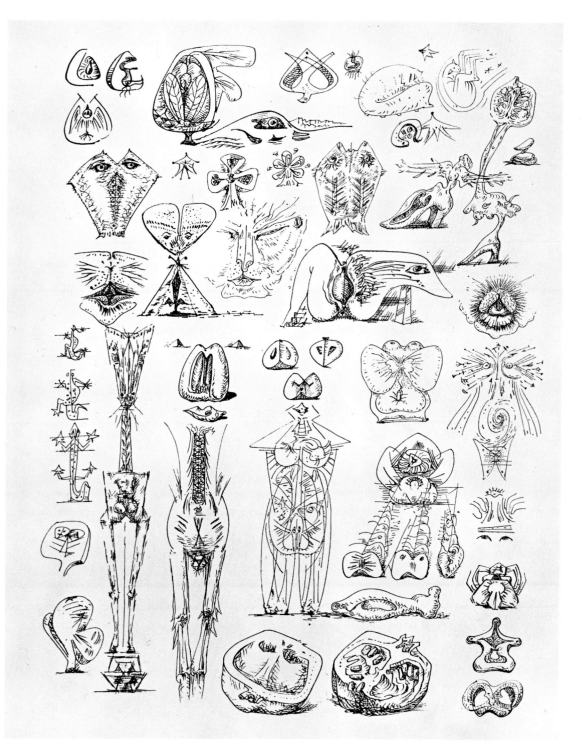

City of the Skull. 1940.
Watercolor, 19 x 25".
Collection Mr. and Mrs. Elliott Goldstein, Atlanta

Breton found the tortured, fantastic imagery of Masson's immediate prewar canvases particularly fine—ethically valid, as it were. Writing in *Minotaure* of May 1939, he says:

. . . the problem is no longer, as it once was, to know if a painting "stands up" in a wheat field for instance, but if it stands up alongside the daily newspaper . . . Very few contemporary works are strong enough to meet such a test, and applying it entails a radical upheaval of values . . . No one has been as willing and able to submit to the test as has André Masson; no one comes out of it more creditably . . . It's high time we react against the notion of the work of art as ribbon sold by the yard (I'm thinking of that carrousel of paintings turning endlessly round the same objects, the same effects, of those poetry mills that, year after year, serve to export to greater and greater distances sacks of the same flour) and to choose instead the work of art as event . . . The taste for risk is undeniably the main motive power capable of advancing man toward the unknown. André Masson is possessed by it to the utmost . . . [186]

Indeed, although much of Masson's painting in 1938 and 1939 is based on pagan myth, its pervading sense of dissonance and its astonishing teratology stem directly from the artist's anguish at events in Europe. His art was a cry of protest consciously intended, in Picasso's words, as "an instrument of war against brutality and darkness." While several extremely powerful paintings came out of this period, Masson's means were, for the most part, not the most conducive to his ends. His graphic work remained as strong as ever, but his painting was generally flawed by an over-literal description of his dreams and visions. Masson himself was later to remark, "I know that the desire

for phantasmagoria is at bottom not very creative: too much recourse to the prop room . . . to the kaleidoscope of imagery . . ." [187]

However one may criticize Masson's work of this second Surrealist period, it nevertheless demonstrates authentic passion and a remarkably rich and inventive elaboration of the Minotaur legend. Unrelated themes are treated, as in the beautiful series of portraits of Goethe (pp. 153, 154), **Metamorphoses** (p. 52), and others, but for the most part motifs derive directly or indirectly from the implications of the Cretan myth. The labyrinth as a subconscious architectural principle lies both in the womb of Pasiphaë and in the mind of Daedalus, and Masson gives us a whole series of images of the Earth Mother and skull-shaped cities— often fusing the two so that the entire body becomes the labyrinth. As there is often a sharing of male and female attributes in the various representations of Pasiphaë and Daedalus, so is there in representations of the Minotaur, both joined with and apart from the archetypal female. The caption of the drawing **Semiramis and the Minotaur** from the chapter "The Elan of Myth" in *Anatomy of My Universe* makes one recurring relationship explicit; it reads "Semiramis: Ishtar, Earth Mother, Mantis. Minotaur: pre-natal life, bestial murder, death." As William L. Pressly writes: "Each female is a prototype of a seductive but deadly force; Semiramis the sexually aggressive queen who murdered her partners the morning after their love making; Ishtar, the cruel goddess of love; and the Earth Mother, an embodiment of nature's fecundity and indifference . . . whose masculine counterpart is the instinctive, brutally creative Minotaur." [188] From this uncompromising vision follow Masson's many images of the trap, whether it is the great vulva-like limbs of a **Sun Trap**, the brutal jaws of the vagina of the mechanized mantis in **Landscape with Praying Mantis**, or the blue steel-toothed limbs of anthropomorphized furniture as in **Bird Hotel**.

In whatever context, the lure of the trap, like the gateway to the labyrinth, is always imaged in a vulva-like configuration. Of the latter Masson says: "It [the labyrinth] has an entrance but no exit. The exit is Death. It is the Minotaur. It begins with Ariadne with her knees half parted. Her vagina serves as an entrance; you feel that in its midst is an evident place of battle, and, at the very end, the exit is blocked by the Minotaur. In the Greek theme the Minotaur is killed, in mine he is the victor. He kills whoever comes inside." [189] True as it is that the Minotaur represents

death, the fatal shadow that threatens from the moment of conception, the various actors in the Cretan drama play interchangeable roles in the Massonian theater, and death comes to the Minotaur as it does to Ariadne and by implication Daedalus and Pasiphaë. Theseus, whose body contains the phoenix,[190] may be the only one spared.

Unlike the fierce **Acéphale** whose headlessness represented his liberation, the Minotaur in such paintings as **The Labyrinth** (p. 53) seems bewildered, fumbling, uncomprehending in his isolation. His macabre wounded figure is stripped of all flesh save for his vulnerable exposed genitals and fragile, spider-like red heart. Standing in front of a dramatically highlighted ocean, not unlike those seen through the windows of Masson's paintings of 1925, the bones of his limbs are ripped open to reveal the imprisoning labyrinth at his entrails, a supporting architectural column in the interior of his left leg, and a stark red eye in his right. As in many other drawings and paintings of the same period his limbs metamorphose; the right leg terminates in the claw that we have seen as early as **The Trap and the Bird** of 1928 (p. 130) and reappears in such Minotaur-related paintings as **The Earth** of 1939. His left arm extends from white shoulder bone to red open wound partially covered with the skin of a fish whose head is where the Minotaur's hand should be. Sprouting from his testicles are leaves and other vegetable life. His body symbolizes, as do many of the drawings in *Mythology of Being* and *Mythology of Nature,* the unity of the animal, vegetable, and mineral kingdoms. Most interesting iconographically is his head, whose starlike eye echoes Ophelia's blind stare. In form the head is clearly that of a bull, yet it also harks back to the skulls of the sand paintings of 1927. The Minotaur, like Ariadne, holds the labyrinth within himself, as is made clear not only by its spiraling walls at his intestines, but by its entrance under the jagged bone of his jaw. With slight, Piranesi-like variations, this conception of the beast's head is repeated in the cover Masson did for the last issue of *Minotaure* in May 1939. Daedalus, the canny genius who was not only the architect of the labyrinth but an accessory in the birth of the Minotaur (it was by his art that Pasiphaë was able to consummate her passion), becomes himself the prisoner of his intricate structure and so, by extension, is as much to be identified with the labyrinth as is the Minotaur or Ariadne. This relationship is expressed in the eerie, melodramatic **Daedalus' Workshop** of 1939, where in the right foreground we see Daedalus before

a phallically erect, altar-like machine whose center is a variation on the "Pensée" motif, struggling to assemble the head of the Minotaur as it is represented in **The Labyrinth** and on the cover of *Minotaure* (p. 49).

The outline of the Minotaur's head is the basic configuration of several sand paintings of 1938 and 1939. All executed on wood, these paintings are an outgrowth of Masson's interest in object-making that was stimulated in 1937 by his reentry into the Surrealist group. Although these pictures are based less on automatist techniques than are the sand paintings of 1927, line again wanders fluidly, elaborate detail is eschewed, and deep perspective abandoned. In two small panels each entitled **Story of Theseus** (pp. 48, 150), the line of the Minotaur's head encloses the embracing figures of Theseus and Ariadne. In a third, **Ariadne's Thread** (p. 55), the outline of the head is only hinted at in the confluence of the black outlines of the lovers' bodies and the meandering red line that

below:
Story of Theseus. 1939.
Oil and sand on board, 11¾ x 19⅝".
Collection Mr. and Mrs. Lawrence M. Saphire, New York

opposite:
The Earth. 1939.
Sand and oil on wood, 17 x 20⅞".
Centre National d'Art et de Culture Georges Pompidou,
Musée National d'Art Moderne, Paris

symbolizes, as in the other two panels, Ariadne's thread. Because of its relative spareness, lack of specific figuration, and an unusually sure handling of color, Ariadne's Thread is the most poetically evocative of the three paintings. The lines of the embracing bodies are etched in black on the painted terra-cotta and sand ground, saturated red suffuses the heart in the center and dilates in the varying thicknesses of the line that encircles the lovers like the heartbeat of the Minotaur. At the upper left, the beast's obsidian eye is surrounded by an oval of tender blue that is counterpointed by a flamelike swirl of yellow-orange at the lower right. In all three pictures the areas of bright red carry the same connotations as did the "blood stains" of Masson's sand paintings of 1927—just as the

Minotaur's head is, to some degree, the counterpart of the watcher figure of 1924-25.

In The Earth (right), another in the series of sand paintings of the late thirties, a configuration deriving from the outline of the Minotaur's head can be discerned only through comparison with The Labyrinth and the three panels discussed above. Evidently related to such paintings of 1928 as The Nudes, The Earth is a schematized version of the Earth Mother image such as is presented in Trap in the Meadow, where we see the sun caught in the figure's grasp—perhaps an allusion to the Egyptian goddess Nut, who swallowed the sun each evening and gave it birth every morning. In The Earth, however, snare and victim are one; the clawlike hand plucks at the flesh of its

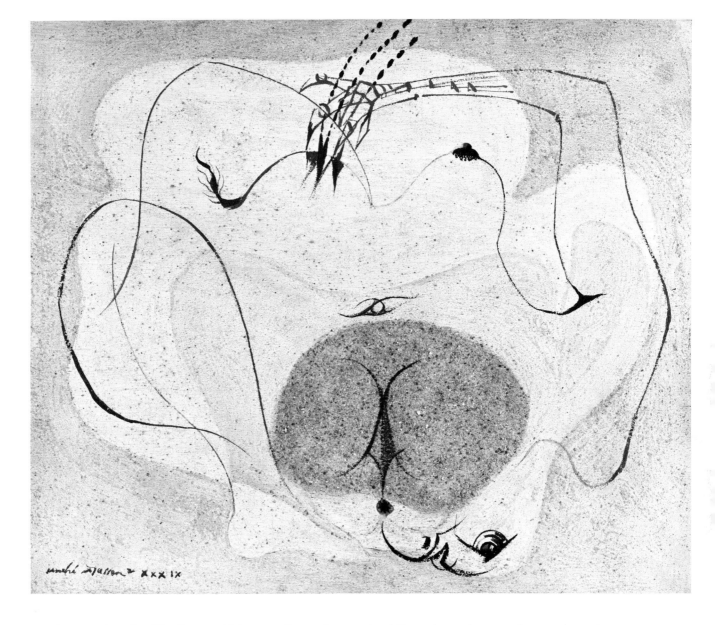

own breast, reiterating "the theme which occurs time and time again in Masson's work, the identity of trap and victim, of arrow and target."[191] The gesture is related to that of the nude woman playing a violin in a Massacre drawing of 1932, and to the anthropomorphic musical instrument at the left of **In the Tower of Sleep**, which tears its own strings with a sawlike bow in a kind of simultaneous onanism and sadomasochism. Partially because of an equation of image and medium similar to that of the sand paintings of 1926-27, **The Earth** is one of the more successful of Masson's many matriarchal landscapes. His obsession with the theme is certainly in part a reflection of his heightened interest in hermetic philosophy, demonstrated in the drawings for his mythologies and *Anatomy of My Universe*. In the words of Paracelsus, whose work was of great interest to Masson, "The study of the womb is also the science of the origins of the world."[192]

Gradiva (p. 46), one of the important paintings of the immediate prewar period, presents the female figure in an attitude very similar to that shown in **The Earth**. The theme derives from a 1903 novel by the North German writer Wilhelm Jensen. The story concerns a young archaeologist who falls in love with a figure from an ancient relief, a young woman whose gait he finds so captivating that he calls her "the girl splendid in walking." Convinced that the object of his passion died in the volcanic eruption that overwhelmed Pompeii A.D. 79, he travels to the site and meets a young girl who is either a spirit or the living incarnation

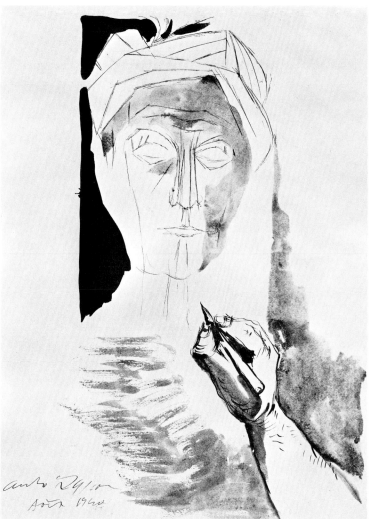

Myself Drawing Dante. 1940.
Pen and ink and wash, 24¾ x 18⅞".
The Museum of Modern Art, New York,
Gift of Andrew Lyndon

opposite:
Portrait of Goethe. 1940.
Oil on canvas, 32 x 25½".
Collection Walter Lugiai, Milan

Gradiva with Ariadne borne out by such examples he cites as the similarity of the figure's pose with that of Ariadne in de Chirico's *The Afternoon of Ariadne* and Poussin's wax copy of the Vatican's *Sleeping Ariadne* in the Louvre, but it is confirmed by a comparison with Masson's contemporaneous picture, **Story of Theseus**, perhaps the only other painting aside from **Pygmalion** of 1937 (a first version of **Gradiva**) in which a slab of raw meat is a prominent iconographic element. The **Story of Theseus**—which presents the cord as we have seen it in the twenties, shows the lovers in a compressed space like the underground vaults of that decade, recapitulates the ubiquitous hand-breast imagery of 1924–27, and parallels the Minotaur with the watcher figure—is especially interesting in illustrating Masson's tendency suddenly to return to previous modes. A further identification of the Gradiva persona with Ariadne is possible in that attributes of Dionysus, Ariadne's husband, have been deliberately included. The paneling of the Villa of the Mysteries in Pompeii, which depicts Dionysiac ritual, is used as a background, and the figure's left breast serves as a hive for the bees traditionally associated with Bacchic festivals. Gradiva's right foot is in the position of the figure in the ancient relief that had first excited the young archaeologist of Jensen's novel; it may have partially been the importance of the foot as an erotic stimulus that attracted Masson to the story. Its sexual symbolism is underscored in Clébert's observation that "the right foot is in erection."[194] Perhaps in some measure related to Masson's return to making sand paintings, the shell appears frequently in the late thirties, and nowhere with greater prominence than in **Gradiva**, where it retains its own identity, in a way that the "Pensée" imagery does not, while at the same time serving as vagina dentata. **Gradiva** may strike the contemporary American sensibility as an overobvious, even somewhat repulsive image; it retains, however, a powerful presence, and its rich and subtle tonalities of red provide a visually sensuous experience.

During the period that Masson painted **Gradiva**, he was also making a series of imaginary portraits—paintings, watercolors, and drawings—of Goethe, Nietzsche, Hölderlin, Kleist, Richter, Dante, and others, later followed in the United States by those of Nerval, Rimbaud, Baudelaire, and Heraclitus. In some of these works, such as **Myself Drawing Dante** (left), the artist's hand is included as it had been in **The Painter and Time** of 1938; in others, such as the portraits of Kleist and Goethe, the subject's head is partially composed of

of his idol. Through the sympathy of the young woman he comes to the realization that she is a creature of flesh and blood who was, in fact, a childhood playmate whom he has forgotten. Not surprisingly, the novel was of considerable interest to Freud, who wrote a paper on it in 1906. Equally unastonishing is the subsequent Surrealist interest in the theme. Dali made several works relating to the motif, and, as we see, Masson drew upon it.

Although Masson's **Gradiva** is faithful in many of its details to the original story, the figure, as Whitney Chadwick has pointed out, is also associated with Ariadne.[193] Not only is Chadwick's identification of

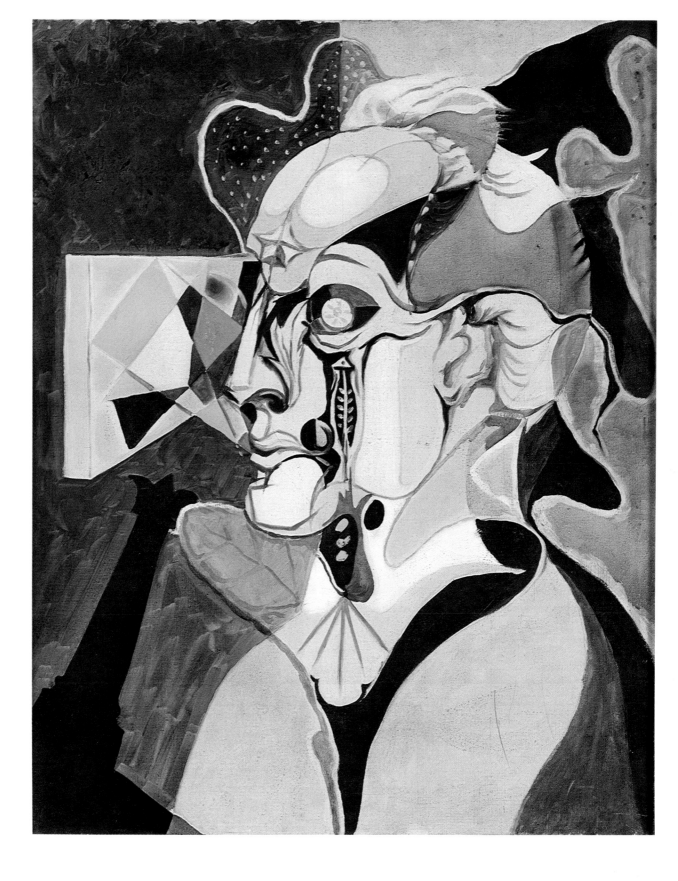

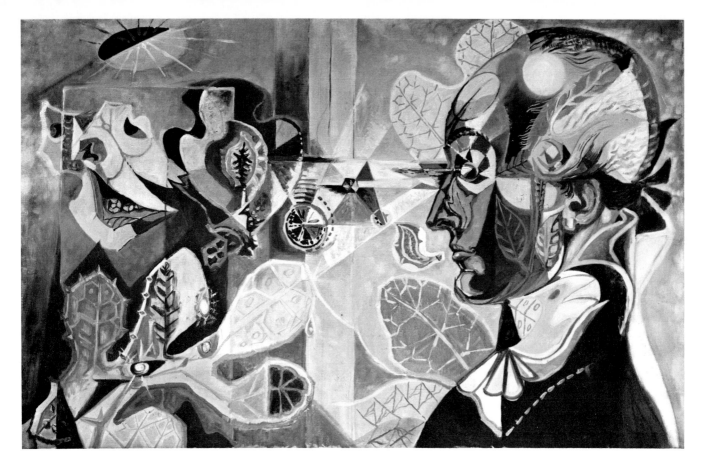

fruits and plants, but not, however, in the total, Arcimboldo-like way of the allegorical young woman of **The Painter and Time. Portrait of Kleist** depicts the writer's suicide, and the bloody pomegranate of his forehead is, like that forming the head of the central struggling figure of **In the Tower of Sleep,** the literal rendition of Masson's association of the pomegranate with a shattered skull. In the several portraits of Goethe, aside from the eyes that appear as glowing minerals, the leaves and other materials do not constitute features as in **The Painter and Time,** but are symbolically superimposed on strongly drawn planes as a kind of metaphoric phrenology.

The Goethe portraits have none of the fevered quality of much of Masson's contemporary work. Marked by a geometric ordering of the support, low-relief modeling, and strong graphism, they are soberly modulated in clear, forceful colors. Masson recalls, "I reread a lot of Goethe at that time, especially the secret Goethe, the erotic Goethe . . . the Goethe of *The Green Serpent,* that alchemic tale."[195] All of the various portraits, **Goethe Listening to the Voices of Nature, Goethe and the Theory of Colors, Goethe and the Metamorphosis of Plants** (above), etc., present us with a philosopher whose science is based on sensuous ex-

perience combined with poetic intuition. Here, indeed, is the seer. These portraits conceptualize, in Oswald Wirth's words from his introduction to Goethe's *The Green Serpent,* "the deep, unexpressed truth which haunted the mind of the prodigious poet, whose clairvoyance was of the highest order."[196]

In the largest and most complex of the Goethe portraits, **Goethe and the Metamorphosis of Plants,** the radiating polyhedron of the eye seems to represent the philosopher's stone, its golden beam distilling the hidden secrets of color and organic life in the refracted light of the prism in the center. This idealized image of the poet seems irreconcilable with the concept of Acéphale, whose apprehensions were transmitted through his groin; but, contradictory as it may be, Masson felt tremendous affinity with this genius whose transcendent intelligence was not compounded of the dry stuff of Cartesian logic, but illumined by the study and contemplation of the marvelous. Unlike Newton who wished to discover the origin of color, Goethe in his often extremely scientific and organized effort attempted to discover its meaning. In **Goethe and the Metamorphosis of Plants** one can read a transliteration of Goethe's words, "When the distinction of yellow and blue is duly comprehended, and especially the

intensification into red, by means of which the opposite qualities tend toward each other and become united in a third, then certainly an especially mysterious interpretation will suggest itself, since a spiritual meaning may be connected with these facts."[197]

On a stylistic level **Goethe and the Metamorphosis of Plants** hints at certain configurations that were to become important in Masson's art in America. The leaf that floats rather inexplicably in the upper right corner of **Pasiphaë** of 1937 is here silhouetted against Goethe's head much as it will appear in **Meditation on an Oak Leaf**, and the larvaesque leaf at the middle right will appear in that picture and many others of his American period. At the left, wrenched slightly away from the picture plane, is an easel-like rectangle (possibly an allusion to the cards Goethe made to study color) which holds images of gestations and germinations very close to those of the work of the next three years. The profiled bust of Goethe staring at his gorgeous visions anticipates the series of Sibyls and Contemplations of 1944 and 1945.

Shortly after painting **Goethe and the Metamorphosis of Plants**, Masson was forced by the fall of France to flee with his family to Freluc in Auvergne, in unoccupied France. There, although unable to paint because of lack of supplies and the difficulties of his living conditions, Masson produced a considerable quantity of gouaches, watercolors, and drawings.

A particularly beautiful watercolor is **Metaphysical Wall** (p. 156), whose jewel-like tones and parallel-stripe technique recall Klee's Egyptian pictures of the late twenties. Masson's layering of parallel bands, however, probably derives less from Klee than from a translation into watercolor of the Bracelli-inspired structuring of many of his contemporary drawings (p. 45). Related to the painting **Metaphysical Landscape** of the previous year, **The Metaphysical Wall** seems to have been abstracted from the imagery of the drawing (p. 138) that serves to illustrate the first page of the Prologue in *Anatomy of My Universe*. Masson's metaphysical wall is a kind of magic mirror simultaneously rendered fluid and solid by the way in which figures and wall and wall and ground are both delineated and meshed by the luminous colored bands. Metaphorically it is the confrontation and resolution of opposites. Slightly left of center extrapolated from previous images of the matriarchal landscape is the traditional round temple of a mother-goddess; at the base of the wall on either side of the "steps" leading to the structure are the fetuses of death and life. Death

is a skeleton enclosed in crystal, and life, the Daphne figure locked in a transparent membrane. Flanking them are the erect figures of male and female whose reflections are captured in the wall that holds the temple. The male, identified with death, is next to the fetal skeleton, and the female, associated with life, next to Daphne. The stylized bird at the right shoulder of the female shadow may be a distant cousin of the birds in **The Crows**, but symbolizes more immediately either the legendary phoenix or the liberating hawk from Goethe's *The Green Serpent*. Its flight from female to male is mimed by the progressively tinier echoes of its form across the sheet. Inevitably the only discrete image not surrounded by the wall is the tailed sun that watches the earth cycle. **The Metaphysical Wall** complements the last paragraph from Masson's text for *Anatomy of My Universe*, written in Freluc: "The sun, like a thinking eye, presides over the vision of the undulant ether, over the movement of the dark air, and the galloping of the sidereal wind. I am the mirror in which the fraternal kingdoms and the four elements are reflected. A cardinal point fixed on the membranes of liberty, I open my living eyes on the window of art on which is imprinted the image of my universe—a mental flowering of hoarfrost—from the skeleton of sand to the flesh of the star."

While at Freluc, Masson made many of the drawings for *Anatomy of My Universe*, which Curt Valentin later published in the United States. *Anatomy of My Universe* is Masson's *summa theologica*, an often brilliant and highly individual potpourri of ideas adopted from occultism, alchemy, astrology, Neo-Platonism, the Cabala, Scholasticism, and, as said the King of Siam, "etcetera." This eclectic collection of drawings and their explications might best be characterized, in Leiris' words, as the "myth of the interpenetration of man and his surrounding."[198] The first and longest chapter, "The Demon of Analogy," is a mystic, esoteric treatise on the unity of the four elements and the three kingdoms, with particular emphasis on correspondences between forms. Its essential message is not far from Buckminster Fuller's thought, "Above all, mathematics, geometry, physics are only manifests of the eternal mysteries, love harmonious integrity beyond further words."[199] A particularly significant drawing from the first chapter is **The Number Five** (p. 157), a title Masson also gave to an oil of 1928, where its symbolism is much less clearly spelled out. The central image is the familiar earth-mother-trap whose body is being entered through the star of her vagina by a male figure in the

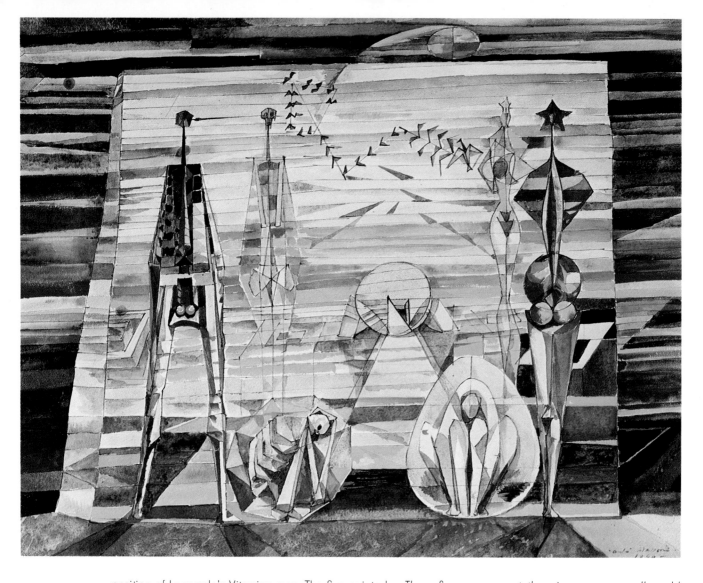

position of Leonardo's Vitruvian man. The five-pointed star as a configuration that can be drawn with a continuous line symbolizes the endless knot—the ever-repeating cycle of birth and death. And five, the sum of its points, is the unity of opposites in that it is "the first complexion of both kinds of number even and odd, two and three."[200] The male figure in the stance of Vitruvian man, first seen in **Les Ecorchés** of 1926 (p. 117)—the imagery of which is echoed in the figure at the right—does not represent some Renaissance principle of perfect proportion. Masson writes in his Prologue: "No hierarchy in the cycle of natural forms. The royal structure of the human body is no more beautiful than the radiolaria, an oceanic star with solid rays." The significance of the Vitruvian figure for Masson is best explicated by drawing from Leiris' essay published in *Documents*, "Notes sur deux figures microcosmiques des XIV et XV siècles." He writes:

These figures represent the microcosm or small world, that is to say man, in his relations with the macrocosm or big world, that is to say the universe . . . man inscribed in a five-pointed star, which constitutes the magic pentagram of Cornelius Agrippa and is called the sign of the Microcosm, as opposed to the six-pointed star or Solomon's seal, which is the sign of the Macrocosm. "If from the center," says Agrippa, "one makes a circle that passes the top of the head, the arms lowered to the point where the digital extremities touch the circumference of that circle and if the distance between the feet in this same circumference is equal to the distance from the head to the extremities of the hands, then this circle, whose center is the base of the pecien (that is to say the pubis), is divided into five equal parts, which produce a perfect pentagon, and the extremities of the heels in relation with the navel make an equilateral triangle." (One should note that from a symbolic point of view the number five is that

of the creation of man, of the incarnation; as for the equilateral triangle, it corresponds to the number three, or to the trinity.) . . . *think of Leonardo da Vinci's famous drawing made to illustrate Vitruvius and representing a naked man inscribed in a circle. This drawing has always been considered the graphic representation of a canon of proportions of the human body. One may rightly suppose that it is far more than an aesthetic canon. Given the resemblance of da Vinci's drawing and Agrippa's pentacle, these proportions can, in effect, be considered as purely symbolic.*[201]

In his notes for the same article, Leiris' quotation from Emile Behier is equally pertinent to an interpretation of Masson's image: ". . . but there is between the stars and us correspondence, an ideal and reversible influence, because all the parts of the universe represent the same total order; the sky is the image of man just as much as man is the image of the sky."

One of the best-known drawings in *Anatomy of My Universe* is **Dream of a Future Desert** (p. 158). Executed in 1938 and reworked as an etching in 1942, this apocalyptic vision of the end of the world embodies the torment of the artist who saw in the Spanish Civil War and the rise of Hitler the sure portent of holocaust. Almost submerged in an engulfing tide are the monuments of civilization, a subterranean labyrinth, a pyramid, and an eighteenth-century piazza. Surmounting all, and itself sinking, is a structure very like one of the first of the City of the Skull drawings (p. 33), the form of which suggests both a widely reproduced print of the ruins of a temple of Minerva by Piranesi's follower Luigi Rossini (fig. 18) and Momper's painting *Landscape-Head* (fig. 19), owned by Masson's acquaintance Robert Lebel. In *Anatomy of My Universe*, Masson captioned **Dream of a Future Desert** with a text that he had written in July of 1936 at Tossa de Mar in Spain: "An ocean of sulphur mounts the somber earth. In the meadow the weeds are signs of fire. The forest bursts into geysers of sap. The incandescent rocks are diamonds of the hour. The furious gallop of the Saturnal wind changes a tomb into a sheaf of dust. A vomit of lead undulates on the terrace of temples, covers up the earth, glides to the dead volcano, to the dried-up river. On the horizon a black sun oscillates for the last time; an eye veiled by a scythe which destroys the landscape of a world's end."[202]

The drawing of a City of the Skull that is most closely related to the structure at the top of **Dream of a Future Desert** was acquired by Saidie May, to whom Masson had written in December of 1938: "I work a lot and try

not to be too disturbed by events. I hope also to make a trip to the United States one day, and maybe—who knows?—work there a while."[203] The rather vague wish expressed in this letter was very close to fulfillment by the end of 1940. Although Masson had been reluctant to exile himself and his family, a combination of the difficulties he had with the Vichy police in Auvergne and the proclamations of "humanist" racial laws pushed him to decide that there was no other course.[204] In January of 1941 he joined Breton and other Surrealists and intellectuals in Marseilles who were trying, with the help of an American rescue committee headed by Varian Fry, to leave Europe. Besides Breton, those in temporary asylum in Marseilles included Victor Brauner, René Char, René Daumal, Robert Delanglade, Oscar Dominguez, Marcel Duchamp, Max Ernst, Jacques Hérold, Sylvain Itkine, Wifredo Lam, Benjamin Péret, and Tristan Tzara.

Through the good offices of the Comtesse Pastre, Masson and his family found living quarters in a hunting lodge in Montredon. In spite of the distress and anxiety caused by an uncertain exile in their own land, most of the refugees in Marseilles waited in outward good spirits for the day of departure. Masson describes the winter as having passed "in a feeling of brotherhood all round; in order to exorcise the anxiety resulting from exhausting and uncertain legal procedures, there were group readings and drawing ses-

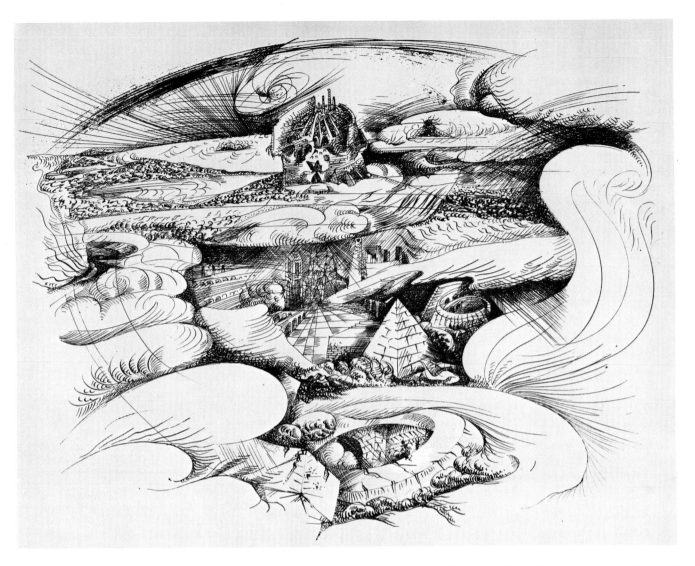

sions, and the collective invention of a Marseilles Game of Cards, in which the usual figures were replaced by new signs and figures from our Pantheon. In the distribution of the sketches to be done, Novalis and the Portuguese Nun fell to me."[205] This picture of camaraderie on the eve of exile offers poignant contrast to the boisterous reunions of youth in the rue Blomet and rue Fontaine.

Less than two months before his departure for America, Masson drew a powerful double portrait of Breton (right) in which the many-layered symbolic content reflects old concerns of the two reconciled veterans of Surrealism, and comments on the situation of those facing exodus through a synthesis of particularly Massonian concepts with a visual exegisis of the poem "Fata Morgana" that Breton wrote in Marseilles. Set like some megalith in a landscape whose contours are only suggested, Breton's head is seen simultaneously from left and right. The image

presents Breton's left profile eyes-open, a diamond encased in crystal in his cheek, and above a scintillating sun; in the right profile Breton's eyes are closed and an emblematic bird soars off into the heavens. Centered in the joined heads is a five-pointed star, and at its center is the tear that Masson later locates in the middle of an etching that encloses the shell, the star, and the pansy in a skull and is titled **Emblem of Being**. Under the star is an oval, metaphoric X-ray of the interior of the head revealing on the "conscious" left side the multiplied profiles of men and on the right "unconscious" side those of women. Separating them is a twisting, vulva-shaped flame. Adjacent to Breton's right profile is a narrow rectangular trough filled with the repeating images of spheres locked in transparent cubes. Receding in depth, the trough and its steplike cubes lead to a distant horizon where wispy, swirling lines indicate a flame.

The opposed eyes-open and eyes-closed profiles

Dream of a Future Desert.
1938. Ink.
(Published in *Anatomy of My Universe*)

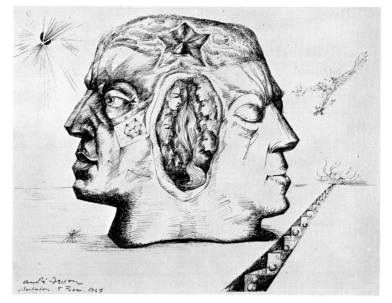

recall the Surrealist preoccupation with conscious versus the unconscious—exterior cognition as opposed to interior, instinctual intuition. The star, the sun, the bird, the flame are all icons which we have seen repeatedly in Masson's imagery, and which had, as well, particular significance for Breton. The diamond represents, as it had in many of the drawings of the late thirties, the unity of opposites: colorless, it contains all colors; it can cut anything but nothing can cut it; and, composed of the same atoms as coal or graphite, it presents in its transformation the concrete symbol of the metamorphosis of one substance to another—if one will, from base perception to transcendent understanding. The trough leading to a flame is the visual parallel of Masson's words from the Prologue to *Anatomy of My Universe*: "I think of an infinite repetition of basalt columns which would lead to the eternal light fixed by Dante . . . This ecstatic fusion with wholly luminous space projects the seer up to the place of liberty, where, bound by love into a single volume, he brings together in one sheaf the falling leaves of the whole world."

Allusions to "Fata Morgana" are several. The poem begins with a one-way conversation with a woman whose part in the interchange is silence—the interior of the poet's head—and continues with a prayer to the god Thoth personified as a mummy of Ibis, the emblematic bird of the drawing. A "new day" is a recurring theme, and the last line of the poem consists of the single noun "sun."

Thus bound in one image are the private and public concerns of Masson and Breton. At that moment of spiritual alienation and physical disorientation they shared the belief that "The problem of the dispersion of human lives by the explosion of war is one with the fragmentation of the soul in its inability to relate to the universe. The disharmony in man's own self-fashioned world is part of the disjunction between man and nature." [206]

ABOUT SIX WEEKS after Masson had drawn his double portrait, Breton left for Martinique on the same ship as Claude Lévi-Strauss. Eight days later, on March 31, Masson, Rose, and their two boys embarked for the same destination on an old cargo boat, the *Carimari*. After a difficult month-long voyage they arrived in Fort-de-France, where they spent three weeks before leaving for the United States. During those three weeks Masson and Breton explored the island together. Horrified by the colonial government's repressive policies,

they were, at the same time, totally astonished and enchanted by the island's natural phenomena and luxuriant vegetation, finding in such wonders as the Gouffre d'Absalon the realization of the visions of Henri Rousseau. Together they wrote "Le Dialogue créole," which was later published along with Masson's poem "Antille" and other texts by Breton in *Martinique, charmeuse de serpents*. [207] Included in the book are several of the many drawings (p. 56) Masson made inspired by the tropical foliage and exotic ambience of the island. The impact of the experience of Martinique was profound for Masson, and two years later was to be the source of one of the most beautiful works of his American period, **Antille**.

After some anxiety and difficulty, Masson and his family were able to gain passage on a steamer to New York, where they arrived on May 29. Although Masson remembers America as "the land of welcome," and contrasts it, in this respect, to Spain, and even to the Normandy of his native land, his initial experience of the United States was not pleasant. In one of his bags was a sheaf of drawings from his mythology series that customs officials found obscene and confiscated. Through the subsequent intercession of Masson's old friend Archibald MacLeish, who was then Librarian of Congress, Masson's moral character was cleared and most of the drawings returned. Among the five that the authorities destroyed was **La Pensée** (p. 146).

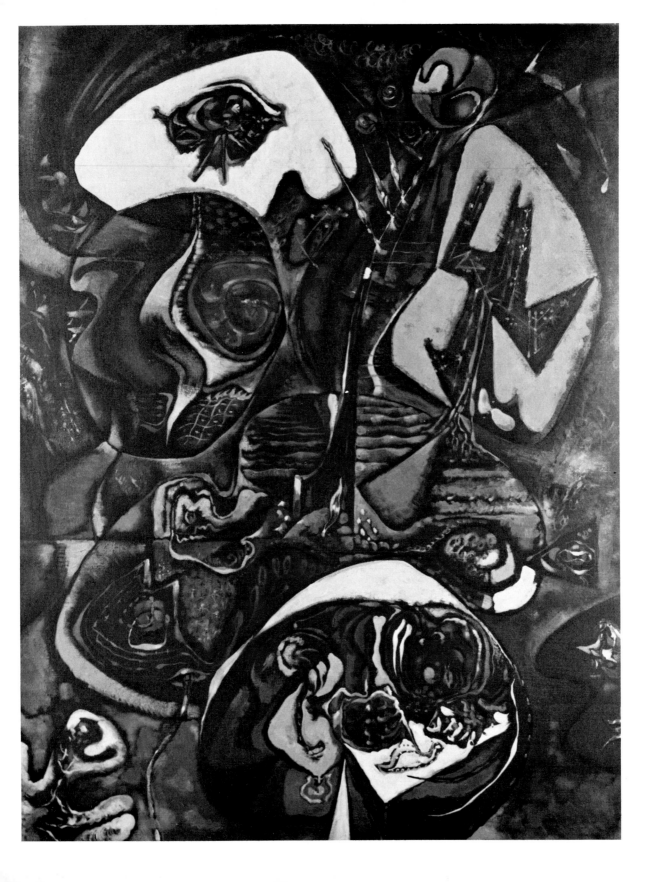

Meditation of the Painter. 1943.
Oil and tempera on canvas, 51⅛ x 39⅜".
Collection Richard S. Zeisler, New York

Praying Mantis. 1942.
Bronze, 9¼ x 16⅞".
Galerie Louise Leiris, Paris

Masson found New York "a sublime city . . . entirely made by our contemporaries" and describes one aspect of it: "You are in Central Park, night approaches, the very high houses are like vertiginous cliffs of marble—and—after a while they are as though riddled with lights, like so many giant fireflies; it becomes as prodigious as Great Nature. It unites with her." [208] Nevertheless, Masson, whose old horror of urban life was intensified by a city in which the vastness, pace of life, and language were completely alien to him, sought refuge in the country. He wrote to Saidie May: "I like New York but it devours me. I hope to live in the country . . ." [209] Shortly thereafter Masson and his family moved to an old Colonial house in New Preston, Connecticut, where their near neighbors were Alexander Calder and Yves Tanguy and his wife, Kay Sage.

Masson's uprooting to America proved to be the catalyst for an extraordinary revitalization of his art. In the face of recurring worry about the fate of family and friends in Europe and the depression that even this avowedly nonnationalist Frenchman felt at the fall of the mother country—poignantly expressed in a drawing of 1942 entitled **The Defeat** that is a symbolic reworking of **Woman** of 1925—Masson turned as often before to nature, and it nourished him abundantly. In a 1958 interview, Alain Jouffroy says of Masson, "[He] isolates himself from 1942 to 1945, which he considers the moment of his maturity, when he touches upon the center of what he is." [210] In the marvelous Telluric series of paintings, mostly of 1942, such as **Meditation on an Oak Leaf** (p. 60), **Meditation of the Painter** (left), **Iroquois Landscape** (p. 165), and **Indian Spring** (p. 164), Masson achieves as never before the successful synthesis of his innate gifts as a draftsman with his great skill as a painter. Form is often determined from the inside, by color, in a way unprecedented for Masson. Succeeding the series of paintings whose inspirational force was largely drawn from the earth itself are paintings that syncretize landscape and human attributes, such as **Antille** (1943; p. 29), and even **Andromeda** (1943; p. 167), the title of which reverts to Greek myth. The dark, glowing palette of **Pasiphaë** (p. 59), one of the last works in the Minotaur cycle as such, derives from the colors of an American autumn. Masson drew as consistently as ever, and by the end of 1943 calligraphy was entering his paintings with increasing frequency. The reemergence of line as a central compositional element is chiefly apparent in a series of Sibyls and Contemplations of the Void that probably reflect a turning away from the initial ab-

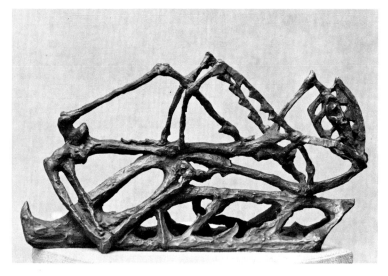

sorption in the phenomena of nature in America toward a nostalgia for Europe that brought with it a heightened apprehension about the war. Toward the end of his stay in America Masson did a series of trenchant self-portraits, tender, sensitive images of his sons in the American forest, and a rigorous suite of drawings and lithographs for the album *Bestiary.*

Masson's work of 1941, the period of his first experience of America, is so varied and exhibits such radically different stylistic modes that it is phenomenal even for this artist, who, more than any of his contemporaries except Picasso, shuttles back and forth between divergent way-stations of technique and pictorial representation. Not only had Masson's work been marked by this tendency to explore and experiment, but, as is the case with most artists, it had, at given moments, both expanded and retracted its boundaries. These interrelated propensities were so heightened by Masson's exodus from Europe and his initial contact with America that his art simultaneously pushed out in many, sometimes wholly opposite, directions. Retreating to his Spanish Period, he painted **Torero Insects**; summing up his Surrealist canvases of the late thirties is **Hotel of the Automatons**, just as **The Sleeper** resumes an earlier preoccupation. Anticipating in an astonishing manner modes that would characterize certain of his postwar works, he executed the nearly totally abstract **Entanglement** and made the highly prophetic automatic drypoint, **Rape**. Unexpectedly branching out, he did two collages, **Martinique** (p. 57) and **Street Singer** (over), that are unique within his work, and at the

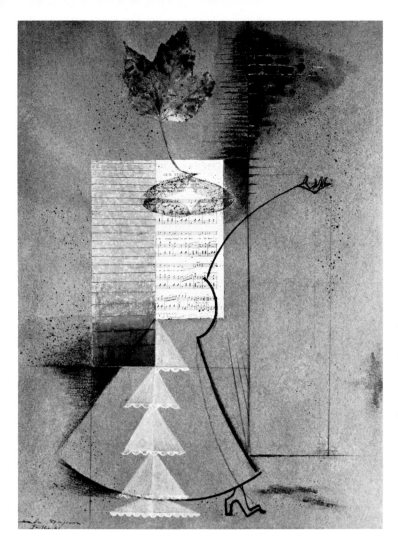

Street Singer. 1941.
Pastel and collage of paper, leaf, and dragonfly wings,
23½ x 17½".
The Museum of Modern Art, New York, Purchase

Another in the series of four prints is Entangled Beings, which is related to the painting Entanglement (p. 69). Like Rape, Entanglement is an extraordinary leap forward, and, like Rape, had no direct suite in Masson's painting until several years later. Although close scrutiny reveals figurative hints such as the hand in the upper left corner, it is, as its title indicates, the visual rendering of a psychological and physical state of being; depicted is the concept of entanglement itself, whereas the related print is a comparatively readable image of jumbled-up, queerly vegetable and anthropoid beings. While the syntactical principles of Cubism inform the substructure of Entanglement, they are so buried within the interwoven mesh of curvilinear, energetic brushstrokes and exuberant color that it is perhaps wisdom to leave them interred and let, among other aspects, the flickering blue accents wink out unanalyzed.

Unlike Rape and Entanglement that predicate new directions in Masson's art, Street Singer (left) and Martinique (p. 57) stand virtually alone within the body of Masson's art. It is not that they do not draw upon techniques and pictorial conventions that we have previously seen; it is simply that Masson neither before nor after combined elements in a truly comparable way. Street Singer is particularly interesting on three counts: first, because it is, in its nonrhetorical way, a first-class work; second, because, coming directly after the overelaborate work of the thirties (even simultaneously with, viz. Hotel of the Automatons), it illustrates again, in its fine calibration of figuration and suggestion, how good Masson's art can be when he eschews the overexplicit; and, third, because it shows Masson flattening form—one of the more important factors in the success of his American work.

Aside from his sand paintings of all periods—principally 1926-27, 1937-39, 1955-59—Masson rarely used collage. In Street Singer he has, however, employed the technique impeccably. His deft orchestration of the collaged elements—the wine-red, almost varnished maple leaf, the delicate splayed-out butterfly wings, "brick" wall, and sheet music—with the mauve and yellow triangles of skirt and the black line that indicates just enough against the flecked brownish-red ground that is the natural color of the construction-paper support, provides an extraordinarily rich mixture of texture, line, and color. Understated, Street Singer is nonetheless extremely erotic. We hardly need know that the little high-heeled shoe is the inheritor of such sexually charged imagery as

studio Lipchitz was using he began modeling a series of small expressionistic sculptures whose surfaces exhibit the mark of a painterly hand in much the same way as do those of de Kooning. Toward the end of the year he made Landscape in Form of a Fish, the configurations of which clearly announce the great series of Telluric paintings of 1942, while its pallette and much of its subsidiary iconography remain tied to the work of the late thirties.

Among the first of the stunningly disparate works executed in 1941 was a series of four drypoints of which Rape (p. 62) is one. In this print figuration is all but dissolved in the rhythmic sweep of line whose velocity and force testify to an automatic technique pushed beyond the borders of Masson's work of 1924-27. In no sense contained or impeded by the kind of a priori imagery of the earlier work, Rape achieves an unprecedented gestural freedom, and the web of its lightning-quick line locks the composition in an allover configuration.

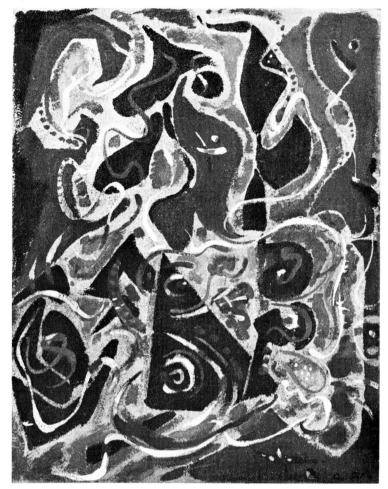

Movement. 1942.
Oil and sand on canvas, 17⅞ x 14⅜".
Collection of the artist, Paris

that of **Erotic Scene** (p. 129) or **Nudes** (p. 128); its taut contours and the predatory curve of the toe evoke the same sense of unease as do the deliberately disturbing pointed slippers in many of Goya's portraits of women. The figure's seductive gait is made unmistakable by the sure line that sweeps down from the gesturing hand, breaks for the provocative lump of the stomach, and comes to rest just over the foot defining the edge of the skirt. Primarily this right contour of the singer's profiled body posits a swinging forward of the figure, which the roll of the bottom and back contour of skirt reinforce; however, as one continues to look at the picture the function of the right outline vacillates between delineating profile and becoming a convex outer element pressing against the singer's body. Indications of the provocative quality of the figure's walk are, especially in view of a drawing done shortly before in Martinique, allusions to Gradiva. Consistent with the counterpointed pattern of rectilinear and curvilinear line, of solid and open form that governs the work, the lace-edged triangles of the singer's petticoats rise rigidly in the center of her curving skirt. The fragile, transparent pair of butterfly wings that are the singer's breasts are arranged in a vulva-like configuration that seems the palpable realization of the membrane that we have seen enclosing the figure of Daphne. In total effect **Street Singer** is an extremely poetic picture, a mixture of bitter and sweet—what can be felt and grasped and what cannot. The most "real" elements, the wings, the leaf, and the sheet music, are the most abstract, and the most recognizable, the ruffles, the hand, and the foot, are imitations of reality. The mood of the picture is carried in the choice of song of the sheet music, *Our Times.* Although Masson knew no English, and never learned any during his stay in America, his wife spoke it fluently, and it is likely that Masson's selection was not unwitting.

In July, the same month that Masson made **Street Singer,** he wrote to his friend Jean Ballard in Marseilles: "America has been friendly in the extreme and I work like hell. Devoured by painting and by writing as well. I'm asked to do an article . . . and a lecture . . . I'm amazed to see my paintings in the museums and I have the feeling of having become a very respectable gentleman . . ."[211] Indeed, Masson found in America a tribute that had not yet been accorded him in Europe—his first museum retrospective, which took place at the Baltimore Museum of Art in November of the year of his arrival. The lecture he refers to was probably "Origins of Cubism and Surrealism," which he gave at the time of his show in Baltimore. Curt Valentin became his principal dealer, and, with the exception of 1943, Masson found himself the subject of one-man exhibitions every year of his exile.

Although the work of 1942, as in almost every year of Masson's career, was not exclusively concerned with one motif, it is nonetheless dominated by those paintings in which the expressive force derives from Masson's impassioned study of the American countryside. In an interview just before his departure for France in 1945, Masson said: "My idea of America was, and perhaps still is, rooted in Chateaubriand. Nature: the might of Nature . . . What characterizes my American work is its manner of expressing this feeling for nature. Such pictures as **Printemps indien, Paysage iroquois, La Grande Melle, Les Gens de mais, Méditation sur une feuille de chêne,** embody a correspondence—express something which never could have been painted in Europe."[212] And elsewhere he states, "It was in the United States that I began to paint in the way which I ambitiously call chthonic, belong-

Indian Spring. 1942.
Distemper on canvas, 33 x 39¾".
Collection Mr. and Mrs. William Mazer, New York

Iroquois Landscape. 1942.
Oil on canvas, 30 x 39½".
Collection Simone Collinet, Paris

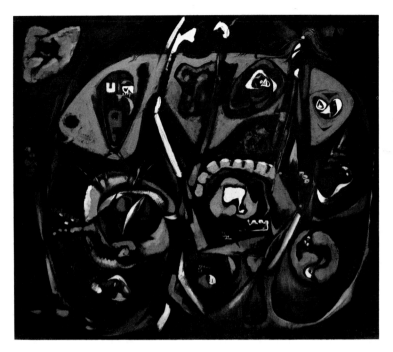

ing to the subterranean forces . . . I didn't abandon Surrealism but I gave it a new meaning, telluric . . ."[213]

Significantly the series was not begun until after Masson's first experience of an American autumn. Most of the paintings in this group are done in tempera on a dark ground, usually black or bistre. Glowing, almost phosphorescent colors are heightened by pastel overlays, and rich textural effects were obtained both by mixing sand with paint and by scattering its sparkling grains over the painted surfaces. The works of this series offer a lush, visually sensual experience that accords with Masson's description of an American fall: "When Indian summer comes, in October, there's no end to the variety of colors. There are the maples, under a sky of stained-glass blue; they range from yellow to violet, from purple to orange and vermilion, as if the sky had poured cans of paint on the vegetation."[214] Common to every painting in the group, which began with a canvas titled **The Cosmic Egg,** is the concept of germination, of gestating energy. Cocoon- and larva-like forms are pervasive, and the sense of imminent metamorphosis rests on Masson's projection of the alchemy of nature. In these paintings Masson attains his ambition "to paint the sex of Nature." Klee's characteristically ironic title, *Site of Unusual Happen-*

ings, for his 1929 drawing of an embryo, might well be used to describe any one of Masson's Telluric works.

Typical is **Indian Spring** (left), the central configuration of which is a huge egg whose interior is stratified by a multitude of highly unusual beings in various stages of embryonic development. The exterior egg seems to be buried in the ground and, at the same time, to be the nurturing earth itself. Although the movement of form and color rises toward the top of the canvas, we do not have the sense that the germinating life compressed within the egg will emerge at the top, but rather that is will burst forth, willy-nilly, over the surface of the earth-egg, as it were—so that what might be thought of as a horizon line at the upper edge of the egg is really the boundary of a flat cross section, or magic X-ray, of the earth's surface. Aside from the easily recognizable bird embryos at the lower right and center right, most of the forms within the egg are difficult to read without considerable knowledge of Masson's work. At the left is the fish, which, buried within the earth, symbolizes generation, as is made clear by a contemporary canvas that depicts a fish in the depths of the earth and is titled **The Seeded Earth.** Less clear are the other, somewhat hieroglyphic images; however, correlates for almost all can be found through a comparison with the drawing **Hatchings and Germinations** (p. 147).

Among the finest of the Telluric pictures is **Meditation on an Oak Leaf** (p. 60). Although not graphically automatist, this painting was born of an associative process that is related to automatic techniques. Instead of attempting to begin with the mind blank, the artist without other a priori intent focused his attention on an oak leaf, and the associations so conjured up became the basis for the imagery of the painting. Unlike automatism, however, which Masson has referred to as being like fishing—"You might catch a trout or an old shoe"[215]—**Meditation on an Oak Leaf** owes it success to the ineffable harmony prevailing between Masson's inspiration and his painterly cunning. It represents, to borrow a phrase from Arp, Masson with his "genius fins" showing. It is a sublime result of a process that Masson describes in the Prologue to *Anatomy of My Universe:* "Whence come these imagined forms? They come from my impassioned meditation, an attitude that poses an object, even in its first movement when it seems to be completely sunk in the undetermined. But soon, as in the process of dream-inducing hallucination, or after a first stage composed uniquely of vortical schemas, there appear forms already plastic like

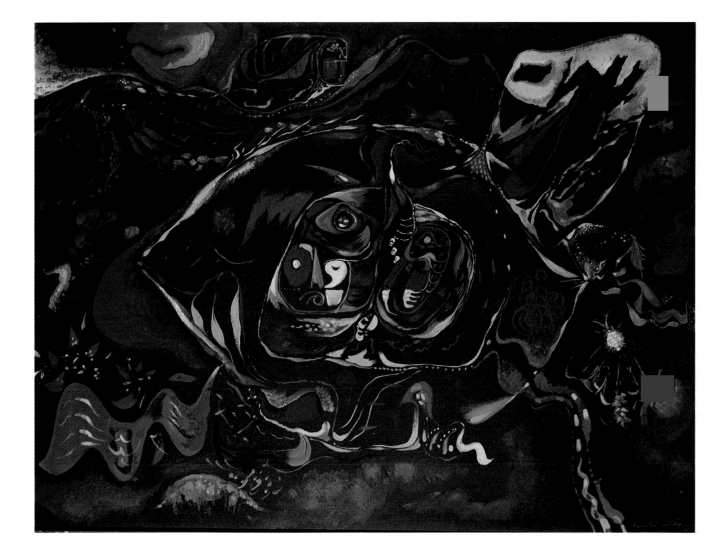

dreams and this meditative disposition calls up forgotten sensations, buried dreams. It is their polymorphous play that I orchestrate in their becoming.''

Play of both form and color is masterfully handled in **Meditation on an Oak Leaf**. In its complexity of internal rhyme, it is reminiscent of the work of 1925, but only in that way, however; there is no illusion of depth—the leaf is behind the other images only as a piece of paper is behind another that partially covers it—and its morphology is biomorphic. Masson speaks of *imbriquement* as a quality essential to good painting, and, in spite of its intricacy, **Meditation on an Oak Leaf** is structured so that each area fits into another in a manner that seems as inevitable as the orderly imbrication of the scales of a fish.

Evidently less abstract than **Entanglement** (p. 69), or even **Indian Spring** (left), **Meditation on an Oak Leaf** does not, however, yield to easy reading. What may first strike the viewer as a phantasmagoria of flat decorative patterns is actually a rich geography of the artist's imagination. That a meditation upon a leaf should start so many personal symbols suggests that Masson's primary association was to his frequently expressed poetic fantasy that the world itself is held in the sparkling of a drop of water on the tip of a leaf. Among the more immediately discernible motifs are the leaf whose glowing blue silhouette slides behind a welter of superimposed images and emerges at the middle right as the cactus-like foliage familiar from **Goethe and the Metamorphosis of Plants** (p. 154), the cat's head at the upper right, and next to it, two eyes—one a glowing red. As we know, the leaf plays a particularly rich iconographic role in Masson's art. The head of the cat has, however, no precedent in Masson's painting, and might seem to have been included without symbolic reference—exclusively for its value as a mysterious and unsettling presence. Comparison of the head to the imagery of the drawing **Hatchings and**

By the Sea. 1943.
Oil and sand on wood, 10 x 14".
Collection Mr. and Mrs. Dan R. Johnson, New York

In descending order of readability from the leaf, the cat, and the eyes are the images enclosed within the two largest cocoon-like forms that seem to issue from one another. Indeed, in a metaphoric sense, the entire painting might be said to issue from the lower oval, which is, in fact, a depiction of the artist in meditation—his figure a linear descendant both symbolically and plastically of the 1923-24 Sleeper (p. 100) and its related semiautomatic drawing (p. 101). Masson repeated this figure in **Meditation of the Painter**, a canvas that, by its palette and imagery, belongs to the Telluric series, although it was not painted until 1943 and its motif is not specifically related. Very similar to the plump, snail-like creature whose contours are being drawn in **Meditation of the Painter** (p. 160) is the larva below the dreaming painter in **Meditation on an Oak Leaf**. In the latter image a fertilization is unmistakably taking place, as indicated by the broken line that almost always signifies movement in Masson's art. A thicker broken line leads from the back of the artist's head to the outer contour of the upper cocoon, inside which we see a tree twisted by storm juxtaposed with what is probably a germinating seed. The fish at the middle left and most of the other images not enclosed by the two largest ovals are procreative symbols.

The viewer's complicity in Masson's dilation of his own consciousness cannot, of course, be explained by scrutinizing either iconography or methodology. If **Meditation on an Oak Leaf** draws us in and expands our own horizons, it is through ineffable qualities that obtain in the experience of visual art. We can, however, remark that not least of the magic properties of **Meditation on an Oak Leaf** is the operation of color. Painted in tempera over a black field, its yellows, reds, and blues achieve a brilliancy of impact not possible on a lighter ground. Particularly interesting is the handling of blue, normally considered a "cool" color. The blue of **Meditation on an Oak Leaf** generates greater heat than its reds or yellows; it seems, indeed, a blue flame. This appearance is achieved by scattered grains of sparkling sand in the silhouette of the leaf at the top left, by the blue pastel that is ground into the blue paint next to the red eye, and by its astute placement as a kind of atmospheric haze on the right, and its sudden appearance again at the bottom. Then, on the left, a mist of purple-red dissolves into a soft, scattered cloud of red brushstrokes. The total effect is of an incandescent blue nimbus—the metaphoric equivalent of the psychological vibrations produced in the artist by his impassioned meditation.

Germinations (p. 147) proves that such an interpretation would be too simple. From this drawing it is clear that the cat's mouth is an extrapolation from "La Pensée" form and that the structure of its "face" derives from the anatomical configurations of the female pelvis. Startling as this association seems initially, its visual logic is such that a viewer accustomed to the concept will find the cat's face staring out at him from such previously unexpected places as Leonardo's drawing *Dissection of the Principal Organs of a Woman* (fig. 20). The significance of the cat's head in **Meditation on an Oak Leaf** is not, however, fully explained by discovering its syntactical evolution. Masson associates the cat with Heraclitus, as is irrefutably clear from the portrait of that philosopher, made the following year, in which the principal features of the cat have been transposed to Heraclitus (p. 61). In **Meditation on an Oak Leaf** the cat's head rises seerlike above the interlocking depicted "events" in a way that suggests an earlier drawing of Heraclitus (p. 83) published in *Minotaure* in which the philosopher's head surveys a river and landscape from which it seems also to grow.

The two eyes connected by a figure-eight symbol of infinity are almost undoubtedly those of the painter— the glowing red eye on the right is particularly evocative of the navel-eye-suns of the paintings of 1925. An interpretation of the eyes as an updating of the watcher figure is supported by a comparison with the collage Martinique (p. 57) of 1941. In that work, the artist's gaze on Martinique is evoked by two eyes that are the negative impressions of the red eye of **Meditation on an Oak Leaf**, and the line that connects them to the collaged leaves on either side traverses an organically undulating form that is exceedingly like the half-black, half-phosphorescent-blue shape delineated between the eyes in **Meditation on an Oak Leaf**.

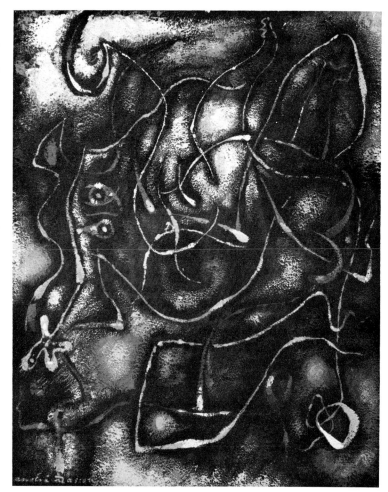

Andromeda. **1943.**
Tempera and sand on canvas board, 12½ x 10".
The Museum of Modern Art, New York,
Gift of Ruth Gilliland Hardman and William Kistler III

The rich palette developed in Meditation on an Oak Leaf and other Telluric paintings of 1942 carried over into 1943, although the motifs are less centered on procreation than they had been. Antille (p. 29) and Pasiphaë (p. 59), two of the most important paintings of the year, are both distinguished by luxuriant, glowing color. Antille is, of course, also related to the Telluric pictures of the previous year, in that its inspiration similarly derives from the impact of a new land upon the painter's sensibility; but, in the case of Antille, it was not the American mainland, but rather, as its title suggests, Martinique.

A voluptuously poetic painting, Antille is one of the finest works of Masson's American period. In it, the undulating curves of a black woman's body are both an erotic evocation of the nude figure and the contours of a lush tropical landscape. In earlier works Masson had often identified the female body with a landscape; but previously the body was always the earth itself. In Antille the body is more of the earth than it is its substance; its analogy might be to a fruit-bearing tree. In fact, in a drawing, Forest—Martinique of 1941 (p. 56), we see in the serpentine curve of a tree the first hint of the figure in Antille. Masson writes: ". . . on a black woman's nudity, the play of reflections becomes an absolute lyricism. In this body, which is a world, all the *savors,* all the *odors* are suggested. Total femininity, but it's also fruit—volcano flower—constellation. Milky river and bloody rain."[216]

A measure of the success of the painting is the "galaxy" of poetic associations that it provokes in the viewer—not only those intended by the artist, but others that inhere in the painting as do the potentials for dreaming in a melody. There is such a strong perfume of Baudelaire in Antille that it is difficult not to believe that Masson, who knew his work well, was not influenced, even if unconsciously, by the poet's rich, exotic imagery. Baudelaire recurrently equates the body of his beloved with a landscape, and often, particularly in the poems to his mulatto mistress, Jeanne Duval, there are evocations of strange lands—"languorous Asia and burning Africa." Haunted by the Gradiva theme, Masson says that Antille was specifically inspired by a beautiful black "with the step of antiquity."[217] Verses from Baudelaire's "Le Serpent qui danse" seem particularly apposite:

> Que j'aime voir, chère indolente,
> De ton corps si beau,
> Comme une étoffe vacillante,
> Miroiter la peau!

>
> A te voir marcher en cadence,
> Belle d'abandon,
> On dirait un serpent qui danse
> Au bout d'un bâton.

Although Masson knew Donne's work and made a drawing, Homage to Donne, in 1942, it is not likely that the English poet's work was in his mind, unconsciously or otherwise, when he painted Antille. Nonetheless the English-speaking viewer is almost irresistibly reminded of the imagery in two of Donne's poems, "Love's Progress" and "Going to Bed." In the latter, Donne's ringing words to his mistress

> O my America! my new-found-land
>
> My mine of precious stones, my Emperie

are perfectly paralleled by Masson's lusty visual paean. Antille is a wayfarer's report of the strange and wonderful things he has seen—of the kind that stimulated Goethe in his studies of plants and colors. He wrote in Part I of *Contributions to Optics,* "We are astounded as though listening to a fairytale, when a delighted traveler tells us about clustered palm trees

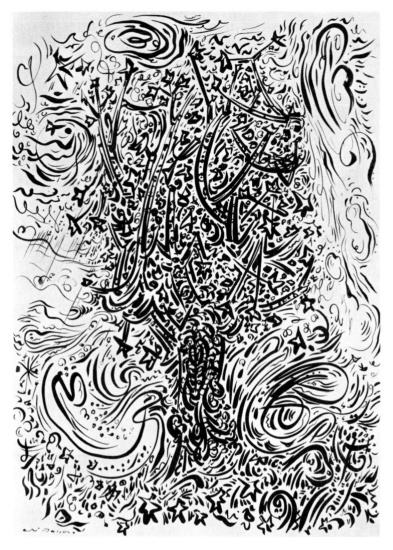

light and shadow round which half-tints gravitate."[219] Indeed, the strong yellow highlights on the woman's body, cradled by soft, shimmering tonalities of light purple that are, in turn, surrounded by velvety purple-black shadow, define the mounds and hollows of her anatomy—the inward curve just before the swell of the buttocks, the protuberance of collarbone, and the sheen of smooth rising shoulder. These and similar areas, enhanced by effects obtained by mixing sand with the pigment, contribute to a glistening appearance—as though the black woman's skin had been rubbed with oil. Although the palette of **Antille** is strongly indebted to that developed in the Telluric series of the previous year, the choice of purple as the predominant hue to convey the beauty and sensuality of a black body rests on deep, imaginative associations. Masson, like Baudelaire, certainly saw blackness as exotic—primally erotic. And, as had Picabia, Masson found purple the color to express this particular psychological set.[220] Purple was for him "at the dawn of man."[221] It is entirely likely that the largely purple tonality of **Andromeda**, a small automatist canvas of the same year as **Antille**, alludes symbolically to the fact that the legendary princess' mother was the black Ethiopian queen, Cassiopeia.

Although Masson's painting of 1943 tended to shift away from themes based on nature, his drawing reflects his continued fascination with the American countryside. In this year that he created an image successfully analogizing a black woman's body with tropical vegetation without any reliance on the kind of surrealizing, fantastic imagery that is rife in the late thirties, he made a series of extraordinarily vigorous ink drawings of trees whose expressive anthropomorphism is forceful beyond any of the explicit human-vegetable fusings depicted in the work of the end of the preceding decade. Typical of the series is **The Tree** (p. 64), in which the outer contours of a tree are defined by long, thickening and thinning brush-strokes and the entire area of the sheet is covered with short, choppy markings that are almost Oriental in character. The interaction between the chopped brushstrokes both in the area outside the tree form and within—where they are used to suggest bark and boles—creates a general sense of energy and movement as well as setting up scattered, individual vortices. The whole image appears to vibrate as though the tree and its surrounding vegetation were caught in a high wind or hailstorm. The elemental struggle depicted brings to mind Masson's description of the

infested with large multicolored flocks of parrots swaying within its darkened branches."[218]

The fact that the figure in **Antille** is seen from mid-thigh to shoulder, with the thrust-back head metamorphosing into the lush surrounding vegetable life, gives it a tenuous relationship with **The Armor** of 1925 (p. 115). The thread linking the two is, however, exceedingly thin. The static figure of **The Armor** suggests an antique statue, whereas the swiveling body in **Antille** recalls Mannerist variations on the late Hellenistic Aphrodite Callipyge, "the Venus of the beautiful behind." Because of the intricate interplay of light and dark, color and line, the front-to-back spiraling position of the figure in **Antille** is not as immediately obvious as are those of the figures in two closely related paintings of the same year, **Woman Attacked by Birds** and **Figure in the Wind.**

Describing his technique in painting **Antille** Masson says, "The budding forms are determined by cores of

Bison on the Brink of a Chasm. 1944.
Brush and ink, 31¼ x 22⅝".
Hirshhorn Museum and Sculpture Garden,
Smithsonian Institution, Washington, D.C.

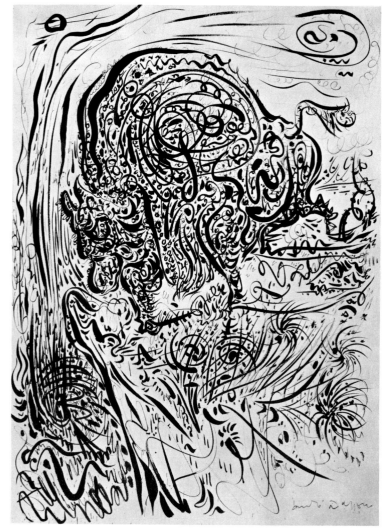

Connecticut trees as "martyred"[222] when, under the weight of ice, their branches crack and break. Devoid of the hyperbolic imagery of the late thirties, **The Tree** comes close to illustrating what Matisse meant when he had, ten years previously, remarked to Masson, "I don't like the word 'vegetative,' it's pejorative and leads to confusion,"[223] apropos of a wild fig tree that the two had seen growing out of a fissure in a large rock near St-Jean-de-Grasse.

Mythology had never ceased to provide a springboard for Masson's art, and in his work of 1942 Greek myth had not so much been supplanted by Indian legend as it had been "reclothed." Masson's renewed concern, in 1943, with the fables of antiquity, as **Andromeda** (p. 167) and the several representations of Pasiphaë witness, probably reflects a reassertion of European influence more than it demonstrates interaction with the American avant-garde of the time. Partly because of his fear of urban life and his inability to speak English, Masson was, in spite of such activities as contributing to the review VVV, more isolated than any of the other well-known Surrealists who spent the war years in America. So, in falling back upon Greek myth for his motifs, Masson was returning to personal and cultural patterns that had governed his mature career. As Clement Greenberg said in reviewing a joint Rosenberg and Buchholz show of Masson's work in 1944, "Masson strains after that same *terribilità* which haunts Picasso, is obsessed by a similar nostalgia for the monstrous, the epically brutal, and the blasphemous . . ."[224] As we know, both Picasso and Masson were almost obsessively interested in the Minotaur legend, and each produced a great deal of work dealing with the theme.

The two painted versions of Pasiphaë of 1943 are essentially extensions of Masson's continuing interest in the idea of human and animal fusion, parallel in concept to such prior works as **The Horses of Diomedes** (1934) and **Actaeon** (1934). In speaking of the larger, "finished" version (p. 59) of the two paintings of Pasiphaë of 1943,[225] Masson says:

What I wanted to do is the confrontation, the woman promised to the bull. And by the way, this painting was preceded by one called Birth of the Minotaur *painted at Lyons-la-Forêt . . . in which coition is the very subject of the painting. In this one, not so. There is a more interior fusion here. You can't see very well where the bull begins. You just make it out. Here is his back, his genitals, his penis is there, in front. Here appears the future Minotaur, it's in the loins of the bull which is impregnating the*

woman. *The hand implores the stars, it invokes them to witness this extraordinary deed which she, the woman, has to accomplish. This was done willingly. As for the woman's sex, it's at the center of the painting, almost on a diagonal with the bull's testicles. It's an entanglement. Here, the second breast becomes constellation. Everything in a universe in fusion.*[226]

The imagery of **Pasiphaë** hardly needs further explication than Masson's own, and its structure remains within the basic schema of flat interlocking forms established in the Telluric paintings of the previous year. The largeness of the figure of Pasiphaë, particularly compared to the bull, and the decorative patterning of her back and interior that suggests the framework of a labyrinth recall the monolithic Earth Mother figures of the late thirties.

Toward the end of 1943, the general pattern of Masson's 1929 rupture with Breton was reenacted. As fifteen years earlier, Masson's essentially nonconform-

Portrait of an Adolescent in the American Forest. 1945.
Oil on canvas, 25⅛ x 18⅛".
Collection Mr. and Mrs. Diego Masson, Paris

ist nature conflicted with Breton's didactic character, and the two men broke definitively. On December 26 Masson wrote to Saidie May:

I heard that the "executive committee" (Breton) was not very happy with me. I knew nothing of it because I was out of it all. But I guess it's because my mind's not easy to regiment, and then I remember I didn't spare my criticisms of the latest issue (VVV). I found the whole thing rather gray (dull) a little "cheap." In short too much Surrealist demagoguery, too much complacency toward dogmas only ruins of which remain. I am convinced that to indulge in mental chaos is as stupid and narrow as to stick to too much reason. And then one has to agree that if the disorder of the mind can furnish materials infinitely more interesting than the stereotypes of a dead order, there'll never be a work of art without a wish for order. . . . What's important is that the wish for order not be of an academic order like most of the painters of the Surrealist Academy (the true conventionalists of our time).[227]

The break with Breton did not affect the pattern of Masson's life, nor his participation in Surrealist activity, which was, in any case, peripheral, but it may have intensified feelings of isolation that his enforced exile had brought about. It was under these circumstances that he began at the end of 1943 to make a series of self-portraits, portraits of his wife, Rose, and of his sons, Diego (left) and Luis. Very quickly the portraits divided into two distinct types—those that were intimate, psychological studies and those that took on visionary depersonalized qualities. All the portraits of Diego and Luis fall in the former group, whereas the majority of self-portraits and those of Rose fall in the latter. There are fewer "pure" portraits of the artist and his wife than there are works whose apocalyptic titles indicate their remove from simple portraiture. From sketches of Rose grew a whole series of Sibyls, and their evolution was paralleled by the metamorphosis of the self-portrait in a group of works most of which are titled **Contemplation of the Abyss.** In both series, the imagery of which is so similar that they can be thought of as a unit, the head is nearly always profiled, calligraphy defines form, and pastel is often the dominant medium. Gone are the earth tones of the previous two years; these canvases abound in pale pinks, greens, mauves, and lavenders. And, in another stylistic reversal almost as abrupt, line has become the central compositional element—fluid and curling in the pictures of 1944, thin and splintery by 1945.

Related to the Sibyl and Abyss series are three works each titled **Demon of Uncertainty.** As is sug-

gested by the title, they depict the profiled head turned Janus-like in two directions. Like the representations of Sibyls and Abysses, the demon group objectifies the artist's introspection and expresses his feelings of anxiety and helplessness about the war. In a large pastel on canvas of the subject (p. 34), the two-headed figure appears to be half-male, half-female—its contours defined by a line so rapid that we feel we are witnessing movement itself. The energy of pull and thrust in opposing directions is intense, as though the demon's two sides were trying to tear free from a central magnet. Yet the endeavor seems rendered hopeless by the taut, elastic, vortical movement of line and shading, which will at any moment snap the straining heads back into a single entity. The conflict symbolized is, of course, largely personal and reflects long-standing philosophical and artistic dilemmas of the painter; such interior divisions were, however, exacerbated by more worldly doubts about the future. As we have seen, Masson's work swings between polarities—from spare and abstract to dense and representational. Although the significance of the **Demon of Uncertainty** can be found on several levels, it is the central problem of Masson's art that it chiefly exemplifies.

Conceptually the Demons are most closely related to the Massacre series and that of the Earth Mother trap. While Masson's art has been centrally involved with conflict, it is most often expressed as the force that ultimately fuses vegetable, mineral, and animal kingdoms within the dominion of the four elements. In the Demon, Massacre, and Earth Mother–trap groups, scope is less cosmic. Violence stems from internal, human conflict, and its resolution does not come from transmutation from one genus to another, but from an ineluctable integrity of pattern: Eros and Thanatos simultaneously govern; maleness and femaleness are locked within the same individual. For man's parochial dilemma there is, in fact, no psychic solution; he may stoically endure his condition or he may, as Masson would prefer, affirm it with a Nietzschean joy. Similar to the Demon works is a drawing, **Light and Dark** of 1945, that states the confrontation of coexisting opposites in a particularly dramatic way. The dark, sinister profile at the left is locked in hypnotic exchange with its positive light image on the right. No issue is implied in their meeting; rather, they stand for the eternal and equal reign of Dionysus and Apollo.

Given the state of mind indicated by **Demon of Uncertainty,** it is entirely natural that portraits of his

Sibyl. 1944.
Ink, 11⅛ x 8¾".
Collection Mr. and Mrs. Joseph Slifka, New York

chiefly distinguishes the Contemplations of the Abyss is the presence, at what appears to be the center of the abyss, of a floating embryo. Symbolizing both the original cosmic flux—Nerval's "void as the shadow of the ancient chaos"—and the uncharted areas of the mind, the abyss has appeared previously in Masson's art. Among other places, we have seen it in the cosmic vistas of the twenties, as the operative principle in automatism, and in the heavens of Montserrat. Similarly, the meditating visage of the artist is another step in the pictorial evolution of the contemplating male figure first seen with bowed head in the Card Players of the twenties and most recently in **Meditation of the Painter.**

Masson's preoccupation with the concept of the abyss in 1944 and 1945 was probably the result of pondering the cataclysmic effects of the war—an association of its annihilating destructiveness with a return to primal chaos. There is a poignancy to these images of contemplation that suggests a wonder similar to that expressed in a contemporaneous American poem, "From the Naked Bed in Plato's Cave": "The Mystery of beginning/Again and again, while history is unforgiven."[228] Viewed in this manner, the embryo signifies both hope, for renewed life, and despair, over the inexplicably recurring cycle.

The embryonic form is usually larger but otherwise essentially the same as it variously appears in the Telluric series, and its presence as a generative symbol in the middle of the abyss corresponds with an ancient Greek cosmogony that goes back at least to the time of Hesiod. According to this account of the creation, Erebus and Eros were the first beings. Floating on the sea of Chaos was the egg of night from which issued Eros, whose fertilizing force caused heaven and earth to embrace, and by various ensuing marvelous occurrences the cosmos, as we know it, came into being. In expounding his ideas on the existence of myths, Masson remarked years later, and with self-evident irony: "At the risk of calling down the wrath of some scholiast, present or to come, I'll assert without any proof that at the dawn of the mythical world there reigned the Blazing Sun and the Tenebrous Mother Earth, uniquely and originally . . . I could find pleasure in this idea; somewhere on this earth is a central point where a vulvar opening receives a solar ray which, privileged, reaches a telluric germ (germ of all germinations) and so gives birth to what we call life."[229]

Although the war may have been the primary impetus in developing the theme of the abyss in the

wife should have led Masson to develop his Sibyl series. His musings on the uncertainty of the future, combined with the reemergence of his interest in Greek myth, had already led him to oracular themes, as is demonstrated in two paintings of the Pythia of Delphi, which (although stylistically much closer to **Pasiphaë** than to the Sibyls) show the increasing compositional importance of line. With the exception of a powerful full-face drawing (above), which is more individuated as a portrait of Rose than other works in the series, the Sibyls are all shown as a classicized profile in a meditative pose with the chin resting on the hands. Whether executed in pastel as the **Sibyl** of 1944 (right) or in a mixed medium the predominant element of which is sand, as in **Auguring Sibyl** of 1945 (p. 184), the contours of the head are described over shifting, organically shaped color areas, the effect of which is to evoke the "pneuma" which the ancients thought to be the source of sibylline clairvoyance.

The Abysses, which are less directly self-portraits than the Sibyls are portraits of Rose, are compositionally so similar to the Sibyls that Masson seems almost to have used the same profile interchangeably. What

Sibyl. 1944.
Pastel on canvas, 39¾ x 32¼".
Collection Rose Masson, Paris

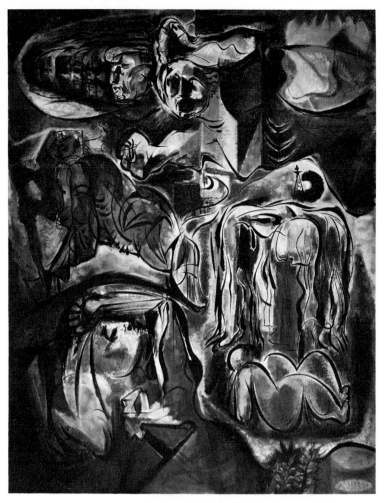

top:
The Resistance. 1944. Oil on canvas,
69¼ x 54¾". Galerie Louise Leiris, Paris
bottom:
Head of a Partisan. 1944. Tempera and gesso on masonite,
17¾ x 13¾". Private collection, New York

mid-forties, it should not, however, be assumed that this diminishes the relevance of the void as a metaphor for the unconscious. The imagery of the Abyss series symbolizes the creative process of the artist even as it operates on another level.

In 1944, the year the portrait became dominant in his art, Masson began making a series of sketches projected for a large painting that would celebrate the spirit of the French underground. Although the painting was never executed in the immense format originally contemplated, Masson did complete a large oil called The Resistance (left) that is, in many respects, reminiscent of his Spanish-related work of the late thirties. Dealing with a motif directly commenting on the war, Masson, not surprisingly, partially reverted to a style that he had previously used polemically. In spite of its overall structural resemblance to previous work, The Resistance reflects the fact that it was painted during the period of Masson's heightened interest in portraiture. The multiplied profiles at the upper left come out of a small oil sketch entitled Head of a Partisan (below), which in technique is related to the vigorous, choppy style of his contemporary drawings, but is "set" on the canvas in a manner analogous to the imagery of the Sibyls and Abysses. It is more than likely that the artist identified with his partisan at least as much as he did with the philosopher of the Abysses. And the silhouetted, elegiac head of the woman at the bottom left is unquestionably related to a portrait of the artist's wife of the same year, entitled Portrait of Mme R. M. (right). Although the arm of the woman in the lower left of The Resistance is raised in the gesture of Pasiphaë, the modeling of her features is, like that in the Portrait of Mme R. M., strongly reminiscent of Delacroix—particularly evoking the facial type of all the female profiles in *The Massacres at Scio* and that of the young girl in the related *Orphan at the Cemetery*. In fact, the movement and placement of the forward-thrusting figure at the upper center of The Resistance suggests the stance of Liberty in Delacroix's *Liberty Guiding the People*. That Masson may have found inspiration in Delacroix would evidence the beginning of a tendency to turn toward the great masters of nineteenth-century painting—particularly French—which would become pronounced after his return to France. While Masson, unlike most of the exiled Surrealists, profited enormously from his American experience, he is profoundly European, and, in spite of his declared non-chauvinism, extremely French; it is entirely natural that a combined nostalgia and

top:
Mme Rose Masson. 1944.
Oil on canvas, 8¼ x 10¼".
Collection Rose Masson, Paris

bottom:
Self-Portrait. 1944.
Oil on canvas mounted on cardboard,
13½ x 9⅜".
Collection of the artist, Paris

homage should begin to manifest itself toward the end of his stay in the United States.

In a small oil sketch of 1944 Masson gives us a self-portrait (below) that vividly illustrates his state of mind. A network of slashing brushstrokes covers the canvas, defining the artist's features while only suggesting the contours of his head. The brooding, hooded eyes stare straight ahead with an unsettling intensity—their gaze penetrating, as it were, the web of spiky brushstrokes that seem to have been laid on by a hand driven by passion and fury. The effect is as though Masson saw himself "mirrored" amid the furious brushstrokes of his own canvas. In another sense, the screen of crisscrossing strokes acts as a metaphor for the artist's feelings of alienation. Articulated in this self-portrait is a sentiment very similar to that expressed by Denis de Rougemont regarding his own wartime exile and addressed to those who had endured the occupation: "You were occupied, we were in exile, and we all were equally in the realm of the unaccepted, in profound dispossession."[230]

In no wise expressionist as is the Self-Portrait, **Elk Attacked by Dogs** (p. 68), the last painting Masson made in America, and drawings such as **Bursts** and **Arborescent Figures**, both of 1945, are syntactically related to the earlier painting. All these works present a rhythm that pulls the composition into a unified pattern echoing Masson's own Massacres and anticipating the alloverness of later American painting. In the drawings the allover design is accomplished by a kind of see-through wash blanket laid relatively evenly over underlying forms; in **Elk Attacked by Dogs** and the related paintings, **The Kill** of late 1944 (p. 65) and **Elk Hunt** of 1945, swirling, sweeping line describes a more or less even distribution of movement over the entire surface of the canvas. Except for **The Burrow** of 1946 (p. 178), which is, in some respects, closer to **Indian Spring** (p. 164) than to **Elk Attacked by Dogs**, Masson did not continue to explore the possibilities posited by the latter painting until several years after his return to France.

The end of the war in 1945 made it possible for Masson to return to Europe. Before his departure in October of that year, he completed a suite of drawings and lithographs for the album *Bestiary* that Curt Valentin published the following year. Of *Bestiary*, which is based generally on the theme of the bestiality of the human animal, Masson remarks: "This *Bestiary* is not pleasant, it's full of black thoughts; it's like a refusal to communicate a furious anguish and all the

while proclaiming it." In a May 1945 review of a Masson exhibition held at Curt Valentin's Buchholz Gallery, Robert Coates singled out the prints for *Bestiary* saying, ". . . especially the lithographs are filled with a brooding quality, half savage and half sombre . . ."

Elsewhere in the same review Coates comments on what the general situation of the Surrealist exiles in America had been, and, justifiably, points to Masson's experience as exceptional. Because Coates's remarks are both of the period and illuminating they are worth citing:

On the whole, the position of the refugee artists in this country has been a tough one, and the complaints that have occasionally been leveled at them by American painters and others should be considered with that fact in mind. If they've been cliquey—and it's true that a good many of them have—it should be remembered that the pulls of old friendships and associations are strong, particularly in a foreign country. If they've shown a certain condescension at times toward certain American art, it should be acknowledged that, in a historical sense at least, that attitude was justified; the French tradition may quite possibly by dying, but it isn't dead yet, and every Frenchman, big or little, carries with him the prestige of Renoir and Cézanne and all the others who have made the wheels of the world go round, artistically, for the past seventy-five years. Add the fact that these men did not really want to come here in the precise way they came, hurriedly and in flight, and with all the regrets and uncertainties that such a way of coming entails, and you have a fair explanation of any recalcitrance in their attitudes.

Where they have failed, I think, is in not taking full advantage pictorially of the physical facts of the country itself. I would cite André Masson . . . as one of the few exceptions. While so many of the others have remained locked away in their studios, painting as if with eyes deliberately averted from everything that wasn't reminiscent of Paris . . . he has had the courage to look around him. Though he is one of the most introspective of painters . . . there is no question but that he has profited by the experience, and his work . . . has shown a richness and variety of pattern that it rarely had before.

I am not chauvinist enough to imply that this country was responsible. There is no magic in the air here or anywhere else, and Masson's gain has derived primarily from his ability to absorb new impressions and integrate them with his previous knowledge.[231]

Masson has always been an artist unafraid of risk, and occasionally, as must happen, that fact has operated to his detriment; however, without that courage he most certainly would not have been able to achieve the cultural mix that gave rise to the finest work of his American period. Masson himself sees his work in the United States as constituting "a definite cell within walls; studies after nature accepting any object whatever without any a priori intentions, without an attempt at analysis, without any aesthetic preconceptions—in short an application of the automatic approach to whatever object comes up . . ."[232]

The difficulty that Masson faced on his return to France was the reaccentuation of a familiar problem in his art, one that Georges Duthuit, his old friend and frequent wartime visitor to Connecticut, expressed as follows: "Masson has to *contend* with his own technical gifts, which have the richness, the precision, the density and balance of the high, classical manner."[233]

ON HIS ARRIVAL in France, Masson and his family spent only three weeks in Paris before settling in Vourneuil-sur-Biord near Poitiers. The deeply desired, return from exile was a bittersweet joy for Masson. Not only was the spectacle of a war-shattered France painful to him, but the sudden return at this midpoint in his life to the land whose artistic traditions had nurtured him set up conflicts in his art that were to prove extremely difficult to resolve. Nonetheless he set to work almost immediately, as he reports in a letter to Curt Valentin of February 19, 1946, that also expresses his deeply felt attitude about the force of the French artistic tradition: "Dear Old Curt—Writing is difficult for me because I'm working my head off. To what end I can't say yet. I had to put down roots here again. America now seems something happy and pacific to me when I see the shambles of France, but I haven't for a second regretted returning. Even if art is on the verge of ending, it's here it will end . . ."[234]

No clearly defined stylistic or thematic current binds the work of Masson's first full three years after his return—an indication of the inner turmoil provoked in the artist by his readjustment to his native land. Besides an initial group of self-portraits, there are works that, in subject matter, palette, or technique, are reminiscent of the Telluric paintings; others employ calligraphy over flat planes of color, in a manner recalling the Sibyl and Abyss series, to depict domestic scenes; and, toward the end of the period, an increasing tendency toward close studies of nature and landscapes is manifest. There are few depictions of explicit conflict or violence, and the evident unease expressed in the self-portraits of 1945–46 and **The Burrow** of 1946 (p. 178)

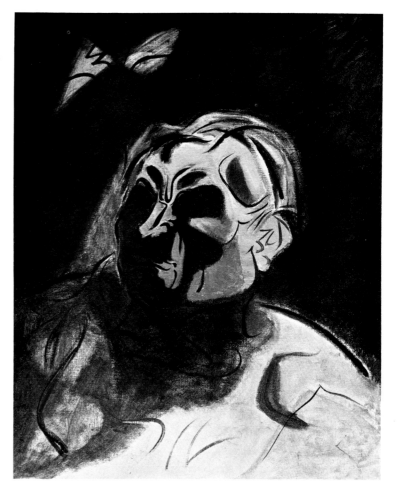

Portrait of the Painter. 1947.
Oil on canvas, 24¾ x 22¼".
Collection of the artist, Paris

is absent from the work of 1948. Perhaps the most pervasive feature of the work of these three years is its tendency toward a reliance on modalities established in past art—a reliance that was to culminate in Masson's Impressionist period of 1950–54.

In a group of cathartic self-portraits executed in the first two years after his return to France, Masson seems to have found a partial means to exorcise his war-induced anguish and the tension that his homecoming initially produced. The first of these, **Torrential Self-Portrait** of 1945 (p. 12), is done with reed pen in the vigorous, dense style of the drawings of his American period. Of its manner of execution Sartre remarks: "Sometimes he works the interior of the body with broad strokes; at the same time he reduces to a minimum the line that forms the outer edge; the accent is placed on the substance; furrows, striae, fissures appear as internal movements of the flesh while the tracing that delimits, dead, inert, loose, seems a provisional limitation of its expansion."[235] Directly related to a very beautiful painting, **L'Éphémère** (p. 80), executed earlier in the year in America, **Torrential Self-Portrait** conveys the artist's anxiety through the extreme violence of its swarming, thickening and thinning lines, just as brilliant, almost Fauve color was used for similar expressive purposes in the earlier painting. Masson's lifelong identification of the struggle of man with that of nature is manifest in the title of **Torrential Self-Portrait**, but no such hint is needed if the viewer compares this drawing with Masson's animistic studies of trees of 1943 (p. 64) or with **The Maple Tree in the Storm** of 1943–44 (p. 168), its conceptual twin.

By 1947 Masson's state of mind had considerably calmed, and the expressive function of the self-portrait had altered. One of the last of the immediate postwar self-portraits, painted toward the middle of 1947, presents us with an image of the artist that is far less a reflection of inner conflict than it is an expression of determined resolve. In the set of the image on the canvas, its reliance on chiaroscuro effects, its preponderantly brown and ocher palette, and above all its handling of line, **Portrait of the Painter** (right) strongly recalls Daumier. This does not imply, however, either a conscious identification or a deliberate pastiche on Masson's part; rather it reflects the impact of his renewed contact with France and a desire to get away from the "grammar" of twentieth-century art.

Aside from self-portraits, the paintings of 1946–47 that most directly reflect the feeling inspired in Masson by the war are **The Burrow** (p. 178) of 1946 and **Niobe**

(p. 179) of 1946–47. Their only point of similarity, however, is that they spring from the same experience. The earlier canvas is a private confession of terror and anxiety syntactically based on the Telluric compositions of 1942–43, and the later is a public statement, "A sort of monument to suffering . . ."[236]

Although **The Burrow** is similar in ostensible subject, palette, and articulation to paintings of the Telluric series, it conveys no sense of germinating energies as do all of the latter. The burrow of the title is a confining labyrinth from which we sense there will be no bursting forth; conceptually it is most analogous to the Piranesian *souterrains* of 1924. Masson, who knew Kafka's work well, may have been partially inspired by the latter's story, "The Burrow," which recounts the agonies of a terrified, haunted creature endlessly moving through underground passageways to escape his enemy. This supposition is supported by the artist's own explication of his painting: ". . . it's a cavern without discernible limits; a being lives there, half insect, half man, his ear to the wall, uneasy, trapped; and for the first time stars appear in this subterranean

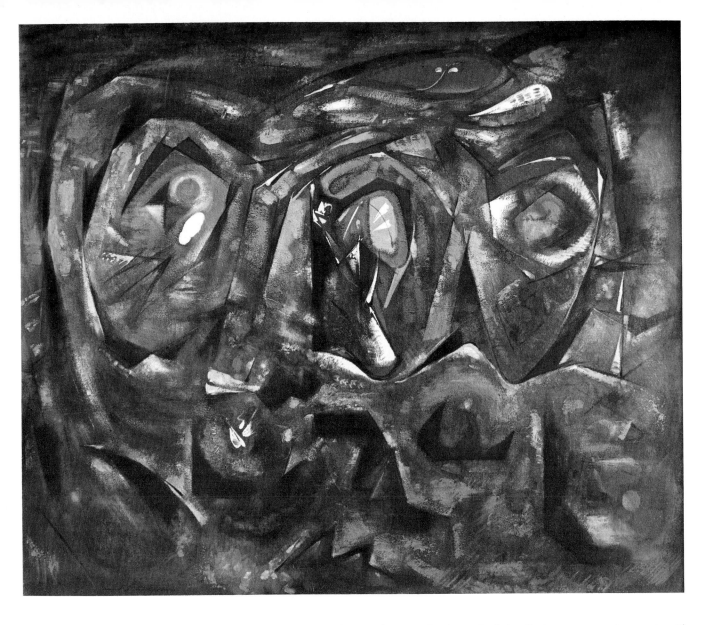

world. They can't be situated. Is it that this earth, become entirely subterranean, allows the sight, through gulfs and corridors, of suns and of orants, of disquieting stars . . . or is it that these stars turn round this earth reduced to this burrow? It's impossible to decide."[237]

For all that **Niobe** was intended as Masson's "official" memorial to war-inflicted suffering, it does not have the bite of either **The Burrow** or the 1944–46 self-portraits. Masson began it in late 1946 and finished it in 1947, at a time when his own war-caused anguish was quieting and he was simultaneously experiencing a crisis in finding the direction of his art. **Niobe** displays Masson's great technical brilliance without, however, finally succeeding in its heroic aims. Based

on the legend of the Theban queen who wept until she was turned to stone after her seven sons and seven daughters were killed by Apollo and Diana, **Niobe** was specifically conceived to commemorate the suffering of women and children in the war. The relevance of the Niobe legend to the significance of the painting makes it entirely natural that Masson should have used it. Georges Duthuit's long, bitter poem about the occupation of Paris, *Le Serpént dans la galère*, which Masson had illustrated in 1945, may also have had a role in suggesting the theme: "For the warriors' enjoyment there were Niobes kneeling along the embankment, screaming in despair . . ."[238] The large size of the canvas, the expanses of brilliant green, orange, and yellow of the ground, and the extravagantly Bar-

The Burrow. 1946.
Oil and tempera on canvas, 33⅛ x 40⅛".
Musée Cantini, Marseilles

Niobe. 1947.
Oil on canvas, 70⅛ x 55⅛".
Musée des Beaux-Arts, Lyons

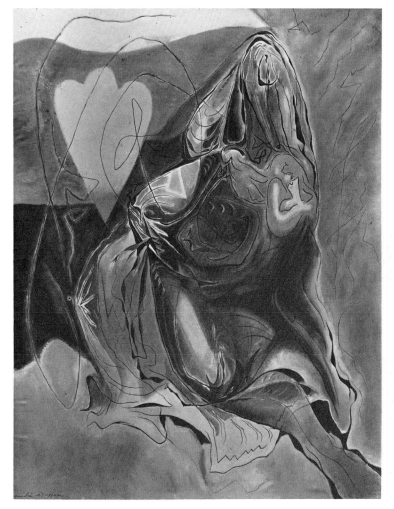

oque attitude of the dying queen combine to impart a rich, decorative presence to the painting.

The radical reappraisal of his art that Masson was making during the years 1947–49 is illustrated by the parallel phenomena of the disappearance of Greek myth—Niobe was virtually the last painting to draw upon it until the late fifties—and the reappearance, for the first time since 1925, of the still life. Masson's choice of subject for his first still life was an old shoe that lay in the moat of the château near Poitiers where he was living. He treated this theme twice, once in a marvelously strong drawing in sepia relieved with red ink and again in a painting of almost equal force. That the object selected was an old shoe invites comparison with van Gogh. But, apart from the gnarled form of the shoe that seems to retain the contours of the wearer's foot as well as suggest his hard, physical labor, the painting has little in common with those of van Gogh on the same subject. Although not in any way influenced by Miró, Masson's painting has in its dramatic highlighting more affinity with his Spanish contemporary's Still Life with Old Shoe than with van Gogh's work. The drawing, however, like all of Masson's drawings of the period, has strong similarities to van Gogh's reed-pen, orientalizing drawings of all subjects of the Arles period. In van Gogh Masson saw the parallel of his own conception of the animism of nature—so clearly expressed not only in **The Old Shoe**, but in the tree series of 1943-44 and **Torrential Self-Portrait** of 1945—characterizing van Gogh's trees as "murderous cypresses." While the influence of older European art was strong in Masson's work at the time, the affinities of his drawing with that of van Gogh predated his return to Europe, and are, in any case, most attributable to the similarly passionate natures of the two artists, the reed-pen technique, and their mutual tendency toward the Oriental.

The reemergence of the still life in Masson's art was a facet of a general movement away from themes of cosmic implication toward genre and landscape motifs. While a painting such as **The Boar** of 1946 depicts animal struggle, it hardly belongs to the prior tradition of Masson's art in which such conflict is viewed as a generative, metamorphizing agent; a scène de chasse, it forms part of a new strain inspired by the domestic and farmyard activities of everyday life. Manifest as early as 1944 in **Bread**, a painting of Rose cutting bread, the impetus to make of his work a record of the sensuous, warm, sometimes banal transactions of domesticity was greatly intensified in

Masson by the growing inner peace his readjustment was bringing about, as is demonstrated in such paintings as **Woman Ironing, The Hurt Bather** of 1946, and **Day Diagram**, 1947. Paradoxically, these pleasing and decorative paintings bear witness not only to the beginning of the only extended period of psychic calm in Masson's life, but also to the intense struggle regarding the direction of his art that was beginning to overtake him.

His strongest work of the period was his drawing, and it was this very mastery that was causing him great self-doubt. As he wrote to Curt Valentin in September of 1947: "My drawing right now takes on such vigor that it has to be watched. I've always feared a display of force."[239] As part of this self-policing he had re-

Before a Cascade. **1949.**
Oil on canvas, 39½ x 37⅞".
Galerie Louise Leiris, Paris

opposite top:
The Mistral. **1947.**
Oil on canvas, 31⅞ x 39⅜".
Private collection, Paris

resemblance to lithography—with the large color areas functioning like those formed by ink washes in color lithography.

Since his return to France Masson had, in fact, worked increasingly in lithography; besides making individual works he produced in 1946 sixty-eight prints to illustrate Malraux's *L'Espoir.*[240] His contribution to Malraux's book was not, however, Masson's only activity in the renascence of French cultural life. Among other projects, he designed the costumes and sets for *Hamlet* produced by the Jean-Louis Barrault–Madeleine Renaud Company at the Théâtre Marigny in November of 1946. For this event a new translation of the play had been made by André Gide. Describing Masson's contribution to the production, Douglas Cooper wrote: ". . . Masson has broken with the conventional English conception and if a parallel is sought it can, I think, be found in the early works of Delacroix. Scenically the play was presented with a permanent but variable set. The backcloth was painted in four horizontal stripes—indigo, blue gray, almond green and beige—symbolical of the four elements . . . Masson's theatrical conception was that the whole court of Elsinore represents death and corruption; accordingly he adopted a very limited color scheme of beige, gray and pale green. . . . Hamlet alone stood out, wearing his conventional black. Try as he would, I remember Masson saying to me, there was no other colour possible . . . Life and sanity first burst into this morbid atmosphere in the form of brilliant scarlet, yellow and blue costumes in the Play Scene . . ."[241] In the same year that he worked on the decor for *Hamlet* Masson designed the sets for a production at the Théâtre St-Antoine of *Morts sans sépultures* at the request of its author, Jean-Paul Sartre, who had admired the artist's work for Barrault's 1938 presentation of Cervantes' *Numance.* Masson did not participate in the first postwar Surrealist exhibition at the Galerie Maeght in 1947, but this demonstrated no lack of involvement in contemporary intellectual tides, for the show was but a pale and moribund reenactment of former Surrealist manifestations.

Despite Masson's resolution to give up drawing, the receipt toward the middle of 1947 of a type of paper that he had not been able to obtain since before the war triggered an irresistible impulse, and in the space of a day and a half he furiously drew a suite of twenty-two drawings, published in 1961 by Mourlot under the title **Vingt-deux Dessins sur le thème du désir,** with an introductory essay by Sartre. Masson remem-

solved in the previous year that, except for printmaking, he would shun drawing to the largest possible extent—no easy effort for this natural and highly accomplished draftsman. Indeed, it was not until 1950 that he was briefly to come near the full realization of this goal in his painting. Although calligraphy is an evident and important element in such canvases as **Woman Ironing, Hurt Bather,** and the **Day Diagram,** as it is also in the various views of the port of La Rochelle (1947), which spring from a similar desire to paint the near and familiar, it is almost exclusively used to articulate the large blocks of color that are the basic structural units of the compositions. This forced attempt to weaken the importance of line does not totally achieve its aim, and gives to the paintings a curious

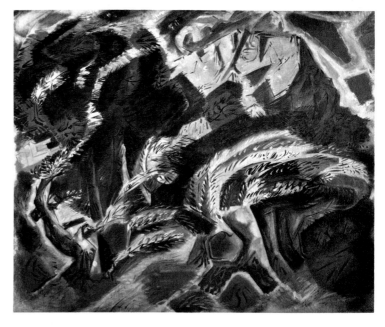

bottom:
The Tree. 1949.
Oil on canvas, 45⅝ x 35".
Formerly Rutland Gallery, London

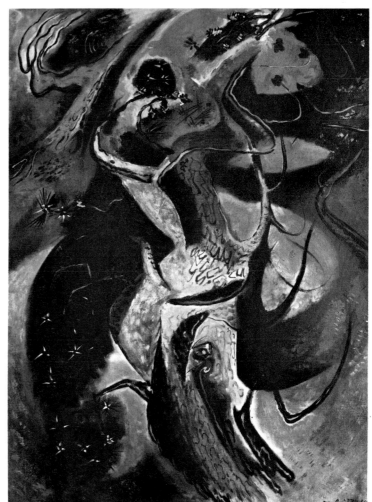

bers that he executed these drawings as though in a trance, and that after their realization he was seized by a tremendous sense of nervous shock. In style and subject matter these drawings are far closer to those executed in the late thirties than anything he had done in the intervening years, and are at a complete remove from the general direction his art was taking in 1947. It is as though the feel and sight of the paper he associated with the work and ambience of a previous decade had acted as a kind of time machine of the imagination briefly transporting him to another era. Whatever level of his subconscious had been plumbed in the unleashing of these drawings, it was to lie almost totally quiescent for the succeeding twelve years until the end of his Asiatic period.

In October of 1947 Masson moved to L'Harmas, a pleasant country villa in the shadow of Mont-Ste-Victoire in Le Tholonet, outside Aix-en-Provence, where he still spends six months of every year. It was here that he began, in a search to find an "art of mist," to paint in the Impressionist manner that would serve as a bridge to his Oriental art of the fifties. Masson recalls his first reaction to his new surroundings: "My strongest impression upon settling in on the Tholonet road was the sight of the Arc Valley bathed in the morning mist, and the Mont-Ste-Victoire, only its summit emerging from the vapors. Exactly like a painting of the Far East . . ."[242] It may seem curious that Masson, whose formation had taken place within a tradition of modernism the foundations of which were laid by Cézanne, should associate the view of the countryside around Aix with Oriental art rather than with the master whose name had by then become virtually synonymous with that of Mont-Ste-Victoire. But, given the fact that Masson was in a period of profound doubt concerning the previous currents of twentieth-century art, it is not so surprising that his thoughts did not turn to that artist whom Picasso had characterized as "like our father."[243] Seeing Cézanne precisely as the forerunner of Cubism, Masson, consciously or unconsciously, wanted to bypass him. Writing in 1950, he remarks: ". . . a century of splendors and pictorial feasts (from Delacroix to Renoir) is succeeded by an ascetic era. Few artists, these fifty years, have escaped the linear imperative . . ."[244] Thus we may regard the Impressionist-type painting of Masson's first years in Aix as representing one of his last and strongest efforts in the struggle to throw off Cubist structuring, a struggle that had engaged him with varying intensity since the early twenties.

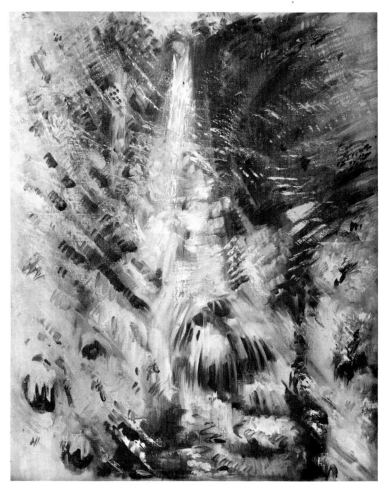

Cascade in Winter. 1951.
Oil on canvas, 24 x 19⅝".
Private collection

In some rather woolly charcoals and pastels done in late 1947 and in 1948, such as **Flow** (1947) and **Bather at Waterfall** (1948), we see the first results of Masson's decision to give up drawing, and his first adaptations of the art of Renoir. It would not, however, be correct to interpret the radical stylistic change heralded by these drawings as indicative of basic change in the philosophy of the artist. Rather they result from a decision, whose wisdom he was later to question, to shift his formal means so that his art might more fully express his vision of a world constantly in flux. In *Métamorphose de l'artiste,* Masson describes his thinking: *I remember being attracted, those many years ago, gripped, obsessed to express the development of moving forms . . . Thinking I commanded a free intelligence in this direction, never a doubt crossed my mind, never a suspicion of having made a wrong turn. So I used a whole arsenal of stains and lines, thinking I had nothing better to dispose of . . . Till the moment facility and then satiety led to doubts as to whether these means had an absolute value. After a period of moulting, really impossible to describe, I began to see what decision to make: to*

abandon every recourse to the linear, to deny myself totally the graphic symbolism that had till then supported me. In other words, the thing was to rediscover for my own good the pictorial. I suddenly realized that I had in fact borrowed the techniques of drawing and introduced them excessively into my paintings, all in the way of expressing these developing forms. And here my thinking forced a confrontation with the pitiless truth: the line, even juxtaposed with colored and fugitive stains, limits the action. In short, these lines were only the skeletons of movement . . . Agitated these paintings were, but where deep movement was concerned, or the universal rhythm, they were only intellectual incitement . . .[245]

As is the case with most artists when they arrive at a decision to alter their expressive means fundamentally, Masson's decision to banish line was not accompanied by a simultaneous total transformation of his work. Rather, from late 1947 through 1949, we see him approaching by starts, stops, and detours the full-blown Impressionist-Turneresque style of 1950–53. This is perhaps fortunate, as many of the paintings executed in the stages of that journey have a freshness and typically Massonian touch that his translation of Impressionism would vitiate. Among such paintings are **The Mistral** of 1947 (p. 181) and **The Tree** of 1949 (p. 181). Both implicitly personify nature, the swirling forms of the former recalling **The Storm** of 1924 and those of the latter **Antille** of 1943 (p. 29) and the related drawing, **Forest—Martinique** (p. 56). Interior forms seem less governed by the right angles of the framing edges than in preceding work, and their contours are defined by juxtapositions of light and dark more than by drawing—line has not been abandoned, although its use is largely peripheral to the ordering of the compositions. Nevertheless its whiplash, calligraphic character in **The Tree** provides a large measure of that painting's interest, and anticipates the use of line in Masson's Oriental period, even as the earthy tones over which it is described recall the palette of the Telluric series. Like **The Tree,** **The Mistral** is painted in strong colors; its hot reds and pinks sweeping in truncated concentric waves from the top right, down, around, and up toward the top left impart the force of the fierce, dry wind and suggest an allusion to van Gogh's words, which Masson himself has quoted: "It is/the Mistral/ a red wind that drives you crazy . . ."[246]

As promising as the path opened by **The Tree** and **The Mistral** seemed to be, it proved, at that moment, a dead end for Masson, as such paintings as **Rising Sun over a Torrent** of 1949 demonstrate. Syntactically

Flight of a Partridge. 1950.
Oil on canvas, 25⅝ x 18⅛".
Formerly collection Pomaret, Nice

analogous to The Mistral, Rising Sun over a Torrent has lost all the gestural freedom of the earlier painting. Masson's self-imposed inderdiction of drawing seems to have acted as a spiritual weight depressing the agility and lightness of the artist's hand. The suppression of drawing has acted to close rather than open form, and the blunt contours of the bulky configurations stop movement in a way that Masson's "drawing edge" had never done. The composition has an inertia extremely rare in Masson's art and completely alien to his temperament. Its rather crude, expressionistic effect was at the opposite pole of Masson's desire to rediscover an art that would disclose the fleeting moment of sensation.

"Rediscover" is, here indeed, the affective word; although with hindsight we may remark that Masson in such works as Rape (p. 62), Elk Attacked by Dogs (p. 68), and The Kill (p. 65) had charted a course holding promise of new realms, his return to France had turned his gaze backward. Since early 1947, when he began to experience on the one hand an assuagement of his lifelong psychic tension and on the other severe self-doubt about the role of drawing in his art, he had been increasingly absorbed in the study of Renoir, Monet, the late Turner, and the painting of the Far East. From what Masson interpreted as the common principles informing these expressions, he extrapolated ideological guidelines that initially—from 1950 through 1952—result in paintings that are unabashedly Impressionistic and later—in 1953 and 1954—lead to work that is overtly Oriental. The chief convergences that Masson found in his elected art of the West and that of the East were what he intuited as their mutual attempts to convey the living, present sensation and to make the depicted object meld with its surrounding space.

If we compare Masson's words on certain kinds of Eastern art with others on Impressionism and Turner, the parallels that attracted Masson become apparent. Of Monet he observed: "Acceptance by the painter of the flight of time, of the ephemeral . . . A mirror of water will suffice for one to identify with the Universe."[247] These comments align with the following: "Tao teaches that the fugacity of a reflection is a true image. Accepted fugacity of this sort is more complete than the imprint, which is dead and deprived of significance. Only the instant, innocently captured, reaches the totality and makes it known."[248]

He writes of Turner: "At first glance, iridescence is all . . . up to the revelation of a sole aquatic surround . . . Disappearance of gravity. The monster, half seen . . . is but another vibration in this hymn to transparency. . . . Turner was ready to shake the confines of his theater, to push aside the porticoes and dissolve the frontiers of the sea."[249] These words find an accord in: "The Chinese painter speaks not of space but of life force. For the European it's always a limit; for the Asiatic it is (implicitly) the unlimited. . . . A masterpiece that touches me like no other is the portrait of Li Po by Liang K'ai. The illustrious personage strolls through space without shadow and without detail . . ."[250]

"My dream," wrote Masson, "would be to do with the nude what the Chinese do with the landscape: make manifest the infinite."[251] This "dream" invites juxtaposition with Masson's summary of his work of 1950-53: "I did a body of happy paintings presenting the female nude in accord with nature—a kind of identification of the female body with nature—what

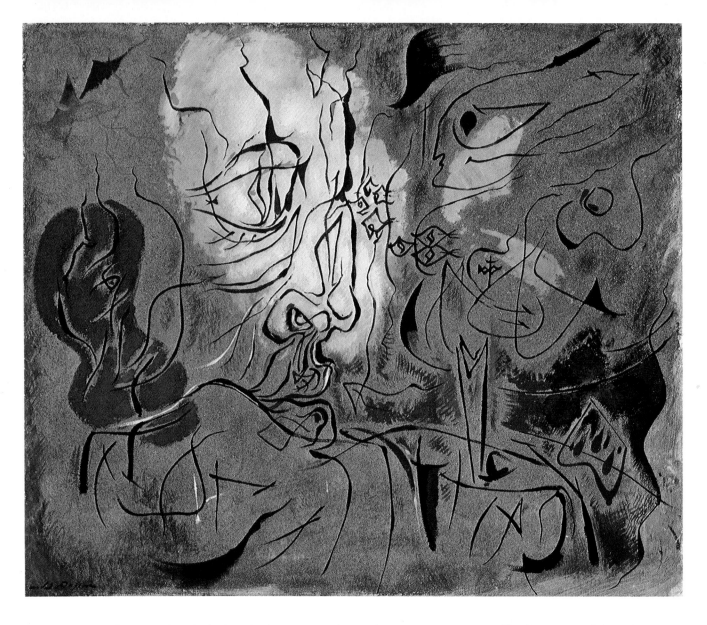

Renoir in fact had already done . . . nudes in the process of metamorphosis, become torrents, cascades. It was woman in nature, identified with it, going from one state to another—which is the very nature of metamorphosis."[252]

If in the works of 1950–53, those evanescent evocations of waterfalls, landscapes, nudes, nudes that are both waterfalls and landscapes, Venetian scenes, and birds in flight, we see little stylistic continuity with Masson's prior work or even that which was to follow, we can nonetheless view them as logical extensions of old philosophical concerns. His ontological perceptions have not altered; he still sees being as in constant flux and metamorphosis as the agent of change, but the emphasis is now on the physical savor of each

passing moment. The loosening of formal pictorial structure, the opening of closed form, and the Impressionistic play of light are the metaphoric vehicles to effect a fusion of being with becoming. In a painting such as **Flight of a Partridge** (1950; p. 183)—here Sartre's words might well apply: "Neither flight nor pheasant nor the flight of a pheasant: a flight that is becoming pheasant; he crosses a field, a flare explodes in the brush, explosion, pheasant; there is his picture"[253] —Masson wished to catch the plenitude of the instant. Only in possessing fully the present can man erase, as Masson quotes Heidegger, "projected being," that is, can he bridge the space between being and his dread of nonbeing that must always be implicit in any projection of future time. Masson remarks: ". . . the paintings

of cascades . . . those instants of nature in which one no longer thinks of the past or of the future, when the moment is sufficient unto itself. I think that that's what Zen is . . .''[254] It is in much this way that we may interpret Limbour's comment of 1956, ''Masson has tamed his old abyss.''[255] Nor is it farfetched to see a parallel between the Zen-Impressionist exaltation of the moment and Nietzsche's injunction to exult in life's experiences as the only means to expunge what would otherwise be the horror of eternal recurrence.

Observation of the progression of Masson's art from 1947 to 1954 brings to mind the artist's account of his first significant encounter with Chinese painting, which took place while he was in the United States in 1942 in Boston: ''When I first saw what I had long wished to see, a collection of Chinese paintings from the great periods, my feelings were not at the level of my satisfaction. It was because I wasn't yet detached from what we call, in the Western world, the object.''[256] Although, as we have seen, Masson's tree drawings of 1943 and such immediate postwar drawings as **The Old Shoe** display an Oriental character, it was not until 1947, after intensive study of the teachings of Zen, that he felt sufficiently ''liberated'' to begin experimenting with washes and spattered ink in the deliberately orientalizing manner of **Bushes in the Wind** of that year. By 1950, however, he drew almost exclusively in the mode of Zen and Ch'an Buddhist art, reducing his forms to their simplest essence and employing his own adaptations of Eastern calligraphy. The full influence of the Oriental on his graphic art at that time was underscored by the publication of seventeen lithographs accompanying a text by Chuang-tza in the album *Sur le vif.* In his painting, however, Masson could not so quickly, nor ever so fully, shift to another culture. Partially this was because of the difficulty of working with oil in a mode inherently inimical to that medium, but mainly it was because as a Western artist he was necessarily most profoundly attached to the great models within his own tradition. Consequently, even though his painting of 1950–53 has frank Oriental overtones, the dominant influence remains that of Turner and Impressionism. Not until 1954, when the mood of inner tranquillity that had marked the previous several years left him, did he abandon his Impressionist style and assimilate Oriental techniques to his older methods of picture-making.

Although in looking back on his Impressionist period Masson characterized it as a ''trap,''[257] he nonetheless saw it as a necessary phase in the progression of his

art. In November of 1954 he wrote Alfred H. Barr, Jr.: ''My painting has suddenly evolved: Renewal, violent renewal, of the imaginary and of vision. The 'return' to sensation that I attempted these last years was *in my eyes* necessary. But now it's an explosion.''[258] Seen from this angle that period, which initially appears as the most incomprehensible of aberrations within the more than fifty years of Masson's artistic activity, can be understood as a classic paradigm of the mature artist's mistrusting his accomplishments to the point of renouncing his natural strengths. Masson's three-year struggle to suppress drawing, to force his art into a mode derived in large part from Renoir, ironically parallels the latter's similar and ultimately futile effort to free his art from what he saw as his Impressionist facility and make it conform to models provided by Raphael and Ingres.

Masson's reconversion, as it were, was sudden and unsolicited. He remembers: ''These returning fires were unexpected . . . The mythic élan has reappeared, claiming its rights all the more urgently for having been so long restrained. The line, banished, is once again favored . . . On the subject of silhouetting I'm more open. On the other hand, volume being the Leviathan of the last decades, I recommend caution . . . Nothing, however, is rejected. Along with lyric inventions . . . appalling realities are encountered—those that the

revelations of nature afford us, or the perhaps epic spectacle of big-city traffic. I have to obey my visions, all of them, and in a single week give body to visions having to do with the subterranean forms of fecundity, with germinations, telluric energy, as well as the half-seen characters who make the Quartier des Halles a tumultuous city in the heart of Paris; then too the mysteries of sidereal space: tourneys of comets or stars rearing before the abyss . . . Another direction: that of primordial themes undertaken long ago and entitled Abduction, Encounter, Tumult, Voracity, followed by new elements, Ecstasy, Conflict, Incandescence, Budding Forms . . ."[259] Indeed, this catholic approach may be said to characterize Masson's art from 1954 to the present. Because, however, of its prevailing Orientalism as well as a pronounced tendency to coalesce into series, the work of 1954-60 forms a distinct unit within the general expansion of Masson's oeuvre in the last twenty years.

Beginning in 1954 Masson abandoned all set formulas of picture-making and, according to what he felt were his expressive needs, drew on his whole past repertory of themes and techniques as well as branching out into new areas, which had been partially opened up by his own prior explorations. A great attraction of Zen for Masson was its emphasis on the immediate mystical experience as the way to ultimate truth. Translated into art, that meant, as he said, "to create a void in the self, first condition, in the Chinese aesthetic, of the act of painting."[260] On the surface this seems identical with the old Surrealist concern with automatism; however, despite the affinity of concept, the artist acting according to the Oriental precept seeks to find in the gestures brought forth by the solicitation of his inner being not an expression of the oneiric, but "an ontological analogy of these gestures and the cosmic rhythm."[261] Masson himself well understood that, as an Occidental and an artist who had then been passionately engaged for over thirty years, he could not attain the spiritual void or creative passivity of the Zen or Ch'an painter. In practice, conjuring the void brought forth in his painting a spontaneous

Fish and Euphorbia. 1952.
Oil on canvas,
21⅝ x 13⅛".
Private collection

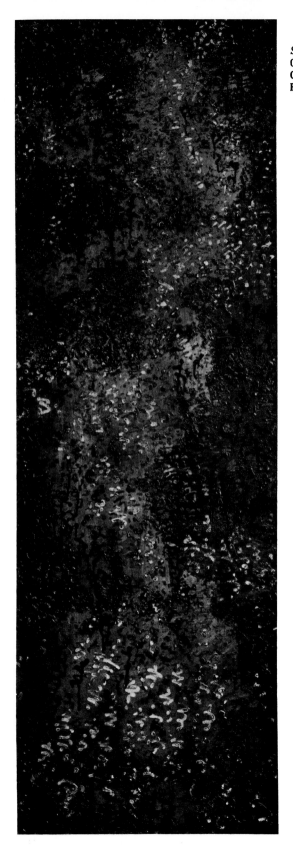

Sylvan Migration. 1960.
Oil on canvas, 59½ x 19¾".
Collection of the artist,
Paris

opposite top:
Meteors. 1956.
Tempera and sand on canvas, 21½ x 28½".
Hirshhorn Museum and Sculpture Garden,
Smithsonian Institution, Washington, D.C.

effusion of his own past art whose tides were stemmed or redirected by the formal concerns of the sophisticated European artist.

What Masson in fact did was to take the concept of "the unlimited and animated Chinese space" and try to make of it the actual ground of his paintings. Temperamentally wholly incapable of achieving the Zen ideal of harmonious identification of consciousness with the creative principle, Masson made deceptively decorative paintings which revert to his old ideas of conflict as the agent of generation, but with the difference that he wants the field of his canvas to represent the void itself. This hybridization, as it were, of Eastern and Western thought patterns brought about an increased abstraction and, concomitantly, a pressing need to get away from the tyranny of the framing edge. This tendency is demonstrated in the three series—which are numerically the largest of the several main groups of 1954–60—the Migrations of 1955–59, the Feminaires of 1955–59, and the sand paintings of 1954–60.

Least abstract are the Feminaires, inspired by the prostitutes that Masson, who was beginning to spend more and more of his time in Paris, saw around the rue St-Denis. Figuration in these pictures is rendered by rapidly brushed, vertically oriented, curvilinear hieroglyphs of the female body that fade in and out against a ground tonally differentiated as subtly as the hazes of a night sky. A sense of the canvas as part of an engulfing space is reinforced by the absence of any perspectival ordering. Although in the quick, synoptic outlines of these feminine figures a certain secularity of gesture relating them to work such as **Street Singer** of 1941 (p. 162) is intended, they are ideationally closer to the female as earth figure of the late thirties. These "truant stars" form part of the "Zodiac of the Quartier St-Merri";[262] they are the first perceptions of an equation of space and the female body, more clearly shown in such related works as **Flesh** of 1955 and **Celestial Body** of 1956, in which breasts, nipples, anatomical curves, and the vulva are the constellations of a night sky. In discussing the Feminaires, Masson writes of "the female body becoming immensity—taking the place of space . . . become abyssal site."[263]

Midway in terms of degree of abstraction between the Feminaire series and the sand paintings stand the Migrations. As in the Feminaires, figuration derives from Oriental calligraphy, but here it is simpler in form and its tracery tends to be deployed in diagonal axes across the support. The format and the signification of

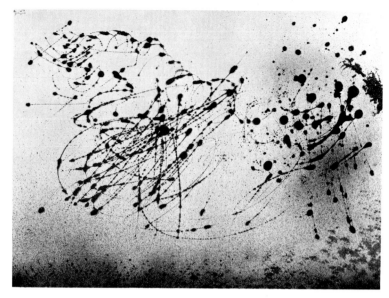

the work in this series have been admirably described by Françoise Will-Levaillant: "A single basic element—a thin zigzag, a kind of made-up ideogram—is repeated with infinite variations across a solid or moiré background. These signs suggest, Masson tells us, the myriads of men who, in the twentieth century, have known migrations less seasonal and more brutal than those of the animals."[264]

Masson all his life has rejected the idea of a totally abstract art, that is, an art whose subject is solely itself. No matter how seemingly without identifiable referent, Masson's work is always predicated on the interaction of man and his universe. In 1955, just after he had begun a series of sand paintings whose extreme gestural freedom sometimes seems to make them completely abstract, he wrote: "But the absence of signification, in the absolute sense, is a mirage. To attain that goal means nothing less than to annihilate analogy." And elsewhere in the same article he states: "Representation—term should be applied regarding any painting carrying the slightest hint of being nameable. The very presence of a title reveals the need for what is, in principle, the property of everyone—that is, language. One must add that its call is imperious. The contemplator, if not the painter . . . always ends up discovering or imagining some allusion to elementary life."[265] Indeed, although the titles that Masson gives us for his sand paintings—from one of the first and most cursory in execution, **Windstorm in the Pines** of 1954, to one of the last and most intricate, **In Pursuit of Birds** of 1958—amply furnish us with clues as to their intended meaning, it seems unlikely that a designation by an anonymous numbering system would substantially diminish what Masson intended to be their poetic allusiveness. As the range of their titles indicates—**Meteors** (right), **Fire beneath the Ash, Attacked by Birds, Sadness of a Spring Day, Jubilation**—there is a wide latitude of interpretation possible; however, almost all stand as metaphors of creative energy, whether it be psychic or physical.

In Europe in the mid-fifties, among the Tachist painters, an interest in texture and the matter of pigment itself was "in the air." Masson's use of sand, glue, and sprayed paint was fully personal, however, and represented a solution to the technical problem presented by his desire to make the field of his canvas the creative matrix. Quite naturally the methods he had used in his sand paintings of 1926–27, in which ground was the metaphoric equivalent of the shore, "that exemplary site of passage," suggested themselves to

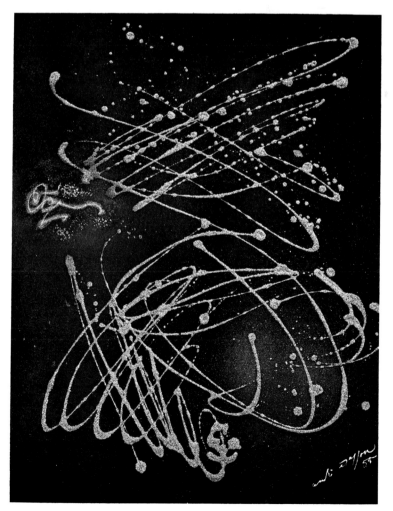

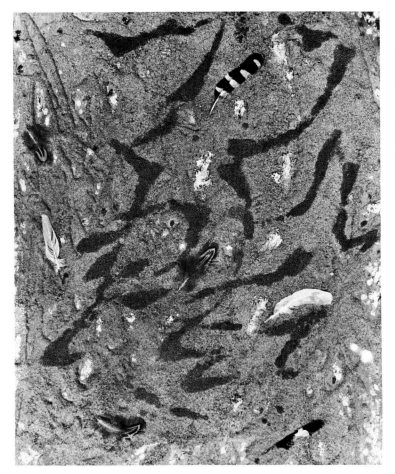

In Pursuit of Birds. 1958.
Sand, tempera, and feathers on canvas, 21⅝ x 18⅛".
Blue Moon Gallery and Lerner-Heller Gallery, New York

Occasionally, as he had done in 1927, Masson in such paintings as **The Blood of Birds** (1956) collaged feathers on his sand paintings. This concretization, as it were, tends to impart a narrative quality to the image that is rare in other paintings of the series. Before abandoning the sand technique Masson made a few works, such as **Grass Shadow** (1957) and **In Pursuit of Birds** (1958; left), in which he sacrificed gestural freedom to a complex methodology, layering the sand so densely that the effect is almost that of an easel-sized earthwork.

The spontaneity that characterizes all but the last of Masson's sand paintings is manifest in practically all of Masson's work from 1954 to 1960. And his remark, "Note that the notion of the abyss has become the very locus of my transmutations . . . ,"[267] may be taken as giving the common denominator of his art of that period. Most obviously illustrative of this observation is **The Abyss** of 1955 (right), in which the head of the philosopher-artist of the Contemplation series reappears; but he no longer meditates on an abyss that is separate from himself. His profiled head, multiplied over and over again in a rapid tracery of fine white brushstrokes, dissolves in and out of the fluidly indicated ground, whose subtly shifting tones of red, pink, brown, and white stand for the gaseous abyss. The intricate, curvilinear filigree of delicate white lines both veils and discloses the profiled heads and imparts to them an unequivocally vertical movement, although whether up or down is impossible to determine. Like the body of woman, which has become the space of the heavens as well as that of the earth, the vertiginous abyss of the vision on Montserrat melds with that of the Contemplation series to become, in Masson's words, "the ascensional abyss."[268] A mystic, lyrical painting, **The Abyss** is a multileveled poetic metaphor expressing the Oriental idea of being and nonbeing as one, the Westerner's confusion before that concept, and the awareness Sartre praised in Masson that "the experimenter is an integral part of the experimental system."[269]

The sense of intimacy with the creative moment is intense in a series of paintings inspired by the moods and phenomena of nature; examples are **Fecundation of Flowers** (1955; p. 74), **End of Summer** (1955), **Insect Nests** (1955), and **The Embellished** (1957). In these canvases the skittering embroidery of thin brushstrokes is more rapid than in **The Abyss** and less figuratively allusive. Certain works of this type have given rise to comparisons with the white-writing style of Mark

him. Now, however, influenced by his knowledge of Ch'an painting, and almost certainly also by the work that was coming out of America, he greatly elaborated his old methods while allowing himself a far larger degree of gestural freedom. Much more colorful than the sand paintings of 1926-27, those of 1954-59 were all executed flat, on the floor or on a table, and there is never any intervention of the brush. Masson's old friend Georges Limbour has described them:

> . . . he used a Chinese technique that consisted in spraying tempera or oil colors onto the canvas or paper—not by the mechanical means of a spray gun but by a more sensitive one, the breath (the Chinese taking the color into the mouth before projecting it, he being content to blow it from a tube inserted in a bottle). The modulations of breath, strong or gentle, from close up or far off, superimposing layers of different degrees of saturation, engender what might be properly called a field rather than a background; to this the varied play of the materials, the molecular explosions, the Milky Way transparencies lend depth, an astral character, and the appearance of infinity. Over these tinted fields, the ample and sinuous lines of uncolored sand weave back and forth, like a network of precious and glittering cords . . .[266]

The Abyss. 1955.
Oil on canvas, 36¼ x 28¾".
Collection Arturo Schwarz, Milan

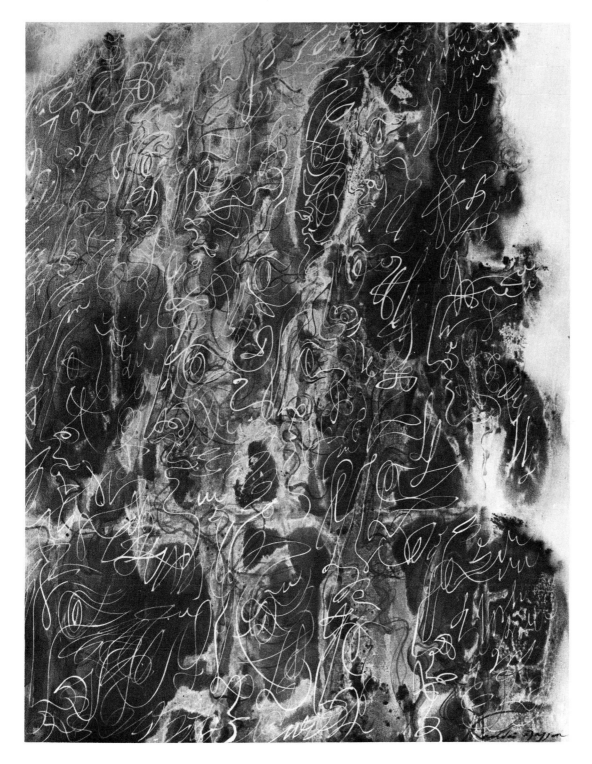

Tobey; in an Oriental calligraphic quality of line and an "alloverness" occasionally present in Masson and frequently in Tobey the two artists have points in common. The latter's work is, however, characterized by a meticulousness and intricate rectilinearity quite alien to Masson. Just as The Abyss injects the philosopher into the chasm that he had formerly only contemplated, Fecundation of Flowers, End of Summer, and The Embellished implicate the artist in the very dynamics of those activities he had so closely observed in the Insect series of 1934–36 and again in Connecticut in 1941–43.

Although the dense structuring and the earthy palette of Animal Labyrinth (1956; right) recall the Telluric paintings of the American period, and thus seem to set it apart from the prevailingly open and luminous compositions of the mid-fifties, its gestural freedom and thematic content tie it to contemporary work. In no previous painting on the labyrinth motif have brushstrokes been so rapid, nor in any prior painting has the labyrinth occupied the entire field of the canvas. In its spontaneity and in the concept of the labyrinth as the sole image, we can find partial parallels only in certain of Masson's early automatic drawings and in others such as Invention of the Labyrinth (1942; p. 50). In the former, however, the principle of the labyrinth was that of a passageway to inner psychic regions, and, despite the highly abstract character of the latter, it was there a metaphor referring to a specific Greek myth. Animal Labyrinth, however, although an evolution of Masson's previous labyrinths, is an expression of his personal mythology. The labyrinth, encompassing as it were the entire canvas, projects Masson's conception of the totally enveloping nature of the creative force.

While Animal Labyrinth can be regarded as an extension of an almost obsessively prevalent concern in a long career, Nocturnal City (p. 72), painted in the same year, represents a thematic departure in Masson's art. Quite suddenly, and perhaps in subconscious response to his former exile and the character of Paris as symbolic of French culture, Masson found himself "at the age of sixty . . . seized by a passion for Paris"; it became one of his "mythic places."[270] Nocturnal City and the related Nocturnal Intersection were painted in hymn and celebration of the artist's newfound experience of Paris. In the very beautiful Nocturnal City, the glittering and flickering of lights against a night sky are evoked without any readable figurative elements. Dabs, drips, and calligraphic squiggles of cadmium orange scatter in an intricate but seemingly random manner with their counterparts rendered in glowing jewel-like

blues and reds over the black ground of the canvas. At its lateral edges and in the bottom center juxtaposed reds and blues and a soft, succulent purple create an iridescence that recalls the similiarly created effect in Meditation on an Oak Leaf (p. 60). There is a volatile, magic quality to Nocturnal City; it is as if the radiant areas of yellow-gold pigment were molten—bubbling in the mysterious distillate of a finally successful alchemist.

Two years later, in Genesis I (p. 195) and Genesis II, Masson similarly projects on his canvas the image of an unstable field of energy. Viewed without a knowledge of Masson's previous work, the two Genesis pictures appear as abstract as Nocturnal City, and, like that painting, they are strong enough to stand titleless, evoking by their visual poetry alone a sense of elemental force and movement. But given titles and seen in the light of Masson's earlier work, they reveal some very specific extensions of the artist's prior concerns. Their tonally shifting brown grounds have two spatial referents: in their vortical, whorling movement, luminosity, and atmospheric qualities, they allude to the heavens; and in the choice of brown pigment texturally enriched by scattered sand, they allude to the earth. Thus Masson expresses the coessential nature of all manifestations of creative force. These paintings represent a fusion of the earth and ether as the site of creation, as is made particularly clear in Genesis I. Here sweeping white calligraphic lines schematically disclose the form of a bird at the upper right, the philosopher's eye of both the Contemplation paintings and Meditation on an Oak Leaf (p. 60) in the middle right, and just below it the embryo-cocoon shape from the Telluric pictures. As is true of the larger part of Masson's best work, these paintings owe much of their success to the artist's restraint in using descriptive elements. In Genesis I and Genesis II we might indeed say that the artist has accomplished a visual articulation of the breaking open of "the egg of dreams, the vanishing point of mind."[271]

Around 1960 Masson displayed an increasing tendency toward figural allusiveness and with that a greater willingness to detach form from ground, although neither of these propensities affected his art in full force until after 1965. Concomitantly, but again less emphatically before 1965, there was an increased disposition to rely on drawing to delimit form, and a more pronounced return to images evocative of his work of the twenties and thirties. Although The Oracle I (p. 196) of 1959 seems by its subject most allusive to the Sibyl and Pythia paintings of 1943–45, in its imagery it is

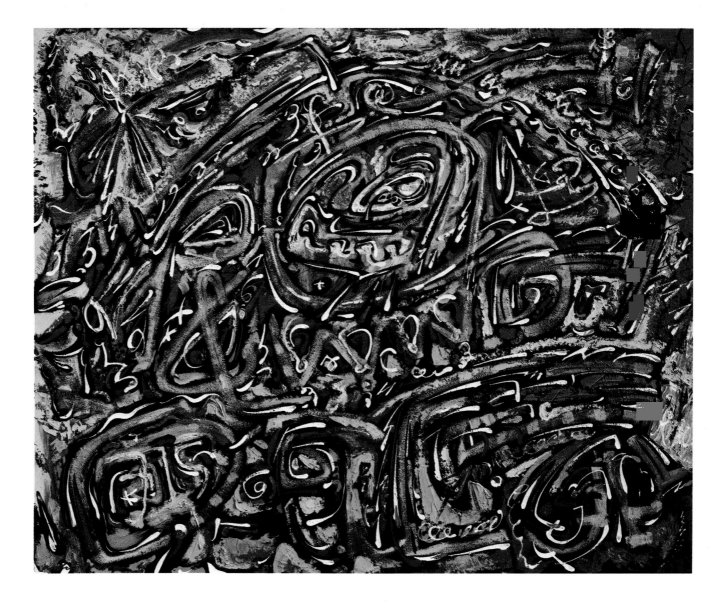

closer to the agitated dreamers of 1931 and the various depictions of Diomedes of 1934. Still invested with the idea of fusion between being and void, **The Oracle I** presents a struggling figure whose shape covers the canvas. There is no touch of modeling; his thinly drawn outlines thus create no sense of interior volume, but rather engender a feeling of the figure and its surrounding space as one. Making a reappearance in **The Oracle I** is the eye-navel that first appeared in the mid-twenties and was seen again in the late thirties.

Similar to **The Oracle** in the sense that all figuration is created by drawing is **La Chute des corps** of 1960 (p. 198). But the latter is by no means a painted drawing in the manner of **The Oracle**. Although the paint is thinly applied, the ground is a marvelously rich mixture of gradations of red hazing toward blue at its lateral edges, suggesting a mutation of Masson's thoughts on a page from the Apocalypse of St-Sever: "Fall of bodies . . . to Lucifer and his retinue fall the beautiful colors."[272] Indeed, a mutation on the definition of the word "fall" seems to have occurred as well, for the silhouetted transparent bodies flow not down but fluidly upward. Their meandering movement is less evocative of the similar white tracery in **The Abyss** than it is of Masson's old interest in the freely determined patterns made by a cord dropped on a flat surface. The feeling that there was an equation, consciously intended or not, of the body's outlines with a cord is reinforced if, in comparing **The Rope** of 1928 with **La Chute des corps**, we regard works such as **Torso of a Woman**, an etching of 1944, as a mediating point between the two.

Although compositionally very different, **The Unseizable** (p. 75), painted in the same year as **La Chute des corps**, also hints at ideas first developed in the twenties. Disengaged from a hazy, atmospheric ground and unfolding diagonally across the canvas from the upper left to the lower right is an indecipherable form the movement of which suggests the unfurling, diaphanous scroll of 1922-26. The fact that the iconographic significance of the scroll is in its ambiguity—its presence testifying to the unknowable—seems to have a parallel in the conception of this painting titled **The Unseizable**. Other allusions to familiar imagery of the twenties can be found in the mask at the upper left, in the heart enmeshed in tendriling lines that recalls the crown, and in the forms like flying birds at upper right and lower left.

In 1962, looking back on his art of the past two years, Masson wrote that it could be "compartmentalized" into three main groups, "Mythical Figures, Emblematic Places, and the Annals of Nature."[273] The very broadness of this grouping is what made it seem specific only to the preceding two-year period. Although all the diverse periods of his past art were encompassed by one or another of Masson's "categories," never prior to 1960 had there been such a simultaneous and equal-weighted convergence of his interests. The year 1960 marks, in Masson's art, the beginning of an epoch that extends to the present. During this period no one philosophical, thematic, or stylistic concern is dominant. Far from feeling "disarmed" as he had during 1947-48, when he was obsessed by the idea of giving up drawing, he looked to the whole arsenal of his formal accomplishments to body forth his conceptions. As he expressed it in 1962, "For anyone who wants to lose nothing of the most vital conquests, throwing everything into the crucible becomes a need."[274] He has declared that "Representation is never free enough for anyone who has long been on the road toward his own being. . . . Abstraction is never expressive enough for one whose sole demand is to listen to the call of being."[275] Such remarks reveal the continuing presence of his old foe, the demon of uncertainty, but Masson's response has changed. He no longer feels compelled to swing the whole direction of his art, but paints each picture as his need dictates, producing in 1961 canvases in such differing styles and degrees of figural allusiveness as **Black Forest** and **Between Plant and Bird**. Reviewing the Masson retrospective exhibition at the Paris Musée d'Art Moderne in 1965, John Ashbery wrote:

Neutral space, enveloping and insidious, or abrupt flares of blue and red, jagged calligraphy, chains of flung pigment—these are the twin poles of Masson's painting, between which he is in constant movement, as he is intellectually between eroticism and death, humanism and cruelty, public statement and private mythology. His art has its mercurial existence in the sensitized space between antitheses.[276]

The only work of the last fifteen years that stands outside the general categories Masson outlined in 1962 is a series of prison paintings that Masson, who was an active opponent of the Algerian war, made in 1961 and 1962. These paintings were not conceived simply in protest, but come from painful, personal experience; his older son, Diego, spent two years in prison for his antiwar activities and sympathies with the Algerian independence movement. Of these poignant images of prison visits and men held captive, Masson says: ". . . prisons, cages where men shut up other men who have chosen to fight for freedom. Let the viewer see in them, more than the mythic élan as source, a few pages from a Diary."[277]

Enriching Masson's personal mythology in the early sixties are several paintings that expand the domain of the "Mythical Figure." Some, partially inspired by the Algerian war, take as their theme the Peasants' War in Germany of 1524-26. The heroes in these works, which are usually titled "Delire Lansquenet," are associated in Masson's mind with such warrior-painters as Manuel-Deutsch, Urs Graf, and Hans Leu the Younger. Masson had in the past, as we have seen, celebrated literary figures in his work; but in a group of paintings having less in common stylistically than they do thematically, Masson now alludes to writers not by portraiture, but through their work—Kleist in several paintings titled **The Delirium of Penthesilea** (1960); Hugo in **Le Sommeil de Booz** (1960); D. H. Lawrence in **Lady Chatterley** (1961); and Nietzsche (Zarathustra) in **He Came Down from the Mountain** (1960).

The decade of the sixties was punctuated by an event that Masson had waited for "since the age of sixteen."[278] In early 1965, André Malraux, his old friend and then Minister of Culture, commissioned Masson to paint the ceiling of the Odéon-Théâtre de France. Taking as his theme "Tragedy and Comedy Dividing Certain Aspects of the Human Passion," and with thoughts of the Delacroix sketch for a Louvre ceiling that had so moved him in his youth in Brussels, Masson worked for almost nine months on the project. The painting, which measures 124 square meters, combines

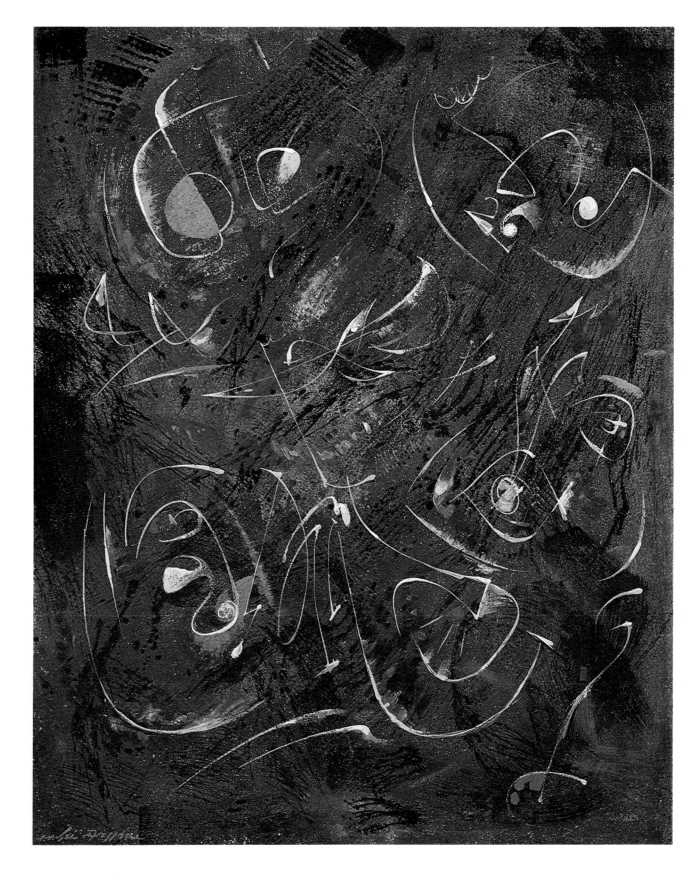

below:
The Oracle I. 1959.
Oil and sand on canvas, 55⅛ x 45¾".
Blue Moon Gallery and Lerner-Heller Gallery, New York

opposite:
Les Halles de Paris. 1967.
Oil on canvas, 44⅞ x 41⅜".
Private collection, New York

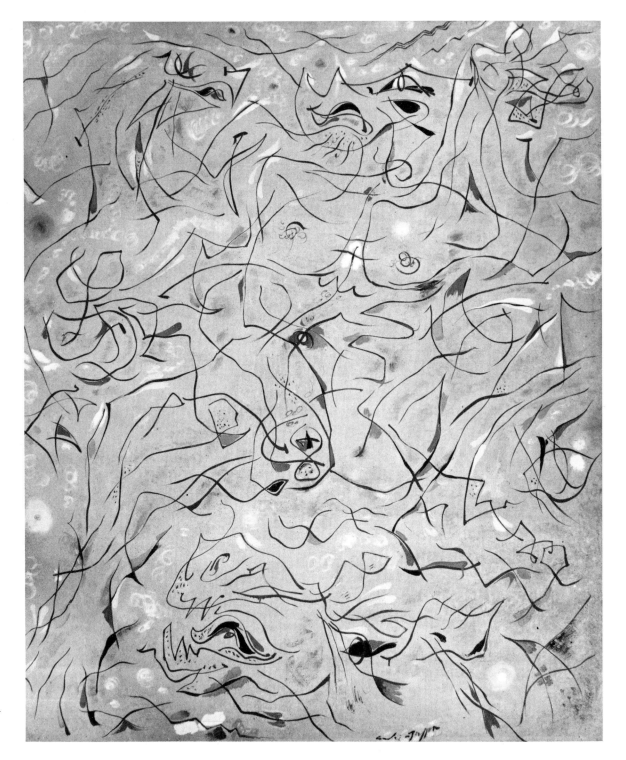

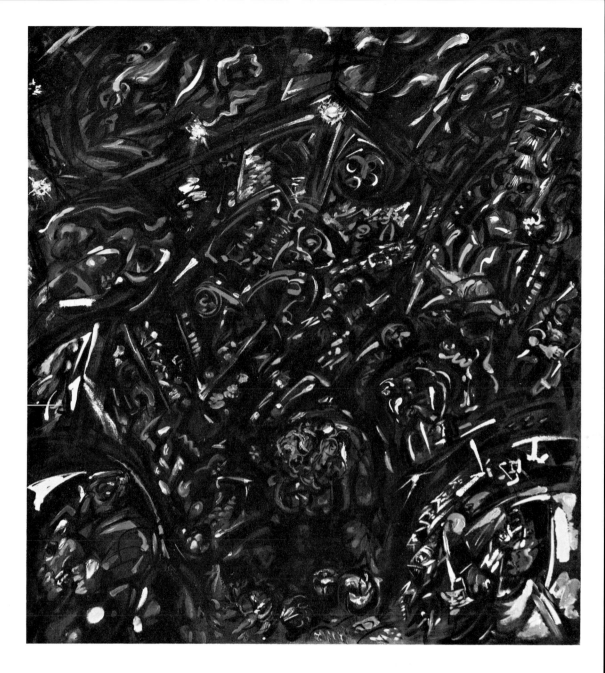

mythological subjects (including, in homage to Malraux, Prometheus seizing the sacred fire) and the depiction of heroes from the works of Aeschylus, Aristophanes, Shakespeare, Kleist, and Claudel. The ceiling was inaugurated in a gala ceremony on the night of November 4, preceding the Jean-Louis Barrault production of Cervantes' *Numance*, for which Masson had designed the set and costumes.

Willingly as it had been undertaken, the effort of painting the Odéon ceiling was exhausting for the sixty-nine-year-old artist. In the spring of 1966, on the advice of doctors who felt he needed a "change of air," Masson made a trip to Belgium, where he visited only cities that were "truly Flemish"—Bruges, Ghent, Antwerp, and on his return Courtrai. Ostensibly undertaken for reasons of health, the trip was decided upon, as Masson himself points out, "at least as much out of a need to return to my youth" as for any other reason.[279] Among the numerous paintings that were inspired by the sights and experiences of this trip are **Fight between Swans at Bruges, Day at Bruges,** and **Battle of Swans and Angels,** all of 1966.

That Masson found city environments an ambience conducive to a restoration of his physical and psychic

La Chute des corps. 1960.
Oil on canvas, 51⅛ x 35″.
Collection Rose Masson, Paris

Homage to William Blake. **1970.**
Chinese ink, 25½ x 19⅝".
Private collection, Paris

energies also manifests a fascination with urban life that first became apparent in the early fifties, when he began to make yearly visits to Italy. Although the hold of both Venice and Rome is still strong, Masson's late-blooming love affair with Paris, evident in his Feminaires and Nocturnal City of 1956, is still his deepest attachment. In 1958, little more than a year after painting Nocturnal City, Masson rented an apartment in Paris, and he has spent every winter in the city since that time.

One of the most intriguing aspects of Paris for Masson was Les Halles. Originally attracted chiefly by the spectacle of activity that the great market afforded, Masson gradually began to see it more and more as a kind of living metaphor of the interrelated destinies of animals, plants, and men. The emblematic significance that the "belly of Paris" came to assume for Masson is attested to in the title of a painting of 1964, Mythology of Les Halles. Three years later, in the large, nearly abstract Les Halles (p. 197), Masson painted the market as a great blue labyrinth structurally similar to Animal Labyrinth of 1956 (p. 193).

In its degree of abstraction, relative lack of reliance on drawing to delineate form, and its sensual handling of paint, Les Halles is unusual in Masson's post-1965 work. Masson's inclination of the last several years to draw from all of his past art is too encompassing to characterize anything but that trait as typical; nonetheless the broad direction may be said to be toward greater figuration, dependence on drawing, and a certain predilection toward the imagery of the late thirties. Although there is no lack of strong color in Masson's post-1965 work, its rich, viscous quality as oil is sometimes vitiated in favor of a bright watercolor-like clarity.

In the same year that he painted Les Halles Masson produced a suite of drawings the collective title of which, "Mythic Autobiography," indicates a motivation parallel with that of *Anatomy of My Universe.* Less occult than *Anatomy of My Universe,* these drawings provide an extremely personal compendium and mystical exegesis of the artist's concerns and their iconographic manifestations over a lifetime. The general aspect of these drawings most recalls those of the thirties, but the touch is lighter, less urgent, and they tend more toward cross-hatchings and clusters of indeterminate squiggles that are reminiscent of Oriental calligraphy. Beginning with a drawing entitled From a natal-immemorial land and ending with one called The newborn Elder seizes what is without birth and beholds what is outside time,

they offer a virtual encyclopedia of Masson's iconography. Among other images are the pomegranate, the imprisoning crystal, disembodied hands, flying birds, the vulva as wound, the sun, feet in high-heeled shoes, the meteor, and the landscape-body-trap.

Although no single work could or should incorporate the lexicon of symbols that we find in the twelve drawings of "Mythic Autobiography," the lyrically beautiful In Pursuit of Hatchings and Germinations (p. 200) which Masson made as a cartoon for a Gobelin tapestry in 1968 provides an extremely wide range. Over a rich brown ground, whose tonal gradations recall Genesis I (p. 195) and Genesis II of the previous decade, are described at the middle right a

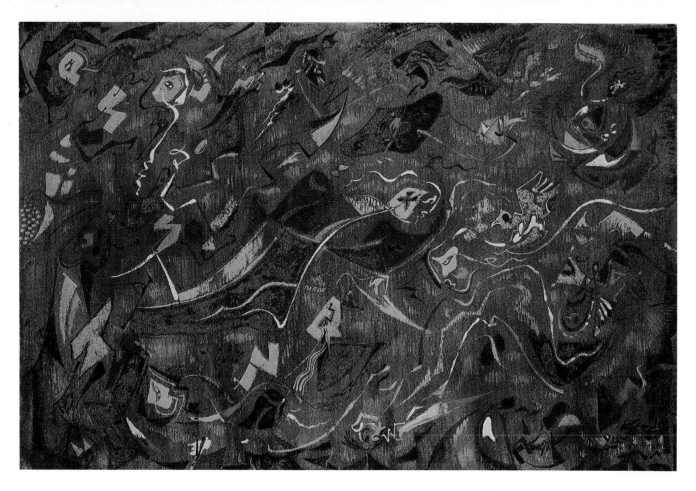

In Pursuit of Hatchings and Germinations. **1967.**
Oil and sand on canvas, 39 ⅜ x 59″.
Mobilier National, Paris

flying bird and a floating figure with profiled head whose hand grasps a fruit; in the upper middle is the heart-vagina, and to the lower left the leaf-vulva; and scattered and multiplied over the field of the canvas are egg and embryo shapes, the butterfly-double-hipbone form, and trailing, cordlike lashes of yellow, green, orange, and red paint.

An imagery more specifically tied to a single past era in Masson's art is evident in such works as **The Boundaries of the Past** (1969), **At the Gates of the Enigma** (1970), and **Emblematic Site of the Eternal Cycle** (1970). In these, as in the several works depicting an Acéphale-like demiurge of the last five years, the metaphysically inspired symbolism familiar from *Anatomy of My Universe* reappears. Indeed, for all that Masson's work of the last several years defies a single general characterization, there blows through it an especially strong Nietzschean wind—particularly evocative of the vivid rhetoric of Zarathustra.

In fragile health, Masson still works with the integrity and passion of his youth. In 1973 Masson wrote: "Here is the great dream: the alliance of broad learning with a powerful imagination, the oath never to ignore the living forces of the unconscious. And may the word be kept."[280] If, in more than a half-century of making art, Masson has sometimes seemed to follow contradictory directions, it is because he does not and cannot stand outside that art. As Sartre has remarked of Masson, "the project of painting cannot be distinguished from the project of being a man."[281] Finally, Masson's accomplishment reflects the courage with which he has always faced that project. As he expressed it in 1973,[282] "My work is an errant one. I can't stay very long in one place; I have preferred the mental labyrinth full of snares to roads that were safe and straight."

NOTES

1. From Nietzsche's explanation for using the name Zarathustra, cited and translated by R. J. Hollingdale in his introduction to *Thus Spoke Zarathustra* (Harmondsworth, Middlesex, England: Penguin, 1969), p. 31.

2. Cited in Jean-Paul Clébert, *Mythologie d'André Masson* (Geneva: Cailler, 1971), p. 12.

3. By Jacques des Gachons, *Je sais tout* (Paris), Apr. 15, 1912, pp. 349–56.

4. Cited in Clébert, p. 18.

5. A true assessment of Giotto's art cannot, however, be made in Tuscany, but must start with the fresco cycle in the Arena Chapel in Padua. In the early part of the century the two fresco cycles in Santa Croce in Florence, which are probably the works Masson saw, were traditionally given to Giotto, but it is now generally doubted that they are by the master himself.

6. *André Masson: Entretiens avec Georges Charbonnier* (Paris: Julliard, 1958), p. 47.

7. For Apollinaire's reaction, see *Apollinaire on Art: Essays and Reviews 1902–1918* (New York: Viking Press, 1972), p. 401. Masson's appreciation of this particular painting was primarily an aesthetic one; however, there was certainly, as there probably was also for Apollinaire, some iconographic interpretation similar to Breton's later reading of the painting as anticipating Surrealist imagery. For a discussion of the latter point see William S. Rubin's *Dada and Surrealist Art* (New York: Abrams, 1968), p. 123.

8. *Entretiens, 1913–1952* (Paris: Gallimard, 1952), p. 21.

9. *La Mémoire du monde* (Geneva: Skira, 1974), p. 100.

10. See "Le Surréalisme et après: Un Entretien au Magnétophone avec André Masson," *L'Oeil* (Paris), May 15, 1955, p. 12.

11. Cited in Clébert, p. 24.

12. Ibid., p. 93.

13. "Peinture tragique," *Le Plaisir de peindre* (Nice: La Diane Française, 1950), p. 67. Reprinted from *Les Temps modernes,* Jan. 1946.

14. "Quelques Préfaces sur André Masson: Lumière blanche et lumière noire," written in 1956 and published in Clébert, p. 131.

15. "Mouvement et métamorphose," *Le Plaisir de peindre,* p. 169. Reprinted from *Les Temps modernes,* Oct. 1949.

16. Cited in Clébert, p. 25.

17. *Entretiens,* p. 71.

18. *La Peinture et son double: Ecrits de peintres* (Paris: Le Bateau Lavoir, 1974), item 123, n.p.

19. "45, rue Blomet (à D.-H. Kahnweiler)," *Atoll* (Paris), no. 2, 1968, p. 15 (written in Mar. 1968).

20. Dubuffet's role was only that of agent in bringing his boyhood friends from Le Havre, Salacrou and Limbour, to the rue Blomet. The latter two became active members of the rue Blomet group and lifelong friends of Masson, whereas Dubuffet was never part of the group.

21. "Le Roi fou à la couronne de flammes," *Cahiers du sud* (Marseilles), no. 275, 1946, p. 16.

22. Ibid. Although Masson read the Dada-oriented review *Littérature,* he was still in Céret when Breton's "discovery" of Lautréamont's "Poésies" caused them to be published in the April and May issues of 1919.

23. "45, rue Blomet," p. 17.

24. A reference to Rimbaud's words, "Je dis qu'il faut être *voyant,* se faire *voyant,*" from letter of May 15, 1871, to Paul Demeny, *Oeuvres complètes* (Paris: Gallimard, Bibliothèque de la Pléiade, 1951), p. 254.

25. "45, rue Blomet," p. 16.

26. Ibid., p. 17.

27. From letter to Rosalind Krauss and Margit Rowell, Apr. 19, 1972, cited in Krauss and Rowell, *Joan Miró: Magnetic Fields* (New York: The Solomon R. Guggenheim Foundation, 1972), p. 40.

28. Introduction (trans. Maria Jolas) to the catalog *André Masson,* Buchholz Gallery and Willard Gallery, New York, Feb. 17–Mar. 14, 1942, n.p.

29. *My Galleries and Painters* (New York: Viking Press, 1971), pp. 96–97. Translated from *Mes Galeries et mes peintres* (Paris: Gallimard, 1961).

30. P. 34.

31. *Métamorphose de l'artiste* (Geneva: Cailler, 1956), vol. 1, p. 18.

32. Cited in Clébert, p. 9.

33. *Oeuvres complètes,* p. 104.

34. The two artists whose specific influences have most often been seen in Masson's work of 1922 to 1924 are Derain and Gris. Masson, who was very friendly with Gris, denies any influence of the latter's art on his work, and, indeed, despite superficial resemblances—all attributable to their common base in Cubism—the cool, classicizing geometry of Gris's work is alien to Masson's. Derain, however, whom Masson, despite reports to the contrary, knew only casually through social gatherings and meetings in cafés, was as Masson freely admits an important source in his art until the middle of 1923.

35. *André Breton: Magus of Surrealism* (New York: Oxford University Press, 1971), p. 37.

36. *Picasso: Fifty Years of His Art* (New York: The Museum of Modern Art, 1946), p. 84.

37. The only two paintings to depict women as other than phantom figures before 1925 are **A Throw of the Dice** of 1922 and **The Sleeper** of 1923.

38. "Au Pays des hommes," in *André Masson:* Textes de Jean-Louis Barrault, Georges Bataille, André Breton, Robert Desnos, Paul Eluard, Armel Guerne, Pierre-Jean Jouve, Madeleine Landsberg, Michel Leiris, Georges Limbour, Benjamin Peret (Rouen: L'Imprimerie Wolf, 1940; commissioned by Armand Salacrou), p. 22. Reprinted in Eluard's *Voir* (Paris and Geneva: Editions des Trois Collines, 1948), p. 64.

39. *Métamorphose de l'artiste,* vol. 1. p. 17.

40. "45, rue Blomet," p. 17.

41. **A Throw of the Dice** was bought by Ernest Hemingway from Masson's studio after Hemingway had seen **The Repast** among other Masson paintings at Gertrude Stein's.

42. Title of essay written in the winter of 1939 at Lyons-la-Forêt; published in *Cahiers du sud* (Marseilles), Mar. 1941. Reworked in the lecture given at The Baltimore Museum of Art in the fall of 1941 under the title "Origines du cubisme et du surréalisme" and published in English in *Horizon* (London), Mar. 1943, pp. 178–83. Original version reprinted in *Le Plaisir de peindre,* pp. 11–18.

43. Georges Limbour, "Histoire de l'homme-plume," introduction to the catalog *André Masson,* Galerie Simon, Paris, Feb. 25–Mar. 8, 1924. Reprinted in *André Masson and His Universe,* by M. Leiris and G. Limbour (London, Paris, Geneva: Editions des Trois Collines, 1947), pp. 25–27; English texts translated by Douglas Cooper.

44. Because of this association of the pomegranate with the battlefield, as well as the fact that the French word *grenade* means both pomegranate and grenade, and that Masson has rendered the object in pictures such as **The Sheets** (1926) as looking very much like a grenade, it may be that his association was also to the grenade-explosive. If, however, this is so, it was entirely unconscious, and Masson himself does not now accept the interpretation.

45. Limbour used this characterization of Masson as the title of the essay he wrote for the introduction to Masson's first one-man exhibition at the Galerie Simon in 1924 (see note 43). Michel Leiris recounts:

"Georges Limbour baptized Masson 'l'Homme-plume' because of Paolo di Dono, called 'the Bird' [Uccello], because of the beautiful birds in the still lifes, and because (finally and especially) of an old woolen sweater the texture of which made it seem that he (Masson) was covered with plumage." (*André Masson: Massacres et autres dessins* [Paris: Hermann, 1971], n.p.)

46. Spherical motifs representing cloud formations are, of course, abundant in much Cubist-based work of Léger, La Fresnaye, and Delaunay from 1911 on; but their signification differs in Masson's art. In their work such motifs have relatively little metaphysical implication, are almost always based on direct, immediate observation, and are, in most respects, a celebration of a new world of mechanics and aeronautics. Despite the astronomical allusiveness of Delaunay's most abstract disk paintings, they are essentially nonfigurative, and their configurations represent the artist's formal means to express his color theories. This being said, it should nonetheless be remarked that Masson, in response to a question put by the author, responded that he thinks it more than likely that the work of La Fresnaye, which he knew and admired, may have been a subliminal factor in his evolution of the motif of the astral sphere.

47. Cited in Clébert, p 25.

48. Ibid., p. 26.

49. Heraclitus, cited in Bertrand Russell, *A History of Western Philosophy* (New York: Simon and Schuster, 1945), pp. 41, 40.

50. "Du point où je suis," *Plaisir de peindre*, p. 136.

51. *Dans la salle des pas perdus c'était écrit* (Paris: Gallimard, 1974), p. 128.

52. *André Masson and His Universe*, p. xii (Cooper translation), p. 197 (original French text).

53. For a discussion of the iconographic significance of fruit in Masson's work see Leiris' chapter "La Terre" in *André Masson and His Universe*, pp. 101–2.

54. *L'Age de l'homme* (Paris: Gallimard, Le Livre de Poche, 1966), p. 221.

55. *André Masson and His Universe*, pp. 33–37. Reprinted from *Intentions* (Paris), Jan.–Feb. 1924.

56. *André Masson and His Universe*, p. vi (English), p. 117 (French).

57. Cited in Clébert, p. 26.

58. Ibid.

59. "Eléments pour une biographie," in *André Masson* (L'Imprimerie Wolf), p. 10.

60. Gertrude Stein also remarked the use of white in Masson's early work: "She was interested in André Masson as a painter particularly as a painter of white and she was interested in his composition in the wandering line in his compositions." *Autobiography of Alice B. Toklas*, (New York: Harcourt Brace, 1933), p. 258. Modern Library edition, p. 210.

61. "Scenes of Everyday Life," *André Masson and His Universe*, p. v (English), pp. 114–15 (French).

62. "45, rue Blomet," pp. 18–19.

63. "Préface, *Entretiens*, p. 11.

64. Ibid., pp. 12–13.

65. "Peindre est une gageure," *Plaisir de peindre*, p. 14.

66. "Eleven Europeans in America," ed. James Johnson Sweeney, *The Museum of Modern Art Bulletin* (New York), nos. 4–5, 1946, p. 4.

67. Arp executed a series of works he called "automatic drawings" around 1918; for a discussion of their relationship to Masson's automatic drawing see William S. Rubin's *Dada and Surrealist Art* (New York: Abrams, 1968), pp. 80, 82. Although automatist elements were involved in Ernst's technique of frottage, automatic drawing as under-

stood by early Surrealism was, aside from Masson, most closely anticipated by Paul Klee in works that the artist characterized as "an expressive movement of the hand with the recording pencil," with the hand the "tool of a remote will." (Cited in Will Grohmann, *Paul Klee*, [New York: Abrams, 1955], p. 149.) Although Picabia has been mentioned in connection with the development of automatism, the very few works he produced by a technique that might be termed automatic were conceived solely as Dada gestures.

68. Michel Leiris, "Eléments pour une biographie," *André Masson* (L'Imprimerie Wolf), p. 10.

69. *Literary Origins of Surrealism: A New Mysticism in French Poetry* (New York: King's Crown Press, 1947; New York University Press, 1966), pp. 11–12, 20.

70. In Clébert, p. 33, Masson is cited as stating that the cord first appeared in **Les Soupiraux,** but that painting must, on stylistic grounds, be placed after **The Sleeper.**

71. See note 67.

72. Rimbaud's phrase in letter to Paul Demeny; see note 24.

73. Masson cannot recall exactly which book on Klee he saw but remembers that it was published in Munich. The only then-extant works on Klee published in Munich were the catalog of an exhibition held at the Galerie Hans Goltz, Munich, in 1920, which was published in a special issue of *Der Ararat* (Munich), no. 2, 1920, pp. 1–25, and Wilhelm Hausenstein's *Kairuan oder Eine Geschichte vom Maler Klee und von der Kunst Dieses Zeitalters* (Munich: Kurt Wolff Verlag, 1921). As Masson's best recollection is of a book format, it would seem likely that it was Hausenstein's monograph that he found on the quays. **The Eye of Eros** is reproduced in that volume on page 69.

74. In spite of obvious affinities in the art of Masson and Ernst, their initial interest in automatism and their sometimes very similar motifs were developed before there was any interaction between the two.

75. Cited in Clébert, p. 27.

76. Cited in Russell, p. 44.

77. "La Terre," *André Masson and His Universe*, p. 101.

78. Ibid.

79. *Dans la salle des pas perdus*, p. 136.

80. *André Breton: Magus of Surrealism*, p. 149.

81. Cited in Clébert, p. 28.

82. *Entretiens*, p. 61.

83. Ibid., p. 76.

84. "Histoire de l'homme-plume," *André Masson and His Universe*, p. 26.

85. Cited in Clébert, p. 28.

86. Masson's remarks on the role of Chateaubriand, cited in Clébert, p. 28, seem to contradict those of Leiris in "Eléments pour une biographie," *André Masson* (L'Imprimerie Wolf), p. 11.

87. "Prestige d'André Masson," *Minotaure* (Paris), May 1939, p. 13. Reprinted in *Le Surréalisme et la peinture* (New York and Paris: Brentano's, 1945), pp. 155–58.

88. Paul Valéry's characterization, reported in Clébert, p. 26, and in conversation between the author and Masson.

89. From "La Roue," published in *Les Soirées de Paris*, June 15, 1914, pp. 345–46.

90. "Souvenir," *L'An I du surréalisme, suivi de l'an dernier* (Paris: Denoël, 1969), p. 286.

91. Cited in Clébert, p. 33.

92. "Le Peintre et ses fantasmes," *Etudes philosophiques*, Oct. 1956, p. 635.

93. *Manifeste du surréalisme, poisson soluble* (Paris: Editions du Sagittaire, Kra, 1924), p. 42.

94. *A Quarterly of the Arts* (London), Apr. 1916, pp. 27–30.

95. Ibid., pp. 28, 30.

96. ''Divagations sur l'espace,'' *Plaisir de peindre*, p. 148. Reprinted in English in the catalog *Minotaure*, L'Oeil–Galerie d'Art, Paris, May–June 1962, n.p. (First published in *Les Temps modernes*, 1949.)

97. Clébert, p. 29.

98. Cited in Clébert, p. 32.

99. Masson speaks of *The Ecstasy of St. Paul* apropos of his first trip to Paris in Clébert, pp. 15–16. In February of 1975, in conversation with the author, he spoke at some length on the significance of this painting to his art of 1924–25.

100. *L'Ombilic des limbes*, in *Oeuvres complètes d'Antonin Artaud* (Paris: Gallimard, 1970), vol. 1, pp. 76–77.

101. ''Du point où je suis,'' *Plaisir de peindre*, p. 136.

102. *Métamorphose de l'artiste*, vol. 1, p. 21.

103. *André Masson and His Universe*, p. 34.

104. Paris: Editions de la Nouvelle Revue Française, 1925.

105. Cited in Clébert, p. 32.

106. *Masson* (New York: Abrams, 1965), pp. 6–7.

107. Galerie Pierre, Paris, Nov. 14–26, 1925. Artists included besides Masson were Arp, Ernst, Klee, Miró, Picasso, Man Ray, and Pierre Roy.

108. The reference to ''a man'' at the beginning of the quote stands for a work by Arp exhibited as no. 3 in the exhibition, and the reference to ''the Man'' beginning the second sentence is to Masson's painting **Man** discussed above and no. 8 in the Galerie Pierre exhibition.

109. Cited in Clébert, p. 30.

110. Ibid.

111. Ibid., p. 11.

112. Ibid., p. 95.

113. William Rubin, unpublished manuscript on Jackson Pollock, p. 116.

114. ''Genesis and Perspective of Surrealism,'' one of three prefaces to *Art of This Century* (other prefaces by Jean Arp and Piet Mondrian), ed. Peggy Guggenheim (New York: Art of This Century, 1942), p. 20. Reprinted in Breton's *Le Surréalisme et la peinture*, pp. 77–106.

115. *Métamorphose de l'artiste*, vol. 2, p. 11.

116. Cited in Nello Ponente, *Klee* (Cleveland: Skira, 1960), p. 56. From *Schöpferische Konfession*, Berlin, E. Reiss, 1920, pp. 28–40 (Tribune der Kunst und Zeit, hrsg. v. Kasimir Edschmid, 13). *Schöpferische Konfession* was reprinted in the catalog *Paul Klee Handzeichnungen aus der Sammlung Felix Klee, Bern*, Städtisches Museum, Wiesbaden, Germany, Mar. 19–May 28, 1967.

117. Cited in Clébert, p. 33.

118. *Métamorphose de l'artiste*, vol. 1, p. 22.

119. ''Mythologies,'' *André Masson and His Universe*, p. viii (English), p. 126 (French).

120. Although **Metamorphosis** was sometimes dated ''1928'' even so shortly after its execution as 1929 (in Galerie Simon catalog; see note 126 below), Masson confirms that the sculpture was executed in 1927.

121. Masson and Giacometti knew of each other through work they had each seen of the other's at the Galerie Jeanne Bucher; but their actual meeting took place in a kind of mystic, spontaneous recognition at the Café du Dôme.

122. ''André Masson—Métamorphose,'' *Le Grand Jeu* (Paris), Spring 1929, p. 33.

123. Cited in Clébert, p. 102.

124. *André Masson and His Universe*, p. 150.

125. Cited in Russell, p. 54.

126. In the catalog *Exposition André Masson*, Galerie Simon, Paris, Apr. 8–20, 1929.

127. The book was never published, although drawings for it still exist.

128. *L'Anus solaire* (Paris: Editions de la Galerie Simon, 1931), n.p.

129. Cited in Balakian, *The Literary Origins of Surrealism*, p. 45.

130. ''André Masson: Etude ethnologique,'' *Documents* (Paris), May 1929, p. 102.

131. ''Tortoise Shout,'' *A Little Treasury of Modern Poetry*,'' ed. Oscar Williams (New York: Scribner's, 1946), pp. 374–75.

132. Friedrich Nietzsche, *Thus Spoke Zarathustra*, trans. R. J. Hollingdale, p. 66.

133. *Clarté* was a Communist review whose editors and writers interacted with those of *La Révolution surréaliste* from 1925 until the end of the decade. For Masson's account of some of the curious adventures of the Surrealists as political activists, see *Entretiens*, pp. 108–14.

134. In castigating Masson and other dissidents in the second Surrealist manifesto (*La Révolution surréaliste*, Dec. 15, 1929, pp. 1–17), Breton remarked that Masson had been among those whose Surrealist convictions were ''très affichées.'' For Masson's discussion of his role as ''affiché'' and his 1929 rupture with Breton, see *Entretiens*, pp. 60–63.

135. *Entretiens*, p. 59.

136. Cited in Georges Charbonnier, *Le Monologue du peintre* (Paris: Julliard, 1959), vol. 1, p. 187.

137. ''Peindre est une gageure,'' *Plaisir de peindre*, p. 16.

138. ''Peinture et rhétorique,'' *Cahiers du sud* (Marseilles), no. 295, 1949, p. 400.

139. *Dans la salle des pas perdus*, p. 262.

140. ''Documentaire sur la jeune peinture, IV: La Réaction littéraire,'' *Cahiers d'art* (Paris), no. 2, 1930, p. 76.

141. Jean Cassou, Preface to the catalog *André Masson*, Musée National d'Art Moderne, Paris, Mar.–May, 1965, p. 5.

142. Cited in Clébert, p. 41.

143. Title of a drawing used as the title of a film on Masson made by Nelly Kaplan in 1965.

144. Cited in Clébert, p. 101.

145. Cited in Clébert, p. 39.

146. ''Heavenly Bodies,'' *Verve* (Paris), no. 2, 1938, p. 99.

147. Cited in Clébert, p. 41.

148. Michel Leiris, *André Masson: Massacres et autres dessins* (Paris: Hermann, 1971), n.p.

149. ''Les Dessins d'André Masson,'' *André Masson* (L'Imprimerie Wolf), p. 64.

150. *L'Anus solaire*, n.p.

151. Cited in Clébert, p. 43.

152. ''Scènes familières,'' *André Masson and His Universe*, p. 118.

153. ''Peindre est une gageure,'' *Plaisir de peindre*, p. 13.

154. *Entretiens*, p. 156.

155. Not until after the war, around 1955, did Masson begin again to spend extended periods of time in Paris.

156. Cited in Clébert, pp. 43–44.

157. ''Conversations avec Henri Matisse,'' *Critique* (Paris), May 1974, p. 393.

158. *Entretiens*, p. 164.

159. Cited in Clébert, p. 43.

160. *Entretiens*, p. 158.

161. Although the drawings were executed in 1932, the book with its accompanying etchings was not published until 1936, by Guy Levis Mano.

162. They were married on December 28, 1934, with Miró and his wife and Georges Duthuit and his wife acting as witnesses.

163. *Entretiens*, p. 176.

164. ''La Saison des insectes,'' *André Masson* (L'Imprimerie Wolf), p. 103.

165. Cited in Clébert, p. 50.

166. "Heavenly Bodies," p. 98.

167. "Le Bleu du ciel," pp. 51–53.

168. See Chronology, entries for 1936, 1937.

169. "Some Notes on the Unusual Georges Bataille," *Art and Literature* (Lausanne), Autumn-Winter 1964, p. 107.

170. Ibid., p. 106.

171. Ibid., pp. 106–7.

172. Cited in Clébert, p. 51.

173. Ibid., p. 47.

174. Ibid., p. 48. For a discussion of the bullfight in Picasso's art and its relation to the Crucifixion, see Rubin, *Dada and Surrealist Art*, pp. 290 ff.

175. Although it is possible to read traditional Christian symbolism into the iconography of Masson's art of 1922–26—in the men playing cards, and dice; in the bread and wine; in the fish, the bird, the crown, and the transparent glass—such an interpretation would be totally removed from the artist's intentions.

176. *Entretiens*, p. 170.

177. Cited in Clébert, p. 53.

178. "Masson et le théâtre," *André Masson* (L'Imprimerie Wolf), p. 108.

179. "Mythologies," *André Masson and His Universe*, pp. 128–29.

180. *The Collected Poetry of W. H. Auden* (New York: Random House, 1945), p. 3.

181. Behind Masson's mannequin was the "rue Vivienne," associated primarily with Lautréamont's Maldoror and secondarily with Apollinaire's *Enchanteur pourrissant*.

182. Cited in Clébert, pp. 59–60.

183. *The History of Surrealist Painting*, trans. Simon Watson Taylor (New York: Grove Press, 1960), p. 209.

184. Cited in Clébert, p. 61.

185. Cited in Clébert, p. 60. Breton's words are from "Prestige d'André Masson," *Minotaure*, May 1939, p. 13.

186. Ibid.

187. *Métamorphose de l'artiste*, vol. 1, p. 118.

188. "The Praying Mantis in Surrealist Art," *Art Bulletin* (New York), Dec. 1973, p. 608.

189. Cited in Clébert, p. 36.

190. See the chapter "The Elan of Myth," *Anatomy of My Universe* (New York: Curt Valentin, 1943), Plate XXV.

191. Leiris, "Portraits," *André Masson and His Universe*, p. xii (English), p. 198 (French).

192. Cited in Serge Hutin, *L'Alchimie* (Paris: Presses Universitaires de France, "Que Sais-Je?" 1966), p. 63.

193. "Masson's 'Gradiva': The Metamorphosis of a Surrealist Myth," *Art Bulletin* (New York), Dec. 1970, pp. 415–22.

194. Clébert, p. 95.

195. Cited in Clébert, p. 55.

196. *Le Serpent vert* (Paris: Dervy, 1966), Introduction, p. 24. Reprinted from 1935 edition "réalisée par Le Maître Oswald Wirth."

197. *Goethe's Color Theory*, Rupprecht Matthaei (New York: Van Nostrand Reinhold, 1971), p. 190.

198. "Mythologies," *André Masson and His Universe*, p. x (English), p. 129 (French).

199. In collaboration with E. J. Applewhite, *Synergetics: Explanations in the Geometry of Thinking* (New York and London: Macmillan, 1975), p. 661.

200. Thomas Stanley, *History of Philosophy* (1701). Cited in *The Oxford English Dictionary*, s.v. "five."

201. *Documents* (Paris), Apr. 1929, pp. 48, 51.

202. Plate XVIII.

203. From documents on file in the Baltimore Museum of Art. These documents came to the Baltimore Museum at the time of the Saidie A. May gift.

204. Masson's Surrealist background, which was viewed by the Vichy government as tantamount to Communist, would have made existence in occupied France tenuous at best, but the fact that Rose Masson is of Jewish parentage made it imperative that the family leave France.

205. Cited in Clébert, p. 64.

206. Balakian, *André Breton*, p. 187.

207. See Bibliography.

208. *Entretiens*, p. 200.

209. May documents in Baltimore Museum of Art.

210. "L'Art commence où le réalisme finit," *Arts* (Paris), Feb. 12–18, 1958, p. 15.

211. Cited by Jean Ballard, "Passages à Marseille d'André Masson, 1929–1939," in the catalog *André Masson*, Musée Cantini, Marseilles, July–Aug. 1968, n.p. Reprinted in Clébert, pp. 132–35.

212. "Eleven Europeans in America," p. 3.

213. Brownstone in the catalog *André Masson*, Galleria Schwarz, Milan, June 4–Sept. 30, 1970, p. 27.

214. Cited in Clébert, p. 66.

215. *Entretiens*, p. 63.

216. *Métamorphose de l'artiste*, vol. 1, p. 29.

217. Cited in Clébert, p. 65.

218. Cited in Matthaei, *Goethe's Color Theory*, p. 14.

219. *Métamorphose de l'artiste*, vol. 1, p. 30.

220. For a discussion of purple as the dominant tonality in Picabia's *Negro Song* of 1913, see Rubin, *Dada and Surrealist Art*, p. 53.

221. Inscription under poetic text on Masson written by Antonin Artaud, published in *La Révolution surréaliste* (Paris), Jan. 15, 1925, p. 7.

222. Cited in Clébert, p. 66.

223. "Conversations avec Henri Matisse," p. 397.

224. *The Nation* (New York), May 20, 1944, pp. 604–5.

225. In the earliest versions of **Pasiphaë** of the late thirties, the posture of the queen derives from figures in Picasso's *Guernica*, and is, as well, genetically related to the figure of the gored horse Picasso first drew in 1917; but the queen's figure in the Pasiphaë paintings and drawings of 1943 and the pastel of 1946 no longer depends to any appreciable extent on outside influences and is very personally Masson's own.

226. Cited in Clébert, p. 74.

227. May documents in Baltimore Museum of Art.

228. Delmore Schwartz in *A Little Treasury of Great Poetry*, ed. Oscar Williams (New York: Scribner's, 1947), p. 184.

229. *La Mémoire du monde*, pp. 124–26.

230. Cited in Clébert, p. 71.

231. "The Art Galleries," *The New Yorker* (New York), May 5, 1945, pp. 67–68.

232. "Eleven Europeans in America," p. 5.

233. "Three Dialogues" (between Duthuit and Samuel Beckett), *Transition Forty-nine* (Paris), no. 5, 1949, p. 99.

234. From Curt Valentin archive on deposit in The Museum of Modern Art.

235. Cited in George Howard Bauer, *Sartre and the Artist* (Chicago and London: University of Chicago Press, 1969), pp. 142–43.

236. Cited in Clébert, p. 76.

237. Ibid.

238. *Le Serpent dans la galère* (New York: Curt Valentin, 1945), n.p.

239. Curt Valentin archive.

240. *L'Espoir* was published in 1946 by Gallimard but never commer-

cially distributed, as only three copies were made. A partial re-edition (the prints were done in offset after the original lithographs) was included in Malraux's *Oeuvres III* (Paris: Gallimard, 1970).

241. In the catalog *Designs for Hamlet, Book Illustrations, Lithographs by André Masson,* Arts Council of Great Britain, 1947.

242. *Métamorphose de l'artiste,* vol. 1, p. 85.

243. Cited in Gyula H. Brassai, *Picasso and Co.* (New York: Double-day, 1966), p. 79.

244. "Formules déclinantes," *Plaisir de peindre,* p. 180.

245. Vol. 2, pp. 53–54.

246. Cited in Clébert, p. 78.

247. "Monet le fondateur," *Verve* (Paris), Dec. 1952, p. 68.

248. "Divagations sur l'espace," *Plaisir de peindre,* p. 152.

249. Citations from "Divagations sur l'espace" and "Petit Traité du paysage" selected by Masson for the "Notes" to the catalog *A Retrospective Exhibition of the Works from 1930 to 1955 by André Masson,* The Leicester Galleries, London, Apr.–May 1955, p. 10.

250. *Métamorphose de l'artiste,* vol. 2, pp. 11, 12.

251. Ibid., vol. 1, p. 75.

252. Cited in Gilbert Brownstone, *André Masson, vagabond du surréalisme* (Paris: Editions St-Germain-des-Prés, 1975), p. 135.

253. Cited in Bauer, pp. 143–44. From "Pour prendre congé de toute mythologie," *Situations,* 4:389.

254. Cited in Clébert, p. 104.

255. "Tableaux récents d'André Masson," *XX Siècle* (Paris), Jan. 1956 (Supplement), n.p.

256. *Métamorphose de l'artiste,* vol. 1, p. 107.

257. "L'Effusioniste," *La Nouvelle Revue française* (Paris), July 1955, p. 37.

258. Letter in the files of The Museum of Modern Art.

259. *Métamorphose de l'artiste,* vol. 2, p. 122.

260. "Divagations sur l'espace," *Plaisir de peindre,* p. 147.

261. Françoise Will-Levaillant in the catalog *André Masson,* Galerie de Seine, Paris, Apr. 26–May 27, 1972, p. 49.

262. "L'Effusioniste," p. 36.

263. Ibid.

264. "La Chine d'André Masson," *Revue de l'art* (Paris), no. 12, 1971, p. 72.

265. "L'Effusioniste," pp. 38, 40–41.

266. "Tableaux récents d'André Masson."

267. "L'Effusioniste," p. 47.

268. Ibid., p. 36.

269. Cited in Bauer, p. 138.

270. Cited in Clébert, p. 83.

271. Adrienne Rich, "Her Waking," *Necessities of Life* (New York: Norton, 1966), p. 25.

272. "Notes," *Plaisir de peindre,* p. 27.

273. In the catalog *André Masson,* Galerie Louise Leiris, Paris, Mar. 1–31, 1962, n.p.

274. Ibid.

275. Ibid.

276. "Masson: The Intellectual Dilemma," *Art News* (New York), Summer 1965, p. 47.

277. Leiris catalog, 1962.

278. Cited in Clébert, p. 87.

279. Ibid., p. 88.

280. In the catalog *André Masson: Entrevisions,* Galerie Louise Leiris, Paris, Oct. 19–Nov. 24, 1973, p. 12.

281. Cited in Bauer, p. 137.

282. Leiris catalog, 1973, p. 11.

REFERENCE ILLUSTRATIONS

Fig. 1:
Hans Hofmann.
Fairy Tale. 1944.
Oil on plywood, 60 x 36".
Estate of the artist

Fig. 2:
Jackson Pollock.
The Totem, Lesson 1. 1944.
Oil on canvas, 70 x 44".
Private collection

Fig. 3:
Jackson Pollock.
Circle. c. 1936.
Oil on smooth side of
masonite, 11½ x 11".
Private collection, New York

Fig. 4:
Jackson Pollock.
Woman. c. 1941.
Oil on hardboard,
21½ x 10¾".
Private collection, New York

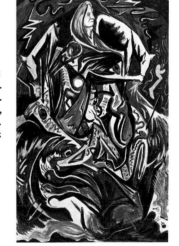

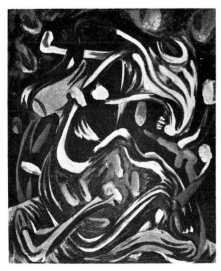

Fig. 5:
Jackson Pollock.
Panel C. c. 1936.
Oil on smooth side of
masonite, 7½ x 5¾".
Private collection, New York

Fig. 6:
Jackson Pollock.
Stenographic Figure. 1942.
Oil on canvas, 40 x 56".
Private collection, New York

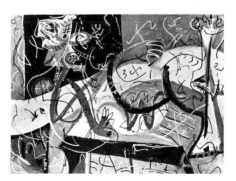

Fig. 7:
Eugène Delacroix.
*Study for "Apollo
Triumphant."* 1849.
Oil, 51⅛ x 38¼".
Musées Royaux des
Beaux-Arts de Belgique,
Brussels

Fig. 8:
James Ensor.
*Christ Calming
the Waves.* 1891.
Oil on canvas,
31½ x 39⅜".
Museum voor Schone Kunsten,
Ostend, Belgium

Fig. 9:
André Derain.
The Drinkers. 1913–14.
Oil on canvas,
55⅛ x 34⅝".
Private collection

Fig. 10:
André Derain.
The Game Bag. 1913.
Oil on canvas, 45⅞ x 31⅞".
Private collection, Paris

1919 Das Auge des Eros

Fig. 11:
Paul Klee.
The Eye of Eros.
1919.

Fig. 12:
Austin O. Spare.
Automatic Drawing. 1916.

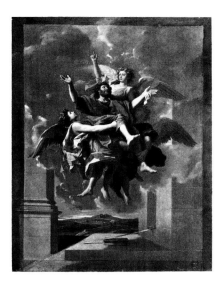

Fig. 13:
Nicolas Poussin.
The Ecstasy of St. Paul. 1649–50.
Oil on canvas, 58¼ x 47¼".
Musée du Louvre, Paris

Fig. 14:
Odilon Redon.
Orpheus. After 1913 (?).
Pastel, 27½ x 22¼".
The Cleveland Museum of Art,
Gift from J. H. Wade

Fig. 15:
Alberto Giacometti.
Man and Woman. 1928–29.
Bronze, 18⅛ x 15¾".
Collection Henriette Gomès, Paris

Fig. 16:
Pablo Picasso.
Figure. 1927–28.
Oil on canvas, 21⅝ x 13".
Private collection

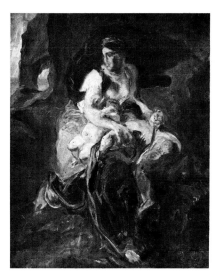

Fig. 17:
Eugène Delacroix.
Study for "Medea."
1838. Oil on canvas, 17¾ x 14½".
Musée des Beaux-Arts, Lille

Fig. 18:
Luigi Rossini.
Ruins of the Temple of Minerva.
1823. Engraving, 19 x 23¾".

Fig. 19:
Josse de Momper.
Flemish 17th century.
Summer. Oil on canvas,
20½ x 15½".
From a set of the Four Seasons.
Collection Robert Lebel, Paris

Fig. 20:
Leonardo da Vinci.
*Dissection of the Principal Organs
of a Woman.*
c. 1510 or later.
Pen and ink and wash
over black chalk, 18½ x 12⅞".
Royal Library, Windsor

CHRONOLOGY

Compiled by Frances Beatty

1896

André Masson, born January 4 in Balagny, a small village in the Oise Department near Senlis, France, eldest of three children. Mother née Marthe Bernard. Father, Aimé Masson, conducts a school in the Oise.

1903–06

Family moves briefly to Lille; municipal museum provides the boy's first opportunity to see paintings. Family settles in Brussels, where father operates an agency that sells wallpaper. Masson attends a primary school run by the Marist Brothers. Visits the Musée Royal des Beaux-Arts frequently; work of Brueghel and David's *Marat* impress him, but he is more profoundly affected by oil sketches of Delacroix and Rubens.

1907–11

Although considerably below regulation age, at eleven Masson is admitted to the Académie Royale des Beaux-Arts et l'Ecole des Arts Décoratifs in Brussels. Draws after antique casts and studies composition and decorative design. Master is Constant Montald, whose practice of teaching students to work in distemper and whose interest in Quattrocento fresco painting deeply influence the early phases of Masson's career. Finds reproductions of works by Cézanne, Gauguin, Seurat, Redon, and van Gogh in a book in the Academy library. Sees Ensor's *Christ Calming the Waves* in the Exposition Universelle et Internationale, May 1–November 15, 1910. Modern art hall provides first actual experience of modern art. To earn money, works afternoons making designs for embroidery concern across the street from the family apartment in the place Julien Dullens. In spare time audits course given by the Flemish writer Georges Eekhoud on Elizabethans.

1912

First encounters Cubism through reproductions of works by Pablo Picasso, Georges Braque, and Fernand Léger seen in spring issue of *Je sais tout*. Dominant style in his own painting is that of the Nabis. Spends summer with Montald at his country home, Woluwe St-Lambert, helping with a project to decorate a church in the Ardennes with the life of St. Francis. Meets Montald's friend Emile Verhaeren, the Flemish poet, Ensor enthusiast, and collector. Impressed by the student's talent, Verhaeren persuades Masson's parents to send him to Paris to study. Masson enters the atelier of Paul Baudoin, who teaches fresco painting at the Ecole Nationale Supérieure des Beaux-Arts in Paris.

1912–14

Lives in Paris near the Musée du Luxembourg. Attends Verhaeren's Sundays, where he meets Paul Signac and becomes familiar with work of Seurat. Virtually only other social contact is with a fellow student, Meurice Loutreuil. Visits Paris museums, studies old masters, particularly Poussin, whose work is of primary importance to him, as it was to remain throughout his career. Encounters paintings by Henri Matisse at Bernheim Jeune, but interest in recent and contemporary art is largely confined to the work of Puvis de Chavannes, who was Baudoin's teacher, and Medardo Rosso.

1914

April: On a grant from the Ecole des Beaux-Arts, Masson and Loutreuil travel through northern Italy to study frescoes. Particularly moved by *The Descent from the Cross* by Pietro Lorenzetti in Assisi. Visits Siena, Pisa, and San Gimignano, where he discovers Barna da Siena's *Crucifixion*. In Florence most impressed with Paolo Uccello's fresco *The Deluge* in the Green Cloister at Santa Maria Novella. Admires works by Rubens, Rembrandt, and Botticelli at the Uffizi.

Late May: Returns to Paris.

Early June: Travels to Switzerland, where he spends six months at house of Mme Bonto in the Bernese Oberland among her circle of literary and artistic friends. Reads Nietzsche avidly. Takes long walking tours.

August 3: Germany declares war on France.

December: Masson returns to Paris to join French forces. Puts off entering army for three weeks to copy Delacroix's mural *Heliodorus Driven from the Temple* in the church of St-Sulpice. Sees the recently opened Camondo collection in the Louvre; particularly impressed by Cézanne's work. Learns about Sade's work through *Le Marquis de Sade et son temps* by Duehren, which he finds in a stall on the quays.

1915

January: Joins the French infantry as a private.

1916

Experiences particularly bloody warfare in the spring near Roye, La Somme. Fights in the battles of the Somme in June and November. Seventy-five out of the hundred men in his company are killed or disabled. Spends freezing winter in the Aisne.

1917

April 17: Severely wounded in the offensive of Chemin des Dames, La Somme. Transferred through a series of army hospitals to convalescent hospital at Le Vésinet.

1918

Escapes from examination at barracks of Clignancourt when wound is ripped open by a doctor who insists on raising his arm, but is forcibly returned and put in mental hospital, the Maison Blanche. Spends latter part of year in mental ward in Ville-Evrard.

November: Discharged from army and from mental ward with doctor's warning never to live in cities because of deep trauma that his war experiences have caused. Lives briefly with his parents in Paris.

November 11: End of World War I.

1919

Leaves Paris to join Loutreuil in Martigues, where, in a hut overlooking the Etang de Berre, he begins to paint. Visits Collioure, then Céret, where he meets the painter Pinchus Krémègne and the sculptor Manuel Manolo. Manolo finds a studio for Masson in the empty Capuchin convent. Paints still lifes and views of Céret. Meets Chaim Soutine, with whom he has frequent discussions, chiefly disagreements concerning modern art.

Summer: Meets Odette Cabalé.

1920

February 13: Marries Odette in Céret, with Frank Haviland and Manolo for witnesses. Works on ceramics in Prades, near Céret, before returning with Odette to live with parents in Paris. Works on ceramics at the Lachenal firm. Meets Max Jacob at the salon of feminist intellectual Mme Aurel.

November 3: Daughter Lili born. Masson finds a job as night editor at the *Journal officiel*, where he meets the painter André Beaudin. Works as film and theater extra, delivery boy, and ceramicist simultaneously during 1920–21 in order to support his family; has little time to paint.

1921

Moves to Hôtel Béquerel, rue Vieuville, in Montmartre, where he is friendly with Jacob and the painter Elie Lascaux, who show his work to the art dealer Daniel-Henry Kahnweiler. Meets Roland Tual at the Club Faubourg, where he goes to look for work. Jean Dubuffet introduces him to Georges Limbour, who becomes one of his lifelong friends.

1921–22

Paints a few still lifes, a view of Montmartre, and portraits of Tual and Limbour. Makes numerous erotic drawings.

Winter: Moves to 45, rue Blomet. At one of Jacob's gatherings of painters and poets at the Café Savoyard, Masson meets Joan Miró and discovers that he has just rented the adjacent atelier.

1922

Works on forest landscapes, still lifes, and groups of men eating and

playing games of chance, themes which occupy him through 1923. A number of these works, particularly the forest landscapes, reflect his interest in André Derain.

Summer: Kahnweiler comes to see Masson's work and offers him a contract. Rue Blomet becomes the center of a group of artists and writers that includes Armand Salacrou, Tual, Limbour, and Michel Leiris, whom Masson meets through Tual. Through Kahnweiler Masson meets Gertrude Stein, who brings Ernest Hemingway to rue Blomet; both buy his work. At Kahnweiler's Sundays in Boulogne, Masson becomes friendly with Juan Gris and sees the work of Léger and Picasso. Discovers Paul Klee's works through reproductions in a German monograph he finds along the quays. Subsequently credits Klee as most important external influence in moving his art away from Cubism.

1922–23

Nightly gatherings at rue Blomet are dominated by passionate literary discussions; of primary interest are Rimbaud and the German Romantics Richter and Novalis. Sade and Lautréamont, introduced by Tual, provide even more exciting discoveries. Masson is aware of Dada but, with the exception of a few humorous gestures such as "faking" a Picabia, is uninvolved with the movement. Reads with great interest André Breton's review *Littérature*. Forest landscapes become more fantastic.

1923

February: Stays with the Beaudins in Thieuley-St-Antoine for a few weeks.

May: Group exhibition at Kahnweiler's Galerie Simon, Paris, includes Masson's work along with that of other gallery artists, Braque, Derain, Gris, Lascaux, Laurens, Manolo, Picasso, Tongores, and Vlaminck. Masson continues to participate regularly in group exhibitions at Kahnweiler's.

Spring: Meets Louis Aragon through Limbour, who attends some of the meetings at Breton's studio in the rue Fontaine and at the Café Cyrano. The separation between Breton's circle and the rue Blomet continues through the spring of 1924. Robert Desnos, Raymond Queneau, and Marcel Jouhandeau are frequent visitors at the rue Blomet. Meets André Malraux at Kahnweiler's.

Summer: Spends with Armand and Lucienne Salacrou in Brittany at Plestin-les-Grèves. Leiris vacations with them and writes the poem "Désert des mains" inspired by Masson's work. Antonin Artaud becomes a frequent visitor at rue Blomet.

Themes of 1922 continued and expanded. Moves away from Derain's influence toward Analytic Cubism, flattening the pictorial space and using faceted, fractured forms by mid-1923. Traditional Cubist imagery is charged with mystic, symbolic content.

Winter: Begins to experiment with automatic drawing in late 1923, and the cord, to become one of his most prevalent icons, makes first appearance.

1924

February 25–March 8: Has first one-man exhibition at Galerie Simon, consisting of fifty-three oils and a number of drawings; catalog preface, "L'Homme-plume," by Limbour. Breton comes to exhibition, buys **The Four Elements** and goes to rue Blomet to meet Masson. Breton expresses great interest in Masson's work and invites him to join the nascent Surrealist group. Masson begins working on his first prints, drypoints illustrating Limbour's book *Soleil bas* (published 1925). Increasing involvement with automatic drawing.

Summer: To Nemours, south of Fontainebleau, with Gris. Joined by Leiris, Tual, and Limbour. Miró visits briefly.

September–October: Masson joins Aragon, Hans Arp, Jacques Baron, Breton, Desnos, Marcel Duhamel, Paul Eluard, Max Ernst, Eugène Jolas, Leiris, Limbour, Pierre Naville, Benjamin and Jacques Peret, Queneau,

Yves Tanguy, Tual, and others in signing "Hands off Love" protesting the charges brought against Charlie Chaplin by his wife, published in *Transition Six*, one of the first public expressions of Surrealist collective activity (reprinted in *La Révolution surréaliste*, October 1927). Ivan Goll publishes first (and only) issue of *Le Surréalisme*. The movement, however, gravitates toward the more convincing and capable Breton, who publishes its charter, "First Manifesto of Surrealism"; Breton stresses automatism as the principal means of artistic expression. Le Bureau de Recherches Surréalistes opens at 15, rue de Grenelle.

December: Two "automatic" drawings by Masson are reproduced in the first issue of *La Révolution surréaliste*, whose directors are Naville and Benjamin Peret. Masson draws automatist portrait of Breton. Commissioned by Jacques Doucet to make portrait drawings of Surrealist writers to illustrate their works. Commission is canceled, but Masson continues to do automatist portrait drawings including those of Aragon, Roger Vitrac, Eluard, Artaud, Peret, Leiris, and Jouhandeau. Visits Salacrous for New Year's. Gradually abandons forest landscapes as a theme. Still lifes contain postcards, Piranesian architecture, and female forms (with increasing frequency). Works on a series of metaphysical portraits. Attempts to incorporate the flowing, curvilinear forms that were developed through automatic drawing into painting; architectural images are disposed around a central open area in which floating figures are "drawn" in oil and left unmodeled.

1925

January: *La Révolution surréaliste* contains text by Artaud inspired by **Man** (1925) and an automatic drawing inserted as Masson's reply to "Le Suicide est-il une solution?" Tanguy, Jacques Prévert, and Duhamel, who share a house on the rue Château, join the combined group from rue Fontaine and rue Blomet. Masson works on seven lithographs for *Simulacre* by Leiris (published in April). Signs the "Déclaration du 27 Janvier" issued by the Bureau de Recherches Surréalistes, in which Surrealism is defined as a means of "total liberation of the spirit," which has nothing to do with literature but is, rather, a "state of mind." Signers include Aragon, Artaud, Breton, Desnos, Eluard, Ernst, Théodore Fraenkel, Leiris, Limbour, Philippe Soupault, and Tual.

April: Work included in group exhibition of gallery artists at Galerie Simon. Leaves Paris to look for house on the Côte d'Azur. Four automatic drawings, **Man,** and his statement "Il faut se faire une idée physique de la révolution" appear in *La Révolution surréaliste*. Designs cover for Artaud's *Le Pèse-nerfs* (published August).

May: Rents Villa Nelly Mariel, Chemin des Sables, Antibes, for summer. Visits the Kahnweilers, who live nearby. Leiris and Lascaux come to visit. Sees Picasso frequently at the beach at Juan-les-Pins. Visits André and Simone Breton in Nice where Desnos, Max Morise, and Peret are also staying.

July: Breton takes over the directorship of *La Révolution surréaliste*. The fourth issue includes the first installment of "Le Surréalisme et la peinture," Eluard's poem "André Masson," André Boiffard's "Nomenclature," in which Masson's name is defined as "the sound of caverns," and a reproduction of the painting **The Armor.**

September: Visits Breton and Desnos in Thorenc-sur-Loup. Returns to Antibes before going back to Paris via Avignon at end of November.

October: *La Révolution surréaliste* contains the automatic drawings **Furious Suns** and **Birth of Birds,** and a letter from Masson (September 2, Antibes) stating his position in favor of the "Dictatorship of the Proletariat"; signs the group's declaration "La Révolution d'abord et toujours!" This specifically political statement, along with the declaration, which had appeared in the April issue, is exceptional for Masson, who remained unengaged through most of his involvement with the Surrealists.

November 14–25: Participates in first Surrealist exhibition at Galerie Pierre, Paris; catalog preface by Desnos and Breton. Exhibits **A Bird** (reproduced), **The Armor,** and **Man.** Works by Arp, Giorgio de Chirico, Ernst, Klee, Miró, Picasso, Man Ray, and Pierre Roy included.

Leiris brings Georges Bataille, who is to become one of Masson's closest friends, to rue Blomet. Bataille acquires **The Armor.** Article, "André Masson" by Jouhandeau, is published in *La Nouvelle Revue française.*

1926–27

Images of aggression and conflict increase, particularly gladiators or warriors coupled with horses. By mid-1926 the Cubist grid becomes the background for curvilinear figure drawings. In late 1926 the grids become more schematic, the compositions more open. Problem of transposing the freedom of automatic drawing into painting is increasingly acute.

At Sanary, searching for a method to paint "automatically," Masson discovers, through the use of sand and glue, a way to make pictures based on random "automatic" gestures.

1926

January 20–February 15: Included in "Braque, Gris, and Masson," group exhibition at Galerie Jeanne Bucher, Paris, of prints and drawings. (Masson's work, primarily graphics and drawings, is shown periodically at Galerie Jeanne Bucher through an arrangement with Kahnweiler.)

March: *La Révolution surréaliste* contains reproductions of **The Constellations** and **Birds Pierced by Arrows** (1925) and a text, "La Tyrannie du temps," by Masson that expresses his horror of the cruelest tyrant, Time. Turns the atelier at rue Blomet over to Desnos and goes to look for house on Côte d'Azur.

March 25–April 1: Opening exhibition at Galerie Surréaliste, Paris, includes all the artists who participated in Galerie Pierre show, plus Marcel Duchamp and Picabia. Tual is the director.

April: In the south of France near Toulon.

May: Rents Le Printemps, Route de Banderol, Sanary-sur-Mer, near Toulon, where he spends nine months. "André Masson" by Leiris published in *The Little Review,* Spring-Summer issue.

June: *La Révolution surréaliste* includes reproductions of **Fish, Man, and Star** (drawing with colored crayon) and **Death of a Bird** (1926).

Summer: Benjamin and Pierre Peret, Tanguy, Duhamel, Tual, and Limbour visit Masson in Sanary.

November 14–December 8: Group exhibition, "Neue Französische Malerei," organized by Kahnweiler and Alfred Flechtheim at Frankfurter Kunstverein, includes works by Braque, Robert Delaunay, Derain, Raoul Dufy, Gris, Lascaux, Marie Laurencin, Matisse, Léger, Picasso, Amedeo Modigliani, Georges Rouault, Maurice Utrillo, and Masson.

December: *La Révolution surréaliste* reproduces an "automatic" drawing and **The Sheets.**

Masson makes four engravings for *C'est les bottes de 7 lieus cette phrase "je me vois"* by Desnos.

1927

March–April: Returns to Paris, stays at Médical Hôtel for about two months.

May: Rents house on avenue Ségur. Future directors of *Le Grand Jeu,* René Daumal and Roger Gilbert-Lecomte, are frequent visitors, along with the rue Château group, Prévert, Tanguy, and Duhamel.

Executes six engravings to illustrate Jouhandeau's *Ximenes Malinjoude.*

Meets Alberto Giacometti at Café du Dôme, who later in the year gives Masson technical advice in executing his first sculpture, **Metamorphosis,** in plaster.

October: *La Révolution surréaliste* includes a reproduction of Masson's sand painting **Personage** and the fourth installment of "Le Surréalisme et la peinture," in which Breton praises Masson for the "dazzling precipitousness" of his work and compliments his "distrust of art."

December: Trip to Holland and Germany with Roland and Colette Tual. Particularly interested in ethnological museums, the aquarium in Amsterdam, and the zoo in Hamburg.

Increasingly abstract imagery, developed in sand pictures, carries through the year in a group of very open compositions with schematically drawn forms.

1928

January: Returns to avenue Ségur.

March: Leaves Paris for the Côte d'Azur, where he rents a villa at Lavandou. Reproduction of **A Metamorphosis** (1927) included in *La Révolution surréaliste.*

April: Participates in Surrealist exhibition at Galerie "Au Sacre du Printemps," Paris. Includes works by Arp, de Chirico, Ernst, Georges Malkine, Miró, Tanguy, and Picabia.

Spring: Works on drawings for Sade's *Justine* (project was subsequently dropped), etchings to illustrate *Le Con d'Irène* by Aragon, and lithographs for Bataille's *Histoire de l'oeil* by Lord Auch.

May: Increasing alienation from the Surrealist group; writes to Kahnweiler that he does not consider himself part of any group and will accept Christian Zervos' offer to write an article about his work provided "Surrealism" is not mentioned anywhere in it.

July–August: Vacations in Dattier, not far from Lavandou, near Vitrac and Kitty Cannel. Meets Lawrence Vail and Peggy Guggenheim, who live nearby in Pramoustier.

September: Returns to Paris, avenue Ségur.

September 30–October 31: In group exhibition at Galerie Flechtheim, Düsseldorf.

Works on open neutral-ground compositions with explicitly sexual imagery through the early spring of 1929. Two types of compositions are developed during the later part of the year and carried into 1929. The first type, in which the field is divided as a grid of flat geometrical, rich-colored areas, appears in a series of abstract nudes. In the second group, which becomes dominant in 1929, the evident grid is abandoned for swirling forms and curvilinear color areas.

1929–30

Sketches in slaughterhouses in Paris on visits with photographer, Elie Lotar. Biomorphic shapes representing fish and animals involved in battles, killings, and devourings appear in pictures.

1929

February: Harold Salemson cites Masson as being the "only Surrealist in painting," in article "Paris Letter," *Transition.*

February–March: At the instigation of Breton, a provocative letter demanding that the recipients state their position on group action is sent out to the Surrealists, including those who had already defected. During the meeting called at the Bar du Château to discuss the responses, Masson makes a dramatic appearance denouncing Breton's authoritarianism and his demands for unity of activity. In a subsequent meeting with Breton, Masson explains that his need for independent, personal activity precludes his adherence to the group.

Spring: *Le Grand Jeu* includes text by Daumal inspired by Masson's sculpture **Metamorphosis** (reproduced), which Daumal feels announces the reign of "Terror Love."

April 8–30: One-man exhibition at Galerie Simon consists of forty-one paintings from 1924–29, plus a number of drawings, watercolors, pastels and illustrated books; catalog preface by Limbour.

Separation from Odette and divorce before end of year.

May: Travels to Provence. Stays briefly in La Ciotat, tours Avignon, and settles in Roussillon, in the Vaucluse. Commissioned by Pierre David-Weil to decorate his apartment; asks Giacometti to collaborate with him. Returns to Paris in August to work through September on two large panels for the project.

November 23–December 25: In group exhibition, "Seit Cézanne in Paris," Galerie Alfred Flechtheim, Berlin.

December: Breton attacks Masson, Vitrac, and Limbour in his second Surrealist manifesto (published in *La Révolution surréaliste*), formally expelling them from the movement; automatism is conspicuously insignificant in this new charter.

Articles on Masson published in 1929 include: "André Masson" by Tériade (*Cahiers d'art*), Waldemar George's article (*La Presse*, April 15), and "André Masson: Etude ethnologique" by Carl Einstein (*Documents, May*). *Cahiers du sud* (February) also publishes a group of articles, poems, poetic texts on, or inspired by, Masson by Baron, Joë Bousquet, Stanislas Boutemer, André Delons, Hubert Dubois, Eluard, Jouhandeau, Leiris, and Limbour; reproductions of **The Storm, The Prisoner, The Prey,** and **The Dead Man** are included.

Executes cover and three drawings for *La Terre n'est à personne* by André Gaillard published by *Cahiers du sud*.

1930–31

Work becomes increasingly figurative. Paints a number of bucolic scenes, then returns to violent subject matter in 1931 with Massacre drawings, a theme that dominates in his work of 1932–33 and continues through 1934.

1930

January: Goes to Boumes on the Côte d'Azur with Tual and visits Piera Cavea in the Alpes-Maritimes.

March: Returns to Paris.

April: Participates in the Salon des Surindépendants.

July: Group exhibition at Gallery of Living Art, New York, includes **Italian Postcard** (1924). A. E. Gallatin is director. Meets Kuni Matsuo, a Japanese writer, who is working on a book about Japanese Buddhist sects and who subsequently organizes the first exhibition of Surrealist art in Japan (1932–33). This contact with Matsuo enables Masson to learn about Zen and Oriental art, which will become primary sources of inspiration for him in the forties and fifties.

Articles include "André Masson" by Vitrac (*Cahiers d'art*) and "André Masson, le dépeceur universel" by Limbour (*Documents*). First monograph, *André Masson*, by Pascal Pia, published in Paris.

Meets Georges Duthuit (c. 1930–31) at La Rotonde in Paris.

1931

Works on drypoints to illustrate Bataille's *L'Anus solaire* (published November) and engravings to illustrate Machiavelli's *The Prince* (this project was abandoned).

Paul Rosenberg begins to buy Masson's works. Interview published in Berlin review *Das Kunstblatt* (August 15).

April 25–May 24: Group exhibition, "Exposition International de l'Art Vivant" at Palais des Beaux-Arts, Brussels, includes **Nudes** and **The Metamorphosis** (1929).

November and December: Included in "Newer Super Realism," at the Wadsworth Atheneum, Hartford, Conn., organized and selected by James Thrall Soby and Charles Austin. Also included in group exhibition at Galerie Vavin-Raspail, Paris.

December: Paris. Rupture with Kahnweiler. Masson is under contract with Rosenberg for two years.

1932–34

Paints expressionistic scenes of ritualistic, erotic killings. Greek mythology becomes a source of themes and continues to grow in importance.

In 1933 Masson makes a series of pastels inspired by Rimbaud's *Illuminations* and executes drawings to accompany Bataille's text on the theme of sacrifices, including **The Crucified One, Mithra, Osiris,** and **Minotaur** (etchings and text published in December 1936). Jagged, angular patterns formed by dark lines cutting out or through acid-colored forms give way in 1933–34 to more curvilinear movements and clearer, more decorative colors.

1932

Leaves Paris to live in St-Jean-de-Grasse on the Côte d'Azur for most of the year. Virtually only social contact, with the brief exception of Matisse, whom he meets through Duthuit, is writer H. G. Wells, whom he sees often.

January: Work included in group exhibition "Quelques Peintres du XXième Siècle," Galerie Paul Rosenberg, Paris.

January 17–February 18: One-man exhibition at Rosenberg and Helft Gallery, London.

February 6–20: Group exhibition "Léger, Masson, and Roux" at Valentine Gallery, New York.

June 3–16: Group exhibition "25 Ans de Peinture Abstraite" at Galerie d'Art Braun, Paris; introduction to catalog by André Salmon. Show includes works by Braque, Delaunay, Gris, Léger, Picabia, and Picasso.

October: Returns to Paris.

October 20–November 19: One-man exhibition at Galerie Paul Rosenberg. "A propos des oeuvres récentes d'André Masson," by Zervos published in *Cahiers d'art*.

1933

January 17–February 11: One-man exhibition, at Pierre Matisse Gallery, New York, includes nine recent paintings.

February–March: Works on stage designs and costumes commissioned by the Ballets Russes de Monte Carlo for *Présages,* choreographed by Léonide Massine to Tchaikovsky's Fifth Symphony. Following a dispute with company, spends fifteen days as Matisse's guest in Nice.

c. April: Returns to Paris.

June 9: *Présages* opens at Théâtre du Châtelet, Paris, where Masson's stage design is controversial, but it subsequently has great success in London.

First issue of *Minotaure* includes an article on *Présages* by Tériade, a statement by Masson, and reproductions of Massacre drawings. The title of this review was suggested by Masson and Bataille during meeting with Vitrac, Desnos, and Tériade, who were in favor of calling the review *L'Age d'Or.*

June 13–23: Masson executes his first prints not meant to illustrate a book, ten engravings (two in color) including **Birth of Horses, Diomedes, The Gorgons,** and **Tiger's Head.**

September: Vacation with Rose Maklès in Les Settons, Nièvre. Returns to Paris and resumes contract with Kahnweiler, who remains his dealer to the present. (During World War II, Kahnweiler's Galerie Simon was renamed Galerie Louise Leiris.)

November: In group exhibition at Gallery of Living Art, New York.

1934–37. "SPANISH PERIOD"

Masson is completely absorbed in Spanish life and culture and derives his themes almost exclusively from them. Reads works by Cervantes, Gongora, Gracián, and Quevedo avidly. Paints landscapes inspired by Toledo, Avila, and Montserrat. Executes Insect pictures. In 1936 theme of corrida dominates. Executes biting satirical drawings in reaction to the Spanish Civil War and continues this subject through 1940.

1934

January 24–February 14: "An Exhibition of Literature and Poetry in Painting since 1850" at Wadsworth Atheneum includes **The Fish** and **Composition.**

February 6: Witnesses a charge of Republican Guards during Stavisky riots in Paris. Decides to exile himself from France.

March: Leaves for Spain with Rose Maklès. Following Duthuit's advice, goes directly to the Escorial; particularly impressed with work of El Greco and Bosch. Travels around Madrid and to Cordova, Granada, and Almería. Returns to Paris via Madrid.

May 4–20: In group exhibition organized by Les Amis de l'Art Contemporain, Paris, which includes works by Vuillard, Bonnard, and Dunoyer de Segonzac.

May 15: *Les Sans-Cou* by Desnos is published with two etchings by Masson.

May 22–June 22: Work included in group exhibition, "La Danse et la Peinture Moderne," Petit Palais, Paris.

May 25–June 8: One-man exhibition of recent work at Galerie Simon.

June 9: Returns to Spain, finds a house in Tossa del Mar on the Costa Brava, where he spends the next two years.

August: Simone Kahn, Breton's ex-wife, and Michel and Louise Leiris visit him at Tossa.

September: Takes walking trip through Aragon and Castile, Sierra de Solario.

October: Spends a few days in Barcelona, where political unrest erupts into violence.

December 28: Marries Rose Maklès, with Miró and Duthuit for witnesses.

Saidie May, who becomes a major collector of Masson's work, acquires her first painting of his from Galerie Simon.

1935

January: On a visit to Montserrat, Masson and Rose are lost on the top of the mountain for a winter night. Masson experiences an epiphany which inspires **Landscape of Wonders** and **Dawn on Montserrat.**

April 29–May 27: One-man exhibition at Pierre Matisse Gallery consists of sixteen works including **The Hunt** (1929), **Lovers** (1930), **Rape, Daphne and Apollo, Harvest** (1933), **Bacchanal, Grave Diggers, Almaradiel,** and **Massacre** (1934).

June 21: Son, Diego, born.

Duthuit prepares a book, *Mystique chinoise et la peinture moderne* (published 1936), dealing with the relationship between contemporary art and Oriental thought and asks Masson to contribute reproductions of his work. Duthuit visits Masson in Tossa during July and August.

Eight drawings in group exhibition, Galerie des Beaux-Arts, Paris.

1936

February 12–March 6: One-man exhibition at Wildenstein Gallery, London, includes paintings, watercolors, drawings, and etchings; catalog preface by Duthuit. Visits London for twelve days; meets Kenneth Clark.

March: During a brief visit to Paris meets Jean-Louis Barrault through Sylvia Bataille (née Maklès, Masson's sister-in-law), who was working with Barrault in the film *Jenny.* Barrault asks Masson to make stage designs and costumes for his production of Cervantes' *Numance* (presented in 1937). Returns to Tossa.

April: Bataille visits Masson and discusses his project for a review, *Acéphale.*

June 11–July 4: Participates in "International Exhibition of Surrealism" at New Burlington Art Gallery, London; catalog preface by Breton. Shows fourteen works including major paintings of the twenties. Exhibition occasions Herbert Read's *Surrealism,* with contributions by Breton, Hugh Sykes Davies, Eluard, and Georges Hugnet.

June 15: Masson's poem "Du haut de Montserrat" and Bataille's article "Le Bleu de ciel," inspired by Masson's account of his epiphany in January 1935, appear in *Minotaure;* **Landscape of Wonders, Dawn on Montserrat** and drawings reproduced. Executes poster for the Front Populaire in Barcelona.

June 24: Masson's drawings of Acéphale appear on the cover of the first issue (and on the two subsequent issues) of *Acéphale* devoted to "La Conjuration sacrée," which includes contributions from Bataille and Pierre Klossowski and reproductions of two drawings.

July 15: Civil War breaks out in Spain.

September 26: Son Luis born.

October: Masson family leaves for Paris, where they remain for approximately three weeks.

November 30: Abduction, The Hunters, and **Composition** shown in group exhibition "Douze Peintures," Galerie Paul Rosenberg, which includes works by Bonnard, Braque, Derain, Léger, and Picasso.

December: Settles in countryside of Lyons-la-Forêt in Normandy.

December 3: Sacrifices, a series of etchings, are published, accompanied by Bataille's text.

December 7–19: One-man exhibition, "André Masson: Espagne 1934–36," at Galerie Simon, consists of seventy-four works.

December 9, 1936–January 17, 1937: Participates in group exhibition, "Fantastic Art, Dada and Surrealism," organized by Alfred Barr, The Museum of Modern Art. Museum acquires **Battle of Fishes** (1926).

1936–37

The Cockfight and **Italian Postcard** shown at the Gallery of Living Art. Spanish themes, particularly the corrida, continue to dominate through 1937. Increasingly preoccupied with the myth of the Minotaur.

1937–41. "Second Surrealist Period"

Reconciliation with Breton and the Surrealists coincides with period of brutally expressionistic paintings dealing with pagan myths, erotic fantasies, and allegorical premonitions of the oncoming war. Transition from Spanish period to second Surrealist period is marked by return to deep space. Myth of the Labyrinth and the Minotaur provides the theme for numerous paintings and drawings. Returns to erotic imagery, which now takes on a particularly aggressive character. Works briefly in 1937 and 1938 on assemblage. In July 1939, begins a series of sand paintings that are less "automatic" than the 1927 sand paintings, but clearly related in style.

1937

Double issue of *Acéphale,* devoted to "Nietzsche et les fascistes, une réparation," contains contributions by Bataille, Klossowski, Jean Rollin, Jean Wahl, and reproductions of three Masson drawings.

Works on set and costumes for Barrault's production of *Numance,* which opens at Nouveau Théâtre Antoine, April 22.

July: *Acéphale,* devoted to "Dionysos," contains contributions by Bataille, Roger Caillois, Klossowski, and Jules Monnerot, and reproductions of five Masson drawings, one entitled **Dionysos.**

September: Visits sister-in-law Simone and her husband Jean Piel in Quiberon, Brittany; walking trip to Carnac.

November: In exhibition "Fransk-Konst" at Svensk-Franska Konstgalleriet, Stockholm, which includes Beaudin, Braque, Cézanne, and Gris.

December: Participates in exhibition "La Mort en Espagne" at Galerie Billiet, Paris. Other participants include Picasso and George Grosz.

At Breton's request Masson makes ten drawings based on *Les Chants de Maldoror* by Lautréamont.

1938–39

Works on suites of ink drawings for *Mythologie de la nature* (May–June 1938), *Anatomy of My Universe* (1938–42), and *Mythologie de l'être* (1939), which (accompanied by poetic texts and captions) set forth his philosophy. Theme of citadel skulls or heads emerges and remains prevalent through 1940. Executes sixteen lithographs illustrating Leiris' *Glossaire: j'y serre mes gloses* (published August 1939).

January–February: Participates in the "Exposition Internationale du Surréalisme" at the Galerie des Beaux-Arts. Exhibits eight paintings, three objects, and the mannequin **Le Bâillon vert à bouche de pensée.** Organizers and advisors include Breton, Eluard, Duchamp, Salvador Dali, and Ernst.

Dictionnaire abrégé du surréalisme (published by Galerie des Beaux-Arts) includes reproductions of four Masson works.

March 8–26: One-man exhibition, "André Masson, Recent Works," Mayor Gallery, London.

March 15: *Verve* includes reproductions of three drawings illustrating Bataille's "Corps célestes" and two color lithographs, **The Sun** and **The Moon.**

March 27–April 18: Group exhibition, "Paris 1938," Galerie S-V, Prague (includes Léger, Lurçat, and Delaunay).

Spring: In "Exposition Internationale du Surréalisme," organized by Breton, Eluard, Georges Hugnet, Roland Penrose, E. L. T. Mesens, and Kristians Tonny at Galerie Robert, Amsterdam (includes work by Arp, Bellmer, Dali, Delvaux, Duchamp, Ernst, Klee, Miró, and Picasso).

April 15: *Solidarité,* a collective edition of engravings by Picasso, Miró, Tanguy, Stanley Hayter, Buckland Wright, Dalla Husband, and Masson, accompanied by a poem by Eluard, published by GLM. These are sold to benefit the International Committee to Aid Refugee Children (Office International pour l'Enfant).

Masson discusses possible fascist threat to himself and his family with Saidie May, who had begun to collect his work and who offers her assistance. Offer is later accepted and greatly facilitates the Masson family's move to America in 1941.

July: *Miroir de la tauromachie* by Leiris is published, with illustrations (three drawings) by Masson.

August: Complete works of Lautréamont are published, illustrated by Brauner, Dominguez, Ernst, Espinoza, Magritte, Malt, Miró, Paalen, Man Ray, Seligmann, Tanguy, and Masson, with introduction by Breton.

September: Vacation in Arcachon. Works on stage designs for *La Terre est ronde* by Salacrou. Play opens in November at the Théâtre de l'Atelier, Paris.

November 3–26: In "Exhibition of Collages and Papiers Collés and Photo Montages," Gallery Guggenheim Jeune, London.

November 8–27: "Modern French Art, New Accessions to the Saidie May Collection," Baltimore Museum, includes Masson's **Ophelia** and a number of his drawings.

February: Works included in group exhibition at Rosenberg and Helft Gallery, London.

March: Satirical drawing, **Tea with Franco,** reproduced in *Révolution,* a Surrealist review.

April: Works on decor for Barrault's production of *Faim,* by Knut Hamsun, which opens April 18 at the Théâtre de l'Atelier. Shows seven works in spring group exhibition, Kunsthalle, Bern.

May 15: *Minotaure,* with cover design by Masson, contains Breton's article "Le Prestige d'André Masson" and reproductions of two drawings. Breton praises Masson's work, and proclaims eroticism as the "keystone" of his art.

July: Visits old friend Lucienne Thalheimer in La Baule; joined by Breton and Pierre Mabille, who urge Masson to make plans to leave Europe; decides to stay in France as long as possible.

August: *Crâne sans lois* by Guy Levis-Mano published, illustrated by five Masson drawings.

October–November: At the suggestion of Ernst, writes an essay on art to send to America. Project is dropped. Text is published as "Peindre

est une gageure" in *Cahiers du sud,* March 1941, translation, "Painting Is a Wager," published in *Horizon,* London, 1943, revised version presented as lecture in Baltimore, 1941. *Les Disciples à Sais* by Novalis, translated by Armel Guerne, frontispiece by Masson, published.

November: Nudes and Architectures and **A Knight** included in "Classic and Romantic Traditions in Abstract Painting," Museum of Modern Art Circulating Exhibition, which is shown throughout the United States from November 1939 to June 1940.

Rereads work by Goethe and Nietzsche's *Origine de la philosophie,* especially interested in passages concerning Heraclitus and Empedocles, from which he derives many of the themes in his work of 1939–43. Begins series of imaginary portraits of Goethe, Nietzsche, Hölderlin, Kleist, Richter, Dante, and others. Increasing use of Bracelli-like parallel blocks or bands, which appear in skull-cities of previous year. Metaphysical landscapes continue through the next two years.

"Mythologie de la nature" published in *Cahiers d'art.*

January–February: Participates in "International Exhibition of Surrealism," Galeria de Arte Mexicano, Mexico City, organized by Breton, Paalen, and Aza Moro.

January 12–February 11: "Modern Isms and How They Grew," an exhibition at the Baltimore Museum of Art, includes Masson's **Lovers, Ophelia,** and **By the Ocean.**

February: Publication of *Le Miroir du merveilleux* by Mabille, illustrated by seven Masson drawings. Executes stage designs and costumes for *Médée,* an opera by Darius Milhaud, produced by Charles Dullin and Serge Lifar; opens May 8 at Paris Opéra.

April: Publication of *André Masson* (Rouen: Wolf) composed of essays by Barrault, Bataille, Breton, Desnos, Eluard, Guerne, Jouve, Madeleine Landsberg, Leiris, Limbour, and Peret. Commissioned by Salacrou.

June: Fall of France. Masson flees Lyons-la-Forêt with family and takes refuge in Fréluc, Auvergne. Prevented from painting because of lack of materials, works principally on drawings for Anatomy of My Universe.

August 31–October 13: Seven works are exhibited in "Sammlung Hermann Rupf," Kunsthalle, Bern, which includes works by Gris, Picasso, Léger, Braque, Derain, and Klee.

December: Leaves Fréluc to join Breton and group of Surrealists, intellectuals, and artists in Marseilles who are trying to leave Europe with the help of the American Rescue Committee headed by Varian Fry. Among them are Brauner, René Char, Daumal, Robert Delanglade, Dominguez, Duchamp, Ernst, Jacques Herold, Sylvain Itkine, Wifredo Lam, Peret, and Tzara.

Peggy Guggenheim acquires **The Armor** (1925).

January–March: Spends the winter in a hunting lodge rented for the Massons by Countess Pastre in Montredon near Marseilles. Visits Breton, Daumal, Ernst, and others at Château Air-Bel in Marseilles and participates in their new Surrealist game, "Le Jeu de cartes de Marseilles" (described in Breton's *La Clé des champs*). Works on stage designs and costumes for Itkine's play *L'Escurial;* the production is forbidden by German authorities.

January 16–March 4: Exhibition of the "Collection of Walter P. Chrysler" at Virginia Museum of Fine Arts, Richmond, which travels to the Philadelphia Museum of Art, March 29–May 11, includes eight important Masson paintings from the twenties.

March: "André Masson" by Robert Melville is published in *Arson* (London).

March 31: Departure for America via Martinique on cargo boat *Carimari.*

April 7–26: Exhibition "Léger, Klee, Beaudin, Braque, Gris, and

Masson'' at Buchholz Gallery, New York. Six ink drawings are shown.
April 30: Arrives in Fort de France, stays in Hôtel de l'Europe. Spends three weeks in Martinique with Breton, Claude Lévi-Strauss, and Lam. Explores island with Breton. They later recount their impressions in *Martinique, charmeuse de serpents.* Meets Martinique poet Aimé César (publisher of review *Tropiques*) and Georges Gracian. Masson is amazed and fascinated by the vegetation, the natural phenomena, and the life in Martinique, and the sketches he makes there become the source of many of his American paintings.
May–June: Departs on steamer for New York. Arrives May 29; customs official confiscates a number of drawings, judging them obscene. Most of the drawings are returned through the help of Archibald MacLeish, who had met Masson in the twenties and bought his work. Stays briefly at Hotel Rensselaer. Spends summer in the Dubois House, Washington, Conn. Neighbors are Alexander Calder, Tanguy, and his wife Kay Sage. Collaborates with Breton on *Martinique, charmeuse de serpents* (published 1948), which contains ''Le Dialogue créole'' (Masson and Breton), Masson's poem ''Antille,'' nine drawings, and one lithograph. Breton introduces Masson to Meyer Schapiro, who later translates *Anatomy of My Universe.*
August–September: Works on lecture, ''The Origins of Cubism and Surrealism,'' for presentation at Baltimore Museum in fall. Writes the foreword for *Vertical,* ''A Yearbook for Romantic Ascensions,'' edited by Eugène Jolas, which includes reproductions of three drawings, **Jean Paul, Kleist,** and **Dionysus.**
September 15: Lives at Maria and Eugène Jolas' near Lake Waramaug for a few weeks before moving into house in New Preston, Conn., in October. Spends most of next four years in Connecticut countryside, making occasional excursions to New York for exhibitions, museum visits, and printmaking. His neighbors in Connecticut with whom he has most frequent contact are the Calders, Arthur Kemp, and Arshile Gorky. Also sees Julien Levy and Patrick Waldberg. Duthuit often visits during his vacations spent at the Jolases.
October–November: Masson's text ''The Bed of Plato'' published in *View.*
October 7–November 1: **Summer Divertissement** (1934) exhibited in ''French Modern Painting,'' Pierre Matisse Gallery.
October 31–November 22: First major museum exhibition takes place at Baltimore Museum; consists of thirty-one works, including paintings, drawings, collages, and sketches for stage designs and costumes for *Présages.*

During 1941 visits the Metropolitan Museum, the Museum of Natural History, and the Museum of the American Indian in New York. Executes a number of diverse paintings that recall earlier styles or themes. Moves into abstraction in such works as **The Rape** and **Entanglement.** Executes two collages, **Street Singer** and **Martinique,** and series of four drypoints including **Rape** (pulled in 1958). During Masson's stay in America the majority of his graphic work was printed at Hayter's Atelier 17 in New York, except for a few works executed at Seligmann's shortly after his arrival.

1942–43
''American Period'' (1942–45) begins with Telluric series of paintings including **Meditation on an Oak Leaf, Iroquois Landscape, Indian Spring,** and **Germination,** inspired by the vegetation and animal life in New Preston. Achieves a more integrated relationship between color, line, and form. Elements directly and indirectly allusive to the human figure are added in a succeeding group of paintings that includes **Leonardo da Vinci and Isabella d'Este, Antille, Andromeda, Meditation of a Painter,** and **Pasiphaë.** Rapid, automatist line appears in such drawings as **Invention of the Labyrinth.** Toward the end of 1943 line

becomes more stylized, acquiring a slightly calligraphic character in pictures such as **Luis** (1943).

1942
February: *Mythology of Being* published by Wittenborn.
February 17–March 14: Joint one-man exhibition at Buchholz and Willard Galleries, pen-and-ink drawings and etchings at former, and paintings, pastels, and collages at latter.
March 3–28: **The Seeded Earth** exhibited in ''Artists in Exile,'' Pierre Matisse Gallery. Other participants include Breton, Ernst, Léger, Lipchitz, Matta, Tanguy, and Zadkine; essays by Soby and Nicolas Calas.
May 5–30: **Bacchanal** and **Voracity** shown in exhibition ''Aspects of Modern Drawing,'' Buchholz Gallery.
May 22–June 13: ''André Masson and Max Ernst,'' reduced version of Baltimore exhibition, shown at Arts Club of Chicago.
June: Publication of first issue of *VVV;* editor is David Hare, editorial advisors are Breton and Ernst. The issue includes reproduction of **Emblematic Man** and Breton's ''Prolegomena to a Third Manifesto of Surrealism or Else.'' Stanley William Hayter, Kurt Seligmann, Frederick Kiesler, and Robert Motherwell are also represented in the issue.
July: At request of Rosenberg, executes a panel, **Liberté, Egalité, et Fraternité,** for a July 14 celebration of the Société des Amis Américains de la France Forever. This display of nationalism is highly disapproved of by Breton and Tanguy and is one of the causes of Masson's subsequent rupture with the Surrealists.
October: Opening exhibition at Peggy Guggenheim's Art of This Century Gallery, New York, includes **The Armor** (1925), **Ladder in Extension** (gouache, 1940), and **Two Children** (bronze, 1941); catalog contains Breton's ''Genesis and Perspective of Surrealism.''
October 14–November 7: **Il n'y a pas de monde achevé** and **Meditation on an Oak Leaf** (1942) exhibited in ''First Papers of Surrealism'' at Reed Mansion, New York, organized by Breton and Duchamp.
November 10–December 5: **Praying Mantis** (bronze) shown in ''European Sculpture of Our Time,'' Buchholz Gallery. Article, ''Life and Liberty,'' by Masson published in *Art in Australia.* Because of extreme cold in New Preston, Masson family moves to Meudon, Marian Willard's grandmother's house in Locust Valley, Long Island, for the winter. Masson makes a few sand paintings and collage-assemblages such as **By the Sea** and **Torso with Stars.** Visits Boston for conference sponsored by the Rescue Committee. Breton, Lipchitz, Chagall, and others also attend. Experience of seeing collection of Asiatic art at Boston Museum of Fine Arts has great impact on Masson; the Oriental will prove a major source of his art from 1944 through 1960.
December 1942–January 1943: Exhibition ''New Acquisitions'' at Museum of Modern Art includes **Street Singer** (1941).

1943–45
Masson again at odds with Breton and breaks relations with him and official Surrealism (1943). Begins a series of portraits of himself and his family. Portraits of his wife, Rose, engender a series of Sibyls (1944–45); the self-portrait evolves into the Contemplation of the Abyss pictures that absorb Masson in 1944 and 1945. Palette is dominated by pale colors; principal medium is pastel. Calligraphic line becomes primary means of defining form.

1943
February 23–March 20: Curt Valentin shows Klee and Masson in context of ''Ancient and Primitive Sculpture.''
March 9–April 3: **Song of Liberty** and **Children Frightened by Demons of War** in group exhibition ''War and the Artist,'' Pierre Matisse Gallery.
March 13–April 10: **The Armor** and **Germination** in group exhibition, ''15 Early, 15 Late,'' Art of This Century Gallery.

March 27–April 24: Leonardo da Vinci and Isabella d'Este shown in group exhibition, "Europe in America," at the Boston Institute of Contemporary Art.

April 16–May 15: Street Singer in "Exhibition of Collage," Art of This Century Gallery. "Notes" translated by Charles Henry Ford published in April issue of View.

June 15–July: "Summer Exhibition" at Pierre Matisse Gallery includes Fish in Combat. Designs cover of View.

August: Visits Smith College Museum. Invited by Lionello Venturi to participate in "Pontigny en Amérique," a conference at Mount Holyoke College. Masson delivers lecture "Unité et variété dans la peinture française" (August 4) for symposium on plastic arts, in which George Boas and Chagall also participate. John Peale Bishop, Wahl, Lévi-Strauss, and Marcel Raymond also attend conference.

Returns to New Preston. Paints a large panel, Story of Theseus, for Valentin. Museum of Modern Art acquires Leonardo da Vinci and Isabella d'Este (1942).

1944

January 14–February 8: Don Quixote in group exhibition, "Eight Moderns," at Pierre Matisse Gallery.

January 15–February 26: Participates in group exhibition, "School of Paris, Abstract Painting," at Curt Valentin Gallery; shows Idol (1941) and The Sorceress (1942).

February 5–March 12: "37th Annual Exhibition of American Painting Today" at St. Louis Museum includes The Cock and the Rose (1941).

February 8–March 12: La Belle Italienne in group exhibition "Abstract and Surrealist Art in America," organized by Sidney Janis, at Cincinnati Art Museum; exhibition travels to Denver, Seattle, Santa Barbara, and San Francisco.

February 16–May 10: Exhibition "Modern Drawings," Museum of Modern Art, includes Birth of Birds, Animals Devouring Themselves, Dream of a Future Desert, and Self-Portrait.

March 21–April 15: The Seeded Earth in group exhibition "Ivory Black" at Pierre Matisse Gallery.

April 11–May 6: Man in Garden (1930) included in "First Exhibition in America of Twenty Paintings" at Art of This Century Gallery.

May 1–20: Joint one-man exhibition "Recent Paintings by André Masson" at Paul Rosenberg Gallery (eleven works) and "André Masson, Drawings" at Buchholz Gallery (forty-six works).

May 24–October 15: Meditation on an Oak Leaf shown in exhibition "Art in Progress," at Museum of Modern Art. Museum of Modern Art acquires Werewolf.

July: "Crise de l'imaginaire" published in Fontaine (Algiers); translation printed in Horizon (1945).

August 12: Chairs symposium on plastic arts entitled "L'Art et la crise" at Pontigny conference (Mount Holyoke). Robert Goldwater, Hayter, Zadkine, and Motherwell give lectures; Masson offers concluding remarks. Anaïs Nin, Jean-Luis Sert, Jean Hélion, Louise Bourgeois, Tina Jolas, and Duthuit also attend.

December 9–30: Group exhibition "Salon de la Liberation" at Pierre Matisse Gallery includes Camp in the Forest.

December 10–30: Nocturnal Notebook shown at exhibition "Contemporary Prints," Buchholz Gallery.

1944–45

Exhibition "New directions in Gravure: Hayter and Studio 17" at Museum of Modern Art includes Little Genius of Wheat and Genius of Species.

1945

Executes an album of twelve lithographs and ten drawings, Bestiaire, with preface by Duthuit (published June 1946), and a group of twenty-eight drawings for Le Serpent dans la galère, text by Duthuit (published August 1945).

January 9–31: "Exhibition of Works by André Masson Lent by Buchholz Gallery" at Dwight Art Memorial, South Hadley, Mass., sponsored by the Department of French Language and Literature and the Mount Holyoke Friends of Art.

March 13–April 11: Couple, Coptic Mirror, Meditation on an Oak Leaf, Elk Hunt, Pasiphaë, and Pythia shown in "European Artists in America" at the Whitney Museum, New York.

April 24–May 12: One-man exhibition at Buchholz Gallery consists of forty-two paintings and drawings.

May 14–July 6: Included in "A Problem for Critics," group exhibition at Howard Putzel's Gallery, New York.

July: Following the liberation of France, prepares to leave America. Meets Jean-Paul Sartre for first time in New Preston. Before leaving Masson again visits the Metropolitan Museum and is particularly struck by Monet's Cliffs at Etretat. This marks the beginning of Masson's rediscovery of Impressionism, which becomes a dominant influence on his work in the early 1950s. Elk Attacked by Dogs is last picture painted before departure.

October: Masson family returns to France. After three weeks in Paris, goes to live near Poitiers at La Sablonnerie with Jean and Simone Piel.

October 17: Hamlet, translated by Gide, produced by the Compagnie Madeleine Renaud–Jean-Louis Barrault, with stage sets and costumes designed by Masson, opens at Théâtre Marigny, Paris.

December: Cover of View designed by Masson.

December 11–29: One-man exhibition, "André Masson: Oeuvres Rapportées d'Amérique," at Galerie Louise Leiris consists of thirty-six works, including paintings, drawings, and lithographs.

December 14, 1945–January 12, 1946: Works included in exhibition "20 ans chez Jeanne Bucher, 1925–1945," Galerie Jeanne Bucher.

1946–50

Paints last picture directly related to Telluric series, Le Terrier, in 1946. Wide range of themes occupy the next three years; childhood memories reappear; aside from Niobe (1947) and The Grotto (1948), mythological subjects tend to disappear; "narrations" of daily life such as Day Diagram make a brief appearance. In 1947 makes a series of twenty-two drawings, Sur le thème du désir (published, accompanied by a text of Sartre, in 1961), in two days; finds himself in an acute state of nervous tension about his art and decides to look for inspiration in nature themes. Makes several trips between Lusignan and Poitiers and to La Rochelle, sketching the countryside, before settling in Aix. Landscapes begin to dominate in 1948–49. Slashing strokes cut into flowing areas of color, creating a hyperactive surface in pictures such as The Mistral (1947). These stormy landscapes are becalmed in 1949. Style becomes more Impressionistic or Turneresque; linear elements are suppressed, and Zen Buddhist art becomes a primary concern.

1946

January 26–February 15: One-man exhibition at the Palais des Beaux-Arts in Brussels consists of forty works from 1943 to 1946; reduced version of exhibition shown at the Association pour le Progrès Intellectuel et Artistique de la Wallonie in Liège, March 10–21. The Belgian press accuses Masson of pornography during the exhibition in Brussels; in Liège exhibition is well received.

Illustrates Tzara's Terre sur terre with ten drawings and Soupault's L'Arme secrète with six drawings and a lithograph. Executes sixty-eight color lithographs illustrating Malraux's L'Espoir (only three copies printed) at Desjobert, Paris.

"Peinture tragique" and "Le Peintre et le temps" (Les Temps modernes, January and July) published.

February 27–March 28: "Exhibition of Contemporary Painting; Ecole de Paris" at the Bern Kunsthalle includes **Emblematic View of Toledo** and **Goethe and the Metamorphosis of Plants.**

March 2–15: **La Résistance** in group exhibition, "Art et Résistance," Musée National d'Art Moderne; show travels to London, New York, and Moscow.

April 12: Statement concerning "L'Art et le public" published in *Lettres françaises.*

May 1: "André Masson" by Bataille published in *Labyrinthe.*

June 19–July 5: One-man exhibition, "André Masson, Oeuvres Graphiques 1940–49," at Galerie de la Pléiade, Paris.

June: "Eloges de Paul Klée" (*Fontaine*) published.

August: "Le Soleil noir" (*Etoiles*) published.

October: In group exhibition, "Peintres de Paris," at Svensk-Franska Konstgalleriet, Stockholm.

November: Sartre's *Mort sans sépulture,* with stage sets designed by Masson, opens at the Théâtre Antoine, Paris.

Statement appears in "Eleven Europeans in America," *Bulletin of The Museum of Modern Art.* Participates in conference at Théâtre Daunou, Club Faubourg, on "Le Divorce entre le public et les artistes."

"Commentaires" (*Saisons,* Winter 1946–47) and "Un Grand Siècle pictural" (*Critique*) are published.

November 18–December 28: **Abduction** in "Exposition Internationale d'Art Moderne," Musée d'Art Moderne, Paris, organized by UNESCO.

1947

January 2–28: Group exhibition "Painting and Sculpture from Europe" at Buchholz Gallery includes **La Poissonnière.**

February 4–March 1: Joint one-man exhibition, "André Masson: Examples of His Work from 1922–1945," at Buchholz and Willard (drawings) galleries, New York, consists of forty-seven works.

One-man exhibition, "Designs for Hamlet/Book Illustrations/Lithographs/by André Masson," Arts Council of Great Britain, London, consists of eighty-two works.

February 8–March 7: In group exhibition "French Painting from Bonnard to Hélion" at Gemeentemuseum, The Hague, Holland.

March 12–April 2: "Atelier 17: New Etchings and Engravings" at the Leicester Galleries, London, includes works by Chagall, Lipchitz, Rattner, Tanguy, and Masson.

March 18–May 3: Mesens presents a group exhibition, "The Cubist Spirit in Its Time," London Gallery, including work by Braque, Picasso, Gris, Léger, and Masson; catalog includes texts by Mesens and Breton.

May 13–31: Over sixty recent works shown at Galerie Louise Leiris.

June 27–September 3: In group exhibition "Peintures et Sculptures Contemporaines" at Palais des Papes, Avignon.

July–August: Last major group exhibition of Surrealists, at Galerie Maeght, Paris. Masson does not participate but is cited in catalog as one of the "Surrealists in spite of themselves, those who have ceased to gravitate to the movement's orbit." (Included in this group are Dali, Dominguez, and Picasso.)

July 3–July 19: Exhibition of drawings for *Terre érotique* by Bataille at Galerie du Chêne, Place Vendôme, is closed by police.

October 15: Moves to Villa L'Harmas, Le Tholonet, near Aix-en-Provence.

Masson et son univers by Leiris and Limbour is published.

Works on lithographs at Atelier Mourlot in Paris.

1948

Meets Leo Marchutz, with whom he works on a number of lithographic suites including *Voyage à Venise* (1951–52).

January 6–31: **Day Diagram** shown in "Painting and Sculpture in Europe," Buchholz Gallery.

February: Works on thirty-three engravings for *Les Conquérants* by Malraux, published February 1949. Begins working on edition of *Un Coup de dés jamais n'abolira le hasard* by Mallarmé, published February 1961, text and illustrations done entirely in lithograph.

June: Trip to the Gorges de Verdun.

October 22–November 20: Exhibition of thirty-six recent works at Galerie Louise Leiris.

1949

January 25–February 19: One-man exhibition at London Gallery organized by Mesens.

March: Trip to the Camargue.

March 22–April 5: "André Masson and Carlos Ferreira" at Buchholz Gallery, Madrid, includes thirty-four Masson lithographs.

Spring and Summer: Exhibition "André Masson, Gemälde und Graphik" at Kunstverein, Fribourg; travels to Hannover, Hamburg, and Würtzburg. Includes thirty oils, twenty drawings, watercolors, gouaches, and numerous illustrated books; catalog text by Elfriede Schulze.

May 12–27: Thirty-three aquatints and etchings illustrating *Les Conquérants* by Malraux exhibited at La Hune, Paris.

June 3–31: Exhibition, "Léger, Masson and Woty Werner," Kestner Gesellschaft, Hannover, includes thirty-four works (reduced version of Fribourg exhibition).

June 6–17: Exhibition of "Livre de luxe français illustré par les peintres de l'Ecole de Paris," Salle le Cavea, Santiago, Chili, includes six works illustrated by Masson.

July: Included in "De Manet à Nuestros Dias," Museo Nacional de Bellas Artes, Buenos Aires.

October–November: Three works included in exhibition "Fransk Konst 1938–48" at National Museum, Stockholm.

Group exhibition "Fransk Konst" at Svensk-Franska Konstgalleriet, Stockholm, shows seventeen works by Masson.

November 8–26: One-man exhibition "Landscapes by André Masson" at Buchholz Gallery consists of thirty works, including nine lithographs; catalog contains "Notes on Landscape Painting" by Masson.

Works on thirty lithographs for *Carnet de croquis* (published February 1950). Takes walking trips through the Camargue, St-Rémy, and Verdun sketching and making notes such as "Lettres de Provence," *Plaisir de peindre.* Writes "Divagations sur l'espace: le principe d'altération" (*Les Temps modernes,* June); "Mouvements et métamorphose" (*Les Temps modernes,* October); and "The Studio of Alexander Calder" (exhibition catalog, Buchholz Gallery, November–December).

1950–54

Paints primarily landscapes and cityscapes around Aix and urban scenes of Italy, especially Venice, which Masson visits for the first time in 1951. Turner, Monet, Renoir, and Zen Buddhist art are his principal sources of inspiration. Abandons chiaroscuro for allover luminosity, palette dominated by soft transparent pastels. Combines Impressionistic style with Oriental technique and imagery. In "Instant Notes for a New Style" (*Art News,* October 1951), Masson states his aim "to abandon the ideograph and linear space and to rediscover aerial space."

1950

March 17–April 16: Exhibition "Saidie A. May Collection of Modern Paintings and Sculpture," Baltimore Museum of Art, includes six paintings by Masson.

May: Commissioned to execute medal representing Malraux for La Monnaie Nationale; depicts *Le Héro arrachant le coeur solaire de l'aigle* on verso.

May 6–June 11: Visits Basel for the opening of the two-man exhibition "André Masson and Alberto Giacometti" at Kunsthalle. Exhibits ninety-four works (oils, pastels, gouaches, drawings, and graphics).

May 24–June 4: Four works in exhibition "Der Antike Mythos in der Neuen Kunst," Kestner Gesellschaft, Hannover.

Summer: Takes short trips to La Ciotat and Mégève. Works on landscapes inspired by the Rhône and the Durance and on series of bathers which continues through 1954. Executes seventeen lithographs for *Sur le vif*, text by Chuang-tza (published May).

October 20–November 11: One-man exhibition of recent works, Galerie Louise Leiris, consists of forty paintings and a group of lithographs.

Plaisir de peindre, volume of collected writings, is published.

Museum of Modern Art, New York, acquires **Meditation on an Oak Leaf** (1942).

1951

January–February: Executes stage designs and costumes for two ballets, *Les Femmes de bonne humeur* and *L'Heure flamande* (*Le Bal du Pont du Nord*), choreographed by Massine and Hubert Devillez, music by Jacques Dupont, Opéra Comique, Paris.

February–March: Group exhibition at Malmö Museum, Sweden, includes three paintings and numerous lithographs.

May 18: Opening of one-man exhibition of ten recent landscapes at Galerie Garibaldi, Marseilles.

September: Visits Italy for the first time since 1914. Travels to Torcello, Verona, Ferrara, Bergamo, Mantua, and Lake Garda. Especially struck by Venice; begins sketches for *Voyage à Venise*, album of color lithographs with text by Masson (also lithographed) printed at Marchutz's Château Noir, Aix. Returns to Italy each year for the next three years, deriving many of his themes from landscapes and towns.

1952

Executes stage design and costumes for *Iphigénie en Tauride* by Gluck (produced by Jean Doat, choreography by Anne Gordon, directed by Carlo Maria Giulini) performed in July at Aix-en-Provence Festival.

March–April: The Crows (1922) and The Cascade (1950) in group exhibition "Cinquante Ans de Peinture Française dans les Collections Particulières de Cézanne à Matisse," Musée des Arts Décoratifs, Paris.

March 11–April 10: Exhibition of recent lithographs by Léger, Masson, and Picasso at Galerie Georges Moos, Geneva.

April 22–May 10: One-man exhibition of thirty-seven recent works at Galerie Louise Leiris.

May–June: The Candle (1924) in group exhibition "L'Oeuvre du XXème Siècle," Musée National d'Art Moderne, Paris.

August 30–October 12: Ten paintings in group exhibition "Phantastische Kunst des XX Jahrhunderts" at Kunsthalle, Basel.

September: Trip to Venice and Milan.

September 11–October 12: In group exhibition "Werk Französischer Meister der Gegenwert," Berliner Festwochen; exhibits nine works.

Winter: In group exhibition "Peinture Surréaliste en Europe," Sarrebruck, shows six paintings. Writes "Monet le fondateur" (*Verve*, December) and "Notes sur la peinture" (*Cahiers du sud*).

1953–54

Oriental character of previous year's work gains dominance over Impressionistic elements. In summer of 1954 sees the Peking Opera in Paris and makes a series of pictures in which the players are represented by abstract calligraphic figures. Lines and strokes become primary means of defining forms. Rapid allover drawing reappears in paintings.

1953

January–September: "French Painting Today," traveling exhibition in Australia, includes **Day Diagram** and **The Port of La Rochelle**.

February 2–21: Exhibition of fifteen works from early thirties at Paul Rosenberg Gallery, New York.

March: Trip to Riez in Basses-Alpes.

April: Visits Rome and Florence.

April 7–May 2: One-man exhibition, "André Masson: Recent Work and Earlier Paintings," Curt Valentin Gallery, consists of forty-two works (oils, drawings, and lithographs); catalog contains statement, "Towards the Boundless," by Masson and an essay, "André Masson," by Kahnweiler.

October 26–November 21: Exhibition of twenty lithographs at University of Kentucky, Louisville.

Works on prints in Paris at Atelier Mourlot (Jacques and Robert Frélaut) and at Lacourière.

1954

January 10–February 9: One-man exhibition, "Das Graphischwerk," organized by Michael Hertz of Bremen, at Kunstverein, Düsseldorf, consists of over 115 works; travels to Cologne, Friburg, Bremen, Wuppertal, and Wiesbaden.

September: Participates in the XXVII Biennale, Venice, exhibiting six works. Visits Venice and Ferrara.

October 5–October 30: "In Memory of Curt Valentin 1902–54, An Exhibition of Modern Masterpieces Lent by American Museums," Curt Valentin Gallery, includes **Leonardo da Vinci and Isabella d'Este**.

October 20–November 20: One-man exhibition at Galerie Louise Leiris of thirty-one works.

December: Wins Prix National de Peinture in France.

1955–60

In 1955 drawing reenters painting in full force; flowing, active lines create allover effect. A group of works depicting birds coupling with women marks return to erotic subject matter. Develops personal vocabulary of calligraphic signs ranging from abstract to figurative. Less abstract calligraphy appears in a large group of works dealing with the prostitutes of the rue St-Denis. In 1954 begins series of "gestural" works using a technique similar to that of 1926–27 sand paintings in which he applies sand and glue on the support.

1955

March 1–April 3: One-man exhibition at Kestner Gesellschaft, Hannover, consists of seventy-one works; catalog text by Alfred Hentzen.

April–May: Retrospective of works of 1930–55 (mostly 1947–53) at Leicester Gallery, London; catalog contains two statements, "Towards the Illimitable" and "Turner," by Masson and preface by Kahnweiler.

"Le Surréalisme et après," interview with Georges Bernier (*L'Oeil*, May 15).

June 8: "Closing Exhibition" at Curt Valentin Gallery includes three works by Masson. Portrait of Valentin by Masson on cover of catalog.

In group exhibition "Abstract and Surrealist Painting," Tel Aviv Museum.

July: "L'Effusioniste," by Masson (*La Nouvelle Revue française*) published.

Winter: Spends large part of winter in Paris, as he will every succeeding winter through present.

1956

February 2: Article on Masson's recent work by Limbour appears in *France Observateur*.

February 4–April 2: Exhibition "Sammlung Rupf" at Bern Kunstmuseum includes six paintings.

May: "Un Peintre de l'essentiel," a study of Oriental wash painting by Masson (*Quadrum*), is published.

July 6: Participates in ceremony honoring Cézanne in Aix-en-Provence with Jean Cassou and Jouve.

July 19–August 15: One-man exhibition "André Masson: Période Aixoise 1947–56," Galerie Lucien Blanc, Aix-en-Provence, consists of over forty works.

September: Heidegger and Venturi visit Masson in Aix.

"Le Peintre et ses fantasmes" by Masson (*Revue philosophique*) is published. *Métamorphose de l'artiste,* two volumes of Masson's writings, published by Pierre Cailler, Lausanne.

1957

January: "Redon, Mystique with a Method" by Masson (*Art News*) is published.

January 15–February 15: One-man exhibition at "Der Spiegel" Gallery, Cologne, includes Féminaire gouaches and drawings.

May 2–May 25: One-man exhibition of recent and earlier works, Galerie Louise Leiris, consists of sixty-one paintings; catalog includes statement by Masson.

May 13–June 8: Work included in group exhibition "Hommage à Kahnweiler," Saidenberg Gallery, New York.

May 21–June 7: One-man exhibition at Galerie R. Hoffman, Hamburg, consists of drawings, watercolors, and graphics.

September: Trip to Italy; visits Florence, Piacenza, Montecatini, Volterra, Pistoia, and Lucca. Jean Gremillon begins filming *André Masson et les quatre éléments* at L'Harmas.

November: Publication of *Mines de rien* by Desnos with illustrations by Masson.

December: Radio broadcast of interviews with Georges Charbonnier on Radio-Télévision Française; published in 1958 with preface by Limbour. Continues working on Migrations and Féminaire series. Gestural sand paintings using bright, vivid palette. Frequent use of tempera, which continues through 1962, often against dark ground, creates effects that recall the Telluric paintings.

1958

Rents an apartment at 65, rue Ste-Anne, Paris.

February 25: Lecture "Peinture et regardant" given by Masson at the Collège Philosophique, Paris.

February 26–March 26: Exhibition of thirty-six lithographs and aquatints, 1946–57, Kunstkabinett Klihm, Munich.

Spring: One-man exhibition of graphic work at Albertina, Vienna, consists of 147 works. Exhibition travels to Tokyo.

April 7–May 17: One-man exhibition at Saidenberg Gallery, New York, consists of thirty-four paintings; catalog essay "The Integrity of André Masson" by William Rubin.

June 1–September: Room devoted to Masson at Venice Biennale contains over thirty works.

Visits Venice and Paestum in June.

June 5–30: One-man exhibition, "Epoque de l'Homme-Plume 1922–27," at Galerie Furstenberg, Paris.

September: On second trip to Italy this year, visits Pompeii, Naples, and Rome.

October: Exhibition of graphic work at Meiji Shobo, Tokyo.

Lecture "Des Nouveaux Rapports entre peinture et regardant," given at Collège Philosophique; published in *Mercure de France*.

October–November: "André Masson Retrospective Exhibition," Marlborough Fine Art Ltd., London, consists of forty-five works; catalog contains "The Integrity of André Masson" by Rubin.

November 3–29: One-man exhibition "André Masson. First Exhibition in California," Edgardo Acosto Gallery, Beverly Hills, consists of twenty-four works. Travels to Pasadena Museum and Santa Barbara Museum. Catalog contains "The Integrity of André Masson" by Rubin.

1959–61

Calligraphic signs give way to less stylized, more erratic linear activity. Uses tempera, oil, and sand in a few pictures. Mythological figures (centaurs, oracles, nymphs), emblematic places, and the Annals of Nature are dominant themes in 1960–61.

1959

March–April: One-man exhibition at Galleria Bussola, Turin, consists of forty-four works, 1923–57. Catalog text by Venturi.

May: *André Masson et les quatre éléments* shown at the Cannes Film Festival and in Paris. Visits Amsterdam and Rotterdam.

Articles include "Le Jardin des délices" (*Critique*) and "Moralités esthétiques, feuillets dans le vent" (*La Nouvelle Revue française*).

Summer: Executes stage designs for Paul Claudel's *Tête d'or* produced by the Compagnie Madeleine Renaud–Jean-Louis Barrault to inaugurate the Théâtre de France; opens October 8.

November: "Notes on Masson and Pollock" by Rubin published in *Arts Magazine*.

December 15, 1959–February, 1960: Le Baiser (pastel, 1928) shown in "L'Exposition Internationale du Surréalisme" devoted to eroticism at Galerie Daniel Cordier, Paris; catalog by Breton.

1960

Winter: Meets Mark Tobey through Marian Willard in Paris.

March 24–April 10: One-man exhibition at Galleria Il Segno, Rome, consists of twenty-three graphics, 1946–58.

April: Sartre's article "André Masson et le temps" published in *L'Arc*.

May: Trip to Switzerland; visits Bern, Zurich, Füssen, and Weingarten (monastery).

May 17–June 17: One-man exhibition of twenty graphic works, 1941–58, Galerie Renée Ziegler, Zurich.

September: Participates in "La Rencontre Orient-Occidentale" in Vienna, a conference organized by UNESCO.

October 22–November 13: One-man exhibition at Svensk-Franska Konstgalleriet, Stockholm, consists of thirty-three oils and thirty-nine graphics; catalog includes statement by Masson.

October 26–November 26: One-man exhibition of eighty drawings, of 1922–60, Galerie Louise Leiris.

November 28, 1960–January 14, 1961: Two works shown in the "International Surrealist Exhibition" directed by Breton and Duchamp, managed by Edouard Jaguer and José Pierre, D'Arcy Gallery, New York. Executes sixteen engravings for *Les Erophages* by André Maurois (published December).

1961

February 14–March 25: Retrospective exhibition, Saidenberg Gallery, consists of forty-three works, chiefly oils.

April 14–May 31: Retrospective exhibition, Richard Feigen Gallery, Chicago, consists of thirty-eight works.

September: Visits the Black Forest and the Feldberg, Germany.

Illustrates *Une Saison en enfer* by Rimbaud with ten engravings (published June); *Im Namen der Republik,* extract of Sade's *Philosophie dans le boudoir* translated by Joachim Klünner, with six ink drawings (published 1961), and *Poèmes insoumis* by Léna le Clercq with eight lithographs (published March 1963). Recent articles translated into German are published in *Eine Kunst des Wesentlichen,* edited by Niedermeyer. Article, "Propos sur le surréalisme," given as lecture at Pavillon de Marsan, is published in *Méditations*.

1962–64

Themes that recall the Massacres of the early thirties appear in suites of paintings. Imagery becomes increasingly violent or agitated in 1963–64. Moves toward figuration in majority of works of 1962–63. Executes a suite of engravings, **Trophées érotiques,** published in January 1962. Erotic imagery increasingly dominant in graphic work of 1960–75.

Articles include "Cela finit toujours par une fête pour les yeux," interview by P. Kahn (*Clarté,* 1962).

Seven illustrations for *Théâtre* by Sartre.

Executes cover for *Clarté* (leftist magazine).

1962

March 1–31: One-man exhibition of forty-five recent paintings, Galerie Louise Leiris; catalog includes statement by Masson.

April 26–May 26: In group exhibition, "Affinities: Masson, Ernst, Edion, Borès, Beaudin, Alix," Crane Kalman Gallery, London.

Makes twelve lithographs for *Oeuvres complètes—Essais philosophiques* of Albert Camus (published April).

May 30–July 8: In exhibition "Surrealismus Phantastische Malerei der Gegenwart," Kunstlerhaus, Vienna.

Illustrates *Eux et lui* by Daniel Guérin with five drawings (published May).

Summer: Trip to Venice and Parma. Visits the Dolomites.

October 18–November 25: "European Print Acquisitions" at Museum of Modern Art includes twenty-two Massons of 1948–58.

November: One-man exhibition of thirty recent works, 1958–62, Marlborough Fine Art Ltd., London.

1963

Executes suite of engravings **Jeux amoureux,** published in spring.

April: Trip to Venice.

June 27–August: One-man exhibition at Galerie du Perron, Geneva, consists of thirty-two works of 1923–62.

September: Moves to apartment at 26, rue de Sévigné in the Marais.

October 28–December 6: One-man exhibition of graphic works, "Le Monde Imaginaire d'André Masson," Galerie Gérald Cramer, Geneva, consists of seventy-five works of 1934–63.

Illustrates *Le Mort* by Bataille with nine engravings (published December 1964) and *Nouvelles et récits* by Hemingway with ten watercolors (published February 1963). Executes stage designs and costumes for *Wozzeck* produced by Barrault at Théâtre National de l'Opéra in November.

Museum of Modern Art, New York, acquires **Battle of Bird and Fish** (1927) and **Attacked by Birds** (1956).

1964

April 15–September: In group exhibition "Le Surréalisme, Sources, Histoire, Affinités," Galerie Charpentier, Paris, showing seventeen works; catalog essays by Patrick Waldberg and Raymond Nacenta.

May 3–24: Visits Berlin for the opening of major retrospective exhibition at Akademie der Kunst, Berlin. Exhibition consists of 125 works; catalog contains essays by Kahnweiler and Werner Haftmann. Exhibition travels to Stedelijk Museum, Amsterdam.

Summer: Trip to Venice.

Articles include "Le Peinture et la culture" (*Art de France*) and "Some Notes on the Unusual Georges Bataille" (*Art and Literature*). Illustrates *Le Libertinage* by Aragon with seven watercolors (published September) and *Le Peuple au peuple* by Théodore Six with ten drawings (published December).

1965

February–April: One-man exhibition of graphic work at Tel Aviv Museum consists of 167 works of 1945–64; catalog includes statement by Masson.

March 5–May: Retrospective at Musée National d'Art Moderne, Paris, consists of 235 works.

April 26–May 30: Participates in "Arte et Resistenza in Europa," Museo Civico, Bologna. Exhibition travels to Galleria Civica d'Arte Moderna, Turin.

June 11–August 15: One-man exhibition at Michael Hertz Gallery, Bremen, consists of twenty-nine paintings and twenty-two drawings.

July 17–October 23: Don Quixote et les enchanteurs (1935) shown in group exhibition, "Aspekte des Surrealismus 1924–65," Galerie d'Art Moderne, Basel.

Autumn: At request of Malraux (now Minister of Cultural Affairs) and Barrault paints **Tragedy and Comedy Dividing Certain Aspects of the Human Passion** for the ceiling of L'Odéon, Théâtre de France.

November–December: One-man exhibition, "Autour d'un Plafond," Galerie Françoise Ledoux, Paris, consists of recent drawings and maquettes for Odéon ceiling.

Executes stage designs, using 1936 models, for Barrault's production of *Numance* at L'Odéon and stage designs and costumes for *Elocquinte* by Limbour, produced by Marcel Maréchal at Théâtre de l'Oeuvre, Paris.

Participates in Bienal VIII, São Paulo, "Surrealismo e Arte Fantástica."

November 15–December 30: One-man exhibition, Galerie Gérald Cramer, Geneva, consists of thirty-six drawings and eight sculptures.

1966–67

Themes of devastation or desolation continue to haunt his work. Contrast of pale tones applied in thin washes against saturated colors results in airier compositions, which continue through the rest of the decade. Executes **Autobiographie mythique,** a suite of drawings accompanied by short texts; semi-automatist character of some of these works appears frequently in drawings of the next ten years.

1966

January 29–February 19: One-man exhibition of drawings at Galerie Renée Ziegler, Zurich.

June 4–July 4: Exhibition "24 Oeuvres Graphiques," Nouveau Musée des Beaux-Arts, Le Havre.

July 6–August 7: One-man exhibition of fifty-three drawings and graphics, Galerie des Contards, Lacoste, Vaucluse.

September 27–October 26: One-man exhibition, "André Masson, Major Directions," Saidenberg Gallery, New York, consists of thirty-two works of 1924–64.

November: One-man exhibition of graphic work at Galerie Wünsche, Bonn.

December 1966–January 1967: Shows five early works in exhibition "Surrealism" at Tel Aviv Museum. Travels to Flanders; visits Bruges, Ghent, Antwerp, and Courtrai.

Nelly Kaplan makes the film *A la source la femme aimée* based on Masson's unpublished erotic drawings. Film subsequently censored.

Illustrated books: *Elégie à Pablo Neruda* by Aragon, six drawings by Masson reproduced (published February); *L'Idiot* by Dostoevski translated by Albert Mousset, twelve watercolors by Masson reproduced (published March); *Le Réservoir des sens* by Belen (pseudonym Nelly Kaplan), eight drawings and one engraving by Masson reproduced (published March); *Théâtre* by Claudel, seven watercolors illustrating *Tête d'or* reproduced (published 1966).

1967

January: Article "Mon Plafond à l'Odéon" published (*Connaissance des arts*).

February: Illustrated the book *Le Monde réel: les communistes,* III and IV, by Aragon; eight drawings reproduced in III, ten in IV.

March 11–April: One-man exhibition at Galleria d'Arte La Nuova Loggia, Bologna, consists of twenty-one works.

April: Article, "Le Surréalisme quand même," published in *La Nouvelle Revue française.*

May: One-man exhibition at Galerie Vincent Kramar, Prague, consists of fifty-nine works of 1924–66.

June: One-man exhibition at the Musée de Lyon consists of ninety-nine works of 1922–66; catalog foreword by Kahnweiler.

September: Trip to Venice.

Executes a cartoon for Gobelin tapestry, **In Pursuit of Hatchings and Germinations.**

1968

March–June: Seventeen works shown in "Dada, Surrealism and Their Heritage," organized by Rubin, Museum of Modern Art. Exhibition travels to Los Angeles County Museum of Art and the Art Institute of Chicago.

April 19–May 18: One-man exhibition "Peintures Récentes et Suite de Douze Dessins d'une Autobiographie Mythique," Galerie Louise Leiris, consists of forty-eight paintings and twelve drawings.

June–July: One-man exhibition at Galerie Lucie Weill, Paris, consists of sixty-seven works.

June–September: Exhibition "Trésors du Surréalisme," Casino Communal, Knokke-le-Zoute, Belgium, includes four oils and two "automatic" drawings.

July–September: One-man exhibition, Musée Cantini, Marseilles, consists of eighty works, 1922–67.

September: Trip to Venice.

September 28–October 20: Group exhibition "Efterars Udstillingen," Udstillingen Ved, Charlottenborg, Copenhagen, includes sixteen paintings, 1959–68.

October 20–November 4: One-man exhibition, organized by L'Office Culturel Municipal, St-Etienne-du-Rouvray, consists of fifty-four works from 1924–67.

1969

February 9–April 7: Retrospective exhibition, Galleria Civica d'Arte Moderna, Palazzo dei Diamanti, Ferrara, consists of 165 paintings, drawings, and graphics of 1923–68; catalog essay by Kahnweiler.

April 12–May 26: Works included in the exhibition "Malerei des Surrealismus von den Anfangen bis heute," Kunstverein, Hamburg.

May 30–June 14: One-man exhibition, Galleria d'Arte Il Fauno, Turin.

June–September: One-man exhibition at Casino Communal, Knokke-le-Zoute, Belgium, consists of sixty-one paintings; fourteen pastels, gouaches, and watercolors; fourteen prints; and twelve sculptures. Catalog text, "Il n'y a pas de monde achevé," by Waldberg.

September: Trip to Ireland.

November 22–December 12: One-man exhibition at Il Milione, Milan, includes thirty-one drawings of 1923–69, plus engravings and lithographs of 1941–68.

1970

January–February: One-man exhibition at La Nuova Loggia "Grafica," Bologna, consists of twenty-two drawings and prints primarily from the forties and sixties.

May 1–June 28: Retrospective exhibition at the Museum am Ostwall, Dortmund, consists of fifty paintings of 1922–68. Exhibition travels to Klingenmuseum, Solingen, and Pfalzgalerie, Kaiserslautern.

June 4–September 30: One-man exhibition at Galleria Schwarz, Milan, consists of 100 works; catalog text by Gilbert Brownstone.

October: One-man exhibition at the Galleria La Bussola, Turin, consists of twenty-six paintings of 1931–66 and forty drawings of 1943–70.

October 30–November 28: One-man exhibition of recent works, Galerie Louise Leiris, consists of twenty-four paintings and twenty-five drawings.

At request of Karlheinz Stockhausen, invited by the Lebanese government, along with son Diego and Max Ernst and Dorothea Tanning, to attend composer's concerts at the Grotto of Jeta. Visits Palmyra.

November: Article, "André Breton, croque-mitaine des peintres surréalistes," published in Le Figaro littéraire (November 23–29).

1971

March 2–April: One-man exhibition, Centre d'Art, Beirut, consists of twenty-four drawings and forty-four prints of 1949–70.

March 13–April 7: One-man exhibition of thirty paintings of 1940–71, organized by the Centre Culturel Communal, Salle des Fêtes, Bobigny.

March 31–April: One-man exhibition, Galerie Andelt, Wiesbaden.

June–August: One-man exhibition at the Maison de la Culture d'Amiens consists of 95 paintings, 45 drawings, 100 lithographs, 14 illustrated books, and 2 tapestries of 1922–70.

June 21–October 16: Exhibition of engravings and lithographs by Ernst and Masson, Galerie Gérald Cramer, Geneva.

June 22–July 13: One-man exhibition of works reproduced in Leiris' Massacres et autres dessins (published in April by Hermann) at publisher's gallery in Paris.

Participates in film Arts et l'éphémère, on Surrealism, made in Aix-en-Provence by Pierre Schneider.

September: Trip to Venice.

October 27: Television program, on O.R.T.F., "Perspectives surréalistes, les métamorphoses," organized by Daniel LeComte, in which Masson, Hérold, Dali, and Matta demonstrate automatic drawing.

Autumn: Major monograph Mythologie d'André Masson by Jean-Paul Clébert published.

1972–75

Article, "André Masson graveur et illustrateur: Histoire d'une de mes folies," published in 1972 (XXe Siècle).

Executes a suite of works, **Entrevisions** (1972–73), a Symbolist term for works of fantasy issuing from unknown, unexpected sources.

Executes a series of paintings, **Les Acteurs anglais,** images inspired by Shakespeare. Themes of 1972–75 include mythology, catacombs, fêtes galantes, and "obsessive sites."

1972

January 12–February 5: One-man exhibition at Waddington Galleries, London, consists of thirty-seven works (primarily oils and pastels).

February 5–March 5: One-man exhibition at Maison des Arts et Loisirs de Montbéliard consists of twenty-two paintings, sixteen drawings, and twenty-eight prints of 1947–71.

March 11–May 7: "Der Surrealismus," Haus der Kunst, Munich, includes twenty-seven works; travels to Musée des Arts Décoratifs, Paris.

April 23–May 7: One-man exhibition "Hommage à André Masson," XXXe Salon de la Quinzaine d'Art en Quercy, Montauban, consists of twenty-five works.

April 26–May 27: One-man exhibition "André Masson, Période Asiatique, 1950–1959," Galerie de Seine, Paris, consists of twenty-five oils, pastels, and gouaches; catalog essay by Françoise Will-Levaillant.

September: Trip to Venice.

October 19–November 20: One-man exhibition of recent pastels, gouaches, and drawings, La Galerie Verrière, Paris.

October 29–November 30: One-man exhibition of graphic work, Galerie Ariane, Gothenburg.

November–December: One-man exhibition, Galerie Michael Hertz, Bremen, consists of twenty-one oils and pastels.

November 14, 1972–April 1973: Exhibits fifteen works in group exhibition, "L'Estampe et le Surréalisme," Galerie Vision, Paris, organized by Waldberg; catalog cover designed by Masson.

November 28–December 23: One-man exhibition, organized by Blue Moon and Lerner-Heller galleries, New York, consists of twenty-eight original works and graphics of 1925–65; catalog includes "Notes on a Study of André Masson" by Lawrence Saphire.

1973

February 10–28: One-man exhibition at Galleria d'Arte Zanini, Rome, consists of seventeen paintings of 1950–71 and drawings and graphics.

May: One-man exhibition, "New Acquisitions," Galleria Schwarz, Milan, consists of fifteen works.

May 7–June 8: One-man exhibition of graphic work, 1953–72, Galleria San Sebastianello, Rome, consists of forty-three works.

May 8–26: One-man exhibition, "Centre d'Art 2," Beirut, consists of twenty-six drawings, six pastels, and one painting of 1960–72, and prints of 1943–71.

May 30–June 17: One-man exhibition, Galerie Jacques Davidson, Tours, consists of drawings and prints of 1934–70; catalog contains "Sémiographie d'André Masson" by Roland Barthes and "Le Dessin vivant" by Denis Hollier (reprinted from *Critique*, January 1972).

June 13–July 13: One-man exhibition, Galerie du Lion, Paris, consists of seven drawings and five pastels.

August: Trip to Beirut.

October 11: Swiss broadcast of *Le Monde imaginaire d'André Masson*, film of interview with sculptor Hansjorg Gesiger.

October 19–November 4: Exhibition of the graphic works reproduced in *André Masson: Gravures* by René Passeron, organized by L'Office du Livre at Musée d'Art et d'Histoire, Fribourg. Exhibition travels to Galerie Gérald Cramer, Geneva.

October 19–November 24: One-man exhibition of recent work, "Entrevisions," Galerie Louise Leiris, consists of thirty-five paintings and pastels and twenty-five graphics; catalog includes statements by Masson concerning pictures exhibited.

November–December: One-man exhibition "The Surrealist Impulse," organized by Blue Moon and Lerner-Heller galleries, New York, consists of fifty-two paintings and drawings and a large number of graphics; catalog essay by Saphire.

November 3: Participates in television program on Matisse with Georges Mathieu and Hans Hartung.

Museum of Modern Art, New York, acquires **Painting (Figure)** (1926–27).

1974

February–April: Three early works shown in exhibition "Surréalisme et Peinture," Galerie Beyeler, Basel.

One-man exhibition at Galleria Il Collezionista, Rome, consists of thirty-seven works of 1925–73; catalog includes tributes to Masson by Leiris, Eluard, and Breton.

November 28–December: One-man exhibition of graphic work and illustrated books at Galerie Benadour, Geneva.

December 8, 1974–February 2, 1975: Exhibits twenty-four works in "Surrealität-Bildrealitat," Städtische Kunsthalle, Düsseldorf. Exhibition travels to Staatliche Kunsthalle, Baden-Baden.

December 11, 1974–January 12, 1975: One-man exhibition Galerie Claude Tchou, Paris, includes **Oeuvres érotiques,** fifty-five lithographs with texts by Masson, André Pieyre de Mandiargues, and Apuleius (published 1974).

Museum of Modern Art, New York, acquires **Card Trick** (1923).

1975

February 5–March 6: Ten works shown in "Surrealism in Art," Knoedler Gallery, New York.

April 22–May 24: One-man exhibition "André Masson: Second Surrealist Period, 1937–43," organized by Blue Moon and Lerner-Heller galleries, New York, consists of thirty-one paintings, drawings, and sculptures and a number of graphics.

July 10–September 15: One-man exhibition of 122 works of 1921–75 at Musée Granet, Palais de Malte, Aix-en-Provence. Catalog includes essay by Louis Malbos.

September 27–November 16: Participates in exhibition "Surrealism" at the National Museum of Modern Art, Tokyo. Exhibition travels to the National Museum of Modern Art, Kyoto.

October–November: One-man exhibition at Galerie de Seine, Paris, consists of twenty works.

BIBLIOGRAPHY

Compiled by Inga Forslund, Librarian, The Museum of Modern Art

I. BOOKS BY MASSON
Arranged chronologically

1. Mythology of being. A poem. Eight pen-and-ink drawings and a frontispiece by André Masson. New York, Wittenborn and Co., 1942. [6] p. plus 9 plates. Edition of 200 numbered copies, each signed by the artist. Copies 1 to 30 carry an original etching signed by the artist.

2. Anatomy of my universe. New York, Curt Valentin, 1943. [88] p. incl. illus. 31 plates (frontis.) Limited edition of 330 numbered and signed copies. Copies no. 1–10 with 1 original pen-and-ink drawing and 1 original etching. Copies no. 11–30 with 1 original etching.

3. Nocturnal notebook. New York, Curt Valentin, 1944. [4] p. plus 14 plates. Limited edition of 665 copies. 50 copies are printed on rag paper, numbered and signed, and contain 1 original etching by the artist. 15 copies contain, in addition, 1 of the original pen-and-ink drawings.

4. Bestiaire: douze lithographies et dix dessins du peintre André Masson. Introduction par Georges Duthuit. New York, Curt Valentin, 1946. [18] p. incl. illus. and 2 plates, plus frontis. and 12 plates. Edition of 135 numbered copies.

5. Mythologies. Paris, Editions de la revue Fontaine, 1946. [100] p. incl. illus. (L'Age d'or.) Contents: Mythologie de la nature.—Mythologie de l'être.—L'Homme emblématique. 41 full-page drawings. The drawings of "Mythologie de l'être" are the same as in the American edition (bibl. 1)—Edition of 830 numbered copies.

6. Martinique, charmeuse de serpents. [Par] André Breton, avec textes et illustrations d'André Masson. Paris, Jean-Jacques Pauvert, 1972. 122 p. plus 7 plates. First published *1948* by Editions du Sagittaire, Paris. Includes: "Antille" par André Masson.—"Le dialogue créole" entre André Breton et André Masson.—Dessins d'André Masson.

7. Carnet de croquis: vingt lithographies. Paris, Editions de la Galerie Louise Leiris, 1950. [6] p. plus 20 plates. Texte signé d'A[ndré] M[asson]. Edition of 57 numbered copies.

8. Le plaisir de peindre. [Nice] La Diane française, c1950. [206] p. incl. illus. plates (some col.) front. (port.) (Collection d'histoire des idées. 2.) A collection of essays the majority of which have already appeared elsewhere.

9. Voyage à Venise. Lithographies en couleurs et texte de André Masson. Paris, Editions de la Galerie Louise Leiris, 1952. [19] p. incl. illus. plus 24 col. plates. Edition of 57 copies, signed by the artist.

10. Métamorphose de l'artiste. Geneva, Cailler, 1956. 2 v. 24 plates. (Collection écrits et documents de peintres, dirigée par Pierre Cailler.) Also in an edition de luxe with 2 original lithographs in 2 colors.

11. La mémoire du monde. Geneva, Skira, 1974. 172 p. incl. illus. (some col.) (Les sentiers de la création. 22.)

II. ARTICLES, INTERVIEWS, AND STATEMENTS BY MASSON
Arranged chronologically

12. Lettre à André Breton. *La Révolution surréaliste* (Paris) v. 1, no. 5, Oct. 15, 1925, p. 30.

13. Tyrannie du temps. *La Révolution surréaliste* (Paris) v. 2, no. 6, Mar. 1, 1926, p. 29.

14. André Masson beantwortet einige Fragen. *Das Kunstblatt* (Berlin) v. 15, no. 8, Aug. 1931, p. 235–238 incl. 3 illus.

15. Du haut de Monserrat. [Poem.] *Minotaure* (Paris) no. 8, June 15, 1936, p. 50 incl. 1 illus.

16. Enquête. *Cahiers d'art* (Paris) v. 14, no. 1–4, 1939, p. 72–73 incl. 1 illus.

17. Mythologie de la nature. *Cahiers d'art* (Paris) v. 14, no. 5–10, 1939, p. 105–135 incl. 15 illus. A poem and 15 pen drawings by Masson.—Introduction by Pierre Mabille. See also bibl. 5.

18. Peindre est une gageure. *Cahiers du sud* (Marseilles) no. 233, Mar. 1941, p. 134–140. Reprinted in "Le plaisir de peindre" (bibl. 8). In English translation "Painting is a wager" in *Horizon* (London) v. 7, no. 39, Mar. 1943, p. 178–183 plus 2 illus. and in bibl. 175.

19. The bed of Plato. *View* (New York) v. 1, no. 7–8, Oct.–Nov. 1941, p. 3. Also in *New Road* (London) 1943, p. 214.

20. Life and liberty. *Art in Australia* (Sydney) s. 4, no. 5, Mar.–May 1942, p. 11–17 incl. 5 illus. (1 col.), port.

21. Re "Minotaure": a letter. *View* (New York) v. 2, no. 2, May 1942, p. 20.

22. L'homme emblématique. (Mar. 1940). *VVV* (New York) no. 1, June 1942, p. 10–11 incl. 4 illus.

23. Mallarmé, portraitist of Baudelaire & Poe. *View* (New York) v. 2, no. 3, Oct. 1942, p. 16–17 incl. illus.

24. Page from a notebook. *View* (New York) v. 3, no. 1, 1943, p. 9.

25. Antille. *Hemispheres* (New York) no. 2–3, Fall/Winter 1943/44, p. 21. Reprinted in bibl. 6.

26. Une crise de l'imaginaire. *Fontaine* (Algiers) no. 35, 1944, p. 539–542. Reprinted in "Le plaisir de peindre" (bibl. 8). In English translation "A crisis of the imaginary" in *Horizon* (London) v. 12, no. 67, July 1945, p. 42–44, in *Magazine of Art* (New York) v. 39, no. 1, Jan. 1946, p. 22–23 and in bibl. 175.

27. Unité et variété de la peinture française. *Renaissance* (New York) v. 2–3, 1944–1945, p. 217–223. Text of lecture given at Mount Holyoke, Summer 1943. Reprinted in bibl. 8.

28. Peinture tragique. *Les Temps modernes* (Paris) v. 1, no. 4, Jan. 1946, p. 725–729 plus 4 illus. Reprinted in bibl. 8.

29. Eloge de Paul Klee. *Fontaine* (Paris) no. 53, June 1946, p. 105–108. Reprinted in "Le plaisir de peindre" (bibl. 8) and in English translation as "Homage to Paul Klee" in *Partisan Review* (New York) v. 14, no. 1, Jan.–Feb. 1947, p. 59–61 and as "Eulogy of Paul Klee," New York, Curt Valentin, 1950. [8] p. incl. illus.

30. Le peintre et le temps. *Les Temps modernes* (Paris) v. 1, no. 10, July 1946, p. 175–184 plus 4 illus. Reprinted in bibl. 8.

31. Un grand siècle pictural. *Critique* (Paris) v. 1, no. 6, Nov. 1946, p. 498–501. Reprinted in bibl. 8.

32. Notes. *Cahiers du sud* (Marseilles) v. 33, no. 279, 1946, p. [215]–219. Reprinted in bibl. 8.

33. Le roi fou à la couronne de flammes. *Cahiers du sud* (Marseilles) v. 33, no. 275, 1946, p. [16]–17.

34. [Statement] *In* Sweeney, James Johnson. Eleven europeans in America. *The Museum of Modern Art Bulletin* (New York) v. 13, no. 4–5, 1946, p. 3–6, 38. incl. 3 illus. port.

35. Commentaires. *Saisons* (Paris) no. 3, Winter 1946/47, p. 105–115 incl. 2 illus. Reprinted in bibl. 8.

36. L'artiste et son portrait. Corot raconté par lui-même et par ses amis. *Critique* (Paris) v. 2, no. 10, Mar. 1947, p. 209–211.

37. Note sur l'imagination sadique. *Cahiers du sud* (Marseilles) v. 34, no. 285, 1947, p. 715–716.

38. La balance faussée. *Les Temps modernes* (Paris) v. 3, no. 29, Feb. 1948, p. 1381–1394 plus 4 illus. Reprinted in bibl. 8.

39. Color and the lithographer. *The Tiger's Eye* (New York) v. 1, no. 8, June 15, 1949, p. 56–58. Reprinted (in the French original) in bibl. 8.

40. Divagations sur l'espace. *Les Temps modernes* (Paris) v. 4, no. 44, June 1949, p. 961–972. Reprinted in bibl. 8.

41. Mouvement et métamorphose. *Les Temps modernes* (Paris) v. 5, no. 48, Oct. 1949, p. 651–662 plus 2 illus. Reprinted in bibl. 8. Extract reprinted in *Carreau* (Lausanne) no. 7, Oct.–Nov. 1950, p. [3] incl. 1 illus.

Notes on landscape painting. Nov. 1949. See bibl. 217.

42. L'atelier de Calder. *Cahiers d'art* (Paris) v. 24, no. 2, 1949, p. 274–275.

43. Peinture et rhétorique. *Cahiers du sud* (Marseilles) v. 36, no. 295, 1949, p. 398–400.

44. [Reprint of answers to a prewar questionnaire in *Cahiers d'art* ''Is creative art affected by contemporary events?'' and in *Les lettres françaises*, 1946 on ''art and the public.''] *Transition forty-nine* (Paris) no. 5, 1949, p. 115, 117–118.

45. Courbet, le réaliste fabuleux. *Critique* (Paris) v. 6, no. 44, Jan. 1951, p. 26–29.

46. The instant. Notes for a new style. *Art News* (New York) v. 50, no. 6, Oct. 1951, p. 20–21, 66–67.

47. Vue d'ensemble: Venise retrouvée. *Critique* (Paris) Nov. 1951, p. 995–998.

48. Proposition. *Le Point* (Souillac) v. 7, no. 41, Apr. 1952, p. 11–15, incl. 4 illus.

49. Monet le fondateur. *Verve* (Paris) v. 7, no. 27–28, 1952, p. 68 plus 1 col. plate.

50. Notes sur la peinture. *Cahiers du sud* (Marseilles) v. 39, no. 314, 1952, p. 67–74.

Toward boundlessness. Feb. 1953. See bibl. 222, 225.

Fragments sur Turner. 1955. See bibl. 225.

51. Le surréalisme et après. Un entretien au magnétophone avec André Masson. *L'Oeil* (Paris) no. 5, May 15, 1955, p. 12–17 incl. illus.

52. L'effusionniste. *La Nouvelle Revue française* (Paris) July 1955, p. 29–47.

53. Une peinture de l'essentiel. *Quadrum* (Brussels) no. 1, May 1956, p. 37–42, incl. 3 illus.

54. Le peintre et ses fantasmes. *Les Etudes philosophiques* (Paris) n.s., v. 11, no. 4, Oct.–Dec. 1956, p. 634–636.

55. Redon: mystique with a method. *Art News* (New York) v. 55, no. 9, Jan. 1957, p. 40–43, 60–62 incl. 5 illus. (1 col.)

56. L'art commence où le réalisme finit. Alain Jouffroy interviews Masson. *Arts* (Paris) no. 657, Feb. 12–18, 1958, p. 15.

57. La brume dans la vallée de l'Arc. *L'Arc* (Aix-en-Provence) no. 2, Spring 1958, p. 1–3.

58. Entretiens avec Georges Charbonnier. Préface de Georges Limbour. Paris, René Julliard, 1958. 204 p. plus illus. Radiobroadcast over the national network R.T.F. under the title: ''Dialogues avec André Masson.'' Une émission de Georges Charbonnier, Oct.–Dec. 1957.

59. Des nouveaux rapports entre peinture et regardant. *Mercure de France* (Paris) v. 334, 1958, p. 193–207. Lecture given at Collège philosophique in Paris.

60. Entretien avec André Masson. *In* Charbonnier, Georges. Le monologue du peintre. v. 1. Paris, René Julliard, c1959. p. 185–195.

61. Paris. Foreword to Paris/New York: Arts Yearbook 3. New York, Art Digest, Inc., 1959, p. 45.

62. Le jardin des délices. *Critique* (Paris) May 1959, p. 427–432.

63. Nicolas Poussin en 1960. *La Nouvelle Revue française* (Paris) June 1, 1960, p. 1142–1144.

64. Le peintre et la culture. *Art de France* (Paris) v. 4, 1964, p. 252–258 incl. 7 illus.

65. Some notes on the unusual Georges Bataille. *Art and Literature* (Lausanne) no. 3, Autumn/Winter 1964, p. 104–111.

Réfexions sur la gravure. 1965. See bibl. 244.

66. ''Mon plafond à l'Odéon.'' *Connaissance des arts* (Paris) no. 167, Jan. 1966, p. 72–75 incl. 2 illus. (1 col.) In conversation with Geneviève Coste.

67. The artists speak: André Masson. *In* Kronhausen, Phyllis & Eberhard. Erotic art: a survey of erotic fact and fancy in the fine arts. New York, Bell, c1968–70. v. 1, p. 42. Illustrations by Masson, v. 1, p. 65, 87, 114–115, and in v. 2, p. 50–53.

68. [Letter] Aug. 1968. *In* MOORE, ETHEL, ed. Letters from 31 artists . . . Albright-Knox Art Gallery. Gallery Notes. v. 31–32, no. 2, Spring 1970, p. 25 incl. 1 illus.

Ne pas choisir des thèmes—être choisi par eux. 1970. See bibl. 257.

69. André Masson, graveur et illustrateur. Histoire d'une de mes folies. *XXe siècle* (Paris) n.s. v. 34, no. 38, June 1972, p. 28–33 incl. 7 illus. (2 col.) Summary in English.

70. Comment j'ai illustré des livres. *Bulletin du bibliophile* (Paris) 1972: pt. 2, p. 127–128.

71. Conversation avec Matisse. ''La décoration Barnes'' par André Masson. *Critique* (Paris) v. 30, no. 324, May 1974, p. 398–399.

72. André Masson, vagabond du surréalisme. Présentation de Gilbert Brownstone. Paris, Editions St-Germain-des-Prés, 1975. 156 p. plus illus. Based on taped interviews.

73. A propos de Claude Monet. Interview d'André Masson. (Transcribed by Alice Rewald.) *In* Chicago. The Art Institute. Paintings by Monet. Mar. 15–May 11, 1975, p. 13–18.

74. André Masson on Claude Monet. (Adapted from the French.) *In* Chicago. The Art Institute. Paintings by Monet. Mar. 15–May 11, 1975, p. 9–12.

III. BOOKS ILLUSTRATED BY MASSON

Arranged chronologically. For a complete listing see ''Catalogue des ouvrages illustrés par André Masson, de 1924 à février 1972'' by Françoise Will-Levaillant (bibl. 162). For books of which Masson is both author and illustrator see under Books by Masson.

75. LIMBOUR, GEORGES. Soleils bas. Poèmes illustrés d'eaux-fortes par André Masson. Paris, Editions de la Galerie Simon [1924]. [10] p. plus 3 plates. 4 original etchings (1 on cover). Edition of 112 numbered copies, signed by the artist and author.

76. VITRAC, ROGER. Les mystères de l'amour. Drame en 3 actes, précédés d'un prologue. Avec un portrait de l'auteur par André Masson gravé sur bois par G[eorges] Aubert. Paris, Editions de la Nouvelle Revue française, 1924. 92 p. Edition of 556 numbered copies.

77. LEIRIS, MICHEL. Simulacre. Poèmes et lithographies. [Par] Michel Leiris & André Masson. Paris, Editions de la Galerie Simon, 1925. [25] p. incl. illus. 7 original lithographs (1 on cover). Edition of 112 numbered copies, signed by the author and the illustrator.

78. DESNOS, ROBERT. C'est les bottes de 7 lieues cette phrase ''je me vois.'' Illustré d'eaux-fortes par André Masson. Paris, Editions de la Galerie Simon, 1926. [22] p. incl. 3 plates. 4 original etchings, 1 front. Edition of 112 numbered copies, signed by author and illustrator.

79. ARTAUD, ANTONIN. Le Pèse-nerfs, suivi des fragments d'un journal d'enfer. Edition ornée d'un frontispice par André Masson. Marseilles, Les Cahiers du Sud, 1927. 80 p. Edition of 553 numbered copies.

80. JOUHANDEAU, MARCEL. Ximenes Malinjoude. Illustré d'eaux-fortes par André Masson. Paris, Editions de la Galerie Simon, 1927. [80] p. 6 full-page original etchings. Edition of 112 numbered copies, signed by the author and the illustrator.

81. [ARAGON, LOUIS] Le con d'Irène. s.l. s.n. 1928. 85 p. plus 5 plates. 5 original etchings by André Masson. Edition of 150 copies (of which 135 were numbered).

82. [BATAILLE, GEORGES] Histoire de l'oeil par Lord Auch, avec huit lithographies originales [par André Masson]. Paris, 1928. 106 p. plus 8 plates. 134 numbered copies.

83. BATAILLE, GEORGES. L'Anus solaire. Illustré de pointes sèches par André Masson. Paris, Editions de la Galerie Simon, 1931. [24] p. incl. illus. 3 original dry points. Edition of 112 numbered copies, signed only by the author.

84. _____. Sacrifices. Paris, G[uy] L[evis] M[ano], 1936. [12] p. plus 5 plates. 5 original etchings by André Masson. Edition of 150 numbered copies. Copies 1–10 signed by the artist.

85. _____. Corps célestes. *Verve* (Paris) v. 1, no. 2, Spring 1938. 124 p. 3 ink drawings, 2 color lithographs by André Masson.

86. LEIRIS, MICHEL. Glossaire: j'y serre mes gloses. Illustré de lithographies par André Masson. Paris, Editions de la Galerie Simon, 1939. 64 p. 16 original lithographs. Edition of 112 numbered copies, signed by the author and the illustrator.

87. DUTHUIT, GEORGES. Le serpent dans la galère. Illustrations d'André Masson. New York, Transition, Curt Valentin, 1945. 102 p. plus 8 plates. 28 ink drawings, 8 drawings and 1 lithograph. Edition of 500.

88. TZARA, TRISTAN. Terre sur terre. Dessins d'André Masson. Geneva, Paris, Editions des Trois Collines, c1946. [72] p. incl. illus. 10 brush and ink drawings. Edition of 3160 numbered copies.—The edition de luxe contains in front 1 original lithograph signed by the artist.

89. COLERIDGE, SAMUEL TAYLOR. Le dit du vieux marin, Christabel et Koubla Khan. Traduit de l'anglais . . . Douze lithographies par André Masson. [Paris] Collections Vrille (Editions Pro-Francia), 1948. 104 p. incl. illus. 12 original lithographs. Edition of 269 numbered copies.

90. MALRAUX, ANDRÉ. Les conquérants. Trente-trois eaux-fortes originales en deux couleurs gravées par André Masson. Paris, Skira, 1949. 222 p. incl. illus., col. plates, front. Edition of 165 numbered copies, all signed by the artist, the author, and the publisher.

91. LEIRIS, MICHEL. Toro. Lithographies en couleurs de André Masson. Avec un poème de Michel Leiris. Paris, Editions de la Galerie Louise Leiris, 1951. [4] p. plus 6 plates. 7 color lithographs (1 on cover). Edition of 57 numbered copies.

92. NERVAL, GERARD DE. Aurelia oder Der Traum und das Leben. Mit zehn Farbillustrationen nach Aquarellen von André Masson. Berlin, Propyläen Verlag, c1970. 147 p. incl. 10 col. plates. Edition of 1485 copies in 3 series. Text translated from the French.

IV. BOOKS ON MASSON

93. ANDRE MASSON. Textes de Jean-Louis Barrault, Georges Bataille, André Breton [et autres]. [Rouen, Impr. Wolf, 1940] 122 p. incl. illus. Edition of 400 copies, all signed by André Masson.—Includes 30 full-page drawings, 25 text-drawings by André Masson. Contents: ''Eléments pour une biographie'' par Michel Leiris.—''Au pays des hommes'' par Paul Eluard.—''Les mangeurs d'étoiles'' par Georges Bataille.—''A nu'' [poème] par Benjamin Péret.—''Magie et métamorphoses'' par Armel Guerne.—''Combat d'animaux'' par Robert Desnos.—''Les dessins d'André Masson'' par Pierre Jean Jouve.—''André Masson et l'Espagne'' par Madeleine Landsberg.—''André Masson le peintre-matador'' par Michel Leiris.—''La saison des insectes'' par Georges Limbour.—''Masson et le théâtre'' par Jean-Louis Barrault.—''Prestige d'André Masson'' par André Breton.—''Livres illustrés par André Masson'' p. 121–122.

BROWNSTONE, GILBERT. André Masson, vagabond du surréalisme. See bibl. 72.

CHARBONNIER, GEORGES. André Masson: Entretiens avec Georges Charbonnier. See bibl. 60.

94. CLEBERT, JEAN-PAUL. Mythologie d'André Masson. Conçue, présentée et ordonnée par Jean-Paul Clébert. Geneva, Pierre Cailler, 1971. 135 p. plus 221 illus., 22 col. mount. plates. (Les grandes monographies. 14.) Text by Masson and commentary by Clébert in 2 parallel columns on each page.—Includes: Chronology, bibliography, exhibitions list. Also published in an edition de luxe with 2 original etchings. 200 numbered copies.

95. HAHN, OTTO. Masson. New York, Abrams, 1965. 77 p. incl. 42 illus. (12 col.) (Modern artists.) Includes biography, list of exhibitions, selected bibliography. Translated from the French edition, Paris, P. Tisné, n.d.—Also English edition, London, Thames & Hudson, 1965, and German edition, Stuttgart, Hatje, 1965.

96. JUIN, HUBERT. André Masson. Paris, Georges Fall, c1963. 88, [42] p. incl. illus. (some col.) port. (Le Musée de poche.) Includes: Ecrits de Masson. Biographie.

97. LEIRIS, M[ICHEL]. André Masson and his universe. [By] M. Leiris and G. Limbour. Geneva, Paris, Editions des Trois Collines, c1947. [249] p. incl. illus. facsim., 120 plates (4 col.) (Les grands peintres par leurs amis. 3.) A collection of writings on Masson, some of which were previously published. French text, with English translation of four of the selections by Douglas Cooper inserted between p. 20 and p. 21. ''Décorations théatrales d'André Masson'' p. 235–[236].—''Livres comportant des gravures originales d'André Masson'' p. 237–[238].—''Albums d'André Masson'' p. 241–[242].

98. _____. André Masson. Massacres et autres dessins. Texte de Michel Leiris. Paris, Hermann, c1971. [28] p. plus 90 plates (some col., some fold.) English edition published by Thames & Hudson, London, 1972, under the title: André Masson drawings.

99. LIMBOUR, GEORGES. Masson: dessins. Paris, Braun & cie, c1951. 11 p. plus 16 plates (some col.) (Collection ''Plastique.'' 11.) Cover illustration.

100. PASSERON, RENE. André Masson et les puissances du signe. Paris, Denoël, 1975. 87 p. incl. illus. (some col.). Published on the occasion of the exhibition at Galerie de Seine, Paris, Oct.–Nov. 1975.

101. PASSERON, ROGER. André Masson. Gravures 1924–1972. Fribourg, Office du Livre, c1973. 176 p. incl. illus. 51 plates (most col., some double), 3 original lithographs. Includes: Introduction.—Les techniques de la gravure d'André Masson.—Catalogue des gravures.—Dates des principales estampes. Limited edition of 700 with 3 unsigned original color lithographs.

102. PIA, PASCAL. André Masson. Paris, Gallimard, c1930. 63 p. incl. 24 plates, port. (Peintres nouveaux. 41.) Includes: ''Ouvrages illustrés par Masson,'' p. 16.

V. ARTICLES ON MASSON
Brief exhibition reviews are listed under the corresponding exhibition.

103. ALFORD, JOHN. The universe of André Masson. *College Art Journal* (New York) v. 3, no. 2, Jan. 1944, p. 42–46.

104. ALLOWAY, LAWRENCE. Masson and his protagonists. *Art News and Review* (London) v. 7, no. 7, Apr. 30, 1955, p. 4.

105. André Masson. *Art News and Review* (London) v. 7, no. 6, Apr. 16, 1955, p. 1 incl. illus.

106. André Masson. *Cahiers du sud* (Marseilles) v. 15 (Feb.–June 1929) n.p. [11] p. plus 5 illus. Articles by Jacques Baron, Joë Bousquet, Stanislas Boutemer, André Delons, Hubert Dubois, Paul Eluard, Marcel Jouhandeau, Michel Leiris, Georges Limbour.

107. ARLAND, MARCEL. Victoire de Masson. *In his* ''Chronique de la peinture moderne.'' Paris, Corrêa, c1949, p. 67–71 plus 1 plate.

108. ARTAUD, ANTONIN. ''Le plus grand peintre du monde'' [André

Masson] *XXe Siècle* (Paris) n.s. v. 36, no. 43, Dec. 1974, p. 78.

BALLARD, JEAN. Passages à Marseille d'André Masson, 1929–1939. See bibl. 252.

109. BATAILLE, GEORGES. André Masson. *Labyrinthe* (Geneva) v. 2, no. 19, May 1, 1946, p. 8 incl. 2 illus.

110. ––––––––––. Le bleu du ciel. *Minotaure* (Paris) no. 8, June 15, 1936, p. 51–52 incl. 1 illus.

111. BECKETT, SAMUEL. Masson. *Transition Forty-nine* (Paris) no. 5, 1949, p. 98–100. A dialogue between Samuel Beckett and Georges Duthuit.

BENESCH, OTTO. See bibl. 228.

112. BETTEX-CAILLER, NANE. André Masson. *Cahiers d'art-documents* (Geneva) no. 107, 1959, p. 1–16 incl. 6 illus. port. facsim. Preface by Georges Limbour.—Includes detailed biographical chronology, bibliography, list of exhibitions, books illustrated, and films.

113. BOURET, JEAN. André Masson et la floraison des joies. *Arts* (Paris) no. 281, Oct. 20, 1950, p. 5.

114. BRETON, ANDRÉ. Prestige d'André Masson. *Minotaure* (Paris) no. 12–13, May 1939, p. [13] plus 2 illus. Reprinted in his "Le surréalisme et la peinture suivi de Genèse et perspective artistiques du surréalisme et de fragments inédits" [p. 105–203] New York, Brentano, 1945, p. 155–158, and in bibl. 93.

BROWNSTONE, GILBERT. André Masson. See bibl. 256.

CASSOU, JEAN. See bibl. 243.

115. CHADWICK, WHITNEY. Masson's "Gradiva": The metamorphosis of a surrealist myth. *Art Bulletin* (New York) v. 52, no. 4, Dec. 1970, p. 415–422 plus 10 illus.

116. CHAMPIGNEULLE, BERNARD. André Masson ou La joie de peindre. *France illustration* (Paris) v. 6, no. 264, Nov. 4, 1950, p. 493 incl. 2 illus. port.

117. CLEBERT, JEAN-PAUL. Georges Bataille et André Masson. Les *Lettres nouvelles* (Paris) May 1971, p. 57–80.

COGNIAT, RAYMOND. See bibl. 229.

COOPER, DOUGLAS. See bibl. 212.

118. CRUM, PRISCILLA. "There is no finished world." *Baltimore Museum of Art News.* Feb. 1949, p. 1–4 incl. 1 illus.

119. DAUMAL, RENE. André Masson—Métamorphose. *Le Grand Jeu* (Paris), no. 2, Spring 1929.—Text accompanying illustration between p. 32 and 33.

120. DU BOUCHET, ANDRE. André Masson. *Transition Forty-nine* (Paris) no. 5, 1949, p. 89–91 plus 3 illus.

121. DUBY, GEORGES. Chronologie d'André Masson. *Cahiers du sud* (Marseilles) v. 48, no. 361, 1961, p. 454–458.

––––––––––. See also bibl. 247, 250, 269.

DUTHUIT, GEORGES. See bibl. 201.

122. EINSTEIN, CARL. André Masson. Etude ethnologique. *Documents* (Paris) v. 1, no. 2, May 1929, p. 93–105 incl. 15 illus.

123. ELUARD, PAUL. André Masson. *In his* "Capitale de la douleur." Paris, Gallimard, 1926, p. 109. Reprinted in his "Donner à voir." Paris, Gallimard, c1939, p. 186.

124. ––––––––––. André Masson: Au pays des hommes. *In his* "Voir." Geneva, Paris, Editions des Trois Collines, c1948. p. 63–65 incl. 2 illus. (1 col.) See also bibl. 93.

125. FRANCA, JOSE-AUGOSTO. André Masson, 1965. *Colóquio* (Lisbon) no. 37, Feb. 1966, p. 21–26 incl. 4 illus. Text in Portuguese.

GAMZU, HAIM. André Masson. See bibl. 244.

126. GEORGE, WALDEMAR. Les anticipations d'André Masson. *Prisme des arts* (Paris) no. 17, 1958, p. 6–8, incl. 3 illus.

127. GUERNE, ARMEL. André Masson. Pertinence de la lumière. *Cahiers du sud* (Marseilles) v. 44, no. 342, 1957, p. 334–336.

HAFTMANN, WERNER. See bibl. 241, 242, 245.

HENTZEN, ALFRED. See bibl. 224.

128. HOLLIER, DENIS. Le dessin vivant. *Critique* (Paris) v. 24, no. 296, Jan. 1972, p. 23–31.

129. HUGNET, GEORGES. Peinture poésie. *Pagany* (Boston) v. 1, no. 2, Spring 1930, p. 107–108.

130. JOUFFROY, ALAIN. André Masson en 1924. *XXe Siècle* (Paris) n.s. v. 36, no. 43, Dec. 1974, p. 79–84 incl. 6 illus.

131. JOUHANDEAU, MARCEL. André Masson. *La Nouvelle Revue française* (Paris) v. 25 (1925), p. 377–379.

132. KAHNWEILER, DANIEL-HENRY. André Masson. *Das Kunstwerk* (Baden-Baden) v. 15, no. 1/2, July/Aug. 1961, p. 3–13 incl. 10 illus.

133. ––––––––––. André Masson, illustrateur. *In* Skira, Albert. [Vingt ans d'activité.] Paris, Skira, 1948, p. 20–22 incl. 1 illus.

––––––––––. See also bibl. 204, 222, 225, 239, 241, 242, 249, 253, 268.

134. LASSAIGNE, JACQUES. L'Evolution d'André Masson. *Revue de la pensée française* (Paris) v. 11, no. 7, July 1952, p. 50–52 incl. 1 illus.

135. LEIRIS, MICHEL. André Masson. *The Little Review* (Chicago) v. 12, no. 1, Summer 1926, p. 16–17 plus 1 illus.

136. ––––––––––. Espagne 1934–1936. (Exposition d'André Masson à la Galerie Simon.) *La Nouvelle Revue française* (Paris) v. 48, Jan. 1937, p. 135–136. Reprinted in bibl. 97.

137. ––––––––––. Le monde imaginaire d'André Masson. *In his* "Brisées." Paris, Mercure de France, 1966, p. 267–268. First written as introduction to bibl. 240.

––––––––––. See also bibl. 246.

138. LIMBOUR, GEORGES. André Masson. *Arts de France* (Paris) no. 15–16, 1947, p. 50–59 incl. 5 illus.

139. ––––––––––. André Masson: le dépeceur universel. *Documents* (Paris) v. 2, no. 5, 1930, p. 286–287 plus 2 p. of illus. Reprinted in bibl. 97.

140. ––––––––––. André Masson et la nature. Les *Temps modernes* (Paris) v. 6, no. 61, Nov. 1950, p. 938–943.

––––––––––. "L'homme-plume." See bibl. 97, 198.

141. ––––––––––. Sur une exposition d'André Masson. Les *Temps modernes* (Paris) v. 1, no. 7, Apr. 1946, p. 1337–1341. Reprinted in bibl. 97.

142. ––––––––––. Tableaux récents d'André Masson, *XXe Siècle* (Paris) n.s. no. 6, Jan. 1956, suppl. p. [78–79] incl. 3 illus.

MALBOS, LOUIS. Le point Aix dans la trajectoire d'André Masson. See bibl. 269.

143. MARTIN, RICHARD. André Masson: anarchism of the spirit. *Arts Magazine* (New York) v. 48, no. 2, Nov. 1973, p. 72–73 incl. 4 illus. (1 col.)

144. Masson, André. *Current biography* (New York) v. 35, 1974, p. 258–260 incl. port.

145. MAURIAC, CLAUDE. André Masson et les quatre éléments. *Figaro littéraire* (Paris) July 25, 1959.

146. MELVILLE, ROBERT. André Masson. *Arson* (London) no. 1, Mar. 1942, p. 25–26.

147. MICHELSON, ANNETTE. Masson and Malraux. *Arts* (New York) v. 34, no. 7, Apr. 1960, p. 9.

148. MILLER, JACQUES-ALAIN. "André Masson n'existe pas." Par Jacques-Alain Miller et François Regnault. *XXe Siècle* (Paris) n.s. v. 34, no. 38, June 1972, p. 34–37 incl. 3 illus.—Summary in English.

149. PAGE, A. FRANKLIN. "Seeded earth" by André Masson. *Bulletin of the Detroit Institute of Arts* v. 32, no. 1, 1952–53, p. 23–25 incl. 1 illus.

150. PIEYRE DE MANDIARGUES, ANDRE. Entre trente-six et vingt-six. A André Masson. *XXe Siècle* (Paris) n.s. v. 36, no. 43, Dec. 1974, p. 78.

151. PLUCHART, FRANÇOIS. Masson au Musée National d'Art Moderne.

XXe Siècle (Paris) n.s. v. 27, no. 25, June 1965, suppl. p. [18–19].

152. PRESSLY, WILLIAM L. The praying mantis in surrealist art. *The Art Bulletin* (New York) v. 55, no. 4, Dec. 1973, p. 600–615. Masson, p. 607–611 incl. 5 illus.

153. ROUDAUT, JEAN. André Masson: L'oeuvre et la lumière. *Critique* (Paris) v. 16, no. 217, June 1965, p. 541–554.

RUBIN, WILLIAM. The integrity of André Masson. See bibl. 227, 231.

154. —————. Notes on Masson and Pollock. The rapports between the two artists' work are here examined in terms of critical analysis rather than of polemics. *Arts* (New York) v. 34, no. 2, Nov. 1959, p. 36–43 incl. 9 illus. by Masson.

155. SANDELIN, BORJE. André Masson—universums malare. (The painter of the Universe.) *Paletten* (Göteborg) v. 21, no. 3, 1960, p. 92–93 incl. 5 illus. Text in Swedish.

SAPHIRE, L. M. André Masson: second surrealist period. See bibl. 268.

—————. Notes on a study of André Masson. See bibl. 263.

—————. The surrealist impulse. See bibl. 266.

156. SARTRE, JEAN-PAUL. André Masson et le temps. *L'Arc* (Aix-en-Provence) v. 3, no. 10, Apr. 1960, p. 19–22 plus 1 illus.

SCHULZE, ELFRIEDE. See bibl. 216.

157. TERIADE, E. André Masson. *Cahiers d'art* (Paris) v. 4, no. 1, 1929, p. 41–[45] incl. 8 illus.

VENTURI, LIONELLO. See bibl. 232.

158. VITRAC, ROGER. André Masson. *Cahiers d'art* (Paris) v. 5, no. 10, 1930, p. 525–531 incl. 12 illus.

159. VOLBOUDT, PIERRE. Picasso et Masson. *XXe Siècle* (Paris) n.s. v. 22, no. 16, May 1961, suppl. p. [100–101] incl. 2 illus.

160. WALDBERG, PATRICK. André Masson ou Le monde dans un grain de sable. *XXe Siècle* (Paris) n.s. v. 31, no. 32, June 1969, p. 29–41 incl. 19 illus. (3 col.)

—————. "Il n'y a pas de monde achevé." See bibl. 254.

—————. See also bibl. 251.

161. WILL-LEVAILLANT, FRANÇOISE. André Masson et le livre: dessin, gravure, illustration. *Bulletin du bibliophile* (Paris) 1972: pt. 2, p. 129–155.

162. —————. Catalogue des ouvrages illustrés par André Masson, de 1924 à février 1972. *Bulletin du bibliophile* (Paris) 1972: pt. 2, p. 156–180 plus 8 illus. and 1972: pt. 3, p. 272–304 plus 8 illus.

163. —————. La Chine d'André Masson. *Revue de l'art* (Paris) no. 12, 1971, p. 64–74 incl. 22 illus. (1 col.)

164. ZERVOS, CHRISTIAN. A propos des oeuvres récentes d'André Masson. *Cahiers d'art* (Paris) v. 7, no. 6–7, 1932, p. 232–242 incl. 11 illus.

VI. GENERAL WORKS

165. ALEXANDRIAN, SARANE. L'art surréaliste. Paris, Hazan, c1969, p. 66–73 incl. 4 illus. (1 col.)

166. ARNASON, H. H. History of modern art. Painting, sculpture, architecture. New York, Abrams, [1969]. p. 341, 354–356, 488, 497–499, 501, 506, 540, 543 incl. 3 illus. plus 1 col. plate.

167. BARR, ALFRED H., JR. Cubism and abstract art. New York, Museum of Modern Art, c1936. p. 180, 182 plus 2 illus.—Paperbound edition 1974. Published on the occasion of the exhibition at The Museum of Modern Art, Mar. 2–Apr. 19, 1936.

168. —————, ed. Fantastic art, dada and surrealism. Edited by Alfred H. Barr, Jr. Essays by Georges Hugnet. 3d ed. New York, Museum of Modern Art, 1947, p. 181–183 (4 illus.), 256 and passim. First edition published 1936 as catalog and text for an exhibition.

169. BAUER, GEORGE HOWARD. Sartre and the artist. Chicago and London, University of Chicago Press, c1969. p. 135–144.

170. BOWNESS, ALAN. Modern European art. New York, Harcourt Brace, Jovanovich, c1972. p. 158, 161–164, 166 incl. 1 illus. Originally published by Thames and Hudson, London, c1972.

171. BRETON, ANDRE. Entretiens 1913–1952 avec André Parinaud. Paris, Gallimard, c1952. p. 94, 98, 117, 135, 150, 179, 195, 227.

172. BRION, MARCEL. L'art fantastique. Paris, Albin Michel, c1961. p. 253, 255–256.

173. CABANNE, PIERRE. Psychologie de l'art érotique. Paris, Editions Somogy, 1971. p. 157 (illus.), 161, 167–173 incl. 3 illus.

174. CASSOU, JEAN. Panorama des arts plastiques contemporains. Paris, Gallimard, c1960. p. 570–573 incl. 1 illus.

CHARBONNIER, GEORGES. Le monologue du peintre. See bibl. 60.

175. CHIPP, HERSCHEL B. Theories of modern art: a source book by artists and critics. Contributions by Peter Selz and Joshua C. Taylor. Berkeley, Los Angeles, and London, c1968. Fourth paperback printing 1973. (California studies in the history of art. 11) p. 436–440 and passim. Includes: "Painting is a wager," 1941.—"A crisis of the imaginary," 1944. See also bibl. 26.

176. DELEVOY, ROBERT L. Dimensions of the 20th century. Geneva, Skira, c1965, p. 133, 205, 207, 209 (col. plate), 212. Translation of the French edition.

177. DICTIONARY OF MODERN PAINTING. General editors: Carlton Lake and Robert Maillard. New York, Tudor, 1964? p. 225–226 incl. 1 illus. Translation of the French edition "Dictionnaire de la peinture moderne," Paris, Hazan.

178. DUTHUIT, GEORGES. Mystique chinoise et peinture moderne. Paris, Editions des chroniques du jour, 1936. p. 122–124, 141, 147 incl. 2 illus. English edition, London, Zwemmer, 1936.

179. EINSTEIN, CARL. Die Kunst des 20. Jahrhunderts. 3. Aufl. Berlin, Propyläen-Verlag, c1931. (Propyläen-Kunstgeschichte. 16.) p. 125, 127, 416–427 (12 illus., 1 col. plate), 640–641. First edition published 1926.

180. ELUARD, PAUL. Anthologie des écrits sur l'art. Préface de Jean Marcenac. Paris, Editions Cercle d'Art, c1972. p. 78, 88, 97, 110, 162, 167, 183, 258.

181. HAFTMANN, WERNER. Painting in the Twentieth Century. New York, Praeger, 1965. v. 1, p. 275–277 and passim. v. 2, p. 234–235 (4 illus.) Translation of the German edition "Malerei im 20. Jahrhundert," Munich, Prestel Verlag, c1954–55.

182. HAMILTON, GEORGE HEARD. 19th and 20th century art. Painting, sculpture, architecture. New York, Abrams, 1970. (Library of Art History.) p. 262, 271, 366 incl. 1 illus.

183. HISTORY OF MODERN PAINTING. v. 3 From Picasso to Surrealism. Geneva, Skira, c1950, p. 11, 150, 184 (incl. 1 col. ill.) Translation of the French edition "Histoire de la peinture moderne."—Also other language editions.

184. HUYGHE, RENE, ed. Histoire de l'art contemporain. La peinture. Paris, F. Alcan, 1935. p. 319, 320, 340, 341, 343, 363, 516 incl. 1 illus. First published by installments in *L'Amour de l'art* (Paris) v. 14–15 (1933–34).

185. JANIS, SIDNEY. Abstract & surrealist art in America. New York, Reynal & Hitchcock, c1944. p. 7, 125, 143 (illus.)

186. JEAN, MARCEL. The history of surrealist painting. New York, Grove Press, c1960. passim. illus. Translation of the French original "Histoire de la peinture surréaliste," Paris, Editions du Seuil, 1959.

KRONHAUSEN, PHYLLIS & EBERHARD. Erotic art. See bibl. 67.

187. MORNAND, PIERRE. Vingt artistes du livre. [Par] Pierre Mornand [et] J.-R. Thomé. Avec une introduction de Raymond Cogniat. Paris, Le Courrier Graphique, 1950. p. 193–202 incl. 10 illus.

188. NADEAU, MAURICE. The history of surrealism. With an introduction by Roger Shattuck. New York, Macmillan, c1965. p. 86, 103, 105, 108,

110, 122, 156, 160, 167, 201, 210, 261, 271. Translation of the French edition "Histoire du surréalisme," first published in 2 volumes by Editions du Seuil, Paris, 1945 and 1948.

189. PASSERON, RENE. Histoire de la peinture surréaliste. Paris, Librairie Générale Française, 1968. p. 69–72, 211–216 and passim. illus.

190. PONENTE, NELLO. Modern painting. Contemporary trends. Geneva, Skira, c1960. p. 97, 99, 100, 106, 134 incl. 1 col. illus. Translated from the Italian.

191. RAYNAL, MAURICE. Modern painting. Geneva, Skira, c1953. p. 251, 252, 259 and passim, 2 illus. Translation of the French edition "Peinture moderne," 1953.

192. RUBIN, WILLIAM S. Dada and surrealist art. New York, Abrams, [1969]. p. 172–178, 364–370 and passim. Illus. (4 col.) Also published by Thames and Hudson, London, 1970.

193. ————. Dada, surrealism, and their heritage. New York, Museum of Modern Art, 1968. passim. illus. Published on the occasion of the exhibition at The Museum of Modern Art, Mar. 27–June 9, 1968.—Also shown in Los Angeles and Chicago.

194. SOBY, JAMES THRALL. After Picasso. New York, Dodd, Mead & Co., 1935. p. 91–93 plus 1 plate.

195. WALDBERG, PATRICK. Surrealism. Lausanne, Skira, c1962. (The taste of our time. 37.) p. 65–70 incl. 3 col. illus. and passim. Translation of the French edition.

196. WILENSKI, R[EGINALD] H[OWARD]. Modern French painters. New York, Harcourt, Brace and Co. [1954] p. 280, 303, 305, 307, 308, 311, 313, 320, 325.

197. ZERVOS, CHRISTIAN. Histoire de l'art contemporain. Préface par Henri Laugier. Paris, Editions "Cahiers d'art," 1938. p. 415 (text), 428–431 (7 illus.)

VII. EXHIBITION CATALOGS
Selected one-man shows, arranged chronologically

198. PARIS. GALERIE SIMON. Exposition André Masson. Feb. 25–Mar. 8, 1924. [8] p. 53 works.—Includes: "Histoire de l'homme-plume" par Georges Limbour. (Reprinted in bibl. 97.)

199. PARIS. GALERIE SIMON. Exposition André Masson. Apr. 8–20, 1929. [10] p. 41 works.—Préface par Georges Limbour. (Reprinted in bibl. 97.) Reviewed in *Cahiers d'art* (Paris), v. 4, no. 2–3, 1929, p. 120.

200. NEW YORK. PIERRE MATISSE GALLERY. André Masson paintings. Apr. 29–May 27, 1935. [4] p. 16 works. Reviewed in *Art Digest* (New York) v. 9, no. 16, May 15, 1935, p. 18 and in *Art News* (New York) v. 33, no. 31, May 4, 1935, p. 11.

201. LONDON. WILDENSTEIN & CO., LTD. Exhibition of works by André Masson. Feb. 12–Mar. 6, 1936. 12 p. 34 works.—Preface by Georges Duthuit (in French).

202. PARIS. GALERIE SIMON. André Masson. Espagne 1934-1936. Dec. 7–19, 1936. [4] p. 74 works. Reviewed in bibl. 136.

203. BALTIMORE. MUSEUM OF ART. An exhibition of paintings and drawings by André Masson. Oct. 31–Nov. 22, 1941. [14] p. incl. illus. Cover designed for the catalog by André Masson. 31 works.—Includes bibliography.

204. NEW YORK. BUCHHOLZ GALLERY AND WILLARD GALLERY. André Masson. Feb. 17–Mar. 14, 1942. [8] p. incl. 7 illus. 50 works.—Includes: "André Masson" by Daniel Henry [Kahnweiler].—Bibliographical notes. Reviewed in *Art Digest* (New York) v. 16, no. 11, Mar. 1, 1942, p. 18 and in *Art News* (New York) v. 41, no. 2, Mar. 1, 1942, p. 29.

205. CHICAGO. ARTS CLUB OF CHICAGO. André Masson. May 22–June 13, 1942. [8] p. incl. 2 illus. 40 works.—Text from bibl. 203.

206. NEW YORK. BUCHHOLZ GALLERY. Paul Klee, André Masson & some aspects of ancient and primitive sculpture. Feb. 23–Mar. 20, 1943. [24] p. 16 works by Masson. Reviewed in *Art Digest* (New York) v. 17, no. 11, Mar. 1, 1943, p. 12 and in *Art News* (New York) v. 42, no. 2, Mar. 1, 1943, p. 23.

207. NEW YORK. BUCHHOLZ GALLERY. Drawings by André Masson. May 1–20, 1944. 8 p. 46 works.

208. NEW YORK. PAUL ROSENBERG & CO. Recent paintings by André Masson. May 1–20, 1944. [4] p. 11 works. Both exhibitions (bibl. 207, 208) reviewed in *Art Digest* (New York) v. 18, no. 15, May 1, 1944, p. 22 and in *Art News* (New York) v. 43, no. 7, May 15, 1944, p. 19.

209. NEW YORK. BUCHHOLZ GALLERY. André Masson. Apr. 24–May 12, 1945. [8] p. 42 works. Reviewed in *Art Digest* (New York) v. 19, no. 15, May 1, 1945, p. 11 and in *Art News* (New York) v. 44, no. 6, May 1, 1945, p. 6.

210. PARIS. GALERIE LOUISE LEIRIS. André Masson. Oeuvres rapportées d'Amérique 1941–1945. Dec. 11–29, 1945. [4] p. 36 works.

211. BRUSSELS. PALAIS DES BEAUX-ARTS. André Masson. Jan. 26–Feb. 13, 1946. [4] p. 40 works.

212. LONDON. ARTS COUNCIL OF GREAT BRITAIN. Designs for *Hamlet*, book illustrations, lithographs by André Masson. 1947. 12 p. 82 works.—Introduction by Douglas Cooper.

213. NEW YORK. BUCHHOLZ GALLERY. André Masson. Examples of his work from 1922 to 1945. Feb. 4–Mar. 1, 1947. 12 p. incl. illus. Includes "André Masson on Surrealism and 'abstract' art" (from bibl. 34 and 26).

214. PARIS. GALERIE LOUISE LEIRIS. André Masson. Oeuvres nouvelles. May 13–31, 1947. [4] p. 61 works. Reviewed in *Arts* (Paris) no. 116, May 23, 1947, p. 5 and in *Emporium* (Bergamo) v. 105, no. 630, June 1947, p. 273.

215. PARIS. GALERIE LOUISE LEIRIS. André Masson. Oeuvres nouvelles. Oct. 22–Nov. 20, 1948. [4] p. 36 works. Reviewed in *Kroniek van Kunst en Kultuur* (Amsterdam) v. 10, no. 1, Jan. 1949, p. 36–37 incl. 1 illus.

216. FREIBURG. LANDESAMT FUR MUSEEN, SAMMLUNGEN UND AUSSTELLUNGEN. André Masson. Gemälde und Graphik. Stuttgart und Calw, Gerd Hatje, 1949. 16 p. incl. illus. 52 works.—Text by Elfriede Schulze.

217. NEW YORK. BUCHHOLZ GALLERY. Landscapes by André Masson. Nov. 8–26, 1949. [16] p. incl. 13 illus. (1 col.) 30 works.—"Notes on landscape painting" by André Masson. Reviewed in *Art Digest* (New York) v. 24, no. 4, Nov. 15, 1949, p. 16 and in *Art News* (New York) v. 48, no. 7, Nov. 1949, p. 49.

218. BASEL. KUNSTHALLE. André Masson. Alberto Giacometti. May 6–June 11, 1950. p. 1–15 plus 4 illus. 94 works by Masson.—Includes: "André Masson écrit" p. 6–7. Reviewed in *Werk* (Zurich) v. 37, no. 7, July 1950, Suppl. p. 88.

219. PARIS. GALERIE LOUISE LEIRIS. André Masson. Oeuvres nouvelles. Oct. 20–Nov. 11, 1950. [4] p. 40 works.

220. PARIS. GALERIE LOUISE LEIRIS. André Masson. Oeuvres récentes. Apr. 22–May 10, 1952. [4] p. 37 works. Reviewed in *Studio* (New York) v. 144, no. 713, Aug. 1952, p. 58.

221. NEW YORK. PAUL ROSENBERG & CO. Paintings by André Masson. Feb. 2–21, 1953. [2] p. 15 works.

222. NEW YORK. CURT VALENTIN GALLERY. André Masson. Recent work and earlier paintings. Apr. 7–May 2, 1953. [16] p. incl. 19 illus. 42 works.—Includes: "Toward boundlessness" by André Masson (Feb. 1953).—"André Masson" by Daniel-Henry Kahnweiler. Reviewed in *Art Digest* (New York) v. 27, no. 14, Apr. 15, 1953, p. 19, in *Art News* (New York) v. 52, no. 3, May 1953, p. 47 and in *Arts & Architecture* (Los Angeles) v. 70, no. 5, May 1953, p. 8.

monde achevé'' par Patrick Waldberg.—Biographie. Exhibition part of ''Festival Belge d'Eté.''

255. DORTMUND. MUSEUM AM OSTWALL. André Masson. May 1–June 28, 1970. 24 p. incl. 13 illus. 49 works.—Biographie, p. 21–23.

256. MILAN. GALLERIA SCHWARZ. André Masson. June 4–Sept. 30, 1970. 38 p. incl. 30 illus. (8 col.) 100 works.—''André Masson'' by Gilbert Brownstone (in English, French, and Italian).—Includes chronology, bibliography.

257. PARIS. GALERIE LOUISE LEIRIS. André Masson. Oeuvres récentes 1968–1970. Oct. 30–Nov. 28, 1970. [60] p. incl. illus. (4 col.) 49 works.—Includes: ''Ne pas choisir ses thèmes—être choisi par eux'' par André Masson (1970). Reviewed in *Art international* (Lugano) v. 15, no. 1, Jan. 20, 1971, p. 55–56.

258. AMIENS. MAISON DE LA CULTURE D'AMIENS. André Masson. June–Aug. 1971. Not seen by compiler.

259. LONDON. WADDINGTON GALLERIES. André Masson. Paintings. Jan. 12–Feb. 5, 1972. [12] p. incl. illus. (4 col.) 37 works.

260. MONTBELIARD. MAISON DES ARTS ET LOISIRS. André Masson. Peintures, dessins, gravures, lithographies. Feb. 5–Mar. 5, 1972. [16] p. incl. 4 illus. 70 works.—Includes: ''Orientation bibliographique.''

261. PARIS. GALERIE DE SEINE. André Masson. Période asiatique 1950–1959. Apr. 26–May 27, 1972. [56] p. incl. illus. (3 col.) 25 works (all reproduced).—Texte de Françoise Will-Levaillant. (Reprint, with a few modifications, of bibl. 163.)—Chronology. Reviewed in *Art international* (Lugano) v. 16, no. 6–7, Summer 1972, p. 128–129.

262. BREMEN. MICHAEL HERTZ. André Masson. Bilder aus den Jahren 1922 bis 1972. Nov.–Dec. 1972. [8] p. incl. illus. (1 col.) 21 works.—Includes: ''André Masson,'' Prosa-Poem von Michel Leiris aus Leiris and Limbour ''André Masson et son univers,'' Paris, 1947 (bibl. 97).

263. NEW YORK. LERNER-HELLER GALLERY AND BLUE MOON GALLERY. André Masson. Four decades. Nov. 28–Dec. 23, 1972. [26] p. incl. illus. 28 works.—''Notes on a study of André Masson'' by L. M. Saphire. Reviewed in *Art News* (New York) v. 72, no. 1, Jan. 1973, p. 79.

264. MILAN. GALLERIA SCHWARZ. André Masson. Nuovi acquiti. New acquisitions. Nouveaux achats. May 1973. [4] p. incl. illus. 15 works (all reproduced).

265. PARIS. GALERIE LOUISE LEIRIS. André Masson. Entrevisions. Oeuvres récentes juillet 1972–juillet 1973. Oct. 19–Nov. 24, 1973. [54] p. incl. illus. (12 col.) 35 works.—Includes: ''Notes ayant quelque rapport avec les tableaux et gravures exposés'' par André Masson. Fastened with this: André Masson. Gravures. Oct. 19–Nov. 24, 1973. [28] p. incl. illus. 23 works (all reproduced).

266. NEW YORK. LERNER-HELLER GALLERY AND BLUE MOON GALLERY. André Masson. Nov. 1973. 60 p. incl. illus. (13 col.) 52 works.—''The surrealist impulse'' by L. M. Saphire.

267. ROME. IL COLLEZIONISTA D'ARTE CONTEMPORANEA. André Masson. Opere 1925–1973. Mar.–Apr. 1974. 109 p. incl. illus. (5 col.) 37 works.—Includes tributes to Masson by Michel Leiris, Paul Eluard, André Breton [and others].—Biography.—Bibliography.

268. NEW YORK. LERNER-HELLER GALLERY AND BLUE MOON GALLERY. André Masson. Second surrealist period 1937–43. Apr. 22–May 24, 1975. 32 p. incl. illus. (8 col.) 41 works.—Introduction written by Daniel-Henry Kahnweiler for André Masson's first exhibition at the Buchholz Gallery (Curt Valentin), New York, in April 1942.—''André Masson: second surrealist period'' by L. M. Saphire. Reviewed in *Art international* (Lugano) v. 19, no. 6, June 15, 1975, p. 105.

269. AIX-EN-PROVENCE. MUSEE GRANET–PALAIS DE MALTE. André Masson. Oeuvres de 1921 à 1975. July 10–[Oct.15], 1975. [46] p. plus 24 plates (3 col.) 122 works.—''Chronologie d'André Masson'' par Georges Duby (partial reprint of bibl. 121.)—''Le point Aix dans la trajectoire d'André Masson'' par Louis Malbos.

PHOTOGRAPHY CREDITS

Photographs not acknowledged below were supplied by the owners or custodians of the reproduced works, who are cited in the captions. The Museum of Modern Art, New York, is here abbreviated as MoMA.

The Baltimore Museum of Art: 156; Blue Moon Gallery and Lerner-Heller Gallery, New York: 148, 149, 150, 167, 186, 190, 196; The British Museum, London: 30 bottom; Buchholz Gallery, New York: 66; The Cleveland Museum of Art: 209 upper right; Dupuis, Lausanne: 73; Henri Ely-Aix, Paris: 188; Gianmaria Fontana, Milan: 127 left; Studio Gérondal, Lille: 209 lower left; Harriet Griffin Gallery, New York: 80; Hirshhorn Museum and Sculpture Garden, Smithsonian Institution, Washington, D.C.: 169, 189 top; Jacqueline Hyde, Paris: Frontispiece, 30 top, 33 top, 33 bottom, 40 top, 45 top, 45 bottom, 54, 55, 56, 58, 59 top, 63, 65, 69, 70, 116, 163, 165, 170, 175 bottom, 185, 198, 200; Ralph Kleinhempel, Hamburg: 37; Galerie Louise Leiris, Paris: 8 left, 8 right, 12, 14, 15, 16, 19 bottom, 22 top, 22 bottom, 24, 25 top, 25 bottom, 26,27 top, 27 bottom, 28, 31, 32 top, 34 bottom, 35, 36, 38, 40 bottom, 41 top, 43, 46, 47, 48, 51, 52, 59 bottom, 64, 68, 74, 75, 84, 85 top, 85 bottom, 88 top, 88 bottom, 90 bottom, 91, 92 bottom, 93, 94, 96 bottom, 97, 101 top, 102, 104 top, 104 bottom, 105, 106, 108 bottom, 110 right, 111 top, 111 bottom, 112, 114, 115 left, 115 right, 117 top, 117 bottom, 118, 119 top, 119 bottom, 120, 121, 122, 123 left, 123 right, 124 top, 124 bottom, 126, 127 right, 129 top left, 129 bottom left, 129 bottom right, 130, 131 bottom, 134, 137, 140, 142, 144, 146 top, 154, 161, 168, 173, 174 top, 174 bottom, 175 top, 177, 178, 179, 180, 181 top, 181 bottom, 182, 183, 187, 191, 197, 199; Marlborough Gallery, New York: 207 middle left; The Mayor Gallery, Ltd., London: 42; Mewbourn, Houston: 129 top right; Musées Royaux des Beaux-Arts de Belgique, Brussels: 208 upper left; MoMA, David Allison: 60, 184; MoMA, Kate Keller: 18, 62, 90 top, 92 top, 98, 99, 110 left, 189 bottom, 209 lower right; MoMA, James Mathews: 19 top, 34 top, 172; MoMA, Soichi Sunami: 21 top, 23, 109, 131 top, 152, 166; Museum voor Schone Kunsten, Ostend, Belgium: 208 upper right; Nationalgalerie, Berlin: 17; O. E. Nelson, New York: 207 middle right, 207 lower left, 207 lower right; Piccardy, Grenoble, 96; Eric Pollitzer, New York: 89, 164; Service de Documentation Photographique de la Réunion des Musées Nationaux, Paris: 151, 209 upper left; Royal Library, Windsor Castle, Reproduced by Gracious Permission of Her Majesty Queen Elizabeth II: 210 bottom; John Schiff; New York: 41 bottom, 100, 160; Galerie de Seine, Paris: 61; Adolph Studly, Pennsburg, Pa.: 29, 159, 162; Taylor and Dull, New York: 95; Malcolm Varon, New York: 20, 39, 44, 72, 128, 193, 195

223. Bremen. verlag michael hertz. Das graphische Werk von André Masson. Radierungen und Lithographien, 1924 bis 1952. Vanderausstellung von Januar bis Juli 1954. Bremen, 1954. [15] p. incl. 7 illus., 1 port. 126 works. "Der Verlag Michael Hertz, Bremen organizierte die Ausstellung und besorgte die Herausgabe des Katalogs." Traveled in Germany.

224. Hannover. kestner-gesellschaft. André Masson. Gemälde. Zeichnungen. 1955. [16] p. incl. 14 illus. 71 works.—Text by Alfred Hentzen. Traveled in Germany.

225. London. the leicester galleries. Catalog of a retrospective exhibition of works from 1930 to 1955 by André Masson. Apr.–May 1955. 28 p. incl. illus. 64 works.—Preface by Daniel-Henry Kahnweiler and notes by André Masson "Towards the illimitable" (Feb. 1953) and "Fragments sur Turner." Reviewed in *The Burlington Magazine* (London) v. 97, no. 626, May 1955, p. 155 and *Studio* (New York) v. 150, no. 748, July 1955, p. 25. See also bibl. 104.

226. Paris. galerie louise leiris. André Masson. Peintures récentes et anciennes. May 2–25, 1957. [46] p. incl. illus. (4 col.) 63 works.

227. New York. saidenberg gallery. André Masson. Recent work and earlier paintings. Apr. 7–May 17, 1958. [10] p. incl. illus. 34 works.—Includes: "The integrity of André Masson" by William Rubin, p. [5–7]. Reviewed in *Art News* (New York) v. 57, no. 3, May 1958, p. 13 and in *Arts* (New York) v. 32, no. 8, May 1958, p. 54.

228. Vienna. albertina. André Masson. Graphik. Ausstellung Frühjahr 1958. 15 p. incl. 2 illus. 147 works.—Introduction by Otto Benesch, p. 3–4.

229. Venice. Biennale internazionale d'arte, 29th. June–Sept. 1958. An entire gallery devoted to Masson.—23 works.—Includes: "André Masson" by Raymond Cogniat, p. 246.

230. London. marlborough fine art limited. André Masson. Retrospective exhibition. Oct.–Nov. 1958. [12] p. incl. 8 illus. 45 works.—Includes: "The integrity of André Masson" by William Rubin. Reviewed in *Arts* (New York) v. 33, no. 4, Jan. 1959, p. 17.

231. Beverly hills. edgardo acosta gallery. André Masson. First exhibit in California. Early and recent works. Nov. 3–29, 1958. [4] p. incl. 2 illus. 24 works.—Includes: "The integrity of André Masson" by William Rubin. Also shown in Pasadena, San Francisco, and Santa Barbara.

232. Rome. galleria l'attico. Masson. May 1959. [6] p. incl. 2 illus. (1 col.) 18 works.—Text by Lionello Venturi.

233. Zurich. galerie renee ziegler. André Masson. Gravures 1941–1958. May 17–June 17, 1960. 1 folded p. 20 works.

234. Stockholm. svensk-franska konstgalleriet. André Masson. Oct. 22–Nov. 13, 1960. [14] p. incl. 5 illus. 73 works.—Includes statement by Masson (in French).

235. Paris. galerie louise leiris. André Masson. Dessins 1922–1960. Oct. 26–Nov. 26, 1960. [50] p. incl. illus. (3 col.) 80 works. Reviewed in *Art News* (New York) v. 59, no. 9, Jan. 1961, p. 46, *Arts* (New York) v. 35, no. 4, Jan. 1961, p. 67, *Aujourd'hui. Art et architecture* (Paris) v. 5, no. 29, Dec. 1960, p. 46 and *The Burlington Magazine* (London) v. 102, no. 693, Dec. 1960, p. 550. See also bibl. 159.

236 New York. saidenberg gallery. André Masson. Retrospective exhibition. Feb. 14–Mar. 25, 1961. 10 p. incl. illus. 43 works. Reviewed in *Art News* (New York) v. 60, no. 2, Apr. 1961, p. 13, *Arts* (New York) v. 35, no. 7, Apr. 1961, p. 59 and *The Burlington Magazine* (London) v. 103, no. 697, Apr. 1961, p. 157.

237. Chicago. richard feigen gallery. André Masson. Retrospective exhibition. Apr. 14–May 31, 1961. [16] p. incl. illus. 38 works.—Includes statements by Miró and Matta. Reviewed in *Art News* (New York) v. 60, no. 4, Summer 1961, p. 50.

238. Paris. galerie louise leiris. André Masson. Peintures 1960–1961. Mar. 1–31, 1962. [46] p. incl. illus. (4 col.) 45 works.—Includes statements by André Masson.

239. London. marlborough fine art, ltd. André Masson. Nov. 1962. [8] p. incl. 3 illus. 30 works.—Introduction by Daniel-Henry Kahnweiler. Reviewed in *The Burlington Magazine* (London) v. 104, no. 717, Dec. 1962, p. 561.

240. Geneva. galerie gerald cramer. Le monde imaginaire d'André Masson. Eaux-fortes et lithographies 1934-1963. Oct. 28–Dec. 6, 1963. [12] p. incl. illus. 73 works.—Préface par Michel Leiris.

241. Berlin. akademie der kunste. André Masson. May 3–24, 1964. 59 p. incl. illus. (3 col.) 125 works.—Texts by Daniel-Henry Kahnweiler and Werner von Haftmann. Biography. List of exhibitions. "Bibliographische Notizen."

242. Amsterdam. stedelijk museum. André Masson. June 12–July 19, 1964. [38] p. incl. 16 illus. 124 works.—Texts by Daniel-Henry Kahnweiler and Werner Haftmann (in Dutch).—Includes biography and list of exhibitions.

243. Paris. musee national d'art moderne. André Masson. Mar.–May 1965. [36] p. incl. illus. (6 col.) 237 works.—Préface par Jean Cassou. Notice biographique rédigée par l'artiste. Reviewed in *Art News* (New York) v. 64, no. 4, Summer 1965, p. 47, *Arts* (New York) v. 39, no. 8–9, May–June 1965, p. 80 and *Aujourd'hui. Art et architecture.* (Paris) v. 9, no. 49, Apr. 1965, p. 35. See also bibl. 151.

244. Tel aviv. museum. André Masson. Oeuvre gravée. Apr. 1965. [28] p. incl. illus. 167 works.—Includes: "Réflexions sur la gravure" par André Masson.—"André Masson" par Haim Gamzu.

245. Bremen. michael hertz. André Masson. Gemälde und Zeichnungen aus den Jahren 1923 bis 1964. June 11–Aug. 15, 1965. 28 p. incl. illus. (3 col.) 51 works.—"André Masson" von Werner Haftmann, p. 3–10.—List of exhibitions.

246. Geneva. galerie gerald cramer. André Masson. Dessins, sculptures. Nov. 15–Dec. 30, 1965. 14 p. incl. 17 illus. 44 works.—Préface par Michel Leiris.

247. Lacoste. galerie les contards. Le génie d'André Masson vu à travers ses dessins et ses gravures. July 6–Aug. 7, 1966. [16] p. incl. 7 illus. 53 works.—Avant-propos par Georges Duby.

248. New York. saidenberg gallery. André Masson. Major directions. Sept. 27–Oct. 22, 1966. 10 p. incl. 3 col. illus. 32 works.—List of exhibitions. Reviewed in *Art News* (New York) v. 65, no. 7, Nov. 1966, p. 62.

249. Lyon. musee de lyon. André Masson. 1967. [32] p. plus 24 illus. (2 col.) 99 works.—Avant-propos par Daniel-Henry Kahnweiler.—Biographie. Exhibition part of "Festival de Lyon."

250. Paris. galerie louise leiris. André Masson. Peintures récentes et suite des douze dessins d'une autobiographie mythique. Apr. 19–May 18, 1968. [44], [16] p. incl. 38 illus. (4 col.) Cover illus. is original color lithograph. 60 works.—Préface par Georges Duby.

251. Paris. galerie lucie weil. André Masson. Dessins—pastels—gouaches—sculptures. June–July 1968. [12] p. incl. 4 illus. 67 works.—Introduction by Patrick Waldberg (from: Communication à l'Institut de France, Feb. 7, 1968).

252. Marseille. musee cantini. André Masson. July–Sept. 1968. 80 p. plus 29 illus. (3 col.) 80 works.—Includes: "Passages à Marseille d'André Masson, 1929-1939" par Jean Ballard.—Chronologie, bibliographie.

253. Ferrara. galleria civica d'arte moderna. André Masson. Feb. 9–Apr. 7, 1969. [62] p. incl. illus. (5 col.) 165 works.—Text by Daniel-Henry Kahnweiler (in Italian).—Nota biografica dell'artista.

254. Knokke-le-zoute. casino communal. André Masson. June–Sept. 1969. [88] p. incl. illus. (4 col.) 101 works.—Includes: "Il n'y a pas de